ALBERT PINKHAM RYDER

ALBERT PINKHAM RYDER

Painter of Dreams

by
William Innes Homer
and
Lloyd Goodrich

A Barra Foundation Book

HARRY N. ABRAMS, INC., *Publishers*, NEW YORK

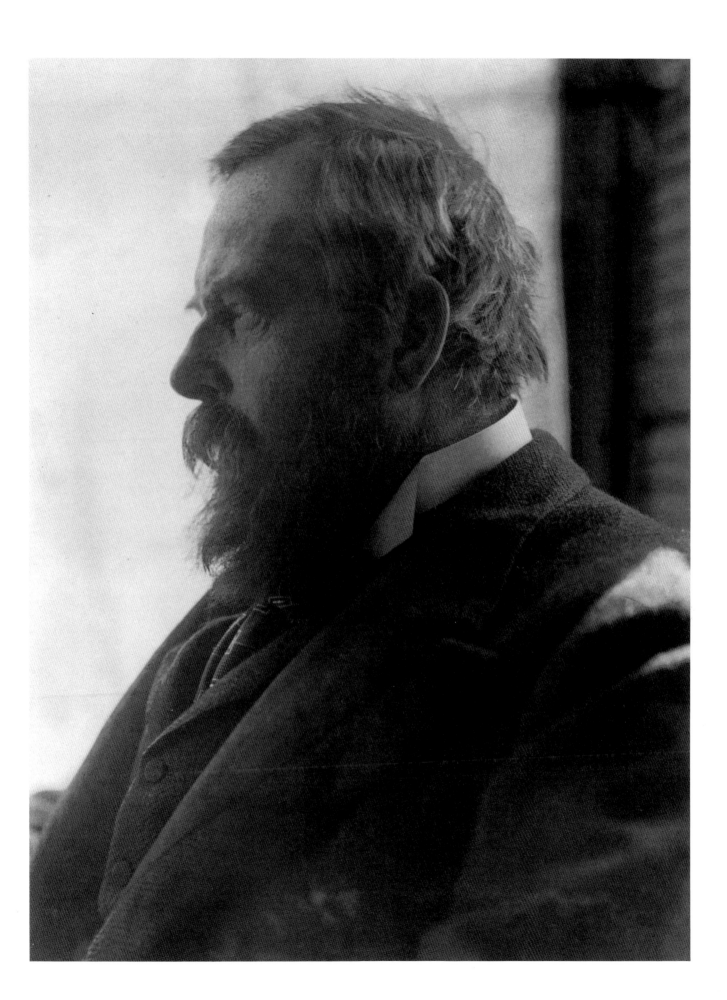

PROJECT DIRECTOR: Margaret L. Kaplan

EDITOR: Mark D. Greenberg

DESIGNER: Dirk J. v O. Luykx

PHOTO RESEARCH: Neil Ryder Hoos

BARRA FOUNDATION CONSULTANT: Regina Ryan

Frontispiece. Alice Boughton. *Albert Pinkham Ryder*. c. 1905.
Photograph, 7⅜ x 5⅝". Private collection

Library of Congress
Cataloging-in-Publication Data
Homer, William Innes.
Albert Pinkham Ryder, painter of dreams / by William Innes Homer
and Lloyd Goodrich.
"A Barra Foundation book."
p. cm.
Bibliography: p. 247
Includes index.
ISBN 0-8109-1599-5
1. Ryder, Albert Pinkham, 1847–1917—Criticism and interpretation.
I. Goodrich, Lloyd, 1897–1987. II. Title.
ND237.R8H66 1989
759.13—dc19
[B] 89-227

Printed and bound in Japan

Contents

Introduction

ALBERT PINKHAM RYDER (1847–1917) was one of the most imaginative painters the American nation has produced. His work flowed from the deeper recesses of his mind, often unconsciously, like a dream. Although he occasionally borrowed—though hardly ever literally—from earlier traditions in European and American painting, his art remained individual and personal. Ryder turned inward during a period when many other American painters looked outward at the world of nature and human activity. Thus he seemed out of tune with his era, a maverick who was overlooked for most of his life. Gradually, during the last few years before his death, he gained wider recognition and after that event rapidly rose to fame and prominence.

Today, Ryder is regarded as one of America's greatest painters, ranking with Winslow Homer and Thomas Eakins. Yet there has never been a full-length scholarly book about him. Previous volumes by Frederic Fairchild Sherman (1920) and Frederic Newlin Price (1932), both dealers, tend toward "appreciation" and are marred (especially the latter) by the inclusion of forgeries.[1] The first and only scholarly book on Ryder was written by Lloyd Goodrich, noted authority on American art and at the time of its publication (1959) director of the Whitney Museum of American Art, New York.[2] Though amply illustrated, it consists of only twenty-six pages of text. Thus, a comprehensive volume about Ryder is urgently needed if we are to recognize fully one of our most accomplished artists.

Ryder has been surrounded by a variety of myths that have clouded our understanding of the man and his work. Many have viewed him as a hermit, an irrational eccentric unable to mix with others. But the research of Lloyd Goodrich and myself has shown that this image is inaccurate and deserves to be changed. Moreover, his paintings were widely forged, and, sadly, some authentic examples were radically altered by others after his death. Thus, existing paintings by or attributed to Ryder have been carefully evaluated so that only genuine works, relatively free of later changes, will serve as the basis for our discussion of his creative development.

Ryder's paintings raise important and intriguing questions about the flowering of American talent far from the main sources of creative invention in Europe. For example, if Ryder was essentially self-taught, how did he align himself so successfully with the great themes of European literary, historical, and religious painting? And how did he become so well acquainted with the styles of this painting when he was supposedly so remote from it? To answer these questions, we have reconstructed as fully as possible what the artist saw, where he traveled, the impressions his fellow artists made upon him, and the nature of his larger cultural environment. In other words, we have examined Ryder's art in context, something done only in a fragmentary way—or not at all—by previous scholars.

Another reason for devoting a book to Ryder is to bring the unusually high quality of his art to the attention of the public. Once his paintings have gone through the sifting process—to reject the spurious—many of them emerge as masterpieces worthy of the deepest appreciation and respect. As one of America's most creative artists, Ryder produced an array of inventive, subtly glowing images that continue to astonish us with their originality. How these works came into existence makes a fascinating story; what they meant to his contemporaries is equally interesting; and the way in which they influenced and inspired a younger generation of artists is also worthy of attention.

This book is a joint effort undertaken by Lloyd Goodrich and me. Unfortunately, Goodrich died on March 27, 1987, and the story of our separate researches, of our eventual collaboration, and of what I did to finish the manuscript after his death should be told here.

Goodrich began his intensive studies of Ryder in 1935. Troubled by a large number of atypical works in a Ryder exhibition at the Kleeman Galleries, New York, held in that year, he began to investigate the thorny question of forgeries in collaboration with Sheldon Keck, conservator of paintings at the Brooklyn Museum, and John I. H. Baur, curator of paintings at that institution. Growing out of this project was Goodrich's effort to gather information about the artist's life and career, with the hope of writing a major Ryder book accompanied by a catalogue raisonné of authentic works. Along the way he organized and wrote a catalogue for a major exhibition of Ryder's work at the Whitney Museum in 1947 and collaborated with Henri Dorra in producing an even larger Ryder show at the Corcoran Gallery of Art, Washington, D.C., in 1961.[3] In 1959 he published his book *Albert Pinkham Ryder*, already mentioned, and also wrote an important text for the Corcoran catalogue. Subsequently, he produced informative articles on Ryder that were printed in *Art News* (1961) and *Art in America* (1968).[4]

In spite of all of these efforts, Goodrich did not complete the definitive book and catalogue he had envisioned. Other concerns—primarily his revised edition of his 1933 Thomas Eakins book and projected catalogue raisonné together with his Winslow Homer research and cataloguing effort and books about Edward Hopper and Reginald Marsh—occupied most of his research time and energy in the 1960s, 1970s, and the better part of the 1980s. Although he was concerned with these and related projects, he continued to reign as the foremost Ryder expert, offering valuable information to museums, galleries, and collectors about works by or attributed to the artist.

For my own part, I had been interested in Ryder's work as early as my teens, especially through reading a laudatory chapter on the artist in Thomas Craven's *Men of Art* (1931). I saw—and continued to admire—Ryder's work in undergrad-

uate and graduate art history courses and during visits to museums; so when I was serving as an instructor at Princeton, I seized the opportunity to write about a newly acquired group of Ryders for the university's *Record of the Art Museum* in 1959.[5]

Having delved deeply into major Ryder issues for this purpose, I continued to collect material on the artist with the hope of writing further about him. This I did in connection with the Corcoran exhibition of 1961, which I reviewed for the *Burlington Magazine*.[6] Subsequently, I gathered still more information about Ryder to satisfy my own curiosity and to support my graduate teaching at the University of Delaware.

From the beginning of my serious Ryder studies I made contact with Goodrich, who graciously provided useful information about the Princeton Ryders. Not only for my Ryder research, but also for my work on Eakins, Goodrich proved to be an indispensable resource and a willing adviser; and throughout the sixties and seventies, our friendship grew. Because he had done so much on Ryder and because our views of the artist were so similar, I asked him in 1984 if he would join me in the writing of a major monograph on Ryder. After thinking the matter over, he agreed that we would actively collaborate, each producing one-half of the manuscript. From that time until his death we worked together in preparing the present book.

Goodrich was to present a biographical and critical text, including a discussion of Ryder's art: its content and imagery; its relation to visual reality; its form, color and design; and Ryder's technical methods. He had hoped to write an introduction, a chapter on Ryder forgeries, and a chronology, but died before he was able to do so. I, in turn, agreed to write on Ryder's pictorial and thematic sources; his artistic development, creative process, and psychological makeup; the critical evaluation of his work, stressing the growth of his reputation; and his influence upon contemporary and younger painters. Goodrich and I also believed it would be important to reprint Ryder's only account of his own views on art and creativity, "Paragraphs from the Studio of a Recluse," and to publish a group of his letters, his poems, and several firsthand accounts of Ryder by those who had known him. We felt, too, that a chronological checklist would be an appropriate addition to this book.

It follows that works discussed and illustrated here, unless otherwise identified, are believed by Goodrich and myself to be authentic; in each case, a combination of stylistic, technical, and documentary evidence points to Ryder's authorship. But if a particular Ryder does not appear in this volume, it is not necessarily thought by us to be a forgery or otherwise unworthy as a work of art. We simply believe that it requires further study, part of a long-range effort to be undertaken in preparation for the publication of a Ryder catalogue raisonné.

For three years Goodrich and I met every two or three weeks (except during the summers) and wrestled with every kind of Ryder problem. One of the byproducts of our collaboration was a series of sessions in which he and I reviewed the records and photographs for each work said to be by Ryder (some one thousand pictures), discussing whether it was or was not a forgery or required further study.

Sheldon Keck agreed to Goodrich's and my offer to write a special section on Ryder's techniques and methods. Keck is the best-qualified person to do this, for he has treated numerous Ryder paintings over the years and understands, better than anyone else, the artist's procedures. It is therefore with great pleasure that we include Keck's contribution to this volume.

Fortunately, I received a fellowship from the University of Delaware's Center for Advanced Studies for the 1985–86 academic year and was able to devote my full

attention to Ryder. During this time, I assembled letters and other documentation helpful to Goodrich, and he, in turn, placed his Ryder archives, including draft catalogue entries for each work, complete through the early 1960s, at my disposal.[7] After an intervening year of teaching and administration, I took a sabbatical leave during the 1987–88 academic year in order to extend my previous researches, inspect personally the great majority of Ryder's extant paintings, and complete my portion of the book. In the meantime—during the summer of 1986—Goodrich had started to write his text.

I did not see Goodrich's manuscript while he was writing. He indicated to me in the winter of 1986–87 that he had completed about three-quarters of it, but I was able to inspect it only after he died. I found that he had worked intensively on his contribution, drawing upon and revising his previous writings and expressing his recent thinking about Ryder. His manuscript consisted of 105 pages, which he had handwritten neatly and precisely on lined paper.

Goodrich and I share an essentially similar view of Ryder. In addition, the resemblance between our writing styles was so great that in chapters 1 through 5 and 7 through 10 I was able to interweave our texts rather than have them stand separately. From time to time within these chapters larger or smaller blocks of Goodrich's text continue without break. The introduction, chapters 6 and 11, the fifteen essays accompanying the full-page color plates, and the afterword were written exclusively by me.

In our thoughts about Ryder there is one noticeable, though not radical, difference between Goodrich and myself. I have treated the artist and his work in a somewhat broader context than Goodrich, moving away from an isolationist or "Americanist" approach, as he himself had begun to do in his last years. Rather than make any major changes in what he wrote, I have merely added more about Ryder's milieu and context, thus creating a picture that I believe is true to Ryder and with which I think Goodrich would have agreed.

For the specialized reader interested in identifying Goodrich's specific contribution, a copy of the typescript of his text has been microfilmed and placed in the Washington office of the Archives of American Art and all of its branches. It is also accessible through interlibrary loan from the Archives' Detroit office.

On behalf of Lloyd Goodrich and myself, I would like to thank the following individuals for their help during the course of our researches: Dr. Doreen Bolger, Paul Cyr, Prof. Henri Dorra, Anita Duquette, Prof. Dorinda Evans, Lawrence Fleischman, Robert C. Friedrich, Leslie Furth, Prof. William Gerdts, Abigail Booth Gerdts, David Goodrich, Christopher Gray, Dr. George Gurney, Joan Haverly, Norman Hirschl, Dr. Susan Hobbs, Jeanne James, Nancy Johnson, Dr. Francis Follin Jones, Dr. Richard Kugler, Maurice J. Leon, M.D., Peggy Madeiros, Alastair B. Martin, Garnett McCoy, Kenneth S. Moser, Tim Murray, Gilder Palmer, Erika D. Passantino, Harold Sandak, Dr. Alice Schreyer, David Smith, Prof. Joyce Stoner, Dr. Kendall Taylor, Robert C. Vose, Jr., Prof. Barbara Weinberg, Thomas Yanul, Virginia Zabriskie, Saul Zalesch, Dr. Judith Zilczer, and the representatives of the numerous museums and galleries who so generously offered information about works by Ryder in their possession. Our heartfelt thanks go to the private collectors who opened their homes to us and provided information about works they own. I also wish to acknowledge Ellen Grossman's photography, in color, of the Ryder works in the Brooklyn Museum; the loan of Sheldon Keck's color transparencies of two of Ryder's paintings reproduced in this volume; and

Harold Sandak's cooperation in providing transparencies of Ryders he photographed at the Corcoran exhibition in 1961, valuable visual records of works that have deteriorated in varying degrees since that time.

During my four years of active research on this project I have benefited from the devoted assistance of Elizabeth Bickley, Jody Blake, Noriko Gamblin, Mark Pohlad, Helen Raye, Laura Rood, and Thayer Tolles. At various times these individuals shared the unglamorous chores associated with the preparation of the manuscript—from photocopying articles to checking end notes, from alphabetizing the bibliography to looking up factual data. My son Stace participated in the editing process, and my daughters Nancy Elizabeth Hyer and Susan Hyer Sharp also helped with filing and proofreading. I am grateful for their cooperation.

Special thanks go to Margaret L. Kaplan, Senior Vice President and Executive Editor of Harry N. Abrams, Inc., for her enthusiastic and continued support of this project. I also wish to acknowledge the editorial expertise provided by Mark D. Greenberg. Regina Ryan, consultant for the Barra Foundation, read the manuscript with great care and made valuable editorial suggestions.

Goodrich and I benefited greatly from a grant awarded to us by the John Sloan Memorial Foundation and wish to thank Mrs. John Sloan for her interest and cooperation. For support of my personal research on Ryder, I am indebted to the Center for Advanced Studies of the University of Delaware, the Delaware Humanities Forum, and the John Sloan Memorial Foundation. Subsidies to help cover the costs of publication of this book were received from the Barra Foundation and the University of Delaware. I am most grateful for this generous financial assistance.

Finally, I would like to express my deepest gratitude to my wife, Christine, who was not only supportive during the entire writing process, but also read the manuscript, chapter by chapter, and made many helpful editorial suggestions.

WILLIAM INNES HOMER

University of Delaware
Newark, Delaware
September 30, 1988

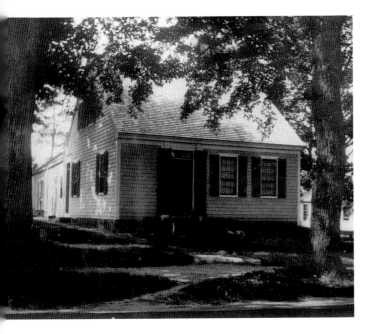

1

Childhood and Youth

Fig. 1–1. The Ryder (or Rider) House, Main Street, Yarmouth, Mass., believed to have been built by Benjamin Rider, Albert Pinkham Ryder's grandfather. Photograph: Frederic Fairchild Sherman scrapbook, in the Lloyd Goodrich–Albert P. Ryder Archive, University of Delaware Library, University of Delaware, Newark, Del. (hereafter abbreviated RA)

ON MARCH 19, 1847, an American artistic genius began his life in the flourishing whaling port of New Bedford, Massachusetts. About Albert Pinkham Ryder's early activities, we know very little. As an adult, he said almost nothing about his upbringing, so to fill in the gaps we must turn to scraps of evidence that have survived the ravages of time.[1] These sources, mostly factual, offer only a skeletal outline which lacks substance and humanity. Yet like detectives working with meager clues, we must use intuition and deductive reasoning to flesh out the picture.

His parents, Alexander Gage Ryder (the family often spelled the name Rider) and Elizabeth Cobb Ryder, had lived in Yarmouth, Massachusetts, on Cape Cod, where their first three children, William Davis (b. 1836), Edward Nash (b. 1837), and Preserved Milton (b. 1839), were born. Albert Pinkham Ryder, the youngest of the four boys, came into the world some seven years after the family moved to New Bedford. We do not know why the Ryders relocated, but judging from the various changes in Alexander's later occupations, including some apparent failures, it may have been to seek employment.

The Ryders and the Cobbs—who often intermarried—could trace their ancestry on the Cape to prominent citizens of the mid-seventeenth century. In the artist's criticism of proofs of a brief sketch of his life that would appear in the *National Cyclopaedia of American Biography* (1900), he urged the publisher to mention Ebenezer Gage, his great-grandfather on his mother's side, "who [had] shouldered arms for the Revolutionary cause."[2] Although the publisher did not follow his suggestion, the biography, as printed, cites the service of Albert Pinkham Ryder's grandfather Benjamin Ryder in the War of 1812.[3] It appears that Benjamin earned his living as a carpenter building houses in Yarmouth, including in all probability the Ryder house on Main Street (fig. 1–1), a typical wooden Cape Cod structure. Benjamin and his second wife Betsy Gage Hawes, widow of Ezra, were said to have been very religious and belonged to a strict Methodist sect whose women dressed in the style of the Quakers.

Little is known of Ryder's father beyond the facts of his later employment and his various places of residence. An intriguing account of Ryder's family, however, by someone known only as "G.C.B.," found among the artist's papers, states that Alexander joined the California gold rush in 1848 and "was distinguished for his nobility of character and high order of courage and decision, and a splendid specimen of one of nature's noblemen; a Titan in strength and stature, suggesting in his manly beauty the heroic characters of Titian's pictures."[4]

The same "G.C.B." wrote a revealing account of Ryder's mother, who was "distinguished for benevolence, self-sacrifice and sympathy . . . a beautiful woman with a beautiful character. It has been said of Albert Ryder's genius that he owed it to his mother—a passionate lover of flowers and beautiful things." Born in Barnstable, near Yarmouth, Elizabeth Cobb Ryder was the granddaughter of Daniel Davis, also of Barnstable, "a gentleman highly esteemed and always prominent in business affairs of both town and country."[5] The account of Ryder's life in the *National Cyclopaedia of American Biography* recited the achievements of this ancestor of whom the painter must have been justly proud: judge of the probate court, judge of common pleas, and later chief justice and "delegate to the Convention that accepted the Declaration of Independence."[6] Of Elizabeth Cobb Ryder's parents, William and Mary, we know nothing.

When Alexander and Elizabeth Ryder brought their three sons to New Bedford about 1840, it was at the height of its activity as the greatest whaling port in the world. City directories cite Alexander's first recorded employment as a laborer; then he became a cab driver, or hackman, later a boarding officer at the United States Customs House; and finally a dealer in prepared fuel—granulated wood. Edward and Preserved at one time or another were seafaring men, the former an ensign on the U.S. gunboat *Young Rover* during the Civil War and later serving on the *Constellation*.[7] William and a partner sold provisions to the Union army during the Civil War, and after the end of hostilities moved to New York City to enter the restaurant business.[8]

Albert was born in an old house at 16 Mill Street opposite the home of Albert Bierstadt's family. Bierstadt, seventeen years older and destined to become a celebrated landscape painter, is rumored to have offered art instruction to the young Ryder, but there is no evidence to support this claim.[9] The neighborhood in which the Bierstadt and Ryder families lived was populated mainly by artisans, mechanics, and tradesmen and was situated close to the commercial district and the nearby wharves. It was not a fashionable location when Ryder was growing up there: the wealthy had moved to higher ground, farther up "the hill," to grander, more pretentious homes. The Ryders eventually moved to this more desirable area, for the New Bedford directories indicate that between 1859 and 1865 they lived at 3 Court Street. Whether they owned or merely boarded in one of the larger houses is not known.

Ryder is said to have attended Miss Knight's School, a private academy;[10] then he went to the Middle Street School, a public grammar school for boys, from which he graduated; but he did not go beyond, as his eyesight had been impaired. If he used his eyes too long they became inflamed and ulcerated—a condition that lasted for the rest of his life. His sister-in-law, Mrs. Edward N. Ryder, told a reporter after his death: "Albert was vaccinated when he was a boy, and the vaccine affected his eyes,"[11] but medical evidence suggests that this was not the cause of his eye trouble.

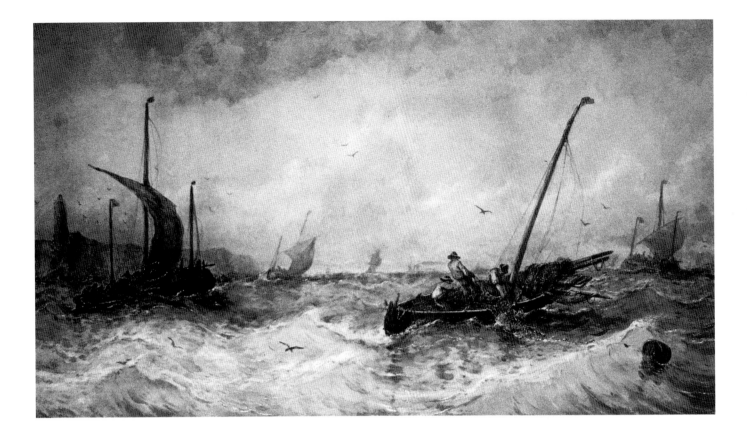

Fig. 1–2. Albert Van Beest. *Fishing Boats, English Channel*. Watercolor and ink, 20¾ x 34½". George Walter Vincent Smith Art Museum, Springfield, Mass.

While it is true that Ryder had only a grammar school education, it should not be judged by today's grade and age levels—first through sixth grade, or ages six through eleven. In his time in New Bedford, grammar school was preceded by primary school (ages four to seven), and "intermedial" school (ages seven to ten). Pupils usually started grammar school when they were ten years old and after completing it took a special test for admission to high school. The majority of Ryder's contemporaries, however, did not advance beyond grammar school. At that level, the curriculum was rigorous and must have offered Ryder substantial training in a variety of fields: geography, moral science, history, physiology, arithmetic, grammar, reading, spelling, and writing.[12]

We assume the young Ryder enjoyed the usual boyhood pursuits in New Bedford, roaming the nearby fields and farmland and absorbing the sights and sounds of the busy waterfront. The sea and sea-lore must have played an important part in his upbringing, for his childhood home was not far from the harbor, and his father and two of his brothers, Edward and Preserved, were involved with maritime pursuits. For Albert, there were cultural advantages as well. Although New Bedford was not Boston, it boasted an athenaeum, a public library, concerts, and lectures. New wealth generated by the whaling industry enabled many of the city's residents to build grand homes in the area surrounding Court Street, where the Ryder family lived after leaving Mill Street. Dignified Greek Revival public buildings were erected during New Bedford's most prosperous years, and these structures, together with numerous imposing homes, nestled close to each other on "the hill," were part of Ryder's daily experience.

There was also a small but flourishing community of artists in New Bedford. Bierstadt has already been mentioned; others of note included William Allen Wall and his student William Bradford, R. Swain Gifford, and, from Holland, Albert Van Beest (one of his marines is reproduced as fig. 1–2). Three of Bierstadt's pictures had been placed on display at the public library, and, besides, this painter had made history in New Bedford by organizing an important exhibition in 1858 of 125 works by 50 artists, mainly living Americans, but including a few Europeans as well. Featuring numerous paintings by Bierstadt himself, the show was held at a music store owned by John Hopkins, who had occasionally displayed a few pictures, including Bierstadt's, on his walls.[13] Although this exhibition was not deemed a success, New Bedford had its share of art patrons and picture-buyers, especially among the whaling merchants. Indeed, the city must have had a strong interest in art, for, during Ryder's boyhood, it was able to support three frame shops.[14]

The proprietor of one of these establishments, Leonard B. Ellis, a public-spirited soul, showed a keen interest in the aesthetic education of his fellow citizens. To that end, he made his shop at 40 William Street a center for the arts (fig.1–3). Although his main source of income seems to have been framing, he continually presented picture shows and semiannual painting auctions, which became major social events. Too, the back room of Ellis's art shop became a rendezvous for a number of prominent citizens who gathered regularly to discuss current cultural and political issues.[15]

Turning again to Ryder: his bent toward art showed early. Mrs. Edward N. Ryder said: "When he was only four years old, he would be found lying on his stomach on the floor, lost to the world in his picture book. He did not care so much about drawing, as long as he had his colors."[16] William, Ryder's older brother by eleven years, gave him a collection of old art magazines that contained engravings of paintings in the Louvre and "sketches of the artists." Ryder studied these intently, writing the artists' names in his scholastic copybook.[17] The classical head reproduced as figure 1–5, drawn in profile, was probably copied from one of these plates.[18]

His first known instruction in art came from an amateur painter named John Sherman, superintendent of the New Bedford Tanning Company on Kempton Street. The young Ryder was sent there by his father to collect a bill and discovered Sherman's paintings covering the walls. According to an early interview, Ryder exclaimed, "Why, if I could paint pictures like that I'd never do anything else."[19] Flattered by this attention, it is reported, Sherman offered to rent a studio on William Street in which the two could paint as they pleased. In this setting, he taught Ryder "to mix colors and to paint" and there encouraged him to copy pictures.[20] Unfortunately, little is known about Sherman or the length of time Ryder spent under his tutelage.

The location of the studio on William Street offers an important clue to Ryder's possible artistic sources. Leonard B. Ellis, already mentioned, not only sold art and framed pictures on the ground floor of his building on that street, but also rented art studios in the upper floors (see fig. 1–4). Because Ellis operated the only establishment of this kind in New Bedford, it is highly probable that the studio in which Sherman and Ryder worked was at Ellis's place. If this is so (or even if it is not), we may assume that Ryder, with his budding artistic interests, would have visited Ellis's gallery to look at paintings and prints, perhaps even to attend the

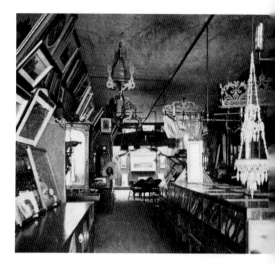

Fig. 1–3. Interior, Ellis's Fine Art Gallery, New Bedford, Mass. c. 1865. Photograph: The Whaling Museum, New Bedford, Mass.

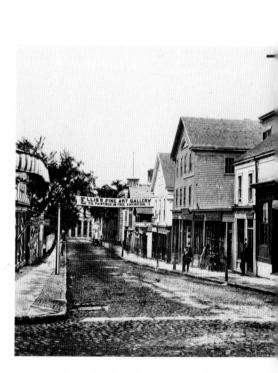

Fig. 1–4. View of William Street, New Bedford, showing, on the right, the building that housed Ellis's Fine Art Gallery. c. 1865. Photograph: The Whaling Museum, New Bedford, Mass.

14

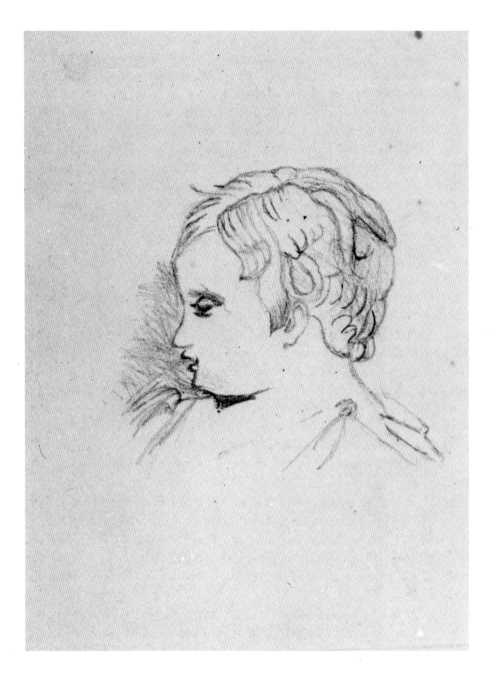

Fig. 1–5. Albert Pinkham Ryder. *Drawing of a Child's Head*. 1853. Pencil on paper, 7 x 5⅛". Present location unknown. Photograph: RA

6 yr old

picture auctions held there. Moving from such circumstantial evidence to educated speculation, it seems likely that Ryder would have come to know Ellis, and that the young artist may even have listened to the lively discussions of art and other matters that took place in the store. Going one step further, it is perhaps no accident that Ryder's wide interests—painting, literature, and music (particularly opera)—exactly parallel Ellis's known concerns. Indeed, we might postulate that Ellis was a major influence on the young Ryder, though to date no conclusive evidence has been found to support this assumption.

It is difficult to generalize about the effects of New Bedford upon Ryder's upbringing during the twenty-odd years he spent there. Certainly no one is immune to the impact of his environment, though, depending upon the individual, it will have a greater or lesser influence. Still, on the most basic level, New Bedford must have

15

offered Ryder substantial cultural resources, both verbal and visual. Art flourished more than one would expect for a city of this size, and there was much civic pride in its cultural benefits, such as lectures and concerts. Being fairly close to Boston there was undoubtedly a degree of influence from that highly cultured city to the north.

On another level, we might attribute Ryder's fascination with the sea and ships to his New Bedford heritage. He could have looked down on the wharves and the sea from both of his houses, the earlier Mill Street home and his later residence at Court Street. These were the wharves to which William Street led, and from a studio there, and from the nearby Customs House where his father worked, he could have seen whaling vessels and other ships entering and leaving port. Even after he moved to New York City, Ryder would often walk down to the Battery and watch the ships, and he is known to have taken ocean voyages to Europe later in life just to observe the sea.

But influence cannot always be measured by a recitation of cultural opportunities and the traits of a physical setting. There is a spirit, an intellectual tone, to be found in every environment; and New Bedford had its own special atmosphere, part of which must have affected Ryder deeply. It was a city, for example, that prized independence and moral virtue. Many of the settlers—Quakers and Primitive Methodists—had come down from the Massachusetts Bay Colony, and thus it became a haven for religious dissenters, intensely pious Protestants who had left religious orthodoxy behind. Although, as already mentioned, culture was prized, it was intended to offer moral edification and to inculcate virtue: sensuality for its own sake was shunned. We do not know if Ryder's parents were religious, or if young Ryder attended church; but the family came from a Methodist background—probably the austere Primitive branch—and Ryder's funeral was conducted by a Methodist minister. Ryder's adult life, as reflected in his letters and reports by his friends, was highly moral and, in the larger sense, committed to spiritual values, with God playing a prominent role in his thoughts and feelings.

On the other side of the coin, New Bedford's major occupation—whaling—called for men with practical minds and physical stamina, down-to-earth and independent. These were the mariners who courageously struggled against two formidable adversaries: powerful mammals of the sea and the sea itself. Indeed, the activity of whaling, involving man's struggle with forces stronger than himself, conjures up romantic images, stories of heroism and conflict, the stuff of which Herman Melville's novels—published as Ryder was growing up—are made. Was not New Bedford the ideal place for Ryder to have been born and raised? Surely these images and legends reinforced his response to the romantic concerns of his era.

In the end, one could almost make a case for Ryder being a mirror of the New Bedford ethos: moral and upright, possessing the Protestant ethic of the middle class, to which he so securely belonged; believing in art and culture for its uplifting, civilizing value, not for sensual delight; embodying a sturdy independence, a quiet demeanor, taciturn, like a sea captain; cherishing the sea and man's relation to it, viewed through clear eyes, yet brimming with romantic tension and conflict. Like the faithful of his city who sought an individual and often mystical relationship to God, he saw his art as a means of spiritual quest and revelation. Like the mystic's meditation, Ryder's art had to satisfy himself as its maker, above all, without concern for public acclaim. If it proved worthy in the personal sense, it might have a larger value, enlightening and instructing others receptive to its message.

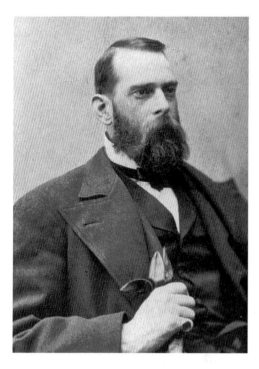

Fig. 2–1. Estabrooke, New York City. *Albert Pinkham Ryder.* c. 1875–80. Copyprint of lost original photograph: RA

Early Years in New York

ALBERT PINKHAM RYDER'S brother William was the most successful businessman of the family. Moving to New York City after the Civil War, he and his wartime partner opened a restaurant at Broadway and Howard Street under the name of Jones and Ryder. It is said to have been the largest of its kind in the city and "much patronized by prominent New Yorkers."[1] Having prospered, he and Jones sold the business in 1876 and bought the Hotel St. Stephen on East Eleventh Street, an establishment William purchased outright two years later. He also became the manager of the nearby Hotel Albert (fig. 2–2) at University Place and East Eleventh Street (contrary to popular belief, it was not named for his artist-brother).[2] About 1867–68, he arranged for his mother, father, and brothers to join him in New York. William, who had married Albertine Burt of New Bedford, appears to have been the main breadwinner of the family and the source of their lodgings. The 1871–72 New York City directory lists William, Edward, Preserved, and Albert, together with their father Alexander, as living at 348 West Thirty-fifth Street (later the family home was moved to 280 West Fourth Street, then to 16 East Twelfth Street). Edward is listed as a clerk and Preserved as a seaman; and for the next three years, Alexander's business is given as "milk." After that, apparently he helped his son William operate the Hotel St. Stephen. From about 1873 to 1880, Edward was employed by the Jones and Ryder restaurant.

At some point after his arrival in the city (the date is not known) Albert Pinkham Ryder applied for admission to the school of the National Academy of Design but was turned down. About this time, however, he was befriended by William Edgar Marshall, a painter and engraver who had studied in Paris under Thomas Couture, Edouard Manet's teacher. Marshall, Ryder said, had been his "master,"[3] and remained, an interviewer reported, "his friendly critic for some years."[4] Although not a teacher in the traditional sense, Marshall encouraged Ryder to persevere and to bring him works for criticism.

Marshall, eight years older than Ryder, was something of a celebrity in his own time, a genial artist who specialized in portraits of famous men—Ulysses S. Grant,

Henry Wadsworth Longfellow, Henry Ward Beecher, and other notables.[5] His most famous work, *Portrait of Abraham Lincoln* (fig. 2–3), was widely admired and often reproduced. After Marshall's death in 1906, Ryder was to write his collector-friend, Dr. A. T. Sanden, with unrestrained admiration, "[Marshall's] portrait [*sic*, read portraits] of Asher B. Durand and his mother are worthy of any museum in the world. Such an insight into character. So true in color. I think he was the greatest portraitist that ever lived."[6] Marshall also painted romantic and religious pictures of a kind that makes one understand why Ryder was attracted to him. Bryson Burroughs, who became curator of paintings at the Metropolitan Museum of Art during the last years of Ryder's life and who knew both Marshall's and Ryder's work well, remarked, "I saw some little paintings by Marshall, romantic and imaginary, inspired perhaps by the late work of Turner, and the idea has often recurred to me that these paintings, while not memorable in themselves, might well have served as the starting-point of Ryder's style."[7] Further, Marshall, as a pupil of Couture, undoubtedly conveyed to Ryder the idea of painting by masses, stressing a broad tonal conception that depended more upon color than drawing. In 1902, one writer, recognizing Ryder's skill as a colorist, asserted that the younger artist "may have imbibed thence [from Marshall] a feeling for warm tonality of color."[8]

Marshall was a lively story-teller and a heavy drinker who, a friend recalled, "was always fond of good food and wine."[9] Although Ryder regretted that he was unable to emulate Marshall's "charming personality,"[10] he may well have followed Marshall's lifestyle in certain other respects. The older artist had an unfashionable studio at 711 Broadway, two flights above a store, and while he enjoyed visits by friends and fellow painters, he did not mix with stylish artists and collectors. Nor did he often exhibit his work. In his later years Marshall became something of a recluse, out of the mainstream.

After working for a time under Marshall's tutelage, Ryder applied again to the National Academy (fig. 2–4), presenting a picture on which Marshall had given a critique, and he was admitted. Ryder studied at the Academy for four seasons: 1870–71, 1871–72, 1872–73, and 1874–75.[11] His studies were in the antique drawing class under Lemuel E. Wilmarth, except for the 1871–72 season in the life class, also under Wilmarth.

Concerning the Academy's antique class, Thomas Anshutz, a student in that class in the mid-1870s and later a successful painter and teacher in Philadelphia, offered the following account:

The Antique is as follows. From the days of ancient Greece and Rome to the present day many fine and perfect figures have been sculptored [*sic*] of which numbers are in a broken and ragged condition while some are perfect. The Antique school consists of models taken from these celebrated statues. . . . These are all arranged in halls, alcoves, rooms, &c in promiscuous order. . . .

Well when the promising young Genius enters the Acad. with the idea of at once making his mark and fortune, he goes into this branch where he is given some head with strongly marked features which he works at for two or three weeks immensely to his own satisfaction. Then there comes an art critic (he comes 3 times per week) who probably say's, "Well your drawing has some good points but you had better not waste any more time on it as it is hopelessly spoiled."

Fig. 2–2. Hotel Albert, University Place at East Eleventh Street, New York City. c. 1950. Photograph: RA. The original Hotel Albert is the building partly visible on the far left. The taller building adjoining it is the "New Albert"

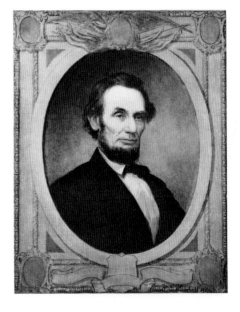

Fig. 2–3. William E. Marshall. *Portrait of Abraham Lincoln*. 1864. Oil on canvas, 21¼ x 16¼". The New-York Historical Society, New York City

So you work away at other heads which he suggests[,] giving you more difficult and delicate faces until you are thoroughly convinced that you are an ass. When you are driven entirely mad and are suicidal he deals out some encouragement and points out your defects in a mild manner.

By and by you are given a full length figure and after much hard labor and many defeats you are (if your ability ever enables you to attain so much) promoted to the life school over which we gently drop the veil.[12]

Drawing, rather than painting, was taught in both the life and antique classes, so Ryder, following the established curriculum, received no instruction in color, composition, or design at the Academy.[13] This limited art education contrasted with the extensive training that many of his colleagues were getting at home and in Europe. The young painter J. Alden Weir, who entered the Academy in 1870 and became Ryder's friend, recalled, "His work done at the school was more in the shape of notes."[14] Color he taught himself, with aid, no doubt, from Marshall. But these efforts were mainly self-directed, and Ryder never enjoyed (or perhaps did not wish to have) thorough formal and technical training, nor did he ever learn to draw really well.

Weir remembered that Ryder's "gentle & timid nature made him a favorite with everyone."[15] Despite his gentleness, however, "one could feel the resolute confidence and high moral courage of the man,"[16] to use the words of another student, James E. Kelly. Besides Weir and Kelly, Ryder made friends with other artists in his classes, such as George de Forest Brush, Abbott Thayer, Francis Lathrop, and Helena de Kay. All of these—and Ryder himself—would soon be associated with the Society of American Artists, a rebellious group that distanced itself from the power and influence of the Academy in 1877.

Ryder also mixed with a fun-loving group of art students at a studio rented by Gilbert Gaul and Stephen G. Putnam called "The Rookery." Putnam recalled, years later, that "Ryder, Olin Warner, the sculptor, [Will] Denslow, C. Y. Turner and others could come up to the Rookery after class hours to talk art and smoke, play poker. . . . "[17] Ryder would also join the student parties that took place in the Academy's coat room. Kelly recalled: "One day [Frederick S.] Church came in with his usual breezy western swagger. Ryder said, 'How do you do, Mr. Church.' Church drawled out, 'Ryder—it's you're the Mister, as the great painter. I am only Church, the student!'"[18] (This Church, who was a fellow student, should not be confused with Frederick E. Church, the great Hudson River School painter.)

In the summer following his first year at the Academy, Ryder returned to Massachusetts to live and paint at his grandfather's place on Cape Cod. Later, he told a reporter that he took easel and canvas into the fields for a month to try to capture nature's colors, but the vibrant panorama of the landscape was simply too overwhelming and thus he could not seize it in pigment.[19] As he recalled at another time, "In my desire to be accurate I became lost in a maze of detail. Try as I would, my colors were not those of nature. My leaves were infinitely below the standard of a leaf, my finest strokes were coarse and crude."[20] He became even more discouraged when he realized that, though his family had supported him and hoped for positive results, he could not produce anything of value. Finally, prodded by one of his aunts who had asked to see his work, Ryder vowed to capture nature on canvas or else give up painting.[21] The outcome of his determined effort changed his way of looking at the world. He recalled:

Fig. 2–4. National Academy of Design, Fourth Avenue and Twenty-third Street, New York City, now demolished. c. 1870. Photograph: National Academy of Design, New York City

19

The old scene presented itself one day before my eyes framed in an opening between two trees. It stood out like a painted canvas—the deep blue of a midday sky—a solitary tree, brilliant with the green of early summer, a foundation of brown earth and gnarled roots. There was no detail to vex the eye. Three solid masses of form and color—sky, foliage and earth—the whole bathed in an atmosphere of golden luminosity. I threw my brushes aside; they were too small for the work in hand. I squeezed out big chunks of pure, moist color and taking my palette knife, I laid on blue, green, white and brown in great sweeping strokes. As I worked I saw that it was good and clean and strong. I saw nature springing into life upon my dead canvas. It was better than nature, for it was vibrating with the thrill of a new creation. Exultantly I painted until the sun sank below the horizon, then I raced around the fields like a colt let loose, and literally bellowed for joy.[22]

Fig. 2–5. Albert Pinkham Ryder. *The Red Cow*. Early to middle 1870s. Oil on wood panel, 11⅜ x 12″. The Freer Gallery of Art, Washington, D.C. Photograph: Modern print from The Metropolitan Museum of Art negative, New York City, 1918 (hereafter designated The Metropolitan Museum of Art, 1918)

Ryder realized that painting was not merely an imitation of nature but an equivalent expression that had a life of its own. Thus he intuitively adopted the governing principle of much late-nineteenth-century painting from James McNeill Whistler through the French Symbolists: that painting is artifice, that it can never fully duplicate what the eye sees. While nature may be a point of departure, it must be transformed through the artist's creative imagination. No matter how Ryder's style changed in later years, he never abandoned this belief.

From all of these experiences, Ryder had gained enough skill, by 1873, to have one of his paintings, *Clearing Away*, accepted by the National Academy for its spring exhibition; and his *Landscape* was shown at the Brooklyn Art Association in December that year. (Neither has been identified; perhaps they were the same picture, or are known by other titles.) The first was noticed by the critic of the *World*: "Promising, but coarsely finished."[23] And in 1874 he showed at Brooklyn two works in the spring and two in the fall.

Ryder did not date his paintings—indeed, he usually did not even sign them; and many of them he worked on for years. So the chronology of his works is difficult to determine. But some of those he exhibited can be identified, and there are references to his works in his letters and in contemporary publications. On this evidence, it is clear that many of his paintings of the 1870s and early 1880s were landscapes, often with horses and cattle (see Chapter 6). His friend the critic Charles de Kay, brother of Helena de Kay, wrote in 1890 that he had "won his way chiefly as a landscapist up to a recent time."[24] It seems probable that these early paintings were such works as *The Red Cow* (fig. 2–5), *Evening Glow* (fig. 2–6), *The Barnyard* (plate 1), *Summer's Fruitful Pasture* (fig. 2–7), and *The Sheepfold* (fig. 2–8). These pictures were smaller and more naturalistic in style than his later compositions; but, unlike the painting he described in detail earlier, it is doubtful that they were direct-from-nature sketches. Rather, they appear to be impressions of the country, to which he retreated during his early summers, no doubt on Cape Cod, with its isolated farms, secluded stony pastures, and old stone walls.

The young artist's affection for animals showed in his grazing cows, horses, and sheep. The illumination was seldom full sunlight but that of late afternoon, sunset, twilight, or moonlight. The pastoral poetry of these pictures was completely personal and authentic; they were re-creations, on a modest scale, of scenes well known and loved: a white horse grazing in golden light; a sheepfold in moonlight, with lighted farmhouse windows; a luminous moon with the dark form of a wander-

Fig. 2–6. Albert Pinkham Ryder. *Evening Glow (The Old Red Cow)*. Early to middle 1870s. Oil on canvas, 8 x 9″. The Brooklyn Museum. Loeser Art Fund

Fig. 2–7. Albert Pinkham Ryder. *Summer's Fruitful Pasture*. Middle to late 1870s. Oil on wood panel, 7¾ x 9⅞″. The Brooklyn Museum. Museum Collection Fund

Fig. 2–8. Albert Pinkham Ryder. *The Sheepfold*. Late 1870s. Oil on canvas, 8½ x 10⅝″. The Brooklyn Museum. Gift of A. Augustus Healy

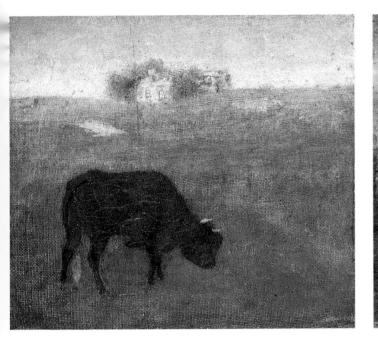

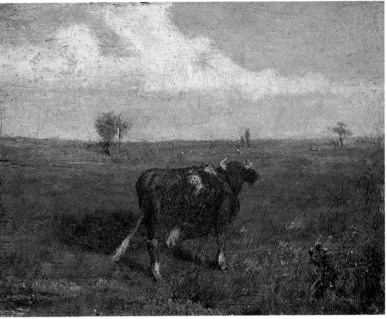

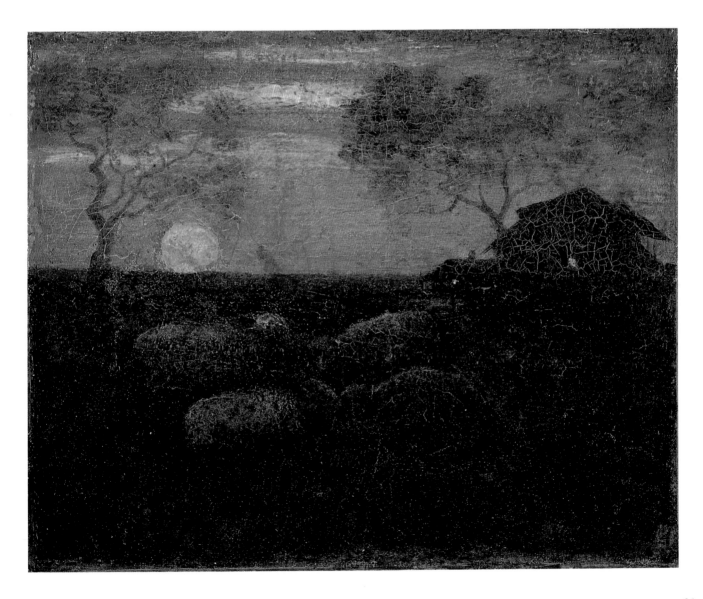

ing cow; a farmer driving home in twilight. The revelation that had come to Ryder in the New England fields remained with him: "No detail to vex the eye. Three solid masses of form and color—sky, foliage and earth—the whole bathed in an atmosphere of golden luminosity."[25] Everything was conceived in large, simple forms, roundly modeled, without precise edges, but alive with an oddly original character. Color and tonality were rich and all-embracing. Although the most naturalistic of Ryder's works, these early paintings already possessed something of the strangeness of dream imagery: landscapes of memory and the inner eye, products of a mind as self-sufficient as that of another near-contemporary, and New Englander, Emily Dickinson. They were at the opposite extreme from the spectacular panoramas of the Hudson River School, then enjoying great popularity.

Ryder did not sell a painting for five years.[26] Like so many others of his kind who had not yet become successful, he exchanged his works with his fellow artists. One of them, Stephen G. Putnam, recalled in later years that "Ryder, the most generous of souls, had been giving some of the boys little color gems he had painted for the pleasure of it."[27] *Landscape with Trees* (fig. 2–9) is one such work; he inscribed on the front: "A. P. Ryder, presented to his friend Geo. de [Forest] Brush about 1880." Henry C. White, Abbott Thayer's biographer, who also got to know Ryder, reported that after W. Gedney Bunce exchanged pictures with Ryder and called on him, Bunce "was disconcerted to discover his own picture, which was painted on a wood panel, lying flat, face upward, on a side table, where Ryder was using it as a place to set his beer mug. The humor of this appealed to Bunce and he did not resent it for he knew that Ryder would have been quite as likely to use one of his own pictures in the same way."[28]

Despite his apparent lack of public appeal, Ryder found a champion in Daniel Cottier (fig. 2–10), a Scot who operated an art and decorating firm in London, with a branch in New York, which opened in 1873.[29] He favored paintings of the Barbizon and Hague schools, and he had imported many such works to sell in the United States. The artists of these schools were considered advanced during their hey-

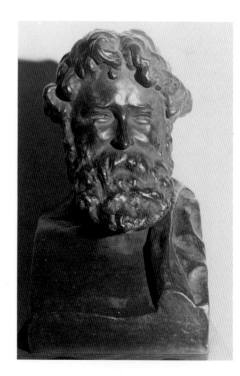

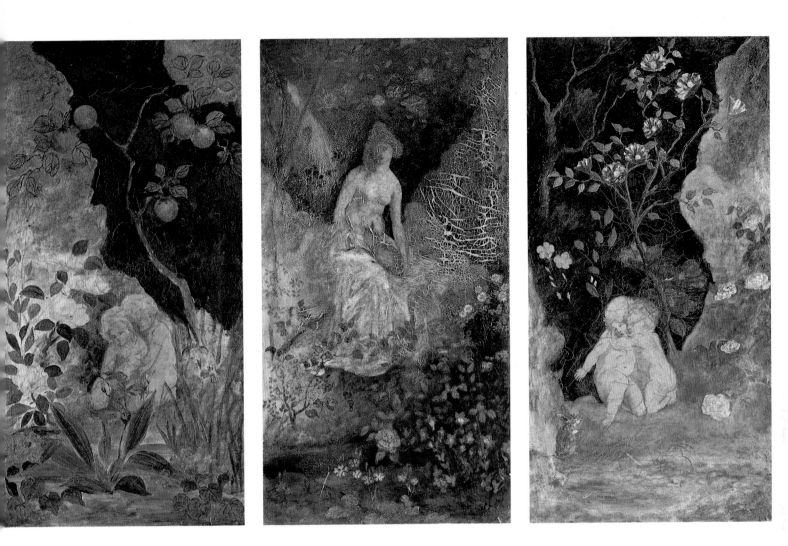

Fig. 2–11. Albert Pinkham Ryder. *Panel for a Screen (Children Playing with a Rabbit)*. Late 1870s. Oil on leather, 38½ x 20¼". National Museum of American Art, Smithsonian Institution, Washington, D.C. Gift of John Gellatly

Fig. 2–12. Albert Pinkham Ryder. *Panel for a Screen (Female Figure)*. Late 1870s. Oil on leather, 38½ x 20¼". National Museum of American Art, Smithsonian Institution, Washington, D.C. Gift of John Gellatly

Fig. 2–13. Albert Pinkham Ryder. *Panel for a Screen (Children and a Rabbit)*. Late 1870s. Oil on leather, 38½ × 20¼". National Museum of American Art, Smithsonian Institution, Washington, D.C. Gift of John Gellatly

day—the 1870s. They stressed tonal values, free painterly brushwork, and the evocation of mood. Landscapes, often populated with rustic figures, were their favorite subject.

Cottier, who maintained homes in London, Paris, and New York, became Ryder's dealer and a good personal friend, as did James S. Inglis, manager of the New York gallery, then a partner, and after Cottier's death in 1891 owner of the business. Walter P. Fearon, an employee of the firm, wrote later: "Mr. Cottier and Mr. Inglis helped support Ryder by giving him from time to time any funds that he was in need of, and it was his custom to give them in return for this accommodation any picture that he thought might please them."[30]

Ryder's entrance into the field of decorative art in the late 1870s and early 1880s may be explained by his ties with Cottier, who undoubtedly secured commissions for him. By this means Ryder came to share that late-nineteenth-century aesthetic credo that brought the decorative arts into prominence and merged them with the fine arts.[31] For instance, in the three screens in the National Museum of American Art (figs. 2–11, 2–12, and 2–13) Ryder applied his ample talents to a decorative problem, creating lively arabesques of flowers and leafy branches, enhanced, in each case, by the presence of nude figures (a female nude in one screen, pairs of children in the other two). In these, Ryder's designs became flatter, more patterned than ever before.

23

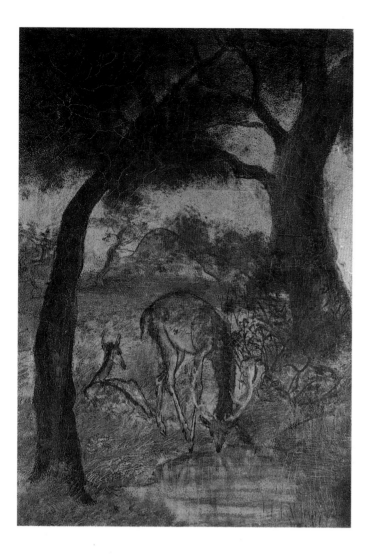

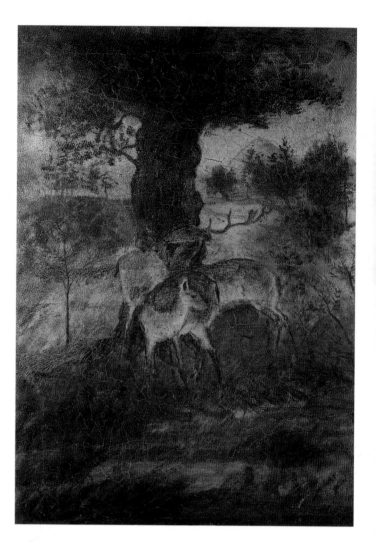

Other decorative pieces flowed from Ryder's brush at this time—*Diana* (fig. 11–17), *A Stag Drinking* (fig. 2–14), and *A Stag and Two Does* (fig. 2–15)—all painted on leather and belonging to a tradition that stressed high aesthetic quality in utilitarian as well as fine arts. Ryder was so successful in this kind of effort that he was lauded by Clarence Cook, art critic for the *New York Tribune*. Lamenting the prohibition against decorative art in the Society of American Artists shows, he asserted: "It might have been allowed to bring here the screen he [Ryder] painted for Mr. Yandell. . . . This is one of the very few examples of real art applied to decoration that has been produced in this country."[32] Unfortunately, we cannot identify the screen in question, but whichever it was, it made a strong and favorable impression on the critic.

During his early years in New York, Ryder entered the circle of progressive artists who gathered around Richard Watson Gilder, poet and assistant editor of *Scribner's Monthly* (and later editor of the *Century*), and his wife Helena de Kay Gilder.[33] She had been a student along with Ryder at the National Academy, a friend of artists Augustus Saint-Gaudens and Winslow Homer, and one of the organizers of the Art Students League, a breakaway group dissatisfied with the teaching at the Academy. The Gilders' home, called "The Studio," at 103 East Fifteenth Street, had become a popular meeting place for creative personalities in the various arts. (Helena is pictured in fig. 2–16.) The architect Stanford White, actors Joseph Jefferson and Madame Helena Modjeska, and the poet Walt Whitman—then a highly controversial figure—received a warm welcome from the Gilders. Artists

Fig. 2–14. Albert Pinkham Ryder. *A Stag Drinking*. Early 1880s. Oil on gilded leather, 27 x 19⅛". Private collection. Photograph: Spanierman Gallery, New York City

Fig. 2–15. Albert Pinkham Ryder. *A Stag and Two Does*. Early 1880s. Oil on gilded leather, 27 x 19". Private collection. Photograph: Spanierman Gallery, New York City

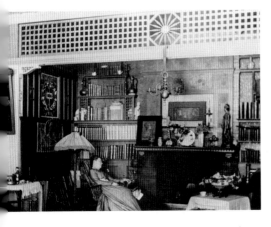

Fig. 2–16. Helena de Kay Gilder at "The Studio," 103 East Fifteenth Street, New York City. c. 1880. Photograph: Collection Gilder Palmer

Fig. 2–17. John Beaufain Irving. *Old Church, Düsseldorf.* 1873. Oil on canvas, 17 x 14″. National Academy of Design, New York City

who were full of excitement about new approaches to their painting and sculpture also found companionship and appreciation at "The Studio."[34]

To this group, academic art seemed stale and conventional. The National Academy of Design, sponsor of the only important exhibitions in New York, was under the absolute control of the conservative academicians, to whom Jean-Baptiste-Camille Corot, leader of the Barbizon School, was a revolutionary. But a new generation trained in Munich or Paris (replacing Rome and Düsseldorf as centers for art training) was beginning to return from Europe with progressive ideas, and some of these artists, in turn, belonged to the Gilder circle. The older academicians refused to adapt themselves to any innovations, and soon battle lines were drawn. Trained mainly in Rome and Düsseldorf, they did not wish to relinquish their power to the younger men and women who considered themselves "full blown artists and the mass of the Academicians as futile old duffers whose work was incompetent or trivial [and] they did not hesitate to say so and even found critics to echo their sentiments in print."[35]

Ryder found himself aligned with the adherents of the "New Movement," as it came to be called. In 1875 he and several other painters, including William Morris Hunt, John La Farge, Abbott Thayer, Francis Lathrop, Maria Oakey, and Helena de Kay Gilder—all of whose paintings had been rejected by the Academy—were invited by Cottier & Co. to hold an exhibition at the firm's Fifth Avenue gallery.[36] This small *salon des refusés*, featuring works mainly in the Barbizon idiom, aroused much interest and generated favorable critical comment. It was one of the events that led to the founding two years later of the Society of American Artists, which was to be the leading liberal artists' organization for the next two decades.

In many respects, the Society grew out of the Gilders' rebellious spirit.[37] Galvanized by the anger of their friend Saint-Gaudens, who in 1877 had had a plaster sketch rejected by the Academy's jury, Helena de Kay Gilder, Wyatt Eaton, Walter Shirlaw, and Saint-Gaudens met at the Gilders' on June 1, 1877, to establish a new art association. (Richard Watson Gilder and Clarence Cook were present but did not become members.) Acting upon a motion by Saint-Gaudens, the American Art Association was formed, its title changed in 1878 to the Society of American Artists.[38]

In the early meetings of the Society additional artists were voted into membership. On June 4, 1877, sculptor Olin L. Warner, soon to be Ryder's close friend, was elected, together with painters R. Swain Gifford, Frederick Dielman, Louis C. Tiffany, and Lathrop. On October 22 J. Alden Weir was elected; and Ryder, along with La Farge and Alexander Wyant, joined in time to participate in the first exhibition of the Society of American Artists held at the Kurtz Gallery in March, 1878.

The Society was far less organized than the National Academy. For many years, it did not have a permanent home for its exhibitions and depended on commercial galleries or even, in one year, the Academy itself. In the long run, there was no real bitterness between the National Academy and Society of American Artists: artists often held dual memberships and submitted their work to exhibitions sponsored by both groups. Yet the Society was clearly a haven for the younger, more progressive artists, often just recently students, who felt free to exhibit works in the newer styles and even sketches or studies; whereas the Academy represented the older, more traditional artists, creators of the larger type of salon picture.

The distinction between the older academicians (fig. 2–17) and the members of the Society of American Artists has been made by Lois Fink: "They favored a

linear style with little interior modeling of forms and a content of sentiment. . . . The new generation was more attracted . . . to artists who were concerned with form as perceived in light and space, and with technique based on direct painting rather than drawing."[39] This change reflected or paralleled the more progressive varieties of European painting in artists such as Édouard Manet and two American expatriates, Whistler and John Singer Sargent, who admired seventeenth-century masters of tone and loose brushwork, such as Rembrandt, Hals, and Velazquez. A fascination with such earlier artists, particularly Hals, is found in the exponents of the Munich School, which enjoyed a following among artists such as Frank Duveneck and William Merritt Chase. Seventeenth-century Dutch landscape appealed especially to the painters of the Barbizon School in France and the Hague School in Holland, and these European artists, in turn, exerted considerable influence upon many of the American painters of the Society of American Artists, Ryder among them.

Ryder remained a member of the Society as long as it lasted. It became his chief exhibiting medium; he showed in its first nine exhibitions, from 1878 to 1887, often several paintings at a time. The critic William C. Brownell wrote in 1880: "If it had not been for the Society of American Artists it is doubtful whether such an unmistakably genuine painter as Mr. A. P. Ryder . . . would ever have had his pictures hung where they could be seen and relatively judged."[40] And on a personal basis he found several good friends among Society members, especially Weir, Warner, and Helena de Kay Gilder.

At the same time, Ryder, like many of his colleagues in the Society, remained on friendly terms with the National Academy and managed to show his work there from 1881 through 1888. But he was not to be elected even an Associate until 1902 (the same year as Thomas Eakins) nor a full Academician until 1906, when the two societies merged.

Because so few newspaper and magazine critics wrote extensively about Ryder's exhibits, it is hard to make generalizations about his reception. Ryder was different, that is certain; and thus he was puzzling to the critics and consequently difficult to deal with. To quote the correspondent of the *Baltimore Sun*: "Mr. Ryder's works have an indescribable charm. They belong to a world of their own, and are more like dream-pictures than like works to be judged by the ordinary canons of criticism."[41]

Nevertheless, from the beginning of his career as a professional artist through the early 1880s, Ryder received comparatively little attention from most critics. His small, unpretentious paintings were usually passed over in silence, or if noticed, received mixed reviews. As the critic of *Scribner's* wrote in June, 1879, about his work in the Society of American Artists exhibition: "Most people did not know what to think of Mr. Albert Ryder's mysterious pictures. . . . They have been much praised and much laughed at."[42] Often his lack of anatomical knowledge and failure to draw "correctly" were condemned. The *New York Times* critic wrote about his *Spring* (fig. 2–18): "Like many of the modern painters, Mr. Ryder appears to be quite deficient in knowledge of the figure. He is an impressionist in so far as he strives for the 'feeling' of a figure rather than to express its anatomy in definite outlines."[43] Many of his early critics, though, excused these failings because Ryder possessed a strong sense of color. About *In the Wood* the same critic remarked: "The artist is a colorist by nature, and in this country, that is a rare thing indeed."[44]

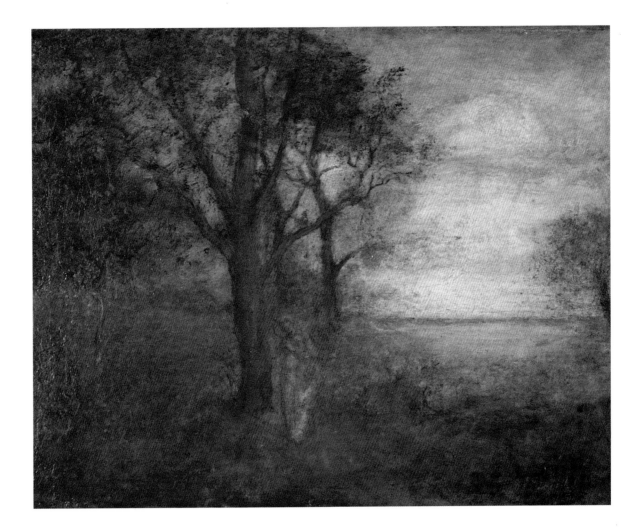

Fig. 2-18. Albert Pinkham Ryder. *Spring (The Spirit of Spring; The Spirit of Dawn)*. Late 1870s. Oil on canvas, 14⅛ x 18⅝″. The Toledo (Ohio) Museum of Art. Gift of Florence Scott Libbey, 1923

Ryder's poetic qualities, like his colorism, seem to have excused his inability to draw in a conventional manner. As the critic for the *Art Journal* wrote about his *Dancing Dryads* (fig. 2–19) in 1881:

> It is full of color, yet we should be at a loss for a color-adjective to apply to its general tone, which seems a kind of illuminated gray. It is morning (early morning before or just at dawn we judge, though that hardly matters to so unreal and imaginative a painter as Mr. Ryder) and three vague and shadowy nymphs have met for their dance before the growing light makes things starkly visible and robs their festival of weird suggestiveness. Anatomically considered, the drawing of these phantoms is not wholly above criticism, perhaps; the one half reclining especially seems visited with impossible angularities from which mortals in general are happily free. But considered as decorative lines and masses embodying a poetic impression, one entertains nothing but admiration for their extreme grace of attitude and harmony of movement.[45]

In view of all that has been said so far, it should be clear that Ryder attached himself to progressive and often unpopular causes in the world of art. In many of his paintings, he reflected the Barbizon tradition, an approach that was then considered very advanced and hence anathema to the more conservative academicians. It is therefore no accident that Daniel Cottier should back Ryder and show his work.

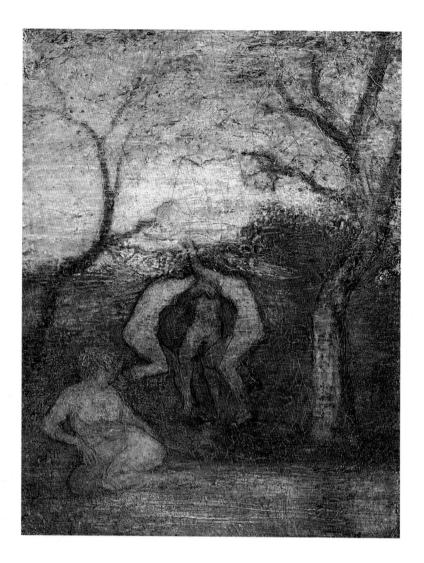

Fig. 2–19. Albert Pinkham Ryder. *Dancing Dryads*. c. 1880. Oil on canvas, 9 x 7⅛". National Museum of American Art, Smithsonian Institution, Washington, D.C. Gift of John Gellatly

Nor should it come as any surprise that the artist was admired and defended in print by Richard Watson Gilder and his wife's brother, Charles de Kay, critic for the *New York Times*. These cultivated individuals, together with Cook, a member of their circle who wrote for the *New York Tribune*, viewed Ryder as an embodiment of all they believed in, artistically and culturally. That they wanted to encourage and nurture Ryder's talent is evident from their writings and actions, but the hopes they pinned on him went beyond personal encouragement. He promised to become a leading American artist who could draw sustenance from our native soil, who was also aware of Europe's achievements but not a slave to them: in other words, an artist who heeded Walt Whitman's call for national pride and identity in our creative productions.[46] Such a strongly pro-American stance was timely because, after the Civil War, patterns of painting, collecting, and criticism had shifted markedly away from American work toward the European, especially that of France and Germany. For a time, those who favored Ryder and artists like him were in the minority; not until the turn of the century did new American art begin to enjoy respect comparable to that given the Hudson River School. It took that long for artists worthy of comparison to Europe's best to emerge and mature. Fortunately, Ryder was to be one of that group, a shining hope for those who believed in him and gave him moral and critical support.

Authors of books on American art published in the 1870s and early 1880s paid little attention to Ryder. George W. Sheldon mentioned the artist in his *American Painters*, published in New York in 1879, but he merely cited Ryder's name as one

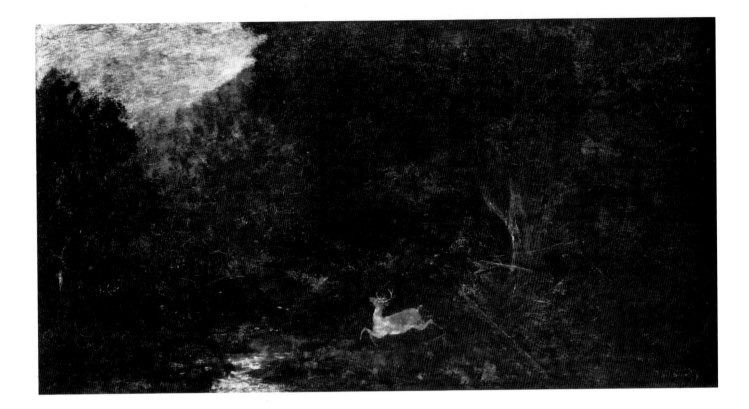

Fig. 2–20. Ralph Blakelock. *The Wounded Stag.*
c. 1880. Oil on wood panel, 21⅜ x 39⅝".
Hirshhorn Museum and Sculpture Garden,
Smithsonian Institution, Washington, D.C. Gift
of Joseph H. Hirshhorn, 1966

of the members of the recently founded Society of American Artists. In the second, enlarged edition of the book, issued in 1880, the author spoke of a fairly large number of painters who were not in the first edition, eighteen who belonged to the "New Movement," many of whom had been associated with the Society, such as George Fuller, Homer Martin, Elihu Vedder, Weir, and Tiffany. But Ryder was dropped from the new edition. In his book *Hours with Art and Artists* (1882), however, Sheldon wrote briefly about Ryder, though without illustrating any of his work. The mention was favorable, stating that his decorations should be considered as artistic as varnish-laden canvases, the implication being that beauty can be found as much in decorative as in conventional easel painting.[46]

In the early 1880s, then, Ryder was far from being a celebrity. His paintings were modest in scale and thus did not command attention on the basis of their size; nor did their quiet, pastoral subjects and delicate poetry cry out from the walls. And while Ryder's work had been taken up by Cottier, his shyness kept him from promoting himself. It is not surprising, therefore, to read De Kay's report that his "first admirers were artists, a sprinkling of amateurs, and one or two art-critics."[48]

One of the marks of an artist's importance is the influence he exerts on other artists. Surprisingly, Ryder had already generated a following—albeit a small one—as early as 1880, when he was only thirty-three. In June of that year, a writer for the *Art Amateur*, reviewing a show at the National Academy of Design, asserted that Ryder now had a "school," which consisted at this point only of Ralph Blakelock, who followed his style closely (fig. 2–20). That writer, however, showed no enthusiasm for the "indigestion of rich, pulpy colors, a series of forms that might be anything" that Blakelock shared with Ryder.[49] In the National Academy's spring, 1882, show, Blakelock's resemblance to Ryder was so close that the catalogue listed one of the latter's works, a marine, as being by the former. According to the critic of the *New York Times*, Blakelock "had caught Mr. Ryder's way of working almost as nearly as it can be done."[50]

Blakelock was not Ryder's only follower in these early years: in the fall Academy show an artist named Grafflin, the *New York Times* noted, joined ranks with Ryder and Blakelock: "Presently we shall have a Ryder school, and a young and modest artist, who has been vegetating obscure and unsought for, may find himself all of a sudden in demand. . . . "[51] Grafflin has dropped from sight, but Blakelock went on to become more famous than Ryder in the opening years of our century—and his paintings brought much higher prices.

Ryder must have gone through some hard times in his early New York years. In a reminiscence written after Ryder's death, his good friend Charles Fitzpatrick, carpenter and former sailor, said:

> Ryder at times would have a fear that he would sometime starve to death. He told me when he first came to New York and started to study at the Academy he did not have much money. His folks were fairly well off, but he wanted to get along by himself, and when he paid his tuition at the Academy and a cheap room rent—there was very little to live on. Sometimes he had bread and milk and sometimes no milk. He kept this up so long he finally broke down, being taken sick with fever and exhaustion. He was found by someone in this state and his brother was notified who took him to his hotel until he recovered.
>
> At first he would eat in the dining room with the guests where his brother gave him a table all to himself, but he would wander about among the help, get chummy with them, and finally dined with the help. This was more than his brother could stand as the help knew they were brothers. So, after some arguments, Ryder left.[52]

In the first ten or twelve years in New York Ryder seems to have lived at various addresses, including a period of residence in the room mentioned above—at Broadway and Ninth Street—and in his family's homes on West Thirty-fifth Street, West Fourth Street, and East Twelfth Street. For a time, his brother William, who encouraged his interest in art, provided a studio for him above the Jones and Ryder restaurant at Broadway and Howard Street. But about 1880 Ryder settled in the Benedick Building at 80 Washington Square East (fig. 2–21), a new six-story edifice in which a number of young bachelor artists lived and worked, including Weir and Warner. Here Ryder remained for about eight or ten years. "I think the room in the Benedict [*sic*] Building was beyond the reach of his purse," his friend John Robinson, an English sea captain and amateur painter, wrote, "at all events, he gave it up, and got domiciled in one of the streets north of 10th Street"[53]—actually East Eleventh Street.

There are few personal accounts of Ryder in his twenties and thirties; most picture him after his forties, when he had begun to be a recluse and an eccentric. In his earlier years he was fairly tall and inclined to be heavy, with a full reddish-brown beard. His fellow student, James E. Kelly, recalled that Ryder possessed "a high, delicately modeled forehead, very fair, almost pearly in effect. Ryder's eyes were inclined to be blue—lustrous, with a frank, confiding look like a fine child. . . . "[54] An early photograph (see fig. 2–1) shows a strong, well-modeled nose, eyes sensitive and introspective—a remarkable face, combining strength and sensibility. Charles de Kay wrote that he had "the highest, most chivalrous, but for the most part silent, admiration for women,"[55] but he was never to marry.

Fig. 2–21. The Benedick Building, 80 Washington Square East (now part of New York University). 1930s. Collections of the Municipal Archives of the City of New York. Courtesy of Christopher Gray

3

Ryder and His Friends

Fig. 3–1. Albert Pinkham Ryder. *Self-Portrait.*
Middle 1870s. Oil on canvas mounted on wood
panel, 6½ x 5″. Collection Mr. and Mrs. Daniel
W. Dietrich II. Photograph, April, 1946, prior
to restoration. RA

RYDER HAS BEEN portrayed as a hermit, a fearful introvert who could not bear
to interact with the people around him. This romantic image, based on his with-
drawal into the privacy of his studio in his later years, has been spread far and wide
by journalists and popular biographers. The result is a distorted portrait of Ryder.
During the 1880s, in particular, he enjoyed many associations with his fellow artists
and others in the world of art, criticism, and literature and with whom he formed
close and lasting friendships. His letters to these people were warm, affectionate,
and idealistic, with no signs of problems or depression; and they reveal how impor-
tant personal relationships were to him. A friend of Daniel Cottier, as well as of
Ryder, Captain John Robinson wrote in 1925: "I have read of Ryder being a re-
cluse. I can hardly think that, for the small luncheon and dinner parties, where a
few friends met, were never complete without him. He never talked much; he was
an excellent listener, and his laugh was very infectious."[1] (Ryder's only extant self-
portrait is reproduced as fig. 3–1.)

Ryder wrote three informative letters from Europe in 1882 (during a trip that
will be discussed in chapter 4), one to the architect William R. Mead (May) and two
to Charles de Kay (May and July), which help us identify his friends and the circle
to which he belonged.[2] In his letter to Mead he asked to be remembered to Stanford
White and Charles Follen McKim, together with George W. Maynard, J. Alden
Weir, Francis Lathrop, and Olin Warner. He instructed Mead to "tell St. Gaudens
to take things easy and to learn to smoke" and inquired about Wyatt Eaton.[3]
Ryder's first letter to De Kay tells of his plan, in Cottier's company, to "hunt up"
the painter Homer Martin after their travels,[4] and in his second letter to De Kay,
Ryder stated that "We met [William Merritt] Chase, [Frederick Porter] Vinton,
[Robert] Blum and [first name unknown] Lundgren in Paris bound for Spain . . .
also R. [Swain] Gifford." He concluded by sending his love to Eaton, White, Weir,
"and everybody."[5] Some of those he mentioned were artist-friends from his years at
the National Academy and some were his associates in the Society of American Art-

ists. But three of them (including the recipient of one of the May letters) were partners in the architectural firm of McKim, Mead, and White, ambitious young professionals who were beginning to break away from traditional designs and were searching for a stylistic language of their own.

Some of the artists just mentioned—Weir, Warner, Eaton, Lathrop, and Maynard—lived in the Benedick Building, where Ryder took up residence about 1880; the painter Robert Loftin Newman, who also became a friend, is known to have lived there, sharing a studio with Eaton. The latter's quarters had become a meeting place for other artists Ryder met and admired: John La Farge and Will H. Low, together with Augustus Saint-Gaudens, whom he knew from the Gilder circle and the Society of American Artists. Gatherings of a more organized kind, also involving Ryder, took place at an informal group, the Art Club of New York, which offered an annual exhibition program. This society, mainly a haven for Society of American Artists members who saw "little or no good in the National Academy,"[6] was founded in 1878 by painters Weir and Bunce. Bunce, together with fellow painter and member Charles Melville Dewey, became a good friend of Ryder, who also belonged.

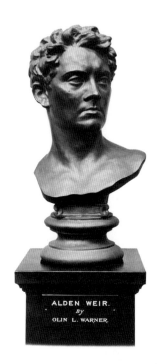

Fig. 3–2. Olin L. Warner. *J. Alden Weir*. 1880. Bronze, h. 22½". The Metropolitan Museum of Art, New York City. Gift of the National Sculpture Society, 1898

Worth mentioning, too, is Theodore Baur, a now-forgotten sculptor, author of a lifesize head of the Sphinx, who remained Ryder's loyal associate over the years. Baur, a member of the Society of American Artists, was described by the critic, playwright, and essayist Sadakichi Hartmann as "a most remarkable Bohemian if there ever was one" and "*ein Schwerenoether erster Klasse*" (a first-class troublemaker). Living with seven cats in Thompson Street, he was, according to Hartmann, "a sculptor of rare ability but too lazy to work." Baur, among others, turned to Ryder for financial help, a request that precipitated the painter's complaint: "It isn't quite fair that people should ask me for money."[7] Yet he remained on good terms with Baur, who visited him from time to time and is mentioned in Ryder's letters.

Ryder's friends were undoubtedly more than just companions. Members of his circle, especially those who lived in the Benedick, had absorbed what Europe had to offer and were now painting, sculpting, and designing independently in New York. This was a time when Weir and Warner were maturing as artists, winning recognition, and gaining a foothold in the New York art world. Undoubtedly through them and his other colleagues Ryder was able to enjoy much of the creative ferment within and outside the confines of the Benedick Building. "There was always time for talk," Weir's daughter Dorothy reported, "at the little French wine shops on the Square or up at a saloon on 14th Street and Fourth Avenue where the barrel beer and Swiss cheese were excellent."[8]

Weir (fig. 3–2), whose father Robert and brother John were painters, was five years younger than Ryder.[9] Paris-trained and a frequent visitor to Europe, fine-looking, energetic, public-spirited, and much liked by his fellow artists, he was an early member of the Society of American Artists and active in its affairs, and a future president of the National Academy of Design. He and Ryder were completely different in personality and in style of painting (fig. 3–3), yet they were devoted friends from their student days at the Academy. Weir married Anna Baker in 1883, and by 1892 the couple had three daughters: Caroline, Dorothy, and Cora. An outdoorsman, a hunter and a fisherman, he and his family passed their summers in Branchville, Connecticut, where Ryder often visited them. Weir was so sensitive to Ryder's needs and desires that he prepared a room for Ryder's exclusive use. As Colonel Charles Erskine Scott Wood, the Portland, Oregon, collector, poet, and

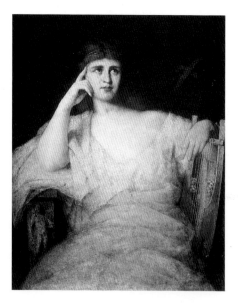

Fig. 3–3. J. Alden Weir. *The Muse of Music*. 1882–84. Oil on canvas, 44¼ x 34½". The Fine Arts Museums of San Francisco. Gift of H. K. S. Williams

lawyer, recalled in 1920: "[Weir] had had a door specially cut from Ryder's room direct into the open so he could come and go without facing the family."[10] The Weirs entertained Ryder in the city, too, offering him a standing invitation to dine with them on Sundays. In turn, he reciprocated by preparing his own homemade perfumes as Christmas presents for the Weirs' daughters. He also showed his gratitude by sending warm, appreciative letters, in which he was able to express himself more openly than he could face-to-face. For important events in their family—marriages, for example—he would send one of his poems especially dedicated to the recipient. (See Appendix 3.)

Like Weir, Olin Warner was completely devoted to Ryder.[11] A gentle and modest soul, amply talented, Warner had struggled heroically in the 1870s to make his mark as a sculptor. As with Ryder, Cottier had become one of his backers, even providing the sculptor with a studio in the firm's Fifth Avenue headquarters. Although Warner had enjoyed thorough academic training in France, he was snubbed by the National Academy of Design and like Weir and Ryder cast his lot with the rebellious Society of American Artists, serving as vice-president in 1881–82. Gradually, Warner obtained a number of commissions, both portraits and architectural works, and in time earned a reputation as one of America's leading sculptors (see fig. 3–4).

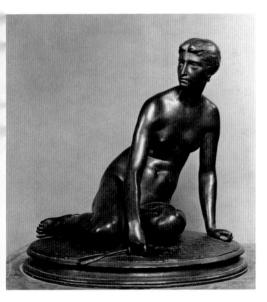

Fig. 3–4. Olin L. Warner. *Diana*. 1887. Bronze, h. 23½". The Metropolitan Museum of Art, New York City. Gift of the National Sculpture Society, 1898

Warner had traveled to Europe with Ryder during the summer of 1882. Four years later, he married Sylvia Martinache, and the couple subsequently had two daughters, Rosalie and Frances. The Warner family, like the Weirs, practically adopted Ryder, often having him to their New York home for dinner, especially on holidays. Tragically, in 1886 Ryder's "dear comrade Olin"[12] was fatally injured in a cycling accident at fifty-two, when he was at the height of his powers.

After Olin Warner's death, Ryder maintained a close and cordial friendship with his widow Sylvia and her daughters, who entertained him at their home from time to time. After one such visit, he wrote her: "I acknowledge how enjoyable the occasion was to me: both in your thought and the feeling that Rosalie and Frances were glad to see me; and the cheery and friendly people you always have and the nice dinner too."[13] Between Ryder and Sylvia Warner there was a great deal of mutual admiration, warmth, and support. In 1897, for example, he wrote her: "I am sure that your letters have done me a world of good in contact with the world."[14] And in a later letter, he stated how ideal she was "in sympathy and touching kindness."[15]

Although Weir and Warner were Ryder's good friends, they were different from him in personality. Closer to Ryder in this regard was Robert Loftin Newman, twenty years his senior.[16] Born in Virginia and raised in Tennessee, Newman had been a student of Couture in Paris and had become acquainted with Jean-François Millet at Barbizon. He painted and taught alternately in Tennessee and in New York City, settling permanently in the latter location in the 1870s. Sometime after his third (1882) trip abroad, Newman took up residence at the Benedick Building, and it is there, presumably, that he and Ryder became fast friends. Charles Fitzpatrick, who with his wife lived below Ryder in later years, recalled "interesting discussions" when Newman would stop to chat with him and Ryder over a cup of tea: "Newman would get very haughty and claim acquaintance with Millet, Corot, Rousseau of the Barbizon School while in France in company with Mr. [William Morris] Hunt. And he would claim that he was among the first to recognize Millet as a great artist."[17]

Although Ryder never was accused of being haughty, similarities between him and Newman were numerous. As art historians Marchal E. Landgren and Albert Boime have pointed out, they shared many friends and collectors, possessed a poetic and mystical temperament, and depended on others to help them deal with practical affairs, including money.[18] Moreover, both painted small works, subtly radiant in color, and in different ways (Newman more than Ryder) reflected the influence of Couture (see fig. 3–5). Moving beyond parallels between the two artists, Boime has suggested that Newman influenced Ryder, presumably in the early 1880s, writing, "It is precisely at this time that Ryder's style shifts abruptly from a pastoral, rural mode to a mystical, religious one."[19] This is an intriguing possibility, but it is more likely, as we will point out later, that the summer Ryder spent in Europe in 1882 was equally or more crucial as a source of change in his art.

Although Ryder counted Weir, Warner, and Newman as his best friends from the artistic community, his ties with Daniel Cottier were also quite close. The Scottish dealer, as already mentioned, exhibited and sold Ryder's work at his gallery at 144 Fifth Avenue; and he promoted the artist in every possible way. Ryder was deeply indebted to Cottier, and to his associate James S. Inglis, both of whom, the artist recalled, "made sterling efforts in the way of patronage and speech to make me understood. . . . " Immensely grateful for Cottier's interest, Ryder praised him

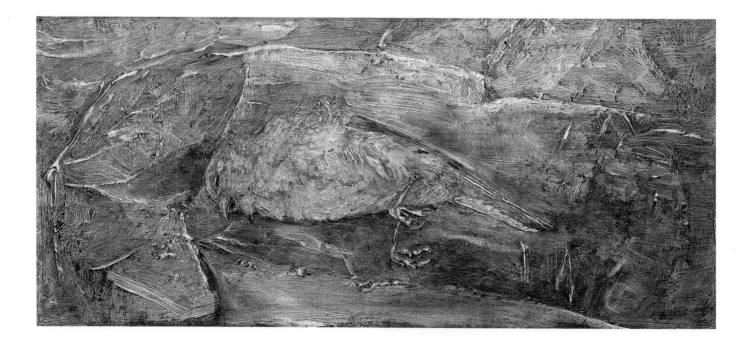

Fig. 3–7. Olin L. Warner. *Charles de Kay.*
1880. Bronze, diam. 8¾″. The Century Association, New York City

as "a man of wonderful intuition and perception in all things; particularly in all art subjects."[20] The genial, witty Cottier had become a tastemaker in New York in the 1870s and by the 1880s was regarded as one of the city's leading dealers. He was unusual among gallery owners because he believed so strongly in American art, being one of the first to take a courageous and controversial stand in favor of native art.

James S. Inglis assumed the ownership of the firm's New York branch after Cottier's sudden death at the age of fifty-three. Also a Scot, Inglis was a collector, particularly of the Barbizon School.[21] For his personal collection he acquired at least nine paintings by Ryder, whom he helped in innumerable ways, not the least of which was aggressively marketing his paintings. As Colonel C. E. S. Wood wrote to Weir: "He [Inglis] has only 3 living Americans he recommends and he does intelligently and forcibly speak of them—Weir, Ryder and Bunce."[22] Feeling that Ryder's drab studio was not suitable for an artist of such genius, Inglis outfitted a room for him in his own beautiful apartment on Fifth Avenue, which he invited Ryder to use any time he wished. "Come and go as you like," said Inglis, "I won't bother you at all." The artist used the room once or twice, but because of "his need of being by himself and without restraint on his moods" returned the key and did not come back.[23]

Inglis remained a bachelor most of his life but eventually married a widow with two nearly grown children. Whenever Mrs. Inglis became tired, she would say: "I feel like a dead canary."[24] No doubt this is what prompted Ryder to give her his painting of that subject, entitled *The Dead Bird* (fig. 3–6), a surprisingly modern work, anticipating Morris Graves, now in the Phillips Collection, Washington, D.C.

Ryder spoke of Charles de Kay (fig. 3–7) "with much warmth and appreciation."[25] A graduate of Yale, he became literary and art critic of the *New York Times* in 1877. He was a prolific poet and essayist and a regular contributor to a variety of periodicals published in New York City and elsewhere. A clubman, De Kay was well connected in New York's artistic and social circles, thanks in part to the prominence of his family. He was, it will be recalled, the brother of Helena de Kay Gilder who, with her husband, Richard Watson Gilder, had become early friends and supporters of Ryder.

Besides being the first to buy a painting by Ryder,[26] De Kay commissioned him to decorate a mirror, entitled *The Culprit Fay* (fig. 3–8), in the early 1880s as a gift for his mother, Janet Halleck de Kay. She was the only child of a New York

doctor, Joseph Rodman Drake, who occasionally wrote poems. One of these was a fanciful verse, "The Culprit Fay" (1816), that dealt with the amorous adventures of a fay (or elf). To illustrate this poem, Ryder created sixteen small panels in a square wooden frame designed by the architect Stanford White and executed under the direction of Cottier.[27] The De Kay family also acquired easel paintings by Ryder and encouraged others, including the Gilders, to do the same. Thomas B. Clarke, the noted collector of American art, was persuaded by De Kay to buy Ryder's *The Temple of the Mind* (plate 5). According to De Kay's widow Edwalyn, "He told Clarke to put the picture on his desk and look at it for several days and he was sure that Clarke would want to get it. . . . Clarke had done so and had fallen in love with the picture and bought it."[28]

Fig. 3–8. Albert Pinkham Ryder. *The Culprit Fay* (frame designed by Stanford White). c. 1882–86. Oil on wood panels, with place for mirror in center, 20¼ x 20¼" (overall). Whitney Museum of American Art, New York City. Joan Whitney Payson Bequest.

4

Europe and Ryder's Emergence as a Mature Artist

Fig. 4–1. The British ship *Britannic* (1874), White Star Line. c. 1880. Modern print from a glass plate negative by an unidentified photographer in the collection of the Mariners' Museum, Newport News, VA

IN A PASSAGE almost certainly provided by Ryder the *National Cyclopaedia of American Biography* (1900) stated, "[He] greatly enlarged his views in the study of the old masters by two trips to Europe in 1877 and 1882."[1] Daniel Cottier, in all likelihood, prodded Ryder into taking his first voyage in 1877 and may even have paid for it. On this journey, lasting a month, he undoubtedly visited with Cottier and his family in London—he and his wife had a son and two daughters—whose company the American greatly enjoyed. On a side excursion to Amsterdam, Ryder went to see the Rijksmuseum, probably in the company of Cottier's Scottish dealer-friend W. Craibe Angus, whose name is paired with Ryder's in the visitors' book.[2] This, however, was a relatively brief trip, not the Grand Tour thought at the time to be essential for an American artist's education. Thanks to Cottier's sale of enough of Ryder's paintings to finance such a tour, the artist was able to spend the summer of 1882 overseas, experiencing Europe's great art treasures.[3]

On May 6, Ryder sailed to Liverpool with the Cottier family on the *Britannic* (fig. 4–1), then proceeded to London, where he stayed in Cottier's fine house, 3 St. James' Terrace, Regent's Park.[4] From there he wrote Charles de Kay that he and Cottier had visited Exeter, Leicester, Coventry ("a delightful old place, so splendid and old that it is moldy"), Stratford on Avon ("what a delightful place"), and had enjoyed a "fine view of the castle at Warwick."[5] On May 27 he wrote his architect-friend William R. Mead that he had just seen the Derby at Epsom, that he had been to Exeter, Salisbury, and Sherborne ("splendid old doorway at latter place in the old cathedral: Ethelbald and Ethelbert[,] brothers of King Alfred are buried there"). In the same letter, he urged Mead to "tell Warner he is a Snoozer not to have been over by this time,"[6] referring to the sculptor's promise to accompany him and Cottier in their travels. Actually, Warner had sailed the day Ryder posted this letter and, after docking at Liverpool, immediately joined his two friends in London. Crossing the Channel, the three made their way to Paris in mid-June to see the official Salon, then continued south to Spain, stopping at Madrid, Seville, and

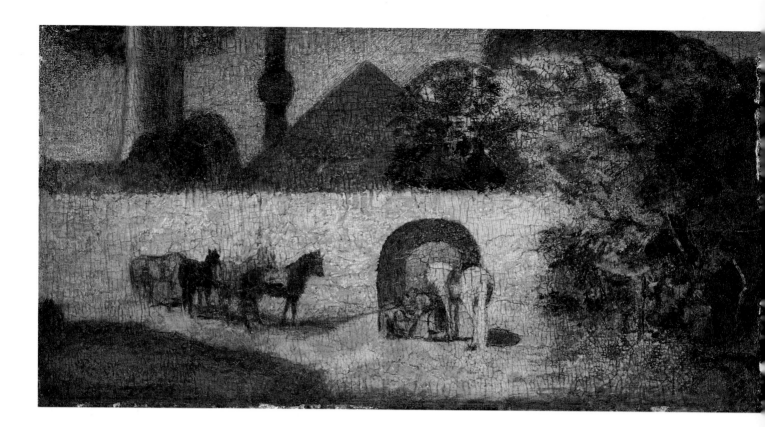

Cadiz. From Cadiz, they sailed to Tangier; and en route, on July 5, Ryder wrote De Kay the first installment of a five-page letter:

Fig. 4–2. Albert Pinkham Ryder. *By the Tomb of the Prophet*. Early 1880s. Oil on wood panel, 5¾ x 11⅜". Delaware Art Museum, Wilmington

> How did you spend the fourth: I passed it on the way between Cadiz and Gibraltar[.]
>
> And am now making with several others including Cottier and Warner a mixed crew or lot of passengers of Moorish, Spanish[,] French, English, Greek[,] Scotch and Americans[.] . . .
>
> I wish you could see the lovely mountains that tower on the Afric coast[;] it would do your poetic soul good, a lovely vapour closes around them and passing over their brow is a lovely cloud between the sight and them giving an indescribable charm to their beauty—Cool and lovely is the air after the hot arid plains of Spain[.] I am quite surfeited with travel and would like to be home again. . . . [7]

We have a record of the Tangier trip in a set of three small sketches of Arabs riding and leading mules with which Ryder illustrated this letter. But this short encounter (plus his imagination) was probably the source of a few presumably later paintings of Arab subjects such as *Oriental Camp* (fig. 6–21) and *By the Tomb of the Prophet* (fig. 4–2).

The letter to De Kay continued:

> I am now aboard the Caldera bound for Marseilles where we expect to bring up Tuesday morning today being Sunday[.]
>
> My trip so far from London has cost me 250 dollars and I have 150 left.
>
> Cottier says I will have to write for money oweing [*sic*] me 150 in New York on the last picture I painted[.] . . . we want to work Rome[,] Naples, Venice, home by way of Switzerland and Germany. Cottier will help me out till we get to London. . . .

Fig. 4–3. Albert Pinkham Ryder. *Untitled* [Venetian Scene]. 1882. Colored pencil on paper, 5⅜ x 7⅞". RA

Fig. 4–4. Albert Pinkham Ryder. *Untitled* [Venetian canal]. 1882. Colored pencil on paper, 5⅜ x 7⅞". RA

I shall be glad to see you once more and all kind friends—
I think I will be benefitted by seeing so much[.] . . .[8]

Ryder's hopes for his agenda were more than fulfilled. The trio traveled to Florence by way of Marseilles and Leghorn, then to Rome and Naples, back to Rome, Florence, and on to Venice, nearby Chioggia, Verona, and Milan. (Ryder represented the Venetian canals in his European sketchbook: figs. 4–3 and 4–4.[9]) Crossing the Alps on foot to Switzerland, they rode on to Cologne, then turned back to Brussels, stopping once again in Paris and London. The three companions sailed from Liverpool on the steamship *Republic*, arriving in New York on October 6.

Although Ryder did not admit in so many words that the works of earlier artists he saw on this trip influenced him, there is considerable evidence that he was indeed affected by these and later contacts with European art. Upon Ryder's and Warner's return, for example, Weir reported: "They are full of the great art treasures they have seen. . . ."[10] Informative, too, are those critics who wrote about Ryder's paintings from 1882 onward. They continually referred to similarities between his style and that of various European schools and masters, both contemporary and earlier. Ryder's work was said to have a medieval Italian look, to resemble the Cinquecento masters, and to be like old Dutch and recent French landscapes. His style was also linked by the critics to such artists as Rembrandt, Frans Hals, Turner, William Blake, Eugène Delacroix, and—closer to his own time—Corot, Millet, Jules Dupré, Narcisse Diaz da La Peña, and Adolphe Monticelli.

The young painter and critic Walter Pach, who knew the artist for the last eight years of his life, observed: "Ryder allowed memories of the great museums to play a constant part in his thinking."[11] Ryder's own extravagant praise of his teacher William Edgar Marshall, "great as Rembrandt and the others are; they were painters and delighted in painting: Marshall's gift for portraiture was more phenomenal," were the words of an enthusiastic and grateful youth—but written in his sixties.[12] Ryder's many surviving letters contain few references to other artists—and those are not revealing—and few general ideas about art. Occasionally, however, hints come from his passing remarks. When Pach left his studio, just before departing for Italy, Ryder hastened to remind his young friend: "Oh, I was forgetting to tell you to give my love to that Rembrandt in the Pitti Palace."[13] Or, from Joseph Lewis French we learn that he "seems to know something on every live topic of importance . . . from Titian's art down to the current sensational murder trial."[14]

Fig. 4–5. Albert Pinkham Ryder. *The Waste of Waters Is Their Field*. Early 1880s. Oil on wood panel, 11¼ x 12". The Brooklyn Museum. John B. Woodward Memorial Fund

For Ryder, one lasting experience, to which he often later referred, was his visit with Cottier and Warner to the London studio of the Dutch painter Matthew Maris, younger brother of the more famous Jacob. Matthew produced decorative work for the Cottier firm, as Ryder himself occasionally did. Eight years older than Ryder, his art had many resemblances to the latter's (see fig. 5–3); and his style of living and working (he was a recluse who labored long over his pictures) had curious parallels to Ryder's future personal life. "Ryder often spoke about this trip and of Maris, his method of painting and manner of living," Charles Fitzpatrick wrote after his friend's death.[15]

From the early 1880s to about 1900 Ryder enjoyed his fullest period of creative activity, a time when he treated his themes with a new, dramatic breadth of vision and a grand mastery of pictorial design. His paintings became deeper in emotional content, more concerned with human and superhuman elements, richer in technique, and, on the whole, larger in size than before. He produced only about sixty works in this mature period, and together they constitute his greatest contribution to the art of the nineteenth century.[16]

Starting in the early and mid-1880s, Ryder began to draw upon subjects from the Bible, classical mythology, and the poetry, prose, and plays of the English-speaking world: the early ballads, Chaucer, Shakespeare (his favorite poet), La Fontaine and the nineteenth-century Romantics—Thomas Moore, Thomas Campbell, Edgar Allan Poe, Keats, Longfellow, and Alfred Tennyson. One of his major paintings, *Siegfried and the Rhine Maidens* (fig. 4–17; plate 10), was inspired by Richard Wagner's opera *Götterdämmerung* (1874), and another, *The Flying Dutchman* (plate 9), was based on a legend popularized by Wagner's opera *Der fliegende Holländer* (1841). *The Lorelei* (plate 14) was drawn from an old legend popularized in Heinrich Heine's poem published in 1824. Sometimes he took from literature

Fig. 4–6. Albert Pinkham Ryder. *Moonlight Marine*. Early to middle 1880s. Oil on wood panel, 11⅜ x 12″. The Metropolitan Museum of Art, New York City. Samuel D. Lee Fund, 1934

Fig. 4–7. Albert Pinkham Ryder. *Marine*. Early to middle 1880s. Oil on canvas, 12⅝ x 9¾″. The Carnegie Museum of Art, Pittsburgh. Howard N. Eavenson Memorial Fund, for Howard N. Eavenson Americana Collection, 1972. Photograph: Sandak, Inc., Stamford, Conn., 1961

only the title of a picture, such as *With Sloping Mast and Dipping Prow* (fig. 6–23) from Samuel Taylor Coleridge's *The Rime of the Ancient Mariner* (1798), *The Toilers of the Sea* (plate 4) from a novel of the same name by Victor Hugo (1866), and *The Waste of Waters Is Their Field* (fig. 4–5) from "Winter" (1726) from either James Thomson's *The Seasons* (1726–30) or Robert Southey's *Madoc* (1805).

These imaginative paintings are never literary in the sense of illustrating literature or history, like those of English and French academicians such as Frederick Leighton, Lawrence Alma-Tadema, or Jean-Léon Gérôme. They are pictorial dramas inspired by great themes, embodied in imagery as personal and original as their sources, and expressed in the physical, sensuous language of form, color, and design. In most of them, too, an essential part is played by nature. To Ryder, as to all true romantics, nature was not a remote, external phenomenon but the accompaniment of man's emotions of wonder, fear, and ecstasy. He was not a simple landscapist; for him, the natural setting was united with the actions and emotions of his human actors.

In the larger version of *Macbeth and the Witches* (plate 15), for example, Macbeth and Banquo are confronted by the weird sisters on a lonely, blasted heath under a moon glimpsed through wind-torn clouds: a scene as expressive of dread as Shakespeare's words. In *Siegfried and the Rhine Maidens* the doomed hero rides beside the river through trees whose wild, agonized movements seem to foretell his fate. In a less tragic mood, in *The Forest of Arden* (plate 12), again based on Shakespeare, the two figures move under the enchantment of the landscape's unearthly beauty.

Before he embarked upon epic themes in a major way, one of Ryder's favorite subjects was the moonlight marine. From his childhood and youth in New Bedford he must have been haunted by memories of the sea; throughout his life he never

41

forgot the sea's vastness and loneliness, the flow of its tides and waves, the majesty of its storms, its terror and its profound peace. His recurring image of a lone boat sailing in moonlit waters—*Moonlight Marine* (fig. 4–6) and *Marine* (fig. 4–7), for example—has a visionary quality: the sea as it lived in the mind, an image of infinity and eternity, and the boat and its crew a symbol of man's journey through the unknown. In his marine nocturnes, the moon, surrounded by luminous clouds, lights the waste of waters, with the boat a dark silhouette against the moonlit sea and sky. These marines were filled with a sensation of motion that had been absent in his landscapes—the driving movement of wind and waves. Their design was simplified to the essential elements of sky, clouds, sea, and boat. Such paintings (most of them, like his landscapes, quite small) were the most moving sea poems in American art of the time, as Winslow Homer's marines were the most vigorous, stirring sea prose. These two New Englanders, otherwise so completely different, were America's greatest nineteenth-century painters of the sea.

As in his earlier, simpler marines, the sea was a major force in several of his imaginative paintings. In *The Flying Dutchman* the helpless boat and its crew are at the mercy of the waves' elemental fury, while the vision of the phantom ship in the

Fig. 4–8. Albert Pinkham Ryder. *Constance.* Middle 1880s–middle 1890s and later. Oil on canvas, 28¼ x 36″. Museum of Fine Arts, Boston. Photograph: The Metropolitan Museum of Art, 1918

Fig. 4–9. Albert Pinkham Ryder. *Resurrection.* c. 1883–85. Oil on canvas, 17⅛ x 14⅛″. The Phillips Collection, Washington, D.C.

Fig. 4–10. Reproduction (wood engraving) of *Resurrection, Magazine of Art* 9 (1886)

sky is a portent of their coming doom; *Jonah* (plate 7) is similar in its raging sea and tortured boat (also in its superb design), but in the sky above, God is watching over his prophet. ("I am in ecstasys [*sic*] over my Jonah," Ryder wrote to Thomas B. Clarke, "such a lovely turmoil of boiling water and everything.")[17]

The sea is completely different in *Constance* (fig. 4–8; plate 8), based on Chaucer's *Canterbury Tales* (c. 1387), telling how Constance, daughter of the emperor of Rome and wife of the king of Northumberland, was treacherously cast adrift with her infant son in a boat without sail or rudder, but was miraculously preserved and after five years was guided safely to Rome. The boat with its mother and child is alone on a limitless ocean under a vast, empty sky lighted by an unseen moon—a penetrating sense of infinite space and solitude, and of serenity.

Ryder was a deeply spiritual artist. In *Jonah* and *Constance* the human subjects at the peril of nature's forces are under divine guardianship. The life of Christ moved him to create three of his most tender and impressive paintings, *Resurrection* (figs. 4–9 and 4–10), *Christ Appearing to Mary* (plate 6), and *The Story of the Cross* (fig. 4–11). To him these were not conventional ecclesiastical motifs but living poetic truths. He was one of the few authentic religious painters of his time, one for

Fig. 4–11. Albert Pinkham Ryder. *The Story of the Cross*. Middle to late 1880s. Oil on canvas, 14 x 11¼″. Private collection. Photograph: Sheldon Keck, 1965

Fig. 4–12. Albert Pinkham Ryder. *King Cophetua and the Beggar Maid*. Early 1890s and later. Oil on canvas, 24½ x 18″. National Museum of American Art, Smithsonian Institution, Washington, D.C. Gift of John Gellatly

Fig. 4–13. Albert Pinkham Ryder. *Lord Ullin's Daughter (The Sea)*. 1890s. Oil on canvas, 20½ x 18⅜″. National Museum of American Art, Smithsonian Institution, Washington, D.C. Gift of John Gellatly

Fig. 4–14. Albert Pinkham Ryder. *Perrette (The Milkmaid)*. Middle to late 1880s. Oil on canvas mounted on wood panel, 12¾ x 7⅝″. Smith College Museum of Art, Northampton, Mass. Photograph: Sandak, Inc., Stamford, Conn., 1961

whom religion was not mere conformity but personal emotion. In his surviving letters there is no mention of organized religion, but the name of God is occasionally cited in them and in his poems. As far as we know he belonged to no church; but judging by his works he was a believer.

Like so much in his personal life, we do not know how much reading he did for his literary sources. The Bible and Shakespeare are obvious, but others less so: *The Canterbury Tales*; Alfred Tennyson's "The Beggar Maid" (1842) (for *King Cophetua and the Beggar Maid* [fig. 4–12]); Thomas Campbell's poem of 1809 (for *Lord Ullin's Daughter* [fig. 4–13]); the *Fables* of La Fontaine (1668–94) (for *Perrette* [fig. 4–14]); Poe's poem "The Haunted Palace" subsequently published in the short story, "The Fall of the House of Usher" (1839) (for *The Temple of the Mind* [fig. 4–15; plate 5]); and Thomas Moore's *Lalla Rookh* (1817) (for *Nourmahal*, now lost). Nor do we know what music he heard, except that the painter Elliott Daingerfield, who knew Ryder, quoted him as saying, about his *Siegfried and the Rhine Maidens*: "I had been to hear the opera and went home about twelve o'clock and began this picture. I worked for forty-eight hours without sleep or food, and the picture was the result."[18] (But the depth of pigment suggests that he worked much longer on

Fig. 4–15. Albert Pinkham Ryder. *The Temple of the Mind*. c. 1883–85. Oil on canvas mounted on wood panel, 17¾ x 16″. Albright-Knox Art Gallery, Buffalo, N.Y. Gift of R. B. Angus, 1918. Photograph: The Metropolitan Museum of Art, 1918

it.) When Ryder was painting *The Lorelei*, Charles Fitzpatrick wrote, "He would go about his room singing the song of Lorelei."[19]

Often in his paintings Ryder so transformed the subject that it was far removed from its original source. Of *The Temple of the Mind* he wrote in 1907: "The theme is Poes Haunted Palace. . . . The finer attributes of the mind are pictured by three graces who stand in the centre of the picture: where their shadows from the moonlight fall toward the spectator. They are waiting for a weeping love to join them[.] On the left is a Temple where a cloven footed faun dances up the steps snapping his fingers in fiendish glee at having dethroned the erstwhile ruling graces."[20] But in Poe's poem there are no three graces, no weeping love, no cloven-footed faun; the building is a palace, not a temple, and it has "ramparts" and "banners yellow, glorious, golden." The poem was merely Ryder's starting point for a moonlight scene, one of his most serene, with three lovely, rather lonely female figures regarding a deserted temple which contains no "hideous throng" of "evil things."

One of his most haunting visions, *The Race Track* (fig. 4–16; plate 11), was purely personal, originating from the suicide of a friend, a waiter at his brother's hotel, the Albert. Of this subject, Ryder wrote:

Fig. 4–16. Albert Pinkham Ryder. *The Race Track (Death on a Pale Horse; The Reverse)*. Late 1880s–early 1890s. Oil on canvas, 28¼ x 35¼". The Cleveland Museum of Art. J. H. Wade Collection. Photograph: The Metropolitan Museum of Art, 1918

In the month of May [1888], the Brooklyn Handicap was run, and the Dwyer brothers had entered their celebrated horse, Hanover to win the race. The day before the race I . . . had a little chat with this waiter, and he told me that he had saved up $500 and that he had placed every penny of it on Hanover winning this race. The next day the race was run, and as racegoers will probably remember, Hanover came in third [actually he was second]. I was immediately reminded that my friend the waiter had lost all his money. That dwelt on my mind . . . so much so that I went around to my brother's hotel for breakfast the next morning, and was shocked to find my waiter friend had shot himself the evening before. This fact formed a cloud over my mind that I could not throw off, and "The Race Track" is the result.[21]

Death, a pale, cadaverous figure carrying a scythe, rides an emaciated horse around a deserted race track, in a desolate landscape with only a dead tree, under a somber sky with ominous clouds. In the foreground there is a broken fence and a writhing serpent: a nightmare image. It is the most austere of any of Ryder's paintings. There is not even a moon; the scene is in semidarkness. The pale figures, dun-colored landscape, and grayed sky form a color harmony that with all its somberness has great depth and richness, recalling the Venetians in their more sober moments, or El Greco. The design is strange and original, with subtle relations between the forms of clouds and earth, and of both with the figures.

Except in his youthful landscapes around New Bedford, Ryder seldom painted directly from nature; but he carefully *observed* nature in and around New York. His collector-friend Colonel C. E. S. Wood noted: "He seems to have a marvellous eye for color in nature, saying of one midnight sky[:] It had a splendid lustre and of the next night which to me seemed the same 'it wasn't so deep and lustrous as the night before.' "[22] Olin Warner's daughter Rosalie recalled as a child walking with him in Central Park, Ryder stopping to look a long time at a vine-covered tree, explaining, "I am looking at it so long because I want to remember it for one of my pictures." When they were walking again she asked him, "Can you remember that tree?" and

he said, "Yes, I can remember it."[23] In September, 1897, when he was painting *The Forest of Arden*, he wrote to J. Alden Weir: "I go out to Bronx Park nearly every day now."[24] And in October, to Sylvia Warner: "I have every faith that my forest of Arden, will be fully as beautiful as any preceding work of mine; Bronx Park has helped me wonderfully, and I would have gone out to day for that breezy agitation of nature that is so beautiful. But the rain has spoiled my plans."[25] The critic, playwright, and essayist Sadakichi Hartmann, after trying in vain to call on him, finally wrote him, and received a note from Ryder excusing himself for not being home, as he had been "absorbing the lovely November skies."[26] Ryder's was an urban study of nature that contrasted with the average landscapist's devotion to the country.

Thus, despite his remoteness from conventional realism in painting, Ryder was deeply involved in the experience of nature. His moonlit skies with their elaborate cloud shapes were well observed, and few artists have painted moonlight so accurately: the way it mutes colors without effacing them, and the unity of tone it imparts to the whole scene. With all the somberness of his nocturnes, light was an essential element in them. A quiet radiance pervades his moonlight scenes; the clouds are fringed with the moon's light, the moon embedded in them shining like a jewel in a setting. By methods opposite from the Impressionists, Ryder created light within the painting, light shining in darkness, filling the whole space, revealing forms, simplifying and unifying them, and creating pictorial drama. (Kenneth Hayes Miller, painter, teacher, and friend of Ryder, said, of a moonlight painting he had seen in an exhibition, that at first he thought "it was the darkest picture he had ever seen," but in the end "he thought it was the lightest.")[27] Like a child or a primitive, Ryder often pictured the source of light, which more conventional painters avoided: the moon or, as in *The Flying Dutchman*, a glorious setting sun.

As we have seen, Ryder portrayed recognizable subject matter all his life. But he was never bound by the doctrine of literal faithfulness to nature that governed earlier American painters and many of those who were his contemporaries. As he was quoted in 1905: "The artist should fear to become the slave of detail. He should strive to express his thought and not the surface of it. What avails a storm cloud accurate in form and color if the storm is not therein?"[28] For him painting was not merely naturalistic representation, but the translation of nature's forms and colors into the physical language of art, speaking as directly to the senses as does sound in music. The work of art was an independent visual and physical creation. Though he never abandoned the forms of the real world, he used them with a freedom unparalleled among the American painters of his time.

From the very first, Ryder revealed that gift which, like poetry, must be inborn—the gift of color. In contrast to many of the paintings of the period, his color was on the dark side, never brilliant. Its range was not wide; some of his finest harmonies were limited to a few dominant tones and their variations, and some were almost monochromatic. Grays entered into almost every color; bright, pure notes were rare. But within its range his color had great sensuous richness and depth. His early landscapes, such as *The Grazing Horse* (fig. 11–14) and *Summer's Fruitful Pasture* (fig. 2–7), had been relatively naturalistic in their variety of local colors; as his art developed, however, his paintings were often set in a particular chromatic key, like the key of a musical composition. Within the picture there are variations of the dominant tones, but comparing one work with another, one sees how distinct the chromatic key is. *Macbeth and the Witches* (plate 15) is somber blue green and warm gray—a midnight tone; *Siegfried and the Rhine Maidens* (plate 10)

Fig. 4–17. Albert Pinkham Ryder. *Siegfried and the Rhine Maidens*. c. 1888–91. Oil on canvas, 19⅞ x 20½". National Gallery of Art, Washington, D.C. Andrew W. Mellon Collection. Photograph: The Metropolitan Museum of Art, 1918

is bronze and greenish golden; *Constance* (plate 8) is gray green in sea and sky, gray brown in the boat and its two figures; *The Forest of Arden* (plate 12) is olive green and gold in the landscape, brownish red in the figures' costumes; *The Race Track* (plate 11) is dun-colored brownish olive, grayed green blue in the sky. Seldom did Ryder attempt the range and variety of a colorist such as Eugène Delacroix. Some works, however, displayed a wider range: *Pegasus* (plate 3); *The Tempest* (plate 13); and the three religious paintings, *Resurrection* (figs. 4–9 and 4–10), *Christ Appearing to Mary* (plate 6), and *The Story of the Cross* (fig. 4–11). And *Jonah* (plate 7) and *The Flying Dutchman* (plate 9) were charged with full-toned color, their red and orange skies contrasting with the dark, cold hues of the menacing waves and the doomed ships.

Ryder's feeling for form was as sensuous as his feeling for color. His forms are not merely representations of man and of nature; they are plastic creations, with an inner life of their own.[29] Even with all of his dark tonality, the apparent obscurity of his forms, and his lack of technical cleverness, every element in his paintings has definite form. These forms are seen and conceived as masses, not outlines; their edges might not be sharply defined, but their cores are solid and substantial. There was nothing rigid about his sense of form; it was completely personal and original; while based on nature, his forms are shaped with idiosyncratic freedom. In *Siegfried and the Rhine Maidens* the wild, upward-reaching forms of the trees are as alive as the gestures of the human actors. In *Jonah* and *The Flying Dutchman* the lines of the ships, in each case, are distorted out of any relation to nautical accuracy, becoming integral parts of the furious turmoil of the waves and creating most extraordinary designs. Ryder possessed that rare talent, a mastery of plastic movement; the forms are not static, they possess flow and direction: the rhythmic movement of waves, the wind-driven speed of boats, the upward swing of the trees. Every form is related to every other, creating designs that are alive in every part. Power is an attribute not generally associated with Ryder, yet his works clearly possess it. His small paintings contain more essential energy than most of the large canvases that filled the galleries of his day.

Ryder's technique was more complex than was usual in his time. (For a further

discussion of this matter, see Sheldon Keck's essay later in this volume.) In a day when Impressionism and facile brushwork had overshadowed traditional methods of underpainting, overpainting, and glazing, and substituted direct, *au premier coup* technique, Ryder strove, without adequate training or knowledge, for greater richness of effect. He built up his paintings with layer on layer of impastos and glazes, until the pigment was sometimes a quarter of an inch thick, and even a small canvas could weigh heavy in the hand. He was aiming for the utmost fullness and depth of color, tone, and substance, and in many works he achieved these qualities as few painters of his time had done.

Siegfried and the Rhine Maidens exemplifies his complex technical processes. It is built up out of layers of solid pigment and glazes, evidently in many applications. Siegfried, the maidens, and the tree are painted in relatively heavy pigment, with free, flowing brushwork, especially in the fantastic, soaring forms of the tree. The more distant elements—sky, clouds, moon, river, and farther shore—are mostly in translucent glazes, the brushstrokes being less evident. This mode of handling creates an interplay between the substantial, moving forms in the foreground and the calm, unearthly sky. Yet even the sky displays technical and pictorial drama, with luminous clouds and its moon veiled in a cloud, not naked—a sky as deep and subtle as Ryder ever painted. The moon's reflection in the river, with the maidens' bodies dark against it, brings luminosity to the foreground. The painting is

Fig. 4–18. Albert Pinkham Ryder. *The Curfew Hour.* Early 1880s. Oil on wood panel, 7½ x 10″. The Metropolitan Museum of Art, New York City. Rogers Fund, 1909. This photograph shows the painting in its present, extremely deteriorated condition

rich in such compositional and technical felicities, more than justifying Ryder's complex methods.

Similarly, in *The Race Track* the clear parts of the sky are presented by means of thin glazes; the clouds in solid pigment; the earth still heavier, especially in its nearer areas; and Death and his horse are the most heavily painted, particularly the rider, whose figure is built up in opaque white pigment glazed over with darker tones, so that it stands out as if in relief.

Unfortunately, however, Ryder had no training in the traditional techniques of mixing and applying paint, and he used dangerously unsound methods. He painted over surfaces when they were still wet, thereby locking in the undersurfaces before they had dried and hardened, so that they have always remained semiliquid, or dried at different rates of speed, causing deep, heavy cracking. Besides oil and turpentine he used unorthodox mediums—varnish, wax, and alcohol, for example. On at least one occasion he mixed turpentine and candle grease, which never dries. (When he told Miller this and Miller scolded him, he said apologetically, "But I only used one candle."[30]) He made much too free use of varnish. In order to bring out the depth and translucency of a painting while he showed it to a visitor, he would sometimes lay it flat and pour varnish over it or he would wipe it with a (not too clean) wet cloth.

As a result, many of Ryder's paintings have deteriorated to a greater or lesser extent, and a few have been completely ruined; for example, the little *Curfew Hour* (fig. 4–18) in the Metropolitan Museum of Art now consists only of small islands of detached pigment surrounded by a sea of varnish. A large proportion of his paintings have had to be extensively and periodically restored—sometimes, in the early days of restoration, with deplorable results. The "restorer" who worked on *Macbeth and the Witches* in the 1920s, for example, repainted a large part of the surface, substituting his own forms for the clouds around the moon shown in the early photographs (fig. 11–25). Comparison of paintings in their present condition with photographs and photographic reproductions made in Ryder's lifetime reveals both the process of deterioration and the fact that it sometimes took many years. The five early Ryders illustrated in the catalogue of the sale of James Inglis's collection in 1909 were still free from their present cracks—and in the case of *The Curfew Hour*, from its ruination.[31]

Contemporary descriptions often spoke of the richness of Ryder's color and surfaces. In 1890 Charles de Kay wrote of "the luxury of enjoyment in color which will be observed in any assemblage of Albert Ryder's works. His pictures glow with an inner radiance, like some minerals. . . . Some have the depth, richness and luster of enamels of the great period."[32] In 1908 the English critic and curator Roger Fry said of *Moonlight Marine* (which he miscalled *The Flying Dutchman*): "The quality of the paint has the perfection and the elusive hardness of some precious stone. . . . He has wrought the slimy clay of oil pigment to this gem-like resistance and translucency. . . . I wish I could translate the ominous splendour of the colouring into words." He went on to speak of the sky, "of a suffused, intense luminosity, so intense that the straw-coloured moon and yellower edges of the clouds barely tell upon it. The clouds themselves . . . are of a terrible, forbidding, slatey grey, not opaque, but rather like the grey of polished agate." The sea, contrasting with these colors, was "an intense malachite green, dark, inscrutable, and yet full of the hidden life of jewels and transparent things."[33] Today, these sensuous qualities of the painting and of too many other Ryders are greatly diminished.

5

Painting, Poetry, and the Creative Process

A MAJOR CLUE to Ryder's creative personality is found in his linking of painting and poetry. Not only was his art the product of an intimate poetic sensibility, but he also took pride in writing poems, even hoping to be remembered for them as much as for his paintings.[1] (According to a friend's report, he wrote his poems in nature, the exact opposite of his procedure in painting.[2]) Although only a few were published during his lifetime, he would often write them out and give or mail them to friends. (Extant poems have been printed in Appendix 3.) One that he often circulated was "The Voice of the Forest":

Oh ye beautiful trees of the forest
Grandest and most eloquent daughters
From the fertile womb of earth:
When first ye spring from her
An infants puny foot
Could spurn ye to the ground
So insignificant ye are;
Yet ye spread your huge limbs
Mightier than the brawny giants of Gath!
How strong! How Beautiful! How wonderful ye are

Yet ye talk only in whispers
Uttering sighs continually
Like melancholy lovers,
Yet I understand thy language
Oh voices of sympathy,
I will draw near to thee
For thou can'st not to me
And embrace thy rugged stems
In all the transports of affection,

Stoop and kiss my brow
With thy cooling leaves
Oh ye beautiful creations of the forest.[3]

At times, his verses stood alone; on other occasions they were meant to go with his pictures, echoing and articulating their meaning. His poem "The Lover's Boat," for example, was published in the Society of American Artists catalogue of 1881 to accompany the painting of the same title; Ryder also wanted to have his poem "The Flying Dutchman" placed on a tablet attached to the frame of his painting of that name.[4] In his poems, Ryder attempted to achieve, with limited success, the noble sentiments and subtle nuances of feeling of his paintings. He felt that the highest compliment to his paintings was to have them compared to poetry.[5]

Besides the other literary sources of some of his paintings, as discussed in chapter 4, Ryder also drew upon poetry by established authors. In addition to the work of Chaucer, Campbell, Poe, and Tennyson, Ryder was inspired by Henry Wadsworth Longfellow's *Evangeline* (1847) for *The Little Maid of Arcady* (fig. 5–1) and John Keats's *The Eve of St. Agnes* (1819) for *The Lovers* (*Saint Agnes' Eve*) (fig. 11–15).

From the Renaissance through the middle of the eighteenth century it was thought that a painting's merit increased the more it resembled poetry.[6] In the early nineteenth century, the common concerns of the two mediums were often reinforced by Romantic artists such as J. M. W. Turner and William Blake, who appended poems to their pictures, either physically in exhibitions, or in the accompanying catalogues, or both. Even as late as John Ruskin's time—he was at the height of his influence in the middle years of the century—painting and poetry were regarded as interdependent allies. With the advent of Realism and Impressionism in France, however, poetic art—indeed, any form of inspiration from literature—was eschewed by advanced painters. Yet living and working in this period, Ryder remained essentially a Romantic in his attitude toward painting and poetry, perhaps reflecting his isolated situation in America, still the home of a largely provincial culture.

Ryder's poems offer important clues about his personal values and cultural orientation. Stylistically, they seem to derive mainly from the English Romantic poets Keats, Shelley, Tennyson, and Wordsworth.[7] Although Ryder's poems are rich in sentiment and metaphoric language, when compared to his sources they appear far less expert in diction, even being trite and formulaic at times. Yet his interests were much the same as the English poets': he addressed such favorite Romantic themes as ideal love between man and woman, often tinged with melancholy and loss; struggle and conflict, culminating in death; and the quiet but inspiring presence of God, both in nature and among men. For Ryder, as revealed in his poems, man's activities in the world, his relation to nature, and the beauty and harmony of nature itself are all infused with deep spiritual meaning, romanticized and idealized, to be sure, but spiritual nonetheless.

A concern with spirituality, however, was not the sole domain of the Romantics. In the 1880s and 1890s, Paul Gauguin and his followers among the French Symbolists directly or indirectly revived the Romantic interest in the spiritual and also transformed it into something modern, more mystical and mysterious. Whether Ryder was aware of such artists is hard to say, but he was, nonetheless, a product of his time, and perhaps he unconsciously absorbed some of the Symbolists' ideas.

In his "Paragraphs from the Studio of a Recluse," he allied himself with progress and the "modern": "Modern art must strike out from the old and assert its individual right to live through Twentieth Century impressionism [not optical impressionism but the subjective kind] and interpretation. The new is not revealed to those whose eyes are fastened in worship upon the old. The artist of to-day must work with his face turned toward the dawn, steadfastly believing that his dream will come true before the setting of the sun."[8]

Ryder's ideas about the creative process sometimes foreshadow the unconscious motives of the Surrealists or, at times, the Abstract Expressionists' existential approach. In voicing views of this kind, he was far in advance of his own era, a genuinely instinctive artist whose Romantic individualism bridged over into a very modern expression of unconscious impulses.

Ryder spoke of the importance of inspiration in his "Paragraphs": "Imitation is not inspiration, and inspiration only can give birth to a work of art." He went on to say that it is the first vision that counts and that the artist must "remain true to his dream"; that the dream will take over and allow him to produce a painting unlike anyone else's. In that article, Ryder said that inspiration is like a seed that must be "planted and nourished": it grows within the artist and he must watch and wait with sincere effort for it to come to fruition in his work.[9] In his letters, Ryder spoke of how important it was to be in the mood to paint and that he could not create at will. The mood seized him at certain times, and when it did he could obtain the desired results. As he wrote to Sylvia Warner: "I have been working very hard, gaining only by inches, and waiting for the light of heaven . . . to come into the Lorelei [plate 14]. . . . "[10] Joseph Lewis French, a writer who interviewed the artist in 1905, provided a revealing account of his method of starting a picture: "He does not choose his subject. It comes to him." With regard to *The Tempest* (plate 13), French reported that the images "do not form themselves in his mind's eye first. . . . He only *feels* them there."[11]

The moment of inspiration for Ryder did not come easily: he had to place himself in a receptive yet searching frame of mind, seeking but not demanding an answer. He placed great store in patience, both in others and in himself, and in a letter to his collector-friend Dr. A. T. Sanden, he spoke of Robert the Bruce, the fourteenth-century Scottish king whose army defeated English intruders, learning a lesson from watching a spider, a story that obviously had analogies to Ryder's own art. Bruce watched "a spider swing at the end of its spun beginning of its web land at the 100th effort to reach the anchoring beam and then busily spin the remaining bit. Bruce took heart again; rallied the Scots, and led them to a magnificent victory." Or as Ryder said about his own work, "I have always believed the fatality in making pictures is part of the process that develops what they are."[12] In this he sounds almost like an Abstract Expressionist, for the existential uncertainty of making a painting becomes part of the painting's content. Related to this idea is Ryder's remark to Dr. Sanden, "With me a day comes when the picture comes as if by magic."[13] Ryder gives great priority to the unconscious: having become quietly receptive, inspiration from another source, an unknown source, mysteriously directs him. Such a view, of course, would not be unexpected in the early and middle part of the twentieth century, when the unconscious mind was purposely allowed to take over and its artistic products valued; but in America in the 1890s such a procedure was unusual.

Once Ryder settled on an idea for a painting and the process of creation began,

Fig. 5–1. Albert Pinkham Ryder. *The Little Maid of Arcady.* Middle 1880s. Oil on wood panel, 9⅞ x 4¾". Collection Mr. and Mrs. Daniel W. Dietrich II. Photograph: Brenwasser, taken in the 1930s

he would often take ten or fifteen years, or more, to refine, change, and perfect the work. As to his method, Walter Pach, the young painter and critic, reported: "According to his own statement, Mr. Ryder uses no sketches from nature, but lays the picture in according to what he feels to be its needs. Then follows a process of small or large changes that frequently extends over a period of years. The position of clouds in a sky, the contour of a hill, or the movement of a figure undergoes infinite modifications until the stability and harmony of masses is attained that the artist's astonishing sense of their beauty demands. . . . "[14] For Ryder, progress was often slow, the result of a gradual unfolding of his artistic insights. To Dr. Sanden, he wrote in 1899: "I like my slow dreamy way with a picture fancying thereby they have a charm peculiar or like self creation."[15]

Often Ryder would feel his way along, moving ahead by trial and error. Sadakichi Hartmann provided an enlightening personal account of Ryder at work on *The Tempest*:

> A tumult of minor aspirations is constantly astir in him—and even aware that he can not realize his visions within such precarious lighting conditions, he can not resist experimenting. At this moment he sees that he committed an error last evening, when he considered a certain passage perfect. . . . Brush in hand, standing, he contemplates his work. Ryder seldom sits down when in action, but restlessly shifts about. . . . He worked at the delinquent spot from below, from various angles, back and forward, and finally bringing his eyes quite close to the canvas, and fumbling about with his brush makes a few dragging strokes with half-dry paint.[16]

In placing his figures, Ryder toiled endlessly to obtain the right results. "I am getting the Lorelei into shape," he wrote to Colonel C. E. S. Wood in 1906. "I think she was too perpendicular on the rock, reclining, more as I have her now, seems to help the feeling of the picture very much: of such little things painted dreams are made of."[17] When Kenneth Hayes Miller complimented him on the placing of the figure, Ryder said, "Do you know, she's been all over that rock."[18] At present, the Lorelei is not visible.

Discussion of Ryder's creative process leads us back to his possible borrowing from earlier and contemporary art. Books constitute one source of visual images, but unfortunately, practically nothing of Ryder's personal collection of books has survived. Two volumes that were in his possession at the time of his death have come down to us through his friend, the painter Philip Evergood. One of these, inscribed by Ryder's teacher William E. Marshall, is *Practical Hints on Light and Shade in Painting* (seventh edition; London, 1864), a work by John Burnet, an English art theorist of wide influence both in England and in the United States.[19] Burnet's book is particularly important because he cites, and reproduces, many examples of Dutch seventeenth-century painting, works that apparently were most congenial to Ryder in their dramatic massing of dark and light. The other volume, *Rural Beauties*, is not on the subject of art, but rather consists of W. Pearson's romantically rendered etchings of rustic cottages in the English countryside. There is no date of publication, but the previous owner signed and dated it "Dec. 4th 1815"; below is Ryder's own name, followed by the notation "from C de K, Dec. 1882."[20]

Kenneth Hayes Miller, who talked with Ryder in and after 1909, reported that the older man's conversation about art was concerned entirely with subjects and

Fig. 5–2. Albert Pinkham Ryder. *The Smugglers' Cove.* Early 1880s. Oil on gilded leather, 10⅛ x 27¾". The Metropolitan Museum of Art, New York City. Rogers Fund, 1909. Photograph: Modern print from The Metropolitan Museum of Art negative, 1909

sentiments, and his own pictures, not with design and purely artistic qualities, in which Miller, a skilled teacher, was primarily interested. To Miller, Ryder's talk was quite sentimental—"all about nature and poetry."[21] He spoke little about individual artists, Miller said, and never about the Old Masters; although Ryder once observed, "They were great painters, but one can still be an artist"—a distinction between "painting" and "art" that he often made, suggesting that there was room for creativity in his own time.[22]

Ryder is known to have gone to museums and galleries in his earlier years, but how often he made such trips and what he saw is open to conjecture. Miller reported that, when he knew the elderly Ryder, he did not visit museums and only occasionally went to dealers' showrooms. In 1909 the Metropolitan Museum acquired three of his paintings, *The Curfew Hour* (fig. 4–18), *The Bridge* (fig. 6–12), and *The Smugglers' Cove* (fig. 5–2); and in 1915, *The Toilers of the Sea* (plate 4). Miller tried to induce him to go up to the museum to see them, but without success. In a dealer's gallery Ryder would look at each picture a long time—"too long," said Miller. "Then he would point out some tiny part and say that it was well painted."[23]

Ryder did speak often of Corot, Miller said; he talked of the French painter "as about a woman he loved."[24] He retold with enjoyment a story of Daniel Cottier's: a collector who owned a Corot, being asked whether, if he were freezing to death, he would burn his Corot, said, "he would have to be pretty cold to do that."[25] Cottier was not only a dealer but also a collector, particularly of the Barbizon painters, as was his partner and successor, James S. Inglis; Ryder was a good friend of both, and in their homes and elsewhere he must have had ample opportunities to see paintings by Corot and other members of the Barbizon School: Millet, Dupré, Daubigny, Rousseau, Diaz, and others. Critics often likened Ryder's work to Monticelli's; yet when Marshall took his pupil to a Monticelli exhibition at Cottier's, it turned out that Ryder had never heard of him.[26] (But he would have from then on, for Monticelli was one of Cottier's and Inglis's favorite artists.)

The other painter, besides Corot, Ryder spoke of most often with admiration was Matthew Maris, whom he had met on his visit to London in 1882. He admired not only Maris's art but also his manner of living, that of a recluse, and his working methods. "He told me how long Maris worked on his pictures," Charles Fitzpat-

rick wrote, "and how hard it was for the dealers to get them, and if they bothered him too much he would kick a hole in the picture."[27] Maris's art (fig. 5–3), more sensitive and introspective than his older brother Jacob's, had definite affinities to Ryder's, but Ryder soon achieved a wider imaginative range and greater freedom in formal invention.

Between Ryder and Corot (fig. 5–4) there were important similarities and differences. Both were devoted to nature, and both transformed nature into the formal language of art. Both were tonalists, working with a relatively limited color range. A few of Ryder's paintings, such as *The Temple of the Mind*, are Corot-like in their subtle grays. But there are fundamental differences. Corot's sunlit naturalism, his direct relation to visual reality, the freshness of his vision and style contrast with Ryder's moonlit nocturnal world. In some ways Ryder is closer to the more romantic Barbizon painters such as Diaz and Dupré, and to Monticelli (fig. 5–5). There are also interesting likenesses between Millet's marines (fig. 5–6) and Ryder's.[28]

Art historians Diane Chalmers Johnson and Dorinda Evans have both pointed out the influence of the seventeenth-century master Claude Lorrain on Ryder's *The Temple of the Mind* (fig. 5–7).[29] Claude's landscapes (fig. 5–8), themselves a source for Corot, had been available to several generations of nineteenth-century American artists, either in the original or through the engravings in the *Liber Veritatis*, a comprehensive visual record of his work. As Johnson points out, apropos of *The Temple of the Mind*: "Ryder's composition strictly repeats the Claudian scheme of dark ground across the first plane, small figures casting long shadows, a middle plane with trees left and right and surrounding a luminous landscape with water curving from the far distance down to the front, complete with the temple format on the left hand side, all unified with that atmospherically misty light."[30]

There are also parallels between Ryder's marines and Turner's spectacular sea paintings. As Evans has pointed out, Turner's *Slave Ship* of 1840 (fig. 5–9) was in loan exhibitions at the Metropolitan Museum in 1873, 1874, and 1876, and Ryder may well have seen it there.[31] And an 1893 article in the *New York Times*, about the Astor Library, New York, said: "Sometimes, on an afternoon, bushy-bearded Al-

Fig. 5–3. Matthew Maris. *He Is Coming*. 1874. Oil on canvas, 16½ x 12½". National Museum of Wales, Cardiff

Fig. 5–4. Jean-Baptiste-Camille Corot. *La Bacchanale à la source: Souvenir de Marly-le-Roi.* [*Bacchanal at the Spring: Souvenir of Marly-le-Roi.*] c. 1872. Oil on canvas, 32½ x 26". Museum of Fine Arts, Boston. Robert Dawson Evans Collection, bequest of Mrs. Robert Dawson Evans

Fig. 5–5. Adolphe Monticelli. *Confidences*. c. 1867. Oil on wood panel, 10½ x 8¼". The Corcoran Gallery of Art, Washington, D.C. William A. Clark Collection, 1926

Fig. 5–6. Jean-François Millet. *The Fishing Boat*. 1871. Oil on canvas. Dimensions and location unknown. Former collection Gabriel Cognacq, Paris. Photograph: Henri Dorra

Fig. 5–7. Albert Pinkham Ryder. *The Temple of the Mind*. c. 1883–85. Oil on canvas mounted on wood panel, 17¾ x 16″. Albright-Knox Art Gallery, Buffalo, N.Y. Gift of R. B. Angus, 1918. Photograph: The Metropolitan Museum of Art, 1918

Fig. 5–8. Claude Lorrain. *Landscape with a Temple of Bacchus*. 1644. Oil on canvas, 37¾ x 48¾″. National Gallery of Canada, Ottawa

bert P. Ryder, colorist and quasi-impressionist, can be seen waiting at the desk for a pile of art books, Turner's 'Liber Studiorum' and the like, which he lugs off to some quiet corner."[32] (The *Liber Studiorum*, which Turner patterned after Claude's *Liber Veritatis*, offered a large number of reproductions of the former's works.) The closest to Turner among Ryder's paintings were *Jonah* (plate 7) and *The Flying*

Fig. 5–9. J. M. W. Turner. *Slave Ship (Slavers Throwing Overboard the Dead and Dying—Typhoon Coming On).* 1840. Oil on canvas, 35¾ x 48¼". Museum of Fine Arts, Boston. Henry Lillie Pierce Fund

Fig. 5–10. Albert Pinkham Ryder. *Oriental Landscape.* Early 1880s. Oil on gilded leather, 8½ x 26". Present location unknown. Photograph: RA

Dutchman (plate 9). In imaginative content, visionary style, and fantastic color there are likenesses between them and Turner's late paintings; but the latter's atmospheric, almost disembodied visions differ from Ryder's physically palpable, tactile presentation of form and rhythmic movement.

Albert Boime has argued convincingly that Ryder, directly or indirectly, came to know Couture's methods of laying in and building up a painting.[33] Although there is no record of Ryder speaking of the nineteenth-century French master, he could well have been affected by Couture's procedures through William E. Marshall, who had studied with him in France, through friendship with Robert Loftin Newman, also a Couture pupil, or by reading Couture's book *Methode et entretiens d'atelier* (Paris, 1867), in English translation, for which his friend and fellow Benedick resident R. Swain Gifford had written the introduction. In his mature works, Boime observed, Ryder adopted a number of the methods Couture had written about and also embodied in his own paintings. Like Couture, he began with a dark, warm underbody and laid in broadly a foundation of monochromatic tonal masses into which he would introduce prismatic colors. Like the French painter, Ryder worked more with value than brilliant hues, preferring subtly nuanced variations on a few major colors, dragging or scumbling his pigments, one over the other, in multiple layers. Of course, Couture's knowledge of pigments and their combination was far better than Ryder's and his painting often more theatrical—and superficial—but nevertheless the parallels that Boime has drawn between the artists are illuminating and convincing.

Turning to another culture, *A Stag Drinking* (fig. 2–14) and *A Stag and Two Does* (fig. 2–15) show many formal similarities to Japanese work (see fig. 5–11): an emphasis on silhouette, a decorative relationship between the elements of the composition (rather than a descriptive or story-telling purpose), and delicate contour drawing, as opposed to three-dimensional modeling. Not only are certain formal

Fig. 5–11. Ki Baitei (Japanese, 1734–1810). *Winter Rider*. Undated. Ink and color on paper, 52⅛ x 22½". University of Michigan Museum of Art, Ann Arbor. Margaret Watson Parker Art Collection

qualities of Oriental art found in *Oriental Landscape* (fig. 5–10), the title of the work clearly reflects Ryder's Oriental interests. Dorinda Evans has found Japanese qualities in Ryder's decorative screens, viewing this influence not only as a matter of personal taste, but also as part of a larger cultural pattern among artists favored by Cottier.[34] In his gallery he promoted works with a Japanese look, and in doing so reflected a larger fascination in America, England, and on the Continent with things Oriental.

Both Johnson and Evans have argued for the influence of particular compositions by other artists upon specific works by Ryder. Johnson, for example, asserted that, in *Siegfried and the Rhine Maidens* (plate 10), Ryder borrowed his conception from Josef Hoffmann's set designs for the opera's New York performance (or illustrations of sketches for them published in *Scribner's*, November, 1887), an event said to have inspired the painting.[35] Similarly, Evans linked the design of *The Lorelei* to an engraving after Turner illustrating Thomas Campbell's poem "Lord Ullin's Daughter."[36]

As to specific motifs, close borrowing can sometimes be found. The critic Sadakichi Hartmann, writing in 1926, observed that in the large *Macbeth and the Witches* (plate 15), Ryder's revision of his outline of Macbeth on a horse, drawn in white chalk, was "an exact copy from an illustration in my 'Shakespeare in Art' which was lying on the window sill open at the tell-tale page 225, a painting by [Carl von] Hafften that I was particularly familiar with. . . . " (fig. 5–12). Hartmann went on to point out that there was an obvious similarity between the sunsets in *The Flying Dutchman* and Turner's *Fighting Temeraire* (1838; National Gallery, London).[37] More recently, Johnson discovered that the "complexly twisted anatomy of the dog" in Ryder's *Joan of Arc* (fig. 8–4) was copied from Gustave Courbet's *The Quarry* (1857; Museum of Fine Arts, Boston) and that not only the spatial composition but also the drawing of the white cow in *Pastoral Study* (fig. 5–13) were inspired by those in Constant Troyon's *Pasture in Normandy* (fig. 5–14).[38] Even though these appear to be direct borrowings, such details were transformed through Ryder's imagination in his creation of the work of art.

With Ryder, there is no evidence of influences such as those of Millet on Richard Morris Hunt, Delacroix on John La Farge, Frans Hals on Frank Duveneck, or

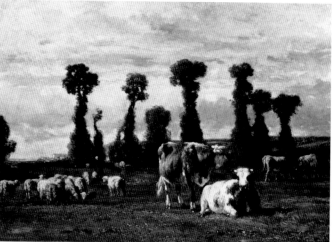

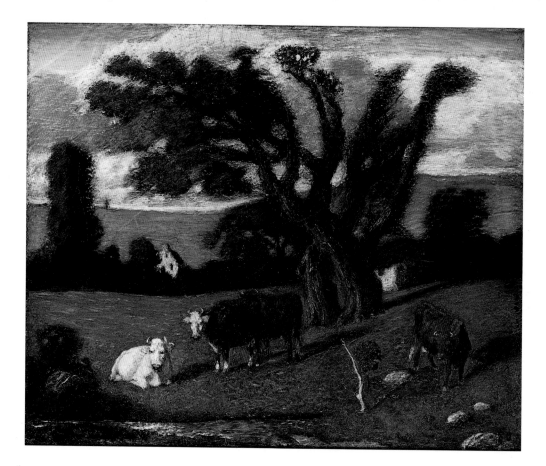

Courbet on young Whistler—direct, unmistakable influences, confirmed by all that we know about the artists. Admittedly, there are affinities between Ryder and Delacroix, and Blake; and to the imaginative tradition in American art exemplified by the moral allegories of Thomas Cole, the dusky, romantic visions of Washington Allston, and the exotic fantasies of Elihu Vedder. But these connections lie more in the realm of spirit and feeling than the actual language of form. Therefore, in searching for influences on Ryder we should not lose sight of his character as an artist whose imagery was essentially subjective, his methods intuitive, his style extremely personal. He undoubtedly had artistic admirations which he did not express verbally, but many of the essential qualities that were valuable in his art came from within.

Fig. 5–12. Carl von Hafften. *Heath Scene (Macbeth)*, detail. Illustration from Sadakichi Hartmann, *Shakespeare in Art* (Boston, 1901).

Fig. 5–13. Albert Pinkham Ryder. *Pastoral Study.* Middle 1870s. Oil on canvas, 23¾ x 29″. National Museum of American Art, Smithsonian Institution, Washington, D.C. Gift of John Gellatly

Fig. 5–14. Constant Troyon. *Pasture in Normandy.* 1852. Oil on wood panel, 15⅛ x 21⅝″. The Art Institute of Chicago

Dating Ryder's Paintings

Fig. 6–1. Albert Pinkham Ryder. *The Stable.* Early to middle 1870s. Oil on canvas, 8 x 10″. The Corcoran Gallery of Art, Washington, D.C.

Fig. 6–2. Albert Pinkham Ryder. *The Stable (Stable Scene).* Middle 1870s. Oil on canvas, 4¼ x 7¼″. Vassar College Art Gallery, Poughkeepsie, N.Y. Gift of Mrs. Lloyd Williams, 1940

BECAUSE RYDER did not date his paintings, his artistic evolution must be reconstructed on the basis of surviving visual and documentary evidence. Published exhibition records, letters by Ryder and his friends, and early magazine articles and citations in books offer important clues. Using guideposts of this kind, it is possible to turn to changes in the style and the subject matter of his paintings as the main source of evidence for his artistic development. It is particularly important to do this because, until now, no one has successfully assessed the step-by-step unfolding of his creative genius.

The result of this effort has been twofold: a list of Ryder's works arranged in

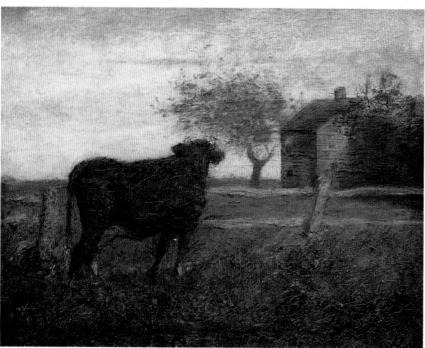

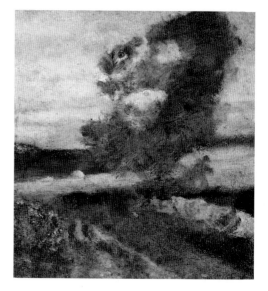

Fig. 6–3. Albert Pinkham Ryder. *The White Horse*. Middle to late 1870s. Oil on canvas mounted on wood panel, 8⅛ x 10″. The Art Museum, Princeton University. Gift of Alastair B. Martin

Fig. 6–4. Albert Pinkham Ryder. *Mending the Harness*. Middle to late 1870s. Oil on canvas, 19 x 22⅝″. National Gallery of Art, Washington, D.C. Gift of Sam A. Lewisohn. Photograph: The Metropolitan Museum of Art, 1918

Fig. 6–5. Albert Pinkham Ryder. *The Pasture*. Middle to late 1870s. Oil on canvas, 12⅛ x 15¼″. North Carolina Museum of Art, Raleigh. Gift of the North Carolina Art Society (Robert F. Phifer Bequest)

Fig. 6–6. Albert Pinkham Ryder. *Late Afternoon (Landscape Near Litchfield)*. Middle 1870s. Oil on academy board, 10 x 9″. Private collection. Photograph, 1938: RA

approximate order of execution, each with a specific or estimated date, printed as Appendix 5; and the following narrative account of this development, supported by documents where possible.

Charles de Kay reported that, early in Ryder's career, the artist went into the New York stables in order to depict the horses he saw there (figs. 6–1 and 6–2);[1] this he often did with considerable accuracy, if we can judge by paintings such as *The White Horse* (fig. 6–3) or, out of doors, *Mending the Harness* (fig. 6–4). He also took to the fields, painting from nature or memory (we cannot be sure which) both the landscape and its animal inhabitants, usually horses or cows (as in *Pastoral Study* [fig. 5–13] and *The Pasture* [fig. 6–5]). The titles of the paintings he exhibited in the early and mid-1870s, as pointed out in chapter 2, frequently reflect such

Fig. 6–7. Albert Pinkham Ryder. *Harlem Lowlands, November (Autumn Landscape)*. Late 1870s. Oil on wood panel, 9½ x 13⅛". Private collection

Fig. 6–8. Albert Pinkham Ryder. *The Pond*. Middle to late 1870s. Oil on canvas, 12¼ x 16½". Walker Art Center, Minneapolis

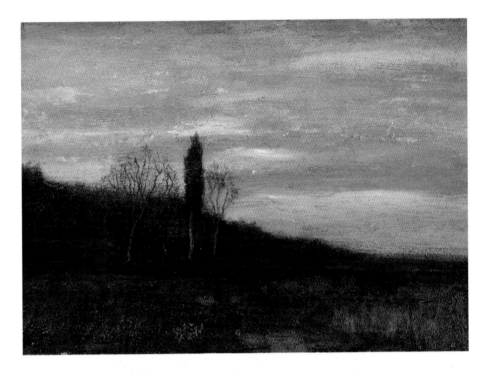

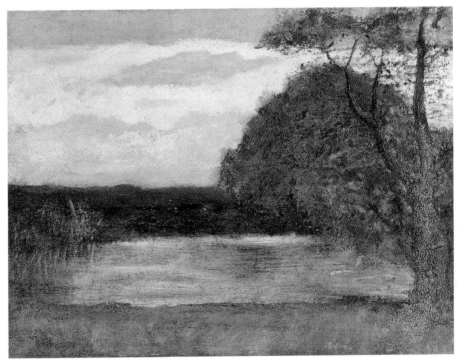

subject matter. Works of the 1870s, such as *Late Afternoon* (fig. 6–6), *Harlem Lowlands, November* (fig. 6–7), and *The Pond* (fig. 6–8), were painted with a warm, brownish palette, typical of the Barbizon School, and in these Ryder's goals are essentially naturalistic. At times, though, his draftsmanship shows naïveté, even crudeness, as in *In the Stable* (fig. 6–9) and *The Grazing Horse* (fig. 11–14).

It is difficult to determine how much of Ryder's eccentric style of drawing was due to his lack of skill and how much of it was intentional. Fellow artist Thomas W. Dewing once asked him: "Ryder, why do you paint those white horses of yours about fifteen feet long?" "Well," said Ryder, dreamily, "I think they are a little more naive that way."[2] Like a primitive, Ryder worked with silhouettes and outlines to a large degree, and his pictures never have much spatial depth. One feels

that he could not produce paintings in which there was a Renaissance space box or truly pronounced modeling; his skill lay in balancing and manipulating flat shapes, one against the other, and in creating subtle tonal and coloristic effects that convey a poetic mood (figs. 6–10 and 6–11). His *Pastoral Study*, for example, parallels Cézanne's early manner of drawing; in both artists there is an intense emotional drive trying to express itself in pictorial terms; but at this point neither had a great deal of visual sophistication or formal training (and perhaps this very lack gives the work its peculiar strength).

Ryder's decorative work was encouraged by Daniel Cottier. In the late seventies and early eighties, the painter seems to have been most involved with this kind of activity, as exemplified by the three leather screens, now in the National Museum of American Art (figs. 2–11, 2–12 and 2–13), commissioned as a wedding gift for Mrs. William C. Banning, an admirer of his work. In these pieces, which the recipient and her son dated to the late 1870s,[3] Ryder seemed completely at home with two-dimensional design. There is relatively little spatial depth in these decorative paintings, inviting us to read them from bottom to top (or left to right), rather than into depth. Ryder used diagonals much as the Japanese did: to create movement and to deny, instead of create, deep space. These traits are also found in *Shore*

Fig. 6–9. Albert Pinkham Ryder. *In the Stable.* Early to middle 1870s. Oil on canvas, 21 x 32″. National Museum of American Art, Smithsonian Institution, Washington, D.C. Gift of John Gellatly

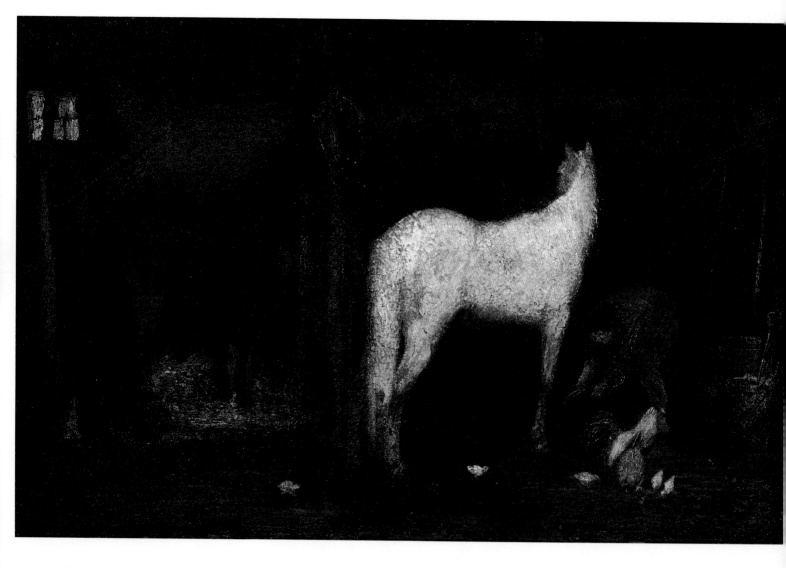

Fig. 6–10. Albert Pinkham Ryder. *Sunset Hour (The Golden Hour)*. Late 1870s. Oil on canvas, 10 x 13″. Collection Stephen C. Clark, Jr. Photograph: The Metropolitan Museum of Art, 1918

Fig. 6–11. Albert Pinkham Ryder. *Autumn Landscape*. Late 1870s. Oil on canvas, 18¼ x 24¼″. Private collection. Photograph: Sandak, Inc., Stamford, Conn., 1961

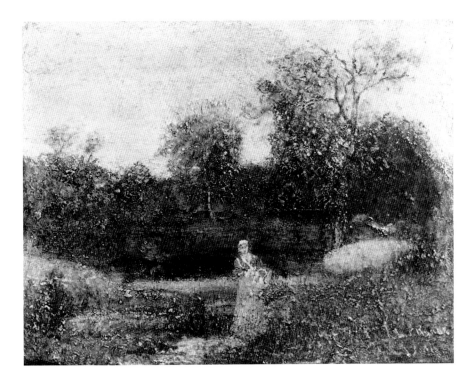

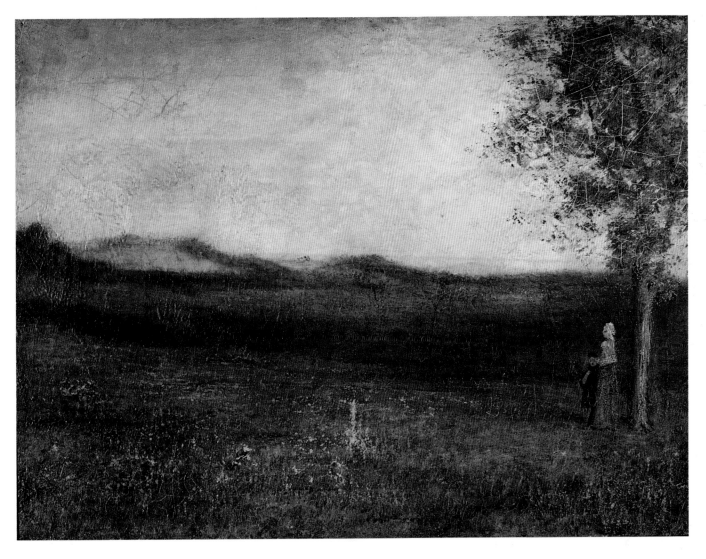

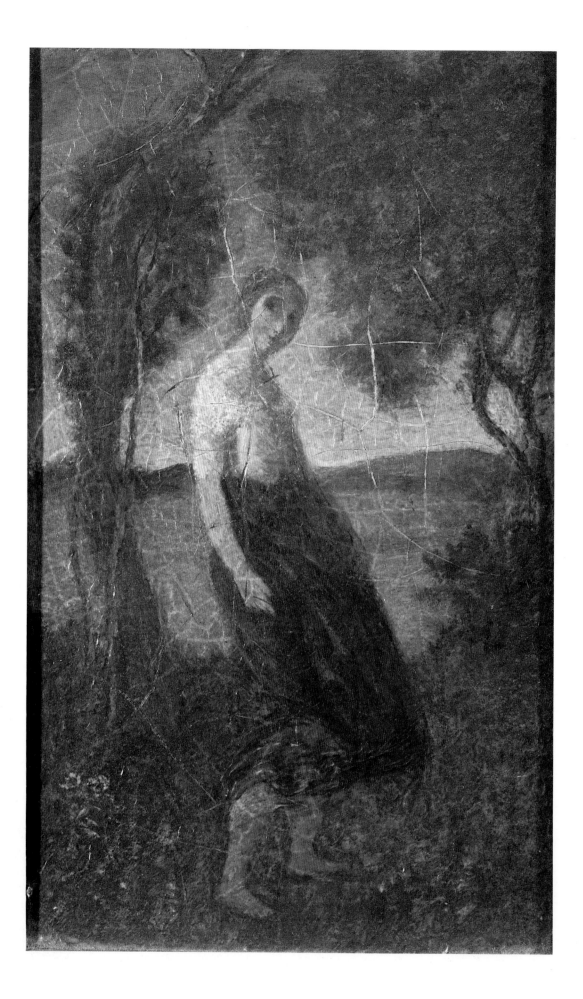

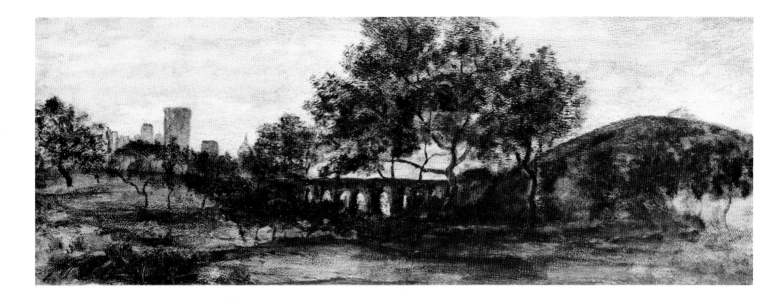

Fig. 6–12. Albert Pinkham Ryder. *A Country Girl (An Idyll; A Spring Song)*. Middle 1880s. Oil on canvas, 10⅛ x 6¼". Maier Museum of Art, Randolph-Macon Woman's College, Lynchburg, Va. Photograph: Sandek, Inc., Stamford, Conn., 1961

Fig. 6–13. Albert Pinkham Ryder. *The Bridge*. Early 1880s. Oil on gilded leather, 10 x 26¾". The Metropolitan Museum of Art, New York City. Photograph: Modern print from The Metropolitan Museum of Art negative, 1909

Fig. 6–14. Albert Pinkham Ryder. *Moonrise*. Late 1870s. Oil on canvas, 8½ x 10⅝". The Brooklyn Museum. Museum Collection Fund

Fig. 6–15. Albert Pinkham Ryder. *The Lover's Boat (Moonlight on the Waters)*. c. 1880. Oil on wood panel, 11⅜ x 12". Private collection

Scene (fig. 6–20) and *The Bridge* (fig. 6–13), works that seem quite Japanese not only in their emphasis on silhouette and simplicity of composition, but also in their long horizontal format, almost like a scroll painting.

Dating from the same period as the works just discussed is a group of more traditional paintings, such as *Spring* (fig. 2–18) and *Moonrise* (fig. 6–14), intended for exhibition (and presumably sale) at the National Academy of Design and the Society of American Artists.[4] Such paintings combine his finely developed decorative sense with vestiges of the poetic naturalism of the Barbizon School to form a style that bridges the 1870s and the 1880s. In a prime example, *The Lover's Boat* (fig. 6–15; plate 2), the subject is shown under the light of the moon (one of Ryder's first moonscapes), and the sky is one of the earliest of the dark, cloudy expanses whose expression of mood becomes increasingly pronounced as time goes on. Together with these subtle elements of romantic sentiment, there is a tendency toward patterning, the composition consisting of broad areas of water, clouds, and a few accents such as the pair of trees on the left and the bark on the right. Many of these pictorial elements are conceived as silhouettes, and they are placed almost decoratively on a plain background.

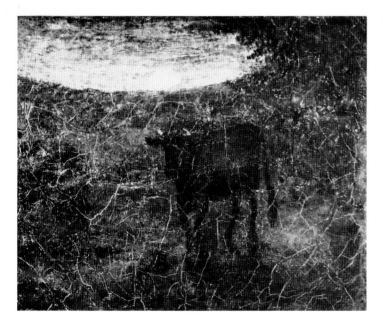

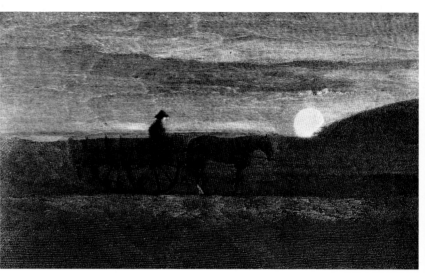

The small version of *Macbeth and the Witches* (fig. 6–16) must have been painted before 1890, because it was described in Charles de Kay's article on Ryder of that year.[5] The early 1880s would be an appropriate date for the work, as it shares much of the design of *The Lover's Boat*, with comparable patterning of moody clouds and the moon placed similarly near the horizon. Macbeth, his horse, the witches, and the roadway appear Japanese in their simplicity and crisp, eloquent silhouettes. *Macbeth and the Witches*, it should also be noted, is painted rather thinly, as are other examples that we can date to the late 1870s and early 1880s.

In certain works executed toward the end of this period, Ryder's paint becomes heavier and more tactile, as in *The Curfew Hour* (fig. 8–2), exhibited in 1882. The increased loading up of pigment points to Ryder's future use of heavy impasto; and this painting and another of the same time, *Plodding Homeward* (fig. 6–17) (also exhibited in 1882), forecast his later work in still other ways. We now find Ryder concentrating less and less on individual subjects against a "neutral" background and focusing increasingly on groups of humans or animals or both in relation to their environment. Not only is space seen more as a totality, but also that environment is filled with light, intensifying the expression of mood—a central feature in Ryder's paintings of the 1880s and 1890s.

After Ryder returned from Europe in 1882, his art took two major new directions: first, a turn to mythological and religious subject matter, together with scenes from literature; and second, an increasingly strong commitment to deeply expressive mood, both in these kinds of themes and in his landscapes and marines. Moreover, he created figures of a much larger scale, as in *Christ Appearing to Mary* (plate 6), bought by Thomas B. Clarke in 1885, and *Resurrection* (fig. 4–10), illustrated in connection with the auction sale of Mary Jane Morgan's collection in 1886.[6] These works show a new emphasis upon the human figure as the chief vehicle of expression. They are no longer landscapes *with* figures—in the manner of *The Shepherdess* (fig. 6–18)—but rather figure paintings in which the landscape reinforces the main narrative.

Another dimension of Ryder's work of the 1880s is found in his more visionary and poetic subjects, such as *The Temple of the Mind* (plate 5), purchased by Clarke in 1885, and *Pegasus* (plate 3), which was being worked on in 1883 and was in-

Fig. 6–16. Albert Pinkham Ryder. *Macbeth and the Witches*. Early 1880s. Oil on canvas mounted on wood panel, 10 x 10″. The Art Museum, Princeton University. Gift of Alastair B. Martin

Fig. 6–17. Albert Pinkham Ryder. *Plodding Homeward (Homeward Plodding; Moonrise)*. Early 1880s. Wood engraving of the painting from *The Century Magazine*, June, 1890. Location of original unknown

Fig. 6–18. Albert Pinkham Ryder. *The Shepherdess*. Early 1880s. Oil on wood panel, 10⅛ x 6¾". The Brooklyn Museum. Frederick Loeser Art Fund

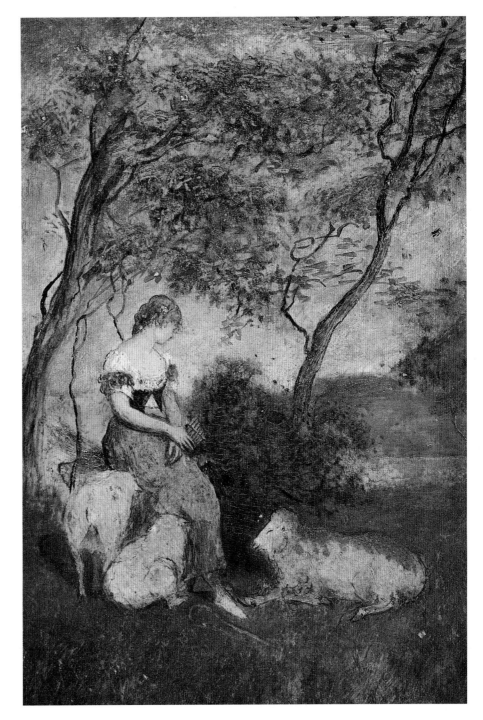

scribed 1887 in a dedication on the back.[7] In the first instance, Ryder created his own pictorial language on the basis of Edgar Allan Poe's poem "The Haunted Palace," but without illustrating the poem literally, or, in the case of *Pegasus*, simply offered his own personal vision of the traditional subject of the mounted poet entering the realm of the muses. In both works, Ryder exhibited a subtlety and skill in drawing that had been emerging in his work of the early eighties, but now reached full fruition in his treatment of the figures. In the broadest sense, they may be said to exude a classical feeling, partly as a result of the drawing and also because of the

Fig. 6–19. Albert Pinkham Ryder. *The Toilers of the Sea*. c. 1883–84. Oil on wood panel, 11½ x 12″. The Metropolitan Museum of Art, New York City. George A. Hearn Fund, 1915. Photograph: The Metropolitan Museum of Art, 1918

classical balance or stasis in their compositions. In *The Temple of the Mind*, we find a pronounced axis, a suggestion of perspective reaching from the foreground to the middle ground which reinforces the centrality of the image, with visual weights placed at the left and right; and in *Pegasus* there is a similar centering, with the main figure dividing the composition into approximately equal halves.

In the 1880s, Ryder also began to produce seascapes on a regular basis. *The Toilers of the Sea* (fig. 6–19; plate 4) and *The Waste of Waters Is Their Field* (fig. 4–7) belong to the early part of the decade. In these paintings, the moon and dark, cloud-filled sky provide a mysterious setting for a lone sailboat making its way through a choppy sea. In spite of the romantic subject, drawing more upon feeling than reason, each work possesses a visual logic that depends in large part on centralized forms that focus and regulate the composition.

Fig. 6–20. Albert Pinkham Ryder. *Shore Scene (Pirate's Isle; Smuggler's Cove)*. Early 1880s. Oil on gilded leather mounted on canvas, 9½ x 27¼″. Georgia Museum of Art, University of Georgia, Athens. Eva Underhill Holbrook Memorial Collection of American Art, gift of Alfred H. Holbrook

Fig. 6–21. Albert Pinkham Ryder. *Oriental Camp (Arab Scene)*. Middle 1880s. Oil on canvas, 7¼ x 12″. Mead Art Museum, Amherst (Mass.) College. Photograph: The Metropolitan Museum of Art, 1918

Fig. 6–22. Albert Pinkham Ryder. *The Hunter's Rest (Hunter and Dog)*. Middle 1880s. Oil on canvas, 14⅜ x 24″. Nebraska Art Association, Thomas C. Woods Memorial Collection, Sheldon Memorial Art Gallery, University of Nebraska-Lincoln. Photograph: The Metropolitan Museum of Art, 1918

Ryder accomplished this without losing his sense of flat pattern. Although his paintings of the mid-1880s, such as *The Little Maid of Arcady* (fig. 5–1), *A Country Girl* (fig. 6–12), *Oriental Camp* (fig. 6–21), and *The Hunter's Rest* (fig. 6–22), do not look as obviously Japanese as before, he remained a master of balancing the various pictorial elements, whether solids or spaces (or positive and negative shapes) on the picture's surface. His compositional unity or integration in this period, and later, depends heavily upon the interlocking of such shapes, through which the work functions as a tightly ordered design. Equally notable is his ability to create eloquent, telling forms that convey some emotional truth. When these are integrated compositionally with their "background," as just mentioned, then the pictorial strength and unity of Ryder's paintings becomes all the more pronounced.

In this phase of his career, Ryder turned even more than in the 1870s to a technique that allowed him to create luminosity and glowing effects comparable to those found in the works of the Old Masters. His color, while no more intense than before, was more resonant and varied, the result of multiple glazings over an essentially monochromatic base. The resulting coloration, in his best preserved works,

Fig. 6–23. Albert Pinkham Ryder. *With Sloping Mast and Dipping Prow.* Late 1880s. Oil on canvas, 12 x 12". National Museum of American Art, Smithsonian Institution, Washington, D.C. Gift of John Gellatly

almost always tends toward somber olive green, with accents of light tan, reddish brown, and touches of bright red and blue. Yet it must also be noted that the subsequent deterioration of his pigments and mediums, together with his heavy varnishes, has caused many of his paintings to become duller and darker in appearance, so it is difficult to assess accurately their original appearance. In the matter of brushwork, however, we can be more certain about his original intentions: his strokes became bolder and coarser, and he began to build up the paint surface with a heavy impasto, much as Rembrandt did.

Throughout the rest of his life beginning in the 1880s, Ryder devoted himself to paintings in which figures play a prominent role, together with landscapes and seascapes resonating with romantic emotion and poetic sentiment. Yet their compositions were often relatively stable and balanced, classical in their quiet repose. Toward the middle and end of the 1880s, however, came a major change, the effects of which persisted at least until the mid-1890s. His new repertory of subject matter—stormy dramas, full of mystery and symbolism—demanded turbulent designs, carried out with visionary intensity and revealing extraordinary painterly inventiveness. At this time, Ryder continued to develop heavily encrusted paint surfaces, building up increasingly dense layers that at times began to resemble sculptural reliefs. And he continued to make his surfaces look like those of the Old Masters, creating an increasingly warm, radiant glow from within.

Fig. 6–24. Albert Pinkham Ryder. *The Flying Dutchman*. Middle to late 1880s and later. Oil on canvas, 14¼ x 17¼". National Museum of American Art, Smithsonian Institution, Washington, D.C. Gift of John Gellatly. Photograph: The Metropolitan Museum of Art, 1918

One of the earliest datable examples showing Ryder's new baroque vigor is *Jonah* (plate 7), a painting he sold in 1885 and which was reproduced in an earlier state in De Kay's *Century Magazine* article on Ryder in 1890 (plate 7A).[8] Here the artist activated the entire surface of the painting from the churning waters to the billowing clouds above. It is as though Ryder had taken the visual conception of *With Sloping Mast and Dipping Prow* (fig. 6–23) and radically stepped up its level of vibrant energy. That energy, that tumult, was his channel for expressing his intense feelings about the subject, a theme charged with epic grandeur and conflict.

Another theme requiring a similar kind of energy and tension, in this case from a legend popularized by Richard Wagner, was *The Flying Dutchman* (fig. 6–24; plate 9), exhibited in 1887. Even more than *Jonah*, this painting is infused with fluid, dynamic movement that permeates—even consumes—the physical matter portrayed within it. As in the late work of Turner, objects melt into each other and almost lose their identity. Again, Ryder's vigorous emotional response led him to a radical, imaginative transformation of his subject in this work. And, as with his later repainting of *Jonah* (we know nothing of its original texture in 1890 or before), he built up the surface of the painting with passionate sweeps and draggings of his brush, applying multiple layers of pigment. The result, echoed in varying degrees in his other works of the period, is a luminous surface, resembling the color treatment of the sixteenth-century Venetians.

Some of the visual excitement of *The Flying Dutchman* can also be found in *Siegfried and the Rhine Maidens* (plate 10), started in 1888 and exhibited in 1891. In this painting Ryder combined a typical cloud-filled sky and glowing moon with figures that act out the dramatic narrative in a landscape dominated by windswept trees. All has been activated and energized so that the trees twist and turn, the clouds swirl about as a visual metaphor for the emotional tension in Siegfried's encounter with the maidens. The figures are integrally locked into the design, rather

Fig. 6–25. Albert Pinkham Ryder. *Homeward Bound*. c. 1893–94. Oil on canvas mounted on wood panel, 8⅞ x 18″. The Phillips Collection, Washington, D.C.

than functioning as separate units, and thus they and the landscape share equally in the grand rhythms of the composition.

The vivid imagination that gave birth to *Siegfried* remained active in *The Race Track* (plate 11), based on an event of 1888 and presumably worked on from then at least through the early 1890s. This is one of Ryder's most inventive paintings, a canvas that reveals spiritual affinities with the extreme, fantastic art of fin-de-siècle Europe and which, in its resemblance to Surrealist imagery, seems to belong more to the twentieth century than to the nineteenth.

Except for *The Race Track*, the paintings just discussed, dating in all probability from the mid- and late 1880s and worked on at least through the mid-1890s, represent the most vigorous, imaginative, and dynamic phase of Ryder's art. This was also his most baroque period, a time when he infused his designs with lively movement and heightened the contrast of his tonal values to convey his profoundly felt sympathy for his subjects. For the remainder of the nineties, he responded no less vigorously to his chosen themes, but for those he selected in this period, he invented an appropriate language that was, in most instances, calmer, more sedate and reflective. *Constance* (plate 8) is a case in point. In this canvas he presented a tranquil image of a mother and child drifting on a calm sea, with soft clouds, mostly in horizontal bands, lingering overhead. While the forms are bold and simple, the touch is fine and delicate, with multiple glazes producing a subdued glow in sea and sky. Not only did the subject call for a more restful visual language in this instance, but there is also now found in Ryder's creative life a kind of détente in a group of peaceful scenes such as *Homeward Bound* (fig. 6–25), dating 1893 or 1894, and *Moonrise, Marine* (fig. 6–26), 1890s and later, that issued from his studio. Even in an ambitious literary painting, such as *The Forest of Arden* (plate 12), which appears to have been reasonably complete by 1897, Ryder avoided the clashing diagonals

Fig. 6–26. Albert Pinkham Ryder. *Moonrise, Marine (Moonlight; Moonlight Landscape)*. 1890s and later. Oil on canvas, 9¼ x 11⅛″. Private collection. Photograph: The Metropolitan Museum of Art, 1918

Fig. 6–27. Albert Pinkham Ryder. *The Monastery*. 1890s. Oil on wood panel, 12⅞ x 9⅜″. The Parrish Art Museum, Southampton, NY. Museum Purchase, Mr. and Mrs. Robert F. Carney Fund

and excited activity of his baroque phase; the painting depends upon overlapping, almost parallel bands of earth, trees, and clouds, allowing the viewer's eye to move into depth in a measured, stately rhythm. There is something sedate and quiet about late works such as this, and in *The Monastery* (fig. 6–27), an "old-age" style as he approached his fifties, one might say, common to many artists from the Renaissance to Ryder's time.

Belonging in the same company as the paintings just discussed is the large version of *Macbeth and the Witches* (fig. 6–28; plate 15), known to have been underway by 1899, and perhaps started earlier. As in *Siegfried*, the landscape helps to set the emotional tone of the narrative, but here the mood is quieter, more reflective, thanks to the painting's mysterious depth of tone. It is an epic moment in the drama portrayed very differently from that in the smaller earlier version; here, decorative patterning gives way to a tense psychological interplay between the mounted pair, Macbeth and Banquo, and the ghostly forms of the witches who confront them. One horse rears up in fright; wind whistles across the heath; and the sky flickers with an eerie light. Ryder has thus used every possible means to bring the event to life, re-creating the drama as he had envisioned it in his mind's eye.

Occasionally Ryder departed from the reflective mood and spirit of calmness just cited: for instance, *The Lorelei* (plate 14), "finished" in 1896 and worked on intermittently until Ryder's death, is filled with jagged mountains and rocky promontories and at first glance appears different from his other works of the nineties. But upon closer inspection, the design reads as roughly symmetrical, and vigorous human movement is held in check. The visual ambience of the canvas—its light and tone—rather than overt action, conveys much of its message.

The foregoing remarks about Ryder's stylistic development have been limited to works, most of them major, that can be dated approximately by the time of their

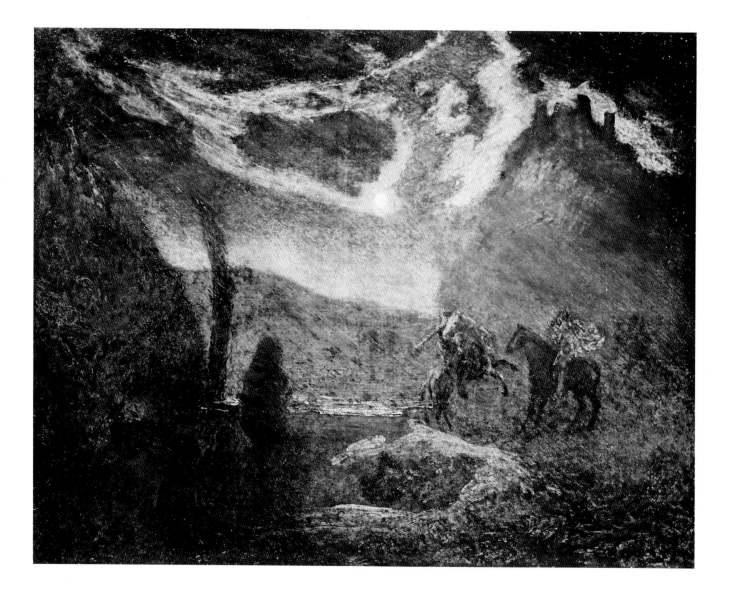

Fig. 6–28. Albert Pinkham Ryder. *Macbeth and the Witches*. Middle 1890s and later. Oil on canvas, 28¼ x 35¾". The Phillips Collection, Washington, D.C. Photograph: The Metropolitan Museum of Art, 1918

exhibition, appearance in an early illustration or text, record of sale, or mention in Ryder's letters. The general steps in his evolution may thus be traced with some accuracy, but there are limits to this method, limits imposed, one could almost say, by Ryder himself. The chief problem is that he frequently repainted and reworked his canvases over long periods of time, so what we see today in a given painting may not be what existed when he first conceived and executed the work. And just as misleading are the restorations of, and other changes imposed on, Ryder's work after his death (see chapter 11). For example, the coloration, drawing, and surface of certain paintings—such as *The Tempest* (plate 13)—were so noticeably altered that works of this kind cannot be used to appraise Ryder's stylistic evolution. Even some of the paintings cited in this narrative—*The Race Track*, for example—are known to have been changed after 1917, and thus only their general composition and tone may be cited as evidence for Ryder's stylistic evolution.

With these words of caution, we can place Ryder's remaining authentic paintings in a chronological sequence on the basis of style and associated subject matter. In almost every case, the dates proposed here and in Appendix 5 must be taken only as approximate, rather than as fixed and final, in keeping with Ryder's distinctively slow method of working.

*Ryder
the Man*

Fig. 7–1. Alice Boughton. *Albert Pinkham Ryder.* c. 1905. Photograph, 7⅞ x 6⅛″. The Library of Congress, Washington, D.C.

WHAT WAS RYDER (fig. 7–1) really like? From those who knew him we hear the same adjectives over and over again: gentle, courteous, shy, kind, generous, otherworldly, impractical, sensitive. To some he appeared saintlike; the Chicago poet and critic Harriet Monroe, who interviewed him, remarked: "The rubbishy place with its litter of masterpieces faded away, as we talked, in the finer light diffused by a man so absorbed in his art, so devoted and selfless, as to rank with the saints of the church or the martyrs of science. . . . I think Ryder was the most heavenly spirit I have ever known, the most happily detached from all earthly and fleshly ties, the most devoted to the acceptance and working out of his particular revelation of truth and beauty."[1] In a similar vein, the dealer N. E. Montross recalled: "He was essentially a man of childlike—not childish—simplicity and bigness. . . . He was absolutely unworldly and felt no need for the conventionalities."[2]

Ryder treasured his solitude not only because he was shy, but also because he wanted to devote himself to his work, without distractions. In his letters and other statements, he repeatedly made it clear that painting was his primary responsibility. He said in 1905: "[The artist] must live to paint and not paint to live. He cannot be a good fellow; he is rarely a wealthy man, and upon the potboiler is inscribed the epitaph of his art."[3] And: "The artist should not sacrifice his ideals to a landlord and a costly studio. A rain-tight roof, frugal living, a box of colors and God's sunlight through clear windows keep the soul attuned and the body vigorous for one's daily work."[4]

Although Ryder treasured his privacy, he was, as already mentioned, far from

being a hermit. He enjoyed the companionship of his close friends in New York with whom he often dined. Or, from time to time he would travel longer distances—to Goshen, New York, or Branchville, Connecticut, for example—to visit with them. On two separate occasions, in 1887 and 1896, Ryder journeyed as far afield as England mainly for the sea voyage, taking ships commanded by his English friend Captain John Robinson. On these trips Ryder would spend a couple of weeks in London, staying with the Cottiers or the Robinsons. Such excursions offered him not only the companionship of his friends, but also the opportunity to study cloud effects or the movement of waves. The 1896 trip, in particular, was urged upon him by his friends to relieve "a low nervous condition."[5]

Among all of Ryder's friends, his closest daily ties were with his neighbors Charles and Louise Fitzpatrick. Charles, as mentioned earlier, had been a seaman and was now a carpenter; his wife was an amateur painter.[6] Their apartment was below Ryder's at 308 West Fifteenth Street, where Ryder lived from the mid-1890s to 1909 (fig. 7–2); then, at an undetermined date, the Fitzpatricks moved next door. Because of their proximity and their mutual interests—the sea and painting—they soon became very friendly, seeing each other constantly. Louise became Ryder's only pupil and learned a great deal from him; she painted very much in his style, though with far less competence (fig. 9–9). Her pictures lack Ryder's depth of content and skill in drawing and design; they are the works of a naive artist, showing a sentimental sweetness alien to Ryder. As far as we know, she did not exhibit, except briefly when she was young in New Orleans, and the artist Philip Evergood, who knew her through his family's close ties with her, thought she had not produced more than fifteen or twenty canvases.[7]

According to Evergood, "Ryder and Charlie [Fitzpatrick] had been good buddies. Occasionally they would go on mild beer drinking sprees together, going from pub to pub singing sea ditties. Ryder and Charlie both had good rousing voices. Ryder himself was a big strong fellow and enjoyed a few beers, though on the whole he was pretty abstemious." Evergood remembered Charles Fitzpatrick as "a raw-boned giant of a man both in stature and strength," but his wife Louise, who was of Scandinavian origin, "looked like a fair haired dimpled Bruegel girl. When she matured, she mellowed into a replica of the pale, plump, misty-eyed glowing mothers of the human race, which Rembrandt painted."[8] She seemed to be a deeply spiritual, caring person—a "good soul," in Ryder's own words[9]—whose life increasingly became intertwined with his. As Evergood observed, she was "a kind of Saint whose fervor and love for humanity was completely tied up in her fervor and love of the master. She would speak of Ryder and Christ in the same breath."[10]

Ryder had always loved children. Thus, Mary, the Fitzpatricks' niece and adopted daughter, must have been a source of joy to him. She sang, played the violin and piano, and, in his idealistic view, was "a little angel."[11] He wrote tenderly about her accomplishments to his friend Dr. Sanden: "[I] was so near the Fitzpatricks[,] dropped in there and heard the little girl play or practice the Ave Maria, and a beautiful composition from Menndelsohn [sic], and some other charming classic: all sweet melodies. The little thing really made some fine music, quite a treat."[12]

Charles Fitzpatrick wrote of the "happy days in Fifteenth Street" when Jack Kenny, the six-year-old son of a newspaperman who lived above Ryder and the Fitzpatricks, would come down and play soldier with Albert and Charles. Fitzpatrick recalled: "Jack would be the captain. I would play the snare drum with my

Fig. 7–2. The building in which Ryder lived from the mid-1890s to 1909, 308 West Fifteenth Street, New York. Collections of the Municipal Archives of the City of New York. Courtesy of Christopher Gray

mouth and Ryder would fall in the ranks and go marching around the room. Then we would have the Cavalry charge. Ryder would get down on his knees and Jack would climb on his back urging his steed on to the charge. This was great fun, all of us roaring with laughter."[13]

Captain Robinson recalled that, when Ryder was visiting London, he came home to find "the dear old fellow seated on the floor amongst a lot of children—about six or eight of them—playing 'Hunt the Slipper.' He was the only grown-up person there. After that they had 'Musical Chairs' and other children's games. . . . He was always at home amongst the little people and on this occasion he thoroughly enjoyed himself."[14] With female children, especially, Ryder seems to have been quite comfortable. He adored the daughters of his friends Weir, Warner, and Harold Bromhead (a Cottier employee and later a London dealer), and, as already mentioned, idealized the Fitzpatricks' adopted child, Mary.

In the same category was Ryder's relationship with the wives and daughters of his close friends, women whom he admired and appreciated in a most chivalrous fashion, as we have seen. These structured relationships allowed Ryder to express his feelings of warmth and love, even at times to indulge in playful baby-talk. For example, in one of his letters he addressed Peggy Williams, Cottier's daughter, who had married Ichabod Williams's son Lloyd, as "Dearest Peddlums" and closed with the following:

> Au Revoir,
> Bon Voyage.
> Delightful days
> The Ocean be at its best
> Pleasant companions
> The winds blow soft.
> And Psycopathic [*sic*] greetings
> Come on the air to you
> All the way.
> Best wishes
> Yours as ever
> And more so
> Your old friend
> Your good friend
> "Pinklets"[15]

With adult women, other than close friends, Ryder was variously ill at ease, childish, or impulsively romantic. His colleagues told the story—in different versions—of his sudden infatuation with a woman who lived in his building, a violinist whose playing so moved him that he called on her and proposed marriage.[16]

Ryder is said to have been in love with an opera singer, but his friends thought she was unsuitable and so Cottier whisked him off to Europe "to get [him] over this."[17] The trip may have been that of 1896, mentioned earlier, which was meant to remedy his "low nervous condition." The painter Arthur B. Davies thought he had been "disappointed in love several times" and speculated that his relationships had faltered because, in Ryder's view, "People had 'interfered.' "[18] Perhaps unfair-

ly, Ryder's friends stepped in to "save" him from what they undoubtedly viewed as an impossible prospect—a conventional relationship with a woman. Clearly, Ryder was capable of feeling deep love for women, but it was so idealized—and his way of life so removed from the practical—that marriage and progeny seem to have been out of the question.

Kenneth Hayes Miller thought he was androgynous, that "there were elements of both man and woman in him, that he was sufficient until [sic] himself." Miller went on to compare Ryder to Thomas Mann's idea of Jehovah, a spiritual being standing far above gender and worldly desires.[19] Ryder, saintlike, transcended earthly sexuality to give birth to another kind of progeny: painted works of sublime beauty and moral persuasiveness. These were his prime concern; all else he sacrificed to a higher calling.

In order to pursue his goals, Ryder spent the great majority of his time in his studio. He made it clear that having visitors would disturb him; so for the most part he avoided all but his closest friends. But on those rare occasions when he agreed to receive someone new, he proved to be a gracious host, telling stories, and patiently showing example after example of his work. As Sadakichi Hartmann recalled, "Ryder was a pleasant man to talk to. Although somewhat inaccessible and aloof from chatter and social diversions, always puttering about, absent-mindedly half of the time, a good listener though, he was genial throughout and easy to get along with. He would have a kind remark to make about this or that, but his utterances seemed to be devoid of enthusiasm. That quality he reserved for his work; he was off duty when he talked with visitors."[20]

If intruders from the world of art threatened his privacy and his composure, he had no such reservations about people he met on the street. Stories are often told of how Ryder would gladly mix with ordinary working people, who seem to have accepted him as one of their own. Even in his early years in New York, as recounted earlier, Ryder abandoned the solitary table his brother had provided in the hotel dining room and would "wander about among the help, get chummy with them, and finally dined with the help."[21] Captain Robinson recalled that, when Ryder and his friends were walking along Fifth Avenue to James Inglis's home, after an evening with Ichabod T. Williams, the collector and lumber merchant, the artist unexpectedly disappeared. "One of the company went back to find him, and discovered him in a hallway sharing his money with a begging tramp."[22]

Except when he occasionally dressed up for a formal event or to see the galleries (then he would wear an old frock coat and top hat), his clothes were completely unpretentious. At home he usually wore blue overalls and slippers, and in the winter a heavy overcoat his father had given him. Indoors and out, he wore a brownish red fisherman's cap.[23] The only known portrait of Ryder in his informal clothes is one done from memory, years after his death, by Marsden Hartley (fig. 7–3). Kenneth Hayes Miller, who knew him in later years, remembered that he "dressed like a workman, with old shabby clothes and a sweater."[24] On the street, people sometimes took him for a beggar and offered him money.

Yet, when Miller painted Ryder's portrait (fig. 7–4), he depicted him in a most respectable-looking suit, although, as Hartley put it, "the true vision of Ryder was nothing of the sort." Hartley went on to say that "there is an intellectual conception there which is justifiable but at the same time it is Ryder 'dressed up' and was doubtless the wish of the dear old man himself. And as he said to me of the wretched condition of his poor apartment—'I never notice all this disorder until someone comes to see me.' So it is I suspect that the gentleman in him rose and he wished to

Fig. 7–3. Marsden Hartley. *Portrait of Albert Pinkham Ryder*. 1938–39. Oil on board, 28½ x 22¼". Collection Milton and Edith Lowenthal

be recorded in his dress clothes and not as the absent one seeking new stratas of lunar desolation."[25]

Interestingly, for his portraits by the noted photographer Alice Boughton (see frontispiece and figs. 7–1 and 10–1), taken at Arthur B. Davies's suggestion, Ryder chose to be recorded in the same formal style of clothing. No doubt he wished to present himself to the world as a New England gentleman, not as a disheveled bohemian.[26]

Ryder's traits of self-sufficiency, otherworldliness, and freedom from conventions were expressed in the way he kept—and viewed—his living quarters. We know that by 1896 he was living in rented rooms in an old house at West Fifteenth Street, in a drab neighborhood in Chelsea, just north of Greenwich Village. It was, as Charles Fitzpatrick reported, "one of those peculiar houses that attract professional people of small means."[27] Ryder's quarters at the rear of the third floor (sometimes identified as the second floor) consisted of a large, high-ceilinged parlor, with a fireplace, and a small adjoining room in which he slept. He did not have a proper studio or even north light, most desired by artists; the house was on the south side of the street and his two windows faced a back yard with trees. Ryder rhapsodized about the view: "I have two windows in my workshop that look out upon an old garden whose great trees thrust their green-laden branches over the casement sills, filtering a network of light and shadow on the bare boards of my floor. Beyond the low roof tops of neighboring houses sweeps the eternal firmament with its ever-changing panorama of mystery and beauty. I would not exchange these two windows for a palace with less a vision than this old garden with its whispering leafage—nature's tender gift to the least of her little ones."[28] Although Ryder had thus romanticized the appearance of this yard, a clear-sighted visitor recalled that it was "draped with clotheslines and washings, and filled with ash barrels, garbage cans and rubbish."[29]

In a similar vein, others recounted Ryder's favorable responses to certain examples of cheap popular art. The painter Paul Dougherty reported that Ryder once said to him: "Paul, I have the most beautiful thing you ever saw." Ryder pulled from his pocket a worn newspaper clipping showing "a photograph of a girl in a tooth-paste advertisement." Dougherty said he thought that "probably Ryder did not really see the tooth-paste advertisement at all, but only what his mind made out of it; that the advertisement was simply a springboard for his imagination."[30]

Kenneth Hayes Miller had two similar experiences. One concerned a lamp in the hallway of the building in which Ryder lived, "a terrible affair, all decorated, with wires strung with little pink beads." Whenever Ryder passed by, he would say, "How pretty."[31] Miller also told the story of J. Alden Weir cleaning Ryder's apartment when the ailing artist had gone to the hospital. In the process, he had thrown away "a little plaster head, a cheap and tawdry thing." Ryder always resented this, according to Miller, because "evidently he saw something beautiful in it."[32]

All reports agree that his living quarters were in a state of incredible disorder. The house agent came once a year to see about repairs and painting, but Ryder would not let him in, so that his rooms were not painted or repapered all the years he lived in them. Wallpaper hung in long strips from the ceiling. He never threw anything away, and the floor became piled two or three feet high with every kind of object: old newspapers and magazines, discarded boxes, ashes, old clothes, soiled collars, empty bottles, unwashed dishes, eggshells, used tubes of paint, and dirty brushes. Over everything lay the dust of years. There were paths through this rub-

Fig. 7–4. Kenneth Hayes Miller. *Portrait of Albert Pinkham Ryder.* 1913. Oil on canvas, 24 x 20″. The Phillips Collection, Washington, D.C.

bish to the door, the easel, the fireplace, and to his bed. Charles Fitzpatrick gave him a pair of window shades and put them up for him, and Louise provided a set of curtains, but he shoved them on top of the window frames, where they "hung like rags for at least fifteen years and were never washed." Fitzpatrick went on to say: "He slept on a cot, but not being able to keep it clean, he abandoned it and slept on the floor. He had a fur rug given to him by Col. Wood on which he slept for some years until it was eaten up with the moths."[33]

Kenneth Hayes Miller had long admired Ryder's paintings, but had never met him. About 1909 he went to West Fifteenth Street to visit the artist. Ryder admitted Miller and asked him to sit down; no chair was visible, so he picked up a stack of rubbish and disclosed one—without a seat. Ryder then produced a cushion for the chair; he himself leaned against the rubbish. The older painter felt that he must entertain his guest; he told little stories and jokes—told them very well— "each ending in a little falsetto giggle." While he was talking he became conscious of an unwashed cup on the floor—there were many of them—and he leaned over, with difficulty because of his weight, "picked it up, and put it in another place on the floor—a little more out of sight."[34]

Ryder did his cooking, of a kind, on an open grate over a small charcoal fire, which he kept alive by blowing on it, until Fitzpatrick bought a bellows for him. Sometimes his meals were continuous: he would take food from the pot, then add more, for several days in a row. Once, when Miller asked him about his eating habits, Ryder said that he would sometimes go out and get "a good meal—a twenty-cent meal."[35] On the other hand, Fitzpatrick recalled: "He lit an extra big fire on Christmas day and roasted a small turkey over it. He brought it down and we had dinner together. He had cooked it as good as a chef."[36]

With few responsibilities, not even that of keeping up appearances, he needed little to live on. Management of money was a deep mystery to him. Checks and cash were left lying around his rooms. Once his painter-friend Horatio Walker asked him if he had any money, and Ryder replied that "there was some on a paper in the cupboard." After rummaging around he produced a check in four figures, months old. Walker explained the wisdom of cashing checks and took him to a bank and helped him open an account.[37] Later Ryder told another friend, the artist Albert Groll, that Walker was not only a fine painter but also a great financier.[38]

Yet in his later years, Ryder did not hesitate to place high prices on his paintings. This did not represent greed or worldly ambition but, rather, a measure of the artistic effort he had expended on his work and his belief in its worth. Colonel Wood reported that, just after Ryder received $1,300 from Sir William Van Horne for *Constance*, the artist announced at a Sunday breakfast meeting with his friends: "I think I shall raise the prices of all my pictures." Then he hastened to add, "After all my *friends* are supplied of course," with an apologetic glance at Wood.[39]

Although Ryder was often portrayed as a dreamer—unworldly and even otherworldly—his letters show that he had another side. Reading them (see Appendix 2 for a selection of his most important letters) we are struck by his common sense, his practical way of dealing with day-to-day problems, and even his awareness of current political issues. In the letters, too, he expresses great warmth and affection toward his friends, though undoubtedly, as stated earlier, opening himself up more in the written word than he was able to do in person. Ryder's letters reveal an educated and polite individual who valued close, loving, and trusting ties with a small circle of friends.

Fig. 8–1. Albert Pinkham Ryder. *Desdemona.* Middle 1880s–middle 1890s. Oil on canvas, 14¼ x 10″. The Phillips Collection, Washington, D.C. Photograph, 1947: RA

8

Growing Recognition

RYDER ENJOYED his greatest outpouring of creativity from the early 1880s to about 1900. This was the period when he conceived and executed (though often working beyond 1900) masterpieces such as *Jonah* (plate 7), *Constance* (plate 8), *The Flying Dutchman* (plate 9), *Siegfried and the Rhine Maidens* (plate 10), and *The Race Track* (plate 11) that guarantee his reputation as a major artist. Today, we enthusiastically acknowledge Ryder's great talent and the extraordinary imagination that gave birth to paintings such as these. But in his own lifetime recognition came slowly. For reasons cited in chapter 2 and for additional ones to be proposed in the following pages, Ryder at first was often misunderstood and attacked; on occasion he was simply ignored. Yet gradually critics came not only to understand and accept him, but also to praise and celebrate his achievements. This change of attitude had more to do with the shifting patterns of taste than with Ryder's own evolution or "improvement"; by the mid-1880s, the terms of his style were essentially set, and it was the critics who grew and gained enlightenment over the following years. As academic art gradually lost its powerful grip on American arbiters of taste, and as imaginative painting began to gain ground toward the end of the century, Ryder suddenly appeared strikingly relevant.

Most of the 1880s, especially after 1882, could be considered for Ryder a time of "pro and con," of mixed reviews, with critics of academic persuasion attacking him for poor drawing and technical ineptitude. No amount of poetic suggestiveness and sensitivity would, in their view, compensate for the artist's faults. "As to Messrs. Ryder and Blakelock, who seem to fancy that art is enough and nature has no place in the studio," wrote "J.M.T." in the *Art Amateur* in 1884, "they will have to learn that if art is the end of the painter's effort, nature is the material of his study, and no such complete divorce as Mr. Ryder, especially, shows can lead to a permanent position."[1] More vitriolic were Ripley Hitchcock's remarks in the *Art Review*. On the subject of *Figure Composition* (actually *Desdemona* [fig. 8–1]), he wrote in 1887:

Fig. 8–2. Albert Pinkham Ryder. *The Curfew Hour.* Early 1880s. Oil on wood panel, 7½ x 10". The Metropolitan Museum of Art, New York City. Photograph: Modern print from the Metropolitan Museum of Art negative, 1909

The figure is without human interest, and the composition is the slightest. Perhaps it would have been better for the artist to have furnished one of his verses as a title, but the picture which requires explanation falls flat. A picture, it need hardly be said, should explain itself, but here this poorly drawn, vague form carries no meaning and one must fall back upon the richness of the color, or adopt the dangerous plan of imagining in the picture all manner of qualities which it does not possess. No doubt the artist has a fund of what is termed poetical sentiment, but this does not always make itself felt, and the method of his expression appeals to the eye rather than to the heart, like the works of artists who use color frankly for color's sake.

Grudgingly, though, Hitchcock added: "Yet imperfect and tentative as this little picture is, it is a pleasant resting place for eyes wearied by discords of the commonplace."[2]

Side by side with negative reviews such as these, we may read the laudatory words of a small but influential corps of Ryder defenders. These authors were mainly members of the Gilder–De Kay circle. Clarence Cook, art critic for the *New York Tribune*, was one of his chief supporters, and Charles de Kay, art critic for the *New York Times*, also wrote favorably about him. One of his earliest supporters, Mariana Griswold Van Rensselaer, a critic who was a friend of the Gilders and De Kays, wrote in glowing terms about Ryder in 1882. Observing "two exquisite little landscapes" at the Society of American Artists exhibition (actually, *The Curfew Hour* [fig. 8–2], and *Plodding Homeward* [fig. 6–17]), she remarked that they were

Rich in color, vague in theme, and full of sentiment to a degree that is attained, I think, by no other painter on our side of the water. To those who do not sympathize with Mr. Ryder's aims in art—the aim, if I may say so, after *beautiful paint* as such, and the aim after strength and individuality and poetry of sentiment rather than after definition and the recording of material facts—his pictures seem meaningless, I am told, or even affected; but to those who *do*

sympathize with his aims, and these seem to include a growing band of lay admirers and all his brother artists, however alien from him in their own kinds of work, his pictures have a charm and value unequalled by that of any work done among his countrymen.[3]

De Kay, writing for the *New York Times*, responded warmly to his works on view at the National Academy of Design and the Society of American Artists in the spring of 1883: "It may seem strong language to say that in these, perhaps the highest qualities of painting, Ryder is unequaled by any artist in Europe; but it is a fact that more and more artists and amateurs are awakening to him every year. Singular that New York, the most bustling, hard-living city of the world, should produce the painter who is able, better than any other artist now, before any public, to express these moods of infinite peace and of serene thoughtfulness in landscape."[4]

Critics unwilling to deal in such superlatives usually accepted his naïveté and primitivism, justifying his works by comparing them to the art of the Middle Ages or the Renaissance, or even Japanese lacquer work. The emerging taste for art outside the classical and Realist-Impressionist traditions, of course, favored Ryder's stylistic innovations and eccentricities, so it is not surprising to find a growing climate of approval among more open-minded viewers. Others simply enjoyed his poetic sense, his originality, and his superb, luminous color—and were not afraid to say so.

Clarence Cook was one of these. Publishing the first substantial notice of Ryder in book-form, in *Art and Artists of Our Time* (1888), he linked him to the poetic-ideal tradition that began with Washington Allston and continued with Abbott Thayer and George Fuller. While Cook thought Ryder often had difficulty in expressing his thoughts completely, Cook praised Ryder's treatment of *The Temple of the Mind*, which Cook reproduced in an almost full-page plate (plate 5A). "We have no artist," he asserted, "who can deal so subtly as Ryder with the glamour of fairy-land."[5] What this author said was not as important as the fact that he chose to include him in his book, a rare occurrence for the painter until the opening years of the twentieth century.

The first article devoted solely to Ryder, as already noted, was penned by Charles de Kay and was published in the *Century*, June, 1890.[6] He revealed not only his own tastes, but also, undoubtedly, those shared by his circle, who cherished Ryder and his work and believed the artist was too little appreciated. De Kay obviously wrote from the heart, with deep and sincere feeling; at the same time, he was a friend of Ryder, eager to offer him the kind of public acclaim he felt he deserved. Thus, he presented himself as an apologist, making it clear that Ryder required sympathetic explanation in order to be fully appreciated.

In his remarks about Ryder, De Kay was very much a product of his time. He mirrored the critical battles between academic art, with its emphasis on correct drawing and rational procedures, and the newer, more intuitive art of color, the domain of the younger, more progressive American artists. He placed Ryder among the latter, and much of his defense hinged on the artist's ties with the coloristic tradition. De Kay treated Ryder, however, as much more than a passive follower of this tradition. The artist was hailed as a preeminent colorist, overshadowing Americans such as George Fuller and R. Swain Gifford; ranking with William Morris Hunt, George Inness, Homer Martin, and John La Farge; rivaling such distinguished European painters as J. M. W. Turner, Anton Mauve, and Matthew

Maris; and surpassing Jules Dupré, Jean-Charles Cazin, and Adolphe Monticelli.

De Kay wished to detach Ryder from official schools and traditions, which he thought had held sway far too long in both European and American art. What he favored was an art produced by individuals with strong personalities and temperaments who do not fit into any neatly prescribed categories, such as the Munich, Hague, or Paris schools. But because Ryder did not belong to such groups, De Kay felt he had won less appreciation than he deserved. Moreover, the critic thought Ryder's devotion to color worked against his popularity, because it made him appear alien to traditional academic values.

De Kay tried to counter negative attitudes by offering a series of eloquent descriptions of Ryder's sense of color, stressing the superbly radiant and glowing qualities of his paintings. Typical are these remarks:

> His pictures glow with an inner radiance, like some minerals, or like the ocean under certain states of cloud, mist, wind. Some have the depth, richness, and luster of enamels of the great period. He is particularly moved by the lapis lazuli of a clear night sky and loves to introduce it with or without a moon. The yellow phase of the moon when she is near the horizon, and also occasionally when she is on the zenith,—in Indian summer, or when fine smoke or dust is distributed through the air,—find him always responsive. The mystery and poetic charms of twilight and deeper night touch him as they do poets; Ryder attempts to reproduce their actuality in colors.[7]

He then linked Ryder's colorism with his imaginative and poetic subject matter, seeing color as the appropriate vehicle for such themes. Those who harbored negative feelings about Ryder, De Kay counseled, should try to view the painter as an idealist, a fantasy artist, a poet in paint. Thus, his weakness in drawing, which De Kay acknowledged, could be excused. If, in turn, the forms in his paintings appeared unconventional, they could be justified by comparison to the art of the Near East, Medieval glass, and Persian decoration. The decorative qualities in his work could be viewed as a strength and a consciously chosen direction, not a weakness.

De Kay admitted that Ryder, at the age of forty-three, was still little known, but he argued that the artist was worthy of attention and had already gained the respect of art students and a select circle of fellow artists. Also, a small but perceptive group of collectors had begun to respond enthusiastically to his works and to purchase them. In this connection, De Kay pointed out that Ryder's art was constantly improving and that although his prices were still low, he would be a good investment and would be treasured by collectors—a prediction that proved to be quite accurate.

Ryder continued to win praise for his formal strength, his vivid imagination, and his color—always his main asset, even from his earliest years. Those who were most enthusiastic about his work wrote about him in glowing terms, comparing him like De Kay and many earlier critics to European masters such as William Blake, Eugène Delacroix, and Jean-François Millet—and finding him their equal in many respects. Critics, moreover, began to develop a sophisticated vocabulary that reflected a far deeper understanding of Ryder's paintings than before, and now he no longer had to depend for approval on sympathetic friends in the press.

Writers such as William Howe Downes and Frank Torrey Robinson ranked Ryder "with the very best American painters of our time."[8] Whereas he was pre-

viously seen as an outsider, a source of confusion to most critics, now he could be treated as part of a worthy art-historical continuum. The increasing acceptance of visionary and imaginative painting in the 1890s no doubt worked in Ryder's favor, as did the general Symbolist climate of that decade. Doubtless, too, his rising reputation was aided by the continuing erosion of the National Academy's power, earlier a source of views and attitudes antagonistic to his. Whatever the reasons, Ryder was finally coming into his own.

Sadakichi Hartmann was one of the first to write about Ryder as a flesh-and-blood personality, rather than merely as the embodiment of a principle, as did De Kay. Hartmann had arranged a meeting with Ryder at a tavern, then went with him to his nearby "workshop." In an article in *Art News* (1897), he described in some detail the artist's environment, his pictures, his color and his method of working, and the general resemblance of his work to the Old Masters. The critic was enchanted by what he saw and came away convinced of Ryder's place in history.[9]

There is a certain irony to the gradual growth of Ryder's reputation in the 1890s, for it was a time when he had almost completely stopped sending his work to exhibitions. After 1887, for example, he exhibited only once with the Society of American Artists, and after 1888 never again at the National Academy. When his pictures were shown in the following years, it was usually when they were lent by their owners: in New York to loan exhibitions in private clubs, such as the Lotos Club or Union League Club, where they were seen by only a limited audience; or infrequently in national exhibitions as at the Pennsylvania Academy of the Fine Arts, the Carnegie Institute, and the Art Institute of Chicago, again lent by owners. As he could probably have exhibited with the Society of American Artists or the Academy if he had wanted to, it is evident that after about the age of forty he was no longer interested in showing with this group.

In principle, Ryder treasured favorable criticism of his work, which, he said, "is of course the highest aim of an artist to reach."[10] We do not know how he responded to published reviews of his work, pro and con, for his letters are virtually silent on this point, and his friends' recollections shed no further light on the matter. Apparently he did little or nothing to seek the attention of the critics, though on one occasion, in the early eighties, when he was at the height of his confidence, he tried to cultivate Mariana Griswold Van Rensselaer, whose favorable remarks about his work were quoted earlier in this chapter. In an undated letter (late 1883–early 1884, judging by its context), Ryder spoke of having written to her earlier of "what I had tried to do and what I had accomplished," but then he felt he had overstated his case and did not mail the letter. He went on to tell her incidental news about himself and to praise her recent article on George Fuller, a chatty, ingratiating epistle apparently designed to keep his name before her.[11] (To our knowledge, she did not write a major piece on Ryder.) This, so far as is known, is the only instance when Ryder attempted to solicit critical attention. Most often he waited patiently for critics to discover him, undoubtedly feeling that an honest, spontaneous response on their part was better than publicity he had actively sought for himself.

Yet, even in later years approval was sometimes slow in coming. We can sense Ryder's frustration in letters such as the one in which he related to De Kay his sculptor-friend Theodore Baur's favorable remarks about *Passing Song* (fig. 8–3), owned by Helena de Kay Gilder. Having been "charmed" by the picture, Baur had told Ryder, who paraphrased his friend's remarks: "If some one was to take it to Germany, they would have a long study over it, write poems about it, speculate as

to its meaning, etc, and altogether get in a state over it."[12] One wonders, too, if he was not saddened by being excluded from the vast exhibition of American art at the World's Columbian Exposition in Chicago in 1893, which included fifteen works each by Winslow Homer and George Inness, ten by Thomas Eakins, as well as proportionate numbers by countless lesser artists.

Even though he did not actively seek public acclaim, a reading of his letters suggests that he felt a duty to his patrons and clients to present himself as a worthy artist, as if to justify their faith and financial investment in him. For instance, he wrote Colonel Wood to tell him the critic Jeannette Gilder, Richard's sister, had called his pictures "poems in paint"[13] and reported to another client, Edward B. Greenshields of Montreal, that *Joan of Arc* (fig. 8–4), a work he had purchased, and another unidentified picture, were deemed by his old friend Frederick S. Church "the two best" in New York's Prize Fund Exhibition of 1887.[14]

It was in the middle 1880s that Ryder's art began to attract collectors—but not many. Influential in this regard were Daniel Cottier and James S. Inglis, who interested the few clients then concerned with American art, acquired several of his pictures for themselves, and, as the artist said, "had a marked influence on my

Fig. 8–3. Albert Pinkham Ryder. *Passing Song.* 1890s and later. Oil on wood panel, 8½ × 4⅜". National Museum of American Art, Smithsonian Institution, Washington, D.C. Gift of John Gellatly

Fig. 8–4. Albert Pinkham Ryder. *Joan of Arc.* Middle to late 1880s. Oil on canvas, 10⅛ x 7⅛". Worcester (Mass.) Art Museum

career."[15] A great boost was given to Ryder by the pioneer collector of contemporary American painting, Thomas B. Clarke, who usually bought directly from artists, and eventually acquired thirty-one works by Homer and thirty-nine by Inness: in 1885 he purchased two major works from Ryder, *The Temple of the Mind* (plate 5) and *Christ Appearing to Mary* (plate 6). Clarke apparently had written Ryder expressing admiration for his work, and the latter replied in 1885.

> Many Thanks for the fifth hundred but so many more for all those nice sentiments.
>
> I find myself so childish in a way. I am so upset with a little appreciation that I can hardly be quick to acknowledge the source.
>
> Everybody is very nice I must say: but you have such a happy confidence and courage that it counts tremendously in nerving a man and and [*sic*] bringing out his endeavors. . . .
>
> I think you can hardly realize how much it means.
>
> For a long time I have observed a marked change in the attitude not only of the press but also of collectors toward the possibilities of something being done here, amongst us: to you much of this credit belongs: and I am so happy to be identified with your mission. . . . [16]

After this purchase, however, there was no stampede of collectors demanding Ryder paintings. As De Kay pointed out in 1890, the artist was still little known to the public. At that time, only twenty-six of his paintings had found their way into private hands, including two owned by Cottier, two by Inglis, two by De Kay's mother, and one by his artist-friend W. Gedney Bunce.[17] De Kay also felt compelled to admit: "Ryder has little financial fame. Art dealers for the most part shrug their shoulders over his pictures. The regular buyers at the sales would much sooner 'handle,' as they express it, the worst daub by a modern Italian. . . . than touch one of Mr. Ryder's little jewels. It should be said, however, that such a thing as a picture by him at an auction has rarely occurred since he has become an exhibitor."[18]

Cottier and Inglis had undoubtedly worked hard to interest their clients in Ryder, placing a few of his works, according to De Kay's account, in private collections in London, Edinburgh, and Paris. His primary collectors outside the United States, however, were situated in Montreal, Robert B. Angus being cited by De Kay, and Sir William C. Van Horne and Edward B. Greenshields of the same city following soon after. (Greenshields had ordered *The Sentimental Journey* [fig. 8–5].)[19] De Kay provided an interesting profile of Ryder's buyers: "For the most part his patrons are men and women of limited incomes, in some cases of very straitened means, busy people, intellectually active and endowed with sympathies broad and refined."[20] While this assessment may have been appropriate for some who bought Ryder paintings, it was inaccurate for others such as Van Horne, Clarke, Mary Jane Morgan, R. H. Halstead, Erwin Davis, Ichabod T. Williams, and James W. Ellsworth. While these individuals and the Canadians just mentioned were not as wealthy as the Vanderbilts or the Altmans, they were, nonetheless, established collectors who had earned reputations for perspicacious buying, especially in the field of American art.

A number of collectors who owned Ryders enjoyed ties with Cottier or Inglis and in many cases appear to have known each other and probably exchanged their appreciation for Ryder by word of mouth. More generally, too, they shared an en-

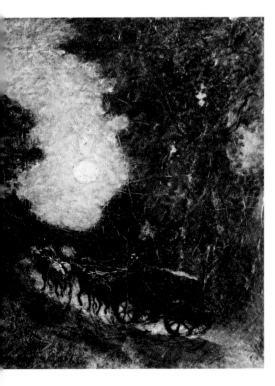

Fig. 8–5. Albert Pinkham Ryder. *The Sentimental Journey (Plodding Homeward)*. Middle to late 1880s. Oil on canvas, 12 x 10″. Canajoharie (N.Y.) Library and Art Gallery. Photograph: The Metropolitan Museum of Art, 1918

thusiasm for American art and, though some bought for investment, were willing to support it when the great majority of collectors were acquiring large numbers of fashionable European paintings. In all likelihood, those who were building important American collections felt they had to have at least one Ryder to round out their holdings. Thus the presence of Ryder's works in their hands was a mark of recognition and respect for an artist who was gradually gaining acceptance.

Ryder's prices, judging by the few that are known, started low and remained relatively low until near the end of his life. Those published in the exhibition catalogues of the 1880s ranged from $250 to $500. For example, in the National Academy exhibitions the published prices were: 1881, *Landscape and Figures*, $250; 1883, *Landscape*, $250, and *Landscape and Figure*, $300; 1886, *Smugglers*, $350; and 1887, *Figure Composition* and *Ophelia*, $500. About the prices Cottier & Co. received for Ryder's paintings we know little, but at the Mary Jane Morgan auction held in 1886, *Resurrection* (fig. 4–10), an important work, brought only $375 (she had bought it from Cottier for $350) and *Woman and Staghound* (fig. 8–6) brought $225 (she paid $150).[21] On the other hand, at the celebrated Thomas B. Clarke auction in 1899, which set record prices for contemporary American art, Ryder's *The Temple of the Mind* sold for $2,250 and *Christ Appearing to Mary* for $1,000—prices that established the financial worth of his paintings, although compared to Inness and Homer, the stars of the sale, these prices were modest.

From the 1890s on, an increasing number of collectors showed appreciation of Ryder's art. Their pattern of collecting was different from that of the earlier buyers who acquired only one or two examples and did not hesitate to sell after a relatively short term of ownership. Many of the collectors who began to buy Ryder's works in this decade and later—John Gellatly, William T. Evans, Dr. A. T. Sanden, and Colonel C. E. S. Wood, and Alexander Morten, for example—amassed fairly large holdings, often six to eight paintings or more, and held them for longer periods of time. Such collectors, too, often entered into friendly competition with each other, vying for paintings that had become increasingly difficult to pry away from the artist.

Although Ryder's circle of loyal collectors may have been small, there was one consolation: he often made friends with them, and thus close personal ties were forged between artist and client, bonds that became even closer as Ryder entered old age. Collectors such as Sanden and Gellatly, for instance, invited Ryder to their homes or, especially in the case of Colonel Wood, who lived in Portland, Oregon, visited his studio. Increasingly, Ryder tried to do without dealers. As Sylvia Warner wrote Wood in 1899, "It is a great matter of pride with him to prove that he can get along without a go-between, and deal with his clients directly, instead of having to go to Jimmy Inglis for a few dollars at a time."[22] When individual collectors commissioned paintings from Ryder, as they often did, he would write them gracious letters on the progress of the work, cautioning them, usually in the most diplomatic terms, to be patient—that worthwhile results would take time.

One of the most devoted Ryder collectors was Alexander Morten, a New York wine merchant, who by 1915 had purchased at least fourteen Ryders, then the largest number in private hands, including *Moonlit Cove* (fig. 11–9); *Pegasus* (plate 3); *Passing Song*; *Diana* (fig. 11–17); *Florizel and Perdita* (fig. 8–7); *The Canal* (fig. 8–8); and *The Hunter's Rest* (fig. 6–20).[23] Most of them he bought from the artist or Cottier, though not all; and a few he sold—and in at least one case, repurchased. Morten, having become a good friend of Ryder, as well as of Weir, Kenneth Hayes

Fig. 8–6. Albert Pinkham Ryder. *Woman and Staghound (Landscape and Figure; Geraldine)*. Early 1880s. Oil on wood panel, 11⅜ x 5⅞". The New Britain (Conn.) Museum of American Art. Harriet Russell Stanley Fund. Photograph, 1930: RA

Fig. 8–7. Albert Pinkham Ryder. *Florizel and Perdita*. Early 1880s. Oil on canvas, 12¼ x 7¼". National Museum of American Art, Smithsonian Institution, Washington, D.C. Gift of John Gellatly

Fig. 8–8. Albert Pinkham Ryder. *The Canal*. Early 1890s. Oil on canvas, 19 x 25". University Art Collections, Arizona State University, Tempe. Oliver B. James Collection of American Art

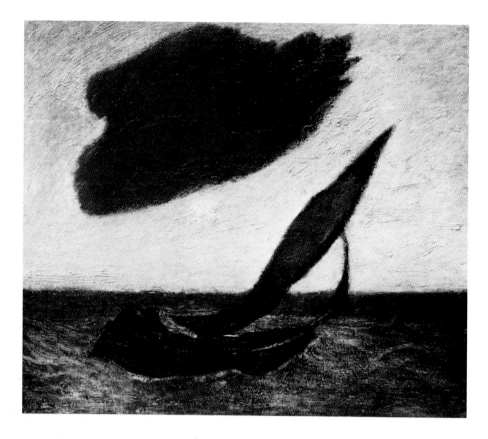

Miller, and other artists, considered buying *The Race Track* but felt that the price Ryder asked, $3,000 was too high.[24]

Another important collection of Ryder's work acquired during the artist's lifetime was assembled by Dr. A. T. Sanden, a physician, who had invented an electric belt that supposedly cured "nervous debility" in men, marketed it, and made a fortune.[25] He was a kindly man, and his wife was a simple and plain woman, who showed "understanding and protectiveness" toward Ryder;[26] they and the artist became close personal friends. Ryder was often their guest at their farm in Goshen, New York, in the mountainous country of Orange County; or in their city house on

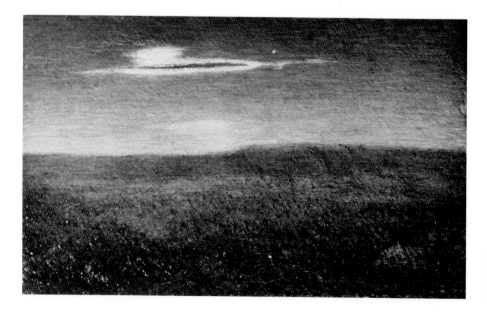

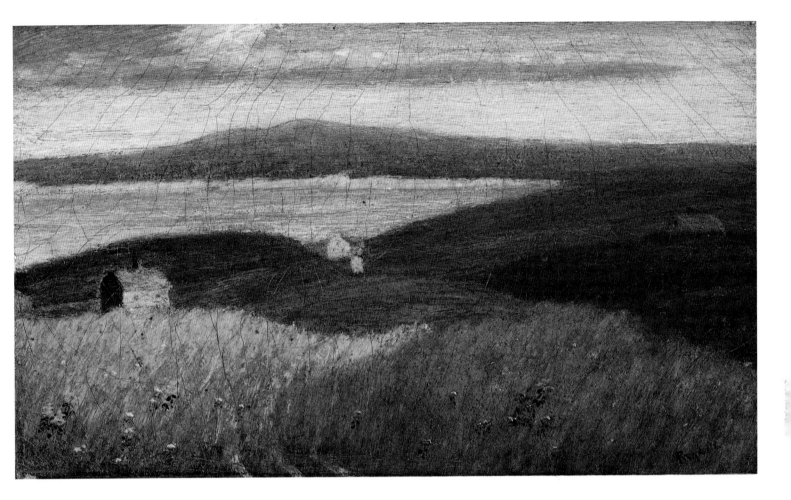

Fig. 8–11. Albert Pinkham Ryder. *Gay Head.* Middle 1880s and later. Oil on canvas, 7½ x 12½". The Phillips Collection, Washington, D.C.

West Eighty-seventh Street, which he often visited in response to a standing invitation to dinner every Friday evening.[27] Ryder wrote the doctor frequently; his surviving letters number in the scores, far more than to any other person.

During Ryder's lifetime Sanden bought, mostly directly from the artist, ten paintings, including several major works: *Macbeth and the Witches* (plate 15); *The Race Track*; *The Forest of Arden* (plate 12); *Under a Cloud* (fig. 8–9); *Night* (fig. 8–10); and *Gay Head* (fig. 8–11). Sanden understood Ryder's monetary problems and his lack of financial knowledge, and they worked out a system of Sanden's paying him a certain amount a month (of how much, there is no record) and Ryder entering the payments in "a little book." To Sanden he wrote: "Stimulated by . . . [Ryder's] friendship and generous regard . . . I feel sure that in the work underway and to be I shall reach a little higher plane, and feel the promise of it in light and sentiment of the Macbeth."[28] And a few months later: "I hope to show in the work more than by words my appreciation of your kind thoughtfulness and generous advance of money on the pictures while going on."[29]

Colonel C. E. S. Wood met Ryder on one of his trips to New York and the two became fast friends. Wood had been a soldier, was a poet, and an enthusiast for contemporary American art, in particular for four artists: Ryder, J. Alden Weir, Olin Warner, and Childe Hassam. Though separated by the breadth of the continent, Weir and Wood were in frequent touch; both were generous, warm-hearted men, constantly thinking of ways to help their friends. Wood promoted an interest in art among collectors on the Pacific coast, inducing them to buy works by his

favorite artists. He would return from trips to New York with their pictures, get collectors to buy them; and if not, buy them himself. Eventually, Wood acquired Ryder's *The Tempest* (plate 13), *The Lorelei* (plate 14), *The Story of the Cross* (fig. 4–11) and *Jonah*—all major paintings—as well as two other oils by the artist.[30] Wood's and Weir's correspondence is full of references to their common friend "Pinkie," as they both called Ryder—his financial problems, his deplorable living conditions, his health.[31]

John Gellatly was especially renowned as a Ryder collector because, in 1929, he gave a group of fifteen of the painter's works (including one now not believed to be by Ryder)[32], together with scores of examples by his contemporaries John Twachtman, Abbott Thayer, Childe Hassam, and Charles Melville Dewey, among others, to the National Gallery of Art, as the National Museum of American Art was once known. Successful in the real estate and insurance businesses, Gellatly became passionately interested in acquiring American paintings, especially Ryders. He made his first Ryder purchase, *The Flying Dutchman*, in 1897, for which he paid $800. Gellatly was not as close a friend to Ryder as the three collectors just mentioned, but he and his wife, who helped him collect, were cordial to the artist, and a series of gracious letters passed between them.[33] Their residence at 34 West Fifty-seventh Street, bedecked with American and a few European paintings, was virtually a museum, which they opened willingly to interested parties, including Ryder and selected friends. One of them was the young painter Marsden Hartley whom Ryder had recommended to them.

Like Gellatly, William T. Evans was a dedicated collector of American art, and he too donated his collection to the nation, making his gift before Gellatly, between 1907 and 1915.[34] Apparently Ryder and Evans, who had made a sizable fortune in the dry goods business, were not close personal friends, but that did not dampen Evans's enthusiasm for his paintings, of which he bought a total of ten. Ranking with Clarke as a dedicated collector of American art, he was a vigorous promoter who was instrumental in arranging New York's "Comparative Exhibition of Native and Foreign Art" (1904), designed to illustrate the strength of American work, and a series of monthly loan shows, often featuring Americans, for the Lotos Club, of which he was chairman of the art committee; and he lent American works from his collection, including Ryders to various exhibitions, mainly in private clubs. Thus Ryder and his fellow American artists' goals were advanced in both a specific and a broader sense by Evans's proselytizing efforts. To cite Charles de Kay's words: "[He] has been engaged in a constant struggle to convince the indifferent and prejudiced of the power and individuality to be found in American art. . . . "[35]

The support of these collectors and the growing critical acclaim for Ryder's work show that, by the turn of the century, Ryder had begun to come unto his own as an artist valued by a select group of connoisseurs and collectors. Judging from his letters, commissions were plentiful. Yet as his paintings grew increasingly attractive to buyers, commanding reasonably good prices, he became more and more of a cult figure, withdrawing from the exhibition scene and parting with his canvases only reluctantly. So the special rarity of his work and his hermitlike character combined to make him all the more remote and mysterious as a creative personality. Had he wished to gain public acclaim and attention, he certainly could have done so, because he had earned that right through the excellence of his work. But Ryder, like Homer and Eakins in their later years, preferred to sequester himself so that he could concentrate on his painting with single-minded devotion.

9

The New Century

ABOUT 1900, when Ryder was in his early fifties, there came a falling off in his creative ability. After this date he originated few, if any, new pictures. To Kenneth Hayes Miller he said that he could no longer "strike a picture in" as he had when he was younger.[1] This decline, normal in old age, came to Ryder earlier than usual. Perhaps it was due to his mode of life; perhaps it was the penalty of living in a world of fantasy; or perhaps his strange visionary gift, like that of the lyric poet, could not last through mature life. Much of his effort was now given to paintings already started, in some cases years before, and his reluctance to part with his pictures became intensified almost to the point of mania. *Macbeth and the Witches* (plate 15) and *The Lorelei* (plate 14) remained for years in his studio. *The Tempest* (plate 13), exhibited as early as 1891, was still being painted on almost up to his death. Sometimes he even borrowed pictures back from the owners, and worked more on them. Because of his failing powers they were seldom improved in the process.

In old age, moreover, Ryder spent some of his time trying to repair his own deteriorated pictures. The painter and dealer Le Roy Ireland recalled visiting Ryder, taking pictures to be retouched.[2] When Salvator Guarino, an artist, asked Ryder if the cracking of his pictures did not bother him, he replied: "*When a thing has the elements of beauty from the beginning it cannot be destroyed. Take for instance Greek sculpture—the Venus de Milo I might say—ages & men have ravaged it—its arms & nose have been knocked off but still it remains a thing of beauty because beauty was with it from the beginning* [italics in original]. . . . "[3] Although he approved of his friend Charles Melville Dewey's restoration of *Moonlight* (fig. 9–1) in 1910,[4] he usually preferred to let his paintings show the marks of age. When the dealer William Macbeth proposed to clean a Ryder painting of a stable interior that his niece's husband had sold to Macbeth, Ryder asked him to leave the work alone. He warned Macbeth not to remove the old varnish ("that you cannot do without injuring the picture seriously"), but only to wash it and apply a new, thin coat of varnish. Ryder

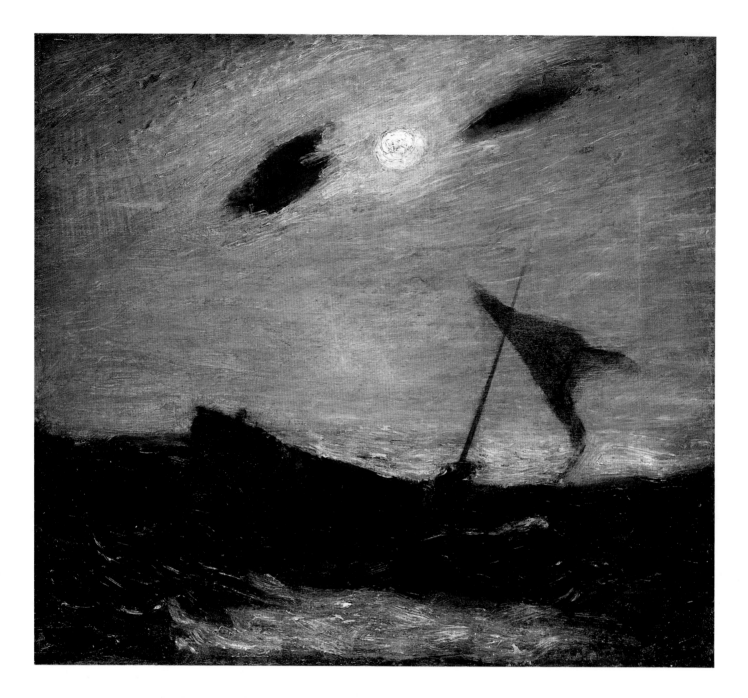

argued, "I have a right to protect my picture from the vandalism of cleaning," adding, "It is appalling this craze for clean looking pictures."[5] Even though Ryder's desire to be true to his own work is admirable, it is still one of the tragedies of modern art that Ryder did not possess sounder technical knowledge.

As a younger man, Ryder had been normally sociable, with many friends among his fellow artists and others in the art world. He had been a founding member of the Society of American Artists, had exhibited frequently, and was associated with one of the leading New York galleries, Cottier & Co. But as he passed the age of fifty, a change began to take place. Though he remained attached to his old friends and made some new ones, he became more and more of a recluse. His letters indicate that he preferred to remain at home rather than go out to public functions; but he did make exceptions, especially for families who had been longtime friends such as the Weirs and the Sandens, also the widows and children of Daniel Cottier

Fig. 9–1. Albert Pinkham Ryder. *Moonlight (Moonlight at Sea).* Early 1890s. Oil on wood panel, 15⅞ x 17¾". National Museum of American Art, Smithsonian Institution, Washington, D.C. Gift of William T. Evans

and Olin Warner. He faithfully corresponded with these and others of his acquaintance, writing letters late into the night that expressed his feelings of warmth and friendship.

His close friends must have become, in a sense, substitutes for his family. His mother, whom he once introduced as "one of his patrons,"[6] died in 1893. His father, though never understanding his art interests, was much revered by Ryder, and his death in 1900 greatly saddened the artist. As he wrote to Dr. A. T. Sanden, "I have been so miserable from it, and am only just coming to myself. Of course there are many palliating circumstances; his quite extreme age and the knowledge he wanted for nothing, and that I could be with him and see him quite himself for the last time[.]"[7]

Ryder's brother Preserved had died much earlier—in 1879—and William, the brother closest to Albert, passed away in 1898. The only surviving brother, Edward (d. 1911), had moved to Falmouth, Massachusetts, where he operated an ice cream business.[8]

Ryder remained at 308 West Fifteenth Street until the fall of 1909, when the owner announced his plan to remodel the building and thus wanted tenants out by November 1.[9] Presumably around that time Ryder secured rooms at 308 West Sixteenth Street, just a block away. "When he got all his stuff in, boxes, barrels, two easels, piles of clothes, etc., there was hardly room to walk around," recalled Charles Fitzpatrick, still living nearby. "He did set up one easel near a window. You couldn't see where he would sleep."[10] Not surprisingly, Ryder's new quarters soon accumulated great quantities of dust, dirt, and litter. Its state, however, appears to have been even worse than at Fifteenth Street: "floor piled high with ashes and all kinds of debris." It was reported that the Board of Health had chastised Ryder more than once for the condition of the place.[11]

In an effort to move Ryder into a proper studio, suitable to his growing stature as an artist, the dealer William Macbeth, who had begun to handle his paintings, made arrangements to obtain new quarters for him. After a long search, Macbeth's nephew Robert McIntyre found a large second-floor front room at 152 West Fourteenth Street, the lease being signed in June, 1912.[12] Macbeth, who remained an anonymous benefactor, commissioned Kenneth Hayes Miller to persuade the reluctant Ryder to move in some of his belongings. It took a year to accomplish this, for Ryder was set in his ways, and only after much gentle persuasion, even agreed to look at the room. Once he saw it, however, he began to use it immediately, though he continued to live on Sixteenth Street. Thus, as a result of Macbeth's generosity, he had a presentable place in which to receive friends and clients. James E. Kelly called on him at Fourteenth Street and reported that it was not as picturesque as his original studio, but it was neat, with a sofa, chair, and easel.[13]

The new studio symbolized a desire for respectability on Macbeth's part and possibly on Ryder's as well. Such a setting, after all, was appropriate for an artist whose work was beginning to sell briskly through galleries and auctions, and was being sought by eager patrons and collectors. Increasingly, too, Ryder was gaining attention from a somewhat wider public, mostly artists, but also intellectuals, critics, journalists, and museum curators. Articles about him continued to appear, albeit sporadically, in magazines and newspapers, with writers of considerable erudition dealing with the major issues of his art. But because Ryder assiduously guarded his privacy and gave out so little information about himself, even to sympathetic visitors, legends and myths became more widespread. The noted critic James

Gibbons Huneker took advantage of this kind of interest by using Ryder as his model for an article on Arne Saknussem, "a painter of genius who is known to few."[14] Saknussem was a creature of fiction (his name was borrowed from a Jules Verne character) but he shared many of Ryder's eccentric traits—much exaggerated by Huneker. So real was his portrayal that many readers sent letters inquiring about the mysterious Saknussem.

Several writers in a more serious vein attempted to account for Ryder and to explain his importance. The first such treatment in a magazine after the turn of the century—by Joseph Lewis French, writing for *Broadway Magazine* in 1905—gave a telling clue to his view of Ryder in the subtitle: "A Painter of Dreams." French wrote that while nature played a constant role in his painting, equally important was Ryder's ability to transform nature in the crucible of his imagination. Slowly, like a dreamer, Ryder materialized his visions on canvas, "pure *tours de force* for the imagination and memory."[15]

Ryder's otherworldly life fascinated French, who established the parameters of the Ryder "image" that has persisted, in varying forms, almost to the present day: he lived in a neighborhood of no particular consequence; was taciturn and remote from society, seeing only a few friends; lived simply, amid a great clutter, "dining often on a crust and a glass of water";[16] painted works of great poetic and human consequence which were much in demand by the select few; and turned his back on wealth and worldly comforts. Although these elements of the Ryder story are true in varying degrees, the aggregate is excessively picturesque and romantic. Yet despite this tendency toward mythmaking, French dealt in artistic superlatives that were certainly Ryder's due, calling him "one of the greatest masters of the brush in the United States of America."[17]

Those who wished to know the personal thoughts of this artist had only to turn to the next page after French's article to find the revealing "Paragraphs from the Studio of a Recluse." This brief piece, a report from memory of an interview by Adelaide Louise Samson, assistant editor of the magazine, was pronounced accurate by the artist, except in the matter of his copying the Old Masters.[18] In this sole recorded statement of any length, Ryder offered rare insights into his personal beliefs and philosophy of art, words frequently quoted in this book. Like French's article, but from a more personal perspective, it gave valuable clues to the thinking of this remarkable artist.

French's pleasure in discovery was shared by Roger Fry in his 1908 article on Ryder in the *Burlington Magazine*.[19] Curator of paintings at the Metropolitan Museum of Art, then European adviser to the department in 1906–10, he was imbued with a formalist approach then considered very advanced for its time. Fry expressed delight in the art of Ryder, who, he felt, existed outside the constraints of his era. Like Edgar Allan Poe, Fry thought, Ryder's personal vision seemed isolated from any established artistic tradition. Ryder's inspired talent, however, led him to invent pictorial structures that were expressive in and of themselves. The results, Fry felt, were achieved only by his slow and constant refinement of his forms, the effort of a grand constructor whose subjects, though not unimportant, were distinctly secondary. Such indifference to Ryder's color—his skillful use of color had been seen as his chief virtue by critics from the 1870s through the 1890s—is a telling comment on his appeal to advanced artists and critics of the early twentieth century: he was increasingly regarded as a master of design, even a composer of abstract forms, in which color played a lesser role.

Three years later, Walter Pach, whose sage advice to Arthur B. Davies and his youthful collaborator Walt Kuhn helped make the Armory Show a success, published a perceptive article on Ryder in *Scribner's Magazine*.[20] In it, he echoed Fry's formalist bias but presented Ryder more completely as an expressive artist. For Pach, subject matter was neither unimportant nor dominant: he found a balance between form and content in Ryder's work that must have been influenced by what the artist told him: "He speaks of the 'inner rhythm' in great poetry and he feels it in a subject, strives above all to get this to him always essential factor into his result."[21]

Pach gains authority, too, because he had interviewed the artist, asking pointed questions about his method and technique, and introducing his answers into his text. Though his view of Ryder was more balanced than Fry's, he ultimately gave his highest praise to Ryder's designs, his construction of the picture. As with Fry, he saw color as secondary.

Just after the turn of the century, Sadakichi Hartmann, author of *A History of American Art* (1902), Samuel Isham, author of *The History of American Painting* (1905), and Charles H. Caffin, author of *The Story of American Painting* (1907), found Ryder worthy of coverage in their respective books. Hartmann, we recall, had "discovered" Ryder in the early 1890s and of the three authors was best equipped to write from personal experience. Yet most of his text is merely a repetition of his 1897 article in *Art News* in which he had praised Ryder for his "bewitching poetry" and his individuality of style and expression. Even though Hartmann was not impressed by Ryder's sense of color, he concluded that he was among the great, a producer of paintings so perfect that they belonged "in the company of illustrious masterpieces."[22]

Isham, whose book was published three years after Hartmann's, felt that Ryder should not be judged by ordinary standards of criticism: his compelling imagination and the resulting strangeness of his work exempted him from such treatment. Isham did not dwell on content, believing Ryder's feeling for pattern and tone, which he thought comparable to Whistler's, transcended any concern with nature as a vehicle for the expression of "ideas." Thus the way was laid open for the appreciation of Ryder in abstract terms, a step taken even more vigorously by Charles Caffin two years later in his book.

Caffin saw little of value in Ryder's literary allusions, his subjects appearing "ill-drawn, ill-placed, and curiously childish in conception."[23] What counted was his treatment of the landscape as "a pattern of color and form, full of emotional appeal." Ryder, in Caffin's view, emphatically departed from nature to create paintings that were "beautiful in color and texture,"[24] the product of a lively imagination. In his formalistic interpretation of Ryder, he revealed his own allegiance to advanced aesthetic thought, especially art-for-art's-sake and French Symbolist theories. Ryder's innate sense of abstract pattern notwithstanding, such theories appear to have had little to do with his real motives. But Caffin and, to a lesser degree, Isham, presented Ryder as a talented creator of abstract pictorial forms, charged with emotional meaning separate from literary associations. In doing so, they undoubtedly influenced their readers' interpretation of the artist's work.

The articles and excerpts from books just cited, together with oral accounts that circulated within the art world, brought Ryder to the attention of a wider audience than ever before. Although he remained a solitary figure, preferring to work at his painting and see only his close friends, younger admirers—mainly artists—be-

Fig. 9–2. Arthur B. Davies. *Chalice*. 1897. Oil on canvas, 31 x 22½". Permanent Collection, Everson Museum of Art, Syracuse, N.Y. Gift of the Children of Mrs. William S. Ladd

Fig. 9–3. Marsden Hartley. *The Dark Mountain No. 1*. 1909. Oil on board, 14 x 12". The Metropolitan Museum of Art, New York City. The Alfred Stieglitz Collection, 1949

gan to seek him out. To them, Ryder seemed both an elder statesman and a prophet, a source of inspiration and wisdom. Hidden from public view, he had courageously pursued his own direction in painting, and the results, once shunned by critics and collectors, now appeared remarkably appealing and relevant. Ryder's individualism, reliance upon imagination, and his feeling for abstract form—all made him attractive to the rising new generation of artists experimenting with Symbolist, formalist, and expressionist ideas just before and after the turn of the century. Among those younger painters who made their pilgrimage to Ryder, Arthur B. Davies, Kenneth Hayes Miller, and Marsden Hartley were most devoted to him, and each in his own way came under Ryder's spell.

Davies, a romantic visionary, and the oldest of the three, became well acquainted with Ryder while still young, and for many years would drop in on him in his studio. At one time, Davies took "some small book plates or covers" to Ryder for his critical evaluation, and received "such a serious and intelligent criticism that ever after he loved him." We do not know whether Ryder gave any further advice to the younger artist, but it is clear that he came under the influence of Ryder's style in the production of his fanciful, poetic paintings of the 1890s and early 1900s (fig. 9–2). Too, Davies's own beliefs about painting corresponded closely to Ryder's: the former said that a picture "was nothing if it lacked mystery and imagination."[25] Among those who wanted to include Ryder in the Armory Show of 1913—ten of his paintings were shown (fig. 9–11)—Davies must be counted heavily. As much as anyone, he recognized the relevance of Ryder's individual language of expression for the modern movement. Davies, in the company of Kuhn, conducted Ryder through the Armory Show, but the elderly artist either would not or could not comment on the works.[26]

The sight, in 1909, of a Ryder seascape with clouds and a boat at the Montross Gallery produced a spiritual conversion in Marsden Hartley. Having gone through an Impressionist and Neo-Impressionist phase, he recalled, "When I learned he [Ryder] was from New England the same feeling came over me . . . as came out of Emerson's Essays when they were first given to me—I felt as if I had read a page of the Bible in both cases." Ryder became a catalyst that enabled Hartley to materialize the deep mystical and romantic tendencies within himself, but which he had

Fig. 9–4. Kenneth Hayes Miller. *Apparition.* 1913. Oil on canvas mounted on board, 25⅝ x 22⅛". The Phillips Collection, Washington, D.C.

Fig. 9–5. Rockwell Kent. *Into the Sun.* 1919. Oil on canvas, 28 x 44½". Bowdoin College Museum of Art, Brunswick, Maine. Gift of Mrs. Charles F. Chillingworth

never been able to express fully. As Hartley said, "I was a convert to the field of imagination into which I was born."[27]

Hartley visited Ryder in his studio several times. There are no verbatim accounts of their conversations, but Hartley's recollections reveal that Ryder had a powerful psychological impact upon him.[28] He said he loved Ryder because he was "among the first citizens of the moon," a visionary, close "to the centre of revelation,"[29] and "the last of the romantics."[30]

In his early paintings, Hartley briefly came under the influence of Ryder. He confessed that, in 1909, "Ryder's spirit lived intensely in me,"[31] as witnessed by "The Dark Landscapes," a series in which Hartley's brooding, somber colors and gloomy skies pay homage to Ryder (see fig. 9–3). These highly emotional works are, in one sense, comparable to Ryder's landscapes, but they are also, more personally, cries from a troubled soul, deep in poverty and on the verge of suicide.[32]

Unlike Hartley, who entered Ryder's life and departed quickly, Kenneth Hayes Miller remained close to him almost until his death.[33] As a young artist already interested in Ryder's style of painting, Miller went to visit him in 1909 and thereafter often stopped by to see and assist the aging artist in every way he could. Ryder's letters occasionally mention Miller's visits, his encouragement, care, and interest; Miller's cousin Rhoda Dunn, a poet, in turn moved Ryder by her sincere praise for his verse, approval that meant a great deal to him.[34] Miller's own letters are full of information about Ryder's last years, a touching chronicle of a younger painter's devotion to an older one.[35] That Ryder influenced Miller's early painting is clear (see fig. 9–4), but more than that, Ryder's integrity and singular commitment to art inspired Miller, who wrote to Rhoda in 1915, "He's a great man, and that is the most enviable state in the world. . . . "[36]

The three individuals just discussed were not alone among the younger artists who looked to Ryder's example for guidance. Robert Henri, leader of The Eight, a group of anti-academic painters of everyday life, admired his work and would have included him in the group if he had been younger.[37] (It is interesting to note that Ryder told Henri, during their only meeting, that he was "strong for the '8' and spoke with enthusiasm of several members of the group.")[38] Although Henri did not paint like Ryder, his student Rockwell Kent was influenced by Ryder's can-

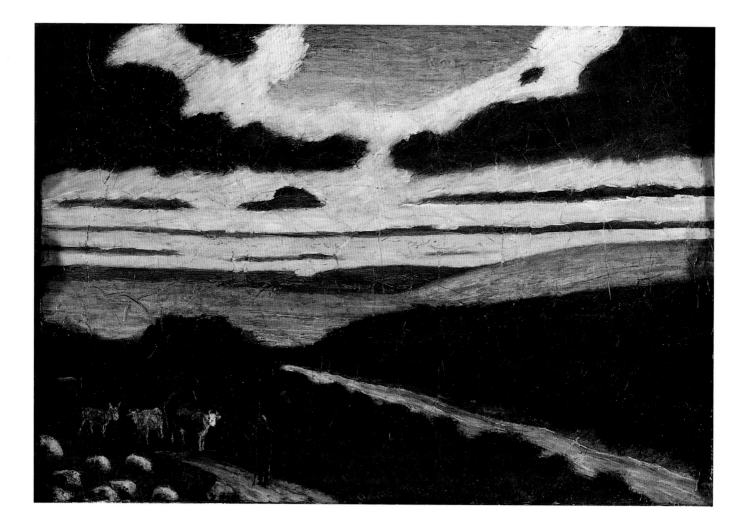

Fig. 9–6. Albert Pinkham Ryder. *Landscape.* c. 1897–98. Oil on canvas, 9½ x 14″. The Metropolitan Museum of Art, New York City. Gift of Frederick Kuhne, 1952. Photograph: Sandak, Inc., Stamford, Conn., 1961

vases for a brief period (see fig. 9–5). Kent also admired the teachings of Miller, who in turn had been much affected by Ryder's style and his thinking.[39] In a more intensely emotional way, E. Middleton Manigault, an avant-garde painter who died young, also came under Ryder's spell, probably through the influence of his teacher Miller: Manigault exaggerated Ryder's curvilinear rhythms and stressed even more consciously than the older painter the abstract relationships of stylized forms.[40] Although we do not know whether Kent and Manigault met Ryder, Louis Eilshemius did—and boasted quite openly that, in his own painting, he could successfully compete with Ryder and work much more rapidly, too.[41]

It is hard, of course, to measure Ryder's influence, but his imaginative fantasies and his compositions of integrated tactile forms appealed in a variety of ways to modernist tastes. Compared to other artists of his generation still painting after the turn of the century, Ryder appears unusually forceful in his form and content, witness a work such as *Landscape* (fig. 9–6). Although much of Ryder remained rooted in the early-nineteenth-century Romantic sensibility, his modern side had extraordinary relevance for his younger contemporaries after the turn of the century—particularly around 1905–13. Duncan Phillips, critic and collector, aptly summarized his appeal in these words: "Modernists would claim him, pointing out his independence from all tradition and pictorial formula [*sic*], his intense inwardness, his simplification, his abstract expression of mass through color."[42]

Yet among Ryder's admirers there was another group—mainly older artist-friends—who claimed him as a hero for reasons other than his incipient modernism. These individuals, who had followed Ryder's career as far back as the nineties and even earlier, saw in his work the final flowering of Romantic, poetic painting in America after the Civil War. Although Ryder's work could easily be viewed as modern, it could just as readily be seen as traditional—intimately linked to the Old Masters and even old-fashioned in appearance. For those who regarded it in this

way, Ryder was the supreme imaginative master who had carried this kind of painting to its highest point of development.

Remaining close to Ryder after 1900 were old friends of similar persuasion, such as Charles Melville Dewey, Elliott Daingerfield, Horatio Walker, and Albert Groll. Increasingly they attached themselves to the hermit-artist who had begun to win acclaim from critics and collectors. At times these admiring painters of lesser talent came under his influence, but, it goes without saying, failed to rival Ryder's unique inspired canvases (see figs. 9–7 and 9–8).

Among these painters, we must also count Louise Fitzpatrick, wife of Charles, mentioned earlier, an amateur artist who had received some criticism and instruction from Ryder and referred to herself as his only pupil.[43] Much influenced by his style and technique, she produced a small number of independent works, modest in scale and scope (see fig. 9–9). But she applied her skills in still another way. As reported by Philip Evergood, on the basis of information Fitzpatrick supplied, she would paint on Ryder's canvases under Ryder's direction when his hands had given out in old age, being told by him what colors to use and how to put them on.[44] It is clear from her own remarks that she altered some of Ryder's works during his lifetime—so they could be sold for his support in old age—and reworked and "completed" unfinished canvases after his death, again, to put them in salable condition.[45] (See chapter 11 for a fuller discussion of this subject.) It is also quite probable that some of her own paintings are now passing for the work of Ryder. Whether these were done as intentional forgeries or her paintings later had the name of Ryder attached to them by others cannot be determined at the present time.[46]

The drive to acquire Ryder paintings, often in relatively large numbers, became quite urgent within a limited but loyal group of collectors. This group, already discussed in chapter 10, included Alexander Morten, Dr. A. T. Sanden, Colonel C. E. S. Wood, John Gellatly, and William T. Evans, together with William M. Ladd and Charles E. Ladd, and Helen Ladd Corbett of Portland, Oregon.[47] In some cases, a Ryder enthusiast such as Colonel Wood would interest several members of a family—the Ladds, for example—in buying Ryder's paintings. Sincere Ryder admirers began to resemble an exclusive club that not only revered his glowing canvases, but also took a personal interest in his well-being. It is almost as though Ryder was a rare, exotic bird that needed thoughtful care and cultivation.

The collectors' desire for Ryder's work was shared—and perhaps also abetted—by several dealers who filled the growing void left by the gradual decline of Cottier & Co., Ryder's first gallery. Although the New York branch of the firm had continued to operate until 1915, the driving forces within it, Daniel Cottier and James S. Inglis, had died in 1891 and 1907, respectively. The gallery's weakened position under their successor, Walter Fearon, allowed two other New York dealers, N. E. Montross and William Macbeth, to trade actively in works by the artist.[48] Both Montross and Macbeth believed passionately in American art at a time when it was not fashionable, and accordingly found in Ryder an opportunity to promote a native artist of rare and genuine talent. In the case of Montross, he acquired at least seven of Ryder's works, most of which he kept for himself and refused to sell. Robert Vose of Vose Galleries in Boston, a dealer specializing in the works of Inness, Blakelock, and Fuller, was also committed to Ryder and, although Vose did not have an opportunity to meet him, Vose's letters make it clear that he

Fig. 9–9. Louise Fitzpatrick. *Untitled (Mother and Child in Landscape)*. c. 1900–15? Oil on board, 4⅜ x 8½". Private collection

fervently believed in the artist and his work.[49] Having close contacts with Macbeth and Montross, Vose presented a small group of Ryder's paintings at his Boston gallery in 1916. From this time onward, the Vose Galleries played a central role in marketing Ryder paintings.

Ryder's works must have become increasingly attractive to collectors who bought for investment or who liked to watch their holdings increase in value. His prices began to escalate around the turn of the century, at first sporadically, but several years before his death in 1917, there came a marked increase in their value. The prices that *The Temple of the Mind* ($2,250) and *Christ Appearing to Mary* ($1,000) fetched at the auction of Thomas B. Clarke's collection in 1899, already mentioned, were perhaps inflated, for Ryder's dealer Cottier & Co. was the buyer in both instances. At the William T. Evans auction of 1900, the highest price paid for any of the six Ryders was $700—for *Moonlight*—the work being knocked down to the Cottier firm. The second highest price for a Ryder at this sale, however, was only $235—for *Autumn Landscape*. But two years later, at the E. F. Milliken collection sale of 1902, *Moonlight*, previously sold by Evans, brought $1,500, an $800 increase, with Cottier again offering the winning bid.

In the Stanford White sale of 1907, *Pegasus* sold for $1,225 to John R. Andrews of Bath, Maine, and *Dancing Dryads* and *The Stable* (*In the Stable*) brought $350 and $325, respectively. More or less comparable prices were paid at the Cottier sale of 1909, where *Moonrise* commanded $1,000 (from collector A. A. Healy); and *The Curfew Hour* ($560) and *Smuggler's Cove* ($300) were acquired for the Metropolitan Museum of Art, the curator Bryson Burroughs making the successful bids. From this point to 1913, no remarkable jumps in auction prices occurred, but in that year *With Sloping Mast and Dipping Prow* commanded $3,050, Ryder's highest recorded auction price during his lifetime, at the William T. Evans sale. The buyer was George S. Palmer of New London, Connecticut. The only auction price approaching that, before Ryder's death in 1917, was the $2,500 paid for *Pegasus* in 1916 by Alexander Morten.

Figures for sales other than auctions are difficult to ascertain because surviving records are fragmentary. (Cottier's accounts have never been found.) Yet the following examples will give an idea of what was paid for selected works by Ryder. John Gellatly, whose records are more complete than most, paid the following for the works listed here (the date of purchase is in parentheses): $800, *The Flying Dutchman* (1900); $1,800, *Pastoral Study* (1904); $1,000, *King Cophetua and the Beggar Maid* (1906–07); and $500, *Lord Ullin's Daughter* (*The Sea*) (c. 1907). Buying from fellow collector Alexander Morten, Gellatly paid $2,800 for *Passing Song* and $3,000 for *Florizel and Perdita* in 1908.[50] In the following year, William T. Evans bought *Moonlight* back from Cottier for $1,750 to give to the National Gallery of Art (now the National Museum of American Art). And J. Alden Weir told of selling a painting Ryder had given him twenty years before for $1,000 in 1910, a sum he turned over to the artist.[51]

Ryder himself placed much higher values on his work, though it is hard to say whether he ever received such sums. For example, in 1913, J. Alden Weir reported that he wanted $7,000 for *The Race Track*,[52] a painting that eventually went to Dr. Sanden for an undisclosed price. Whatever Ryder received from direct sales or works commissioned from him, he seems finally to have attained a degree of financial security at the end of his life. As Weir wrote to Colonel Wood in January, 1916: "He has sold two pictures at good round figures, one to my friend Morten and one

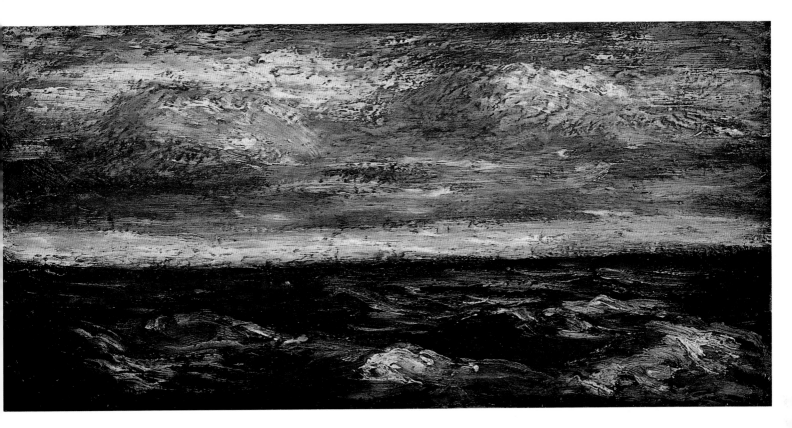

Fig. 9–10. Albert Pinkham Ryder. *Marine.*
Middle 1890s. Oil on wood panel, 8¾ x 17¾".
National Academy of Design, New York City

to someone else. Mrs. Fitzpatrick said he still had some money from the one I sold [in 1910, for $1,000]. So the old fellow is comfortably off for several years."[53] Any future financial worries were alleviated by his sale of a picture for $2,500, as reported by Weir a little over a year later.[54]

Besides the rise in Ryder's prices, there were other tangible measures of his growing recognition. In 1901, he received a silver medal from the Pan-American Exposition in Buffalo, New York, for three of his paintings, *Jonah*, *Siegfried and the Rhine Maidens*, and *The Temple of the Mind*, lent by their owners.[55] Further recognition came when he was elected as an Associate of the National Academy of Design in 1902, and as a full Academician in 1906, his diploma picture a small oil entitled *Marine* (fig. 9–10). Two years later, Ryder was elected to membership in the prestigious National Institute of Arts and Letters, nominated not by a progressive artist, but by the dean of conservatives, Kenyon Cox, and seconded by J. Carroll Beckwith and Gari Melchers, artists almost as traditional as Cox.[56]

Ryder's relevance for modern developments, on the other hand, was acknowledged by having ten works invited to be hung in the Armory Show of 1913 (see fig. 9–11),[57] and as art historian Milton Brown has pointed out, he was an important "discovery" in that groundbreaking display of modern European and American art.[58] The organizers honored Ryder by placing his paintings in one of the cubicles in the center of the Armory, and thus he became the only American to share this prestigious location with Cézanne, Van Gogh, and Gauguin,[59] all artists of France. Joseph Edgar Chamberlin of the *Evening Mail* expressed delight in this: "It is joyous enough to see our own living Impressionist and primitive, A. P. Ryder, looming among these Frenchmen, exactly in his proper artistic place!"[60] Chamberlin did not explain why Ryder deserved to be ranked with the French, but that answer was provided by Charles Caffin, one of the few American critics who understood mod-

ern developments in the arts. He wrote: "In the quality of his work he is much nearer to the modern expression of intellectualized emotion than all but a few of the young men. In his inobtrusive sincerity he, in fact, anticipated that abstract expression toward which painting is returning and may almost be said to take his place as an old master in the modern movement."[61] Caffin thus perceptively spotlighted Ryder's anticipation of modernism, a pioneering role that was to be cited again and again in the press after 1913. It was for this that Ryder received the greatest amount of honor during his lifetime.

Fig. 9–11. Ryder display at the Armory Show of 1913, reconstructed for the 50th Anniversary Exhibition (1963), organized by the Munson-Williams-Proctor Institute, Utica, N.Y., and presented there and at the Armory of the Sixty-ninth Regiment, New York City. Photograph: William Innes Homer

Old Age and Posthumous Fame

Fig. 10–1. Alice Boughton. *Albert Pinkham Ryder.* c. 1910. Photograph, 8⅞ x 7⅜". Private collection

AS RYDER APPROACHED his sixties (fig. 10–1) his health began to fail. He was troubled periodically by painful swellings brought on by gout and gouty arthritis, which was concentrated in his feet, and for years he had suffered from a chronic kidney infection.[1] His collector-friend Dr. A. T. Sanden offered medical advice, and Ryder, on his own, began to follow eccentric health practices such as stuffing his shoes full of oatmeal and wearing garments full of holes. He had great faith in the healthful properties of buttermilk, which he drank in large quantities.

His friends J. Alden Weir and Charles Melville Dewey occasionally brought meals to his quarters; and each time he had dinner with the Sandens, they would give him a large pot of baked beans to take home.[2] Eventually, Ryder stopped cooking for himself and, when he did not have food from friends, went out to eat at neighborhood restaurants and bakeries. Kiel's Bakery was one of his favorite haunts. The young poet and critic Alfred Kreymborg "used to watch him shuffle out of Kiel's, after a breakfast of sweet buns and coffee . . . and follow him. The old man would take a few steps, then stop and turn about, like the slow hub of a great wheel."[3]

Physically, Ryder underwent marked changes in his later years. Originally tall and heavy, he gradually became shrunken and frail. Sadakichi Hartmann recalled seeing him on the street in 1916, "an apparently very old man, with a yellowish white flowing beard and cane in hand, the upper part of the body bent over so far as to make almost a right angle with his tottering legs." Aged before his time, "dizziness and stiffness of the neck," Hartmann reported, "made it impossible for him even to look up to his beloved sky."[4] Although he had always in the past taken long nocturnal walks in Manhattan and across the Hudson River to the Palisades of New Jersey, in his last years he was forced to limit his strolls to an area around the Battery.

Fig. 10–2. The Fitzpatricks' house, 26 Gerry Avenue, Elmhurst, L.I., where Ryder died. c. 1945. Photograph: RA

The Fitzpatricks continued to watch over him. In fact, Louise Fitzpatrick had seen him through so many illnesses, Colonel C. E. S. Wood reported, that "it had broken her health."[5] On one occasion, when Ryder fell ill with gout and could not move, Louise, with the aid of the housekeeper's son, undertook the heroic job of cleaning out his quarters, much to his distress. As Charles Fitzpatrick recalled:

> They cleaned out bags and barrels filled with paper, empty food boxes, ashes, old clothes, especially under garments, and about fifteen white shirts for evening wear, all soiled and in a fearful condition, mice that had decayed in traps, food in pots that had been laid to one side and covered with paper and forgotten. As he laid there helpless, he would accuse them of upsetting his room. When they got one side clean, they would drag him over on the rug to the other.[6]

During the summer of 1915, his kidney infection flared up in an attack that left him helpless on the floor; the Fitzpatricks called a doctor and had him taken to St. Vincent's Hospital for treatment. The young Syrian-American poet Kahlil Gibran, who admired Ryder and often visited him, recalled: "He looked so beautiful in the

hospital, all gone away here (cheekbones) so that the bony structure showed through the flesh—and the hands were so beautiful—he talked slowly, but clearly. His memory is feeble so that he tells you a thing and then repeats it."[7] Ryder's deteriorating condition caused another admirer, Kenneth Hayes Miller, great distress. "The old man is nearly done," he wrote in a letter to his cousin Rhoda Dunn.[8] But Ryder rallied and was released from the hospital after a three-month stay. Miller visited him in a boardinghouse on West Fourteenth Street, where the Fitzpatricks had put him up, no doubt with the thought that he would be under supervision. Miller observed that he "seems better in a way—but he is half in another world now. He will never come back."[9] According to the poet Alanson Hartpence, who called upon him at this time, he looked "utterly miserable" and was afraid to move about because he might put something in its wrong place or leave a mark with his fingers.[10] Soon it became clear that Ryder was becoming too weak to look after himself, and his only close relative in the city, a niece, Gertrude Ryder Smith, was occupied with a sick husband and could not help. The Fitzpatricks therefore agreed to take care of him, and moved from New York to Elmhurst, Long Island, first to a boardinghouse and then to a modest cottage at 26 Gerry Avenue (later redesignated 91–03 50th Avenue), in which Ryder enjoyed a sunny front room on the second floor (fig. 10–2).

We know little of Ryder's life at Elmhurst, but, judging from the reports of his physical condition before he moved there, he must have been feeble and not altogether alert mentally. J. Alden Weir, who had not seen as much of him as in the past, reported to his friend Colonel Wood in January, 1916, "The poor old fellow shuffles about as if he had not the entire use of his legs. . . . The Dr. gives him encouragement but I fear he will not do any more painting. He has the chuckle as of old and his long beard gives him a Rip Van Winkle look."[11] Although Charles Fitzpatrick reported that many of his old friends visited him at Elmhurst,[12] Miller told a different story, stating that Ryder was "in the clutches of a woman" who was "hostile to all his friends and had driven them away," presumably referring to Louise Fitzpatrick.[13] Whatever the truth may be, Ryder was now physically and mentally removed from the New York art world. One day, Kenneth Hayes Miller arranged to visit the Fitzpatricks to ask Ryder to authenticate a painting; for this purpose, Miller showed him a photograph of the work in question. "Ryder sat for a long time with it in his hand, looking at it," and when Miller identified it as a photograph, "Ryder said he thought it was the original."[14]

Louise Fitzpatrick, according to her husband's account, notified Ryder's old friends about the approach of his seventieth birthday on March 19, 1917, and told them it would be "nice to give him a little surprise." The surprise came in the form of letters and cards which they all sent; Ryder, now confined to bed, read them over and over again.[15] On March 28, at 9:15 A.M., he passed away, a victim of kidney failure.[16] Two days later, at the Fitzpatricks' home, a Methodist minister conducted a funeral service,[17] which was attended by Ryder's artist-friends, J. Alden Weir, Arthur B. Davies, Childe Hassam, Charles Melville Dewey, Kenneth Hayes Miller, and Alexander Shilling, several art dealers, and Peggy Williams and John Gellatly, among others.[18] On that day Weir wrote Colonel Wood: "There at the little house of Mrs. Fitzpatrick, dear old Ryder lay in the mystery of Death! There seemed nothing sad. The dear old fellow had a peaceful look and the struggle was over."[19] After the service, Ryder's friends went to Grand Central Station to escort his remains to the train for New Bedford. On the platform, Charles Fitzpatrick

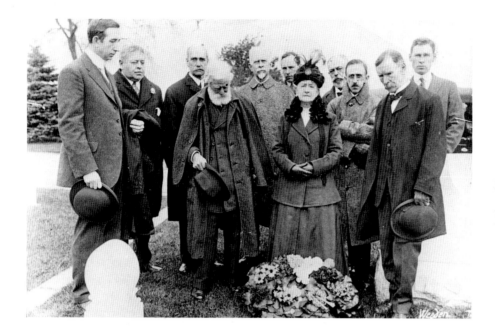

Fig. 10–4. New Bedford Art Club's wreath-laying ceremony, Rural Cemetery, New Bedford, Memorial Day, 1917. Those present included: Walton Ricketson and Mrs. Edward N. Ryder, the painter's sister-in-law, shown in front; Harry Neyland at extreme left, who prepared a memorial paper; Nat C. Smith, Louis H. Richardson, Edmund Wood, Clifford H. Riedell, and John Chase, at far right. Photograph: Weeden, *The Standard-Times* (New Bedford, Mass.) Copyright © *The Standard-Times*, New Bedford, Mass.

reported, they "lifted their hats in a last farewell."[20] Ryder had wanted to be cremated,[21] but the Fitzpatricks thought it would be better to bury him, and so the body was interred in the family plot in Rural Cemetery with his father and mother, his brothers Preserved and Edward, his brother William and his wife Emily, and their infant Bertie.[22]

Ryder's tombstone (fig. 10–3) is a simple piece of granite with a gently arching top, giving only his name and his birth and death dates in bold letters. There is no message or testimonial on it. In the Ryder family plot, the tombstones are lined up solemnly like parishioners in church pews, pressing close upon one another in a sea of other gravemarkers extending in every direction. At rest in this ancient cemetery, Ryder is nestled among the multitudes he could never cope with in life.

On Memorial Day, 1917, a small delegation from the New Bedford Art Club, together with his sister-in-law Sarah Jennie (Mrs. Edward N.) Ryder, placed a floral wreath in the shape of a palette on Ryder's grave and a brief tribute was read (fig. 10–4). In this modest ceremony, they honored Ryder as the city's greatest artist.[23]

Death brought Ryder the broader fame he had never enjoyed while he was alive. He had eluded most viewers during his lifetime, partly because of his voluntary withdrawal from society but also because many of his greatest paintings were in private collections, some as far away as Canada or Oregon. But at his passing, the floodgates of public appreciation were suddenly opened, with most of the major New York newspapers devoting extensive obituaries and news articles to him. Pride in discovery, so appealing to journalists, runs through these articles, and whether or not the writers fully understood Ryder they eagerly heaped praise upon him. Much of their information came from the same sources—friends, associates, and dealers—and thus a remarkably uniform picture began to emerge.

Ryder was portrayed as an artist lacking technical skill, unable to draw conventionally, but deserving praise because he was able to generate such passionate and meaningful content that technique did not matter; in this, he invited comparison with the great American poet Walt Whitman.[24] Such literary parallels were common, one critic calling him the "Thoreau of painting" and another likening him to Edgar Allan Poe.[25] For Ryder, such comparisons to poets would have represented the ultimate stamp of approval, a belated but enthusiastic recognition of the depth and profundity of his message.

According to several reporters, plans for a Ryder memorial exhibition were already being made within a few days after his death. There appears to have been a collective sense of guilt in the New York art world about neglecting so deserving an artist—a feeling no doubt fueled by the vigorous approval of his contribution voiced publicly in the obituaries and news articles just cited.

At the time of Ryder's death Charles Melville Dewey persuaded his niece, Gertrude Ryder Smith, to make him administrator of Ryder's estate.[26] His chief responsibility was to sell Ryder's paintings from his studio in the Chelsea Hotel. Ryder seems to have left only a small number of unsold works behind—*The Tempest* (plate 13) and *The Lorelei* (plate 14) had been commissioned earlier—but some of them, according to Dewey's own account, were unfinished.[27] Dewey claims he destroyed the incomplete works. But the dealer Albert Milch, who saw the paintings in Dewey's hands a few weeks after Ryder's death and then again after Dewey's death in 1937, concluded that the latter had painted on them himself,[28] presumably to get them into salable condition.[29] (See chapter 11 for further discussion of this matter.)

In any event, Milch sold one or more Ryders on behalf of Dewey. Dewey also invited the dealers N. E. Montross, William Macbeth, and Roland Knoedler to purchase Ryder paintings, and he began corresponding with Robert Vose in Boston about acquiring works by Ryder. Letters between Vose and Dewey indicate that the former acquired a group of works from Dewey. He did so with much pleasure, as he believed Ryder "to be one of the greatest of our artists." In addition, Vose planned to work with Dewey to compile jointly a complete checklist of all Ryder paintings, with the aim of excluding forgeries, already a source of trouble. Vose promised that when the list was completed it would be the "official one, which will be a great help to future collectors and students."[30] No such list, however, has come to light.

Vose had displayed a small group of Ryder paintings in his gallery in 1916. In the year following the artist's death, the Boston dealer again showed Ryder's work, this time in tandem with George Fuller's. In 1917, Montross also presented Ryder's work to the public: three important pictures together with Kenneth Hayes Miller's portrait of the artist (fig. 7–4), as a kind of memorial tribute.[31]

Dewey also approached Frederic Fairchild Sherman, a writer, editor, and dealer, about coming to his studio to buy Ryder paintings.[32] Sherman became the

Fig. 10–3. Albert Pinkham Ryder's tombstone, Rural Cemetery, New Bedford, Mass. Photograph: William Innes Homer

first vigorous advocate for Ryder after his death, writing about him in 1917 and beginning to deal in his paintings about that time.[33] Sherman had never met Ryder, but he did know the painter Elliott Daingerfield, who had interested Sherman in Ryder. Daingerfield, together with Montross, Albert Groll, and Walter Fearon (a former Cottier employee), offered Sherman a great deal of information about Ryder, which he painstakingly assembled for the first book on the artist, published in 1920. Besides advising Sherman, Daingerfield and Groll frequently authenticated works allegedly by Ryder on the dealer's behalf; but their testimonials were often placed on photographs of obvious forgeries.[34] This suggests that the two may have gone out of their way to help Sherman, who was making substantial profits on the sale of Ryders and had undoubtedly gained a taste for the income that such works would bring.[35]

The culminating event in the explosion of critical and public acclaim was Ryder's memorial exhibition, held at the Metropolitan Museum of Art from March 11 to April 14, 1918 (fig. 10–5). Initiated by Bryson Burroughs, curator of paintings, the show was to be a comprehensive survey of Ryder's most representative works.[36] Burroughs had inquired among several of Ryder's friends and associates, especially Louise Fitzpatrick, for help and advice in drawing up a list of examples to be shown. To achieve his goal, he placed notices in various art magazines, with the hope that readers who owned suitable paintings by Ryder would come forward and make them available for this important event. Correspondence in the museum's files indicates that a number of people read about these plans, or heard about them, and offered works for possible loan to the museum. Some of these paintings Burroughs considered and accepted for the show; others he reviewed and rejected. As part of this effort, he searched out poems Ryder had written to complement his paintings and printed them in the catalogue.

Burroughs's letters to various lenders and other parties were filled with enthusiasm and hope for the success of the exhibition. The replies he received, in turn, expressed great interest in the project and loyalty and devotion to Ryder's memory. Obviously, many felt this was an appropriate way to honor Ryder, who certainly deserved recognition as one of America's most prominent artists. That Burroughs found so many representative works to place on display—forty-eight in all—is to his great credit. Careful as he was, though, several doubtful paintings found their way into the show.[37]

In a four-page introduction to the catalogue, Burroughs provided a concise appreciation of the artist and his work. The details of Ryder's life mattered little to him: what counted was Ryder's poetic sensibility, his intuition. While Ryder, in Burroughs's opinion, portrayed narrative subjects and belonged in the company of Blake, Coleridge, and Poe, he also transformed the sentiments generated by those subjects into "expressive lines and the significant color that evoke these sensations in a way that cannot be analyzed." The content of his work, Burroughs asserted, was like music, for it derived from the "emotional value of design and color."[38] In these latter analogies he linked Ryder to the tradition of nonverbal expressiveness through the abstract arrangement of the paintings' formal elements, a cornerstone of Symbolist aesthetics, echoed and refined by the Fauves and a variety of other modernists sympathetic to these ideas. (That Ryder was probably unconscious of these connections made no difference to Burroughs.)

Ryder's artistic language, Burroughs thought, could be better understood by observing his similarities to the oriental tradition and "the Sienese" (doubtless

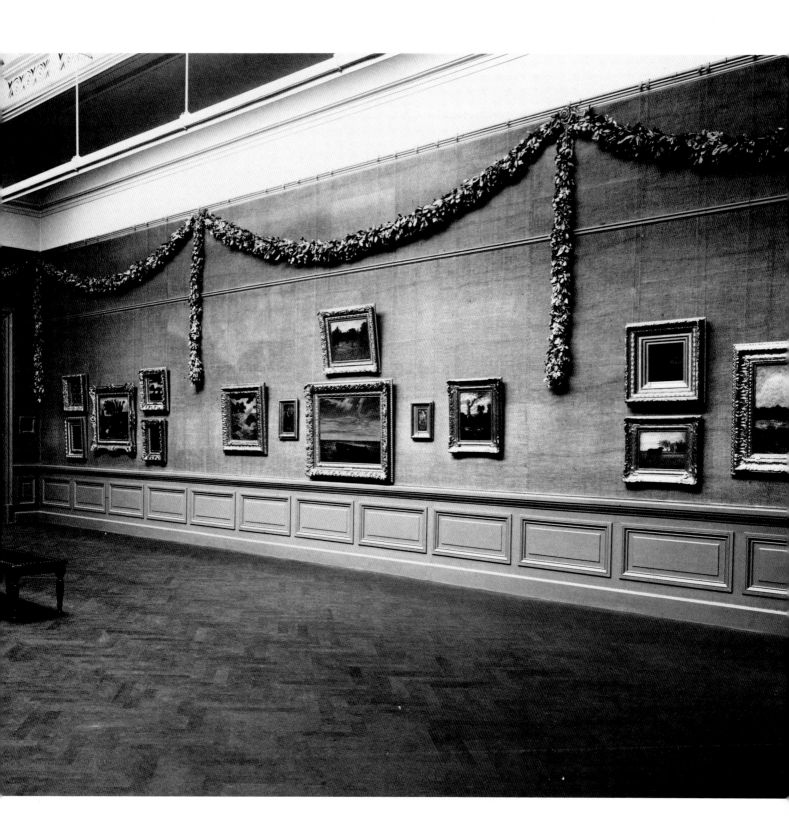

Fig. 10–5. View of Ryder memorial exhibition, The Metropolitan Museum of Art, New York City, March 11–April 14, 1918. Photograph: The Metropolitan Museum of Art, 1918

meaning the so-called Italian primitives, such as Duccio and Simone Martini, practicing in Siena during the late thirteenth and early fourteenth centuries).[39] In both forms of art, design and pattern, tending toward decorative abstractness, were prized by the taste of the day. In making these comparisons, Burroughs was very much in tune with this taste, and his remarks, therefore, made Ryder seem even more relevant to those who read the catalogue and saw the exhibition.

How much Burroughs's remarks influenced the reviewers of the show cannot be determined; but with or without his help Ryder criticism definitely matured in 1918. While those who wrote about him at the time of death sensed that the man was great, critics in the following year were able to demonstrate why this was so. Their task was made easier because the memorial exhibition had placed a choice group of his works on view and because many who had known Ryder came forward and reminisced about the artist and his ideas.

The Ryder memorial show earned critical accolades expressly because the artist appealed to the prevalent taste of the time that could be called middle-of-the-road modernism. Five years before, the Armory Show had brought the message of Post-Impressionism, Cubism, Fauvism, Expressionism, and abstraction to the United States on a large scale, and for many sophisticated viewers, including collectors, dealers, and critics, that message was heard fully or in part. By 1918, it appears that a reasonably large number of Americans had absorbed the aesthetic tenets of Post-Impressionism and, to a limited extent, also the avant-garde movements that followed it. They were thus able to cope with ideas of emotional expression through formal (abstract) means, an art in which the significant relationship of color and volume ("significant form") took precedence over technical flourish and verisimilitude. They were increasingly able, then, to value art that was unconsciously naive, or unsophisticated, precisely because its formal strength was so much more compelling.

It is hard to generalize about the critical appraisals of the event because the writers approached the subject from different personal perspectives; yet there were several common threads. Ryder was enthusiastically embraced because he appealed to the growing acceptance of Post-Impressionism, together with art that was admittedly "primitive" or oriental or both. While virtually all of the reviewers, as usual, praised Ryder's imagination, poetic sensibility, and sensitive response to the literary legends of the past, what counted was his skill in making his colors and forms communicate his feelings about the subject. Or, in a similar vein, he was lauded because he could offer both "literary" content and formal strength at the same time. The creation of "significant form" (to use a term popular in that day) was, in the eyes of the critic Helen Appleton Read, a great asset,[40] as was his skill, noted by the *New York Times*, in balancing positive and negative shapes.[41]

As in the past, most of the critics asserted that Ryder had little talent in drawing and lacked manual dexterity. Yet now the very absence of cleverness in his execution was hailed as a strength, appealing to a taste, as a critic for the New York *Post* observed, for the innocent and unsophisticated. In this regard, the *Post* continued, Ryder's work was like that of the great French Post-Impressionist Paul Cézanne, or as Burroughs also had suggested, like the Italian "primitives."[42]

Because Ryder's art was in accord with the climate of taste, it was immensely appealing not only to critics, but also to a variety of other art enthusiasts, especially collectors and, increasingly, museums. It is as though, for a brief period in the late teens and early twenties, the art world was gripped by "Ryder fever," and that the supply of his works could not satisfy the demand. For this reason, as we shall see in Chapter 11, Ryder forgeries were produced in large numbers—and accepted for the most part uncritically. It was a time, too, when the Ryder myth got underway, when he became, like the poet Walt Whitman before him, a symbol for anything anyone wanted him to be.

11

Forgeries and Alterations of Ryder's Work

THERE ARE MORE fake Ryders than there are forgeries of any other American artist except his contemporary Ralph Blakelock.[1] Such "Ryders," probably numbering over one thousand,[2] frequently appear in the hands of collectors, dealers, and auction firms; continue to be housed in American museums; and are occasionally reproduced in periodicals, books, and catalogues. Even during Ryder's lifetime, forgeries had begun to appear,[3] and in the late teens, 1920s, and 1930s, the number of forged works grew in alarming proportions. Moreover, another kind of deception, just as insidious but far less recognized, may be found in the alteration and "completion" of Ryder's works, including major examples, by hands other than his own. Sometimes the changes were minor but, in other cases, such alterations radically distorted Ryder's artistic aims. Obviously, his creative contribution cannot be fully and accurately appraised without dealing with these issues.

Ryder paintings are relatively easy to forge. The broad tonal effects, lack of precise technique, heavy buildup of pigment, and warm overall glow—all of these elements were not hard for a forger to imitate. The results, however, vary widely in quality. A few—*Sailing by Moonlight* (fig. 11–1), for instance—are quite convincing and show a high degree of formal sophistication and technical skill, while others are unbelievably crude and amateurish, hardly capable of fooling anyone. The majority, though, belong in a kind of aesthetic no-man's-land, imitating Ryder's style superficially, but without showing any real understanding of his carefully worked out designs and his subtle, resonant color (fig. 11–2).[4]

Most often, the forgers seized upon Ryder's favorite motifs and combined them in various ways to make new works that appeared to have come from his brush.[5] There are innumerable spurious versions of the storm-tossed boat on a choppy sea, shrouded in shadow and lit only by a ghostly moon. Popular, too, was the rustic farmhouse, or farmhouses, with glowing casements in a gloomy landscape, often with cows or horses; or at times such animals appear alone in a rural setting. A common variant was the mounted figure, usually male, riding through a

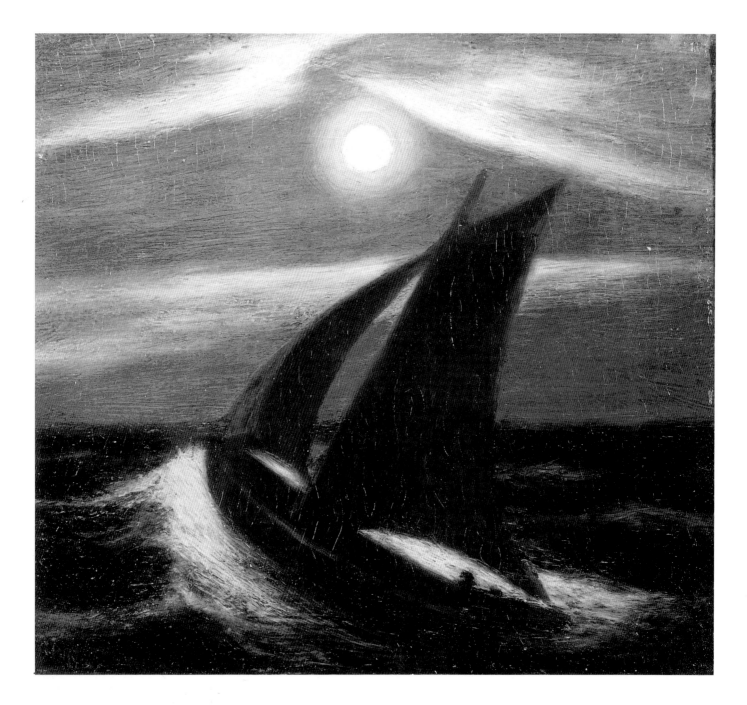

pastoral landscape; or on foot, leading a team of horses and a haycart. Sometimes, the forgers' subjects were given an oriental flavor, and at other times, they became poetic and literary, with dancing nymphs and dryads, even occasionally dramatic and romantic, in tone, borrowing from Ryder's later, more imaginative works such as *The Race Track* (plate 11). The forgers cleverly "anticipated" the kinds of subjects Ryder might have painted, for example, *Moses Breaking the Tablets of the Law*, *Cain and Abel*, *The Crucifixion*, *Christ Appearing to Peter*, *In the Garden of Gethsemane*, *Hero and Leander*. The more ingenious forgers must have combed the early exhibition records to find subjects Ryder had painted, but for which no corresponding authentic work was known to exist, and then produced spurious examples such as *Ophelia* and *Nourmahal* that would fill the gaps. Sometimes oil "studies" were

Fig. 11–1. Ryder forgery. *Sailing by Moonlight.* Oil on wood panel, 12 x 13″. RA

fabricated: smaller works that Ryder might have created in preparation for a major canvas, such as *Macbeth and the Witches* (plate 15), the forgers apparently being unaware of or not caring about his usual procedure of painting directly, without such studies.

Ryder connoisseurship was in a fairly primitive state until the mid-1930s. Many forgeries went undetected, and because there was relatively little resistance to them, they multiplied at an alarming rate. Shortly after Ryder's death, Vose of Boston and Macbeth and Montross of New York—all dealers of good reputation—occasionally traded in uncertain works, undoubtedly doing so in all innocence simply because standards of Ryder connoisseurship were so undefined at the time.

Who fabricated the growing supply of spurious paintings cannot be determined with certainty at the present time. Several of Ryder's acquaintances who painted and knew his style are likely candidates, but it would be unfair to level specific accusations at these individuals without concrete evidence.[6] Suffice it to say that forgeries were produced and circulated shortly before Ryder's death and, in much greater numbers, immediately afterward and well into the 1920s, 1930s, and possibly even later. At one point, as Lloyd Goodrich observed, there came to be so many forgeries that some of the imitators began to copy each other.[7]

At the beginning, forgers had at their disposal a limited repertory of Ryders on which to base their imitations. His works were shown only in small numbers from the mid-1870s through the late 1880s at the National Academy of Design and at the Society of American Artists and were seen occasionally, especially in his later years, at gentlemen's clubs, at auction, and at special loan exhibitions. When reproductions of his works appeared as wood engravings and halftones in periodicals during Ryder's lifetime, forgers could acquaint themselves with his subject matter and themes, if not his color and technique. For these latter elements, it would be necessary to see the original paintings, a few examples of which had already begun to enter public museums, such as the Metropolitan Museum of Art and the Brooklyn Museum, shortly before Ryder's death. His display at the Armory Show of 1913 (fig. 9–11), too, provided an opportunity for study for anyone who wished to imitate his paintings. After Ryder's death in 1917, the forger's task of finding suitable

Fig. 11–2. Ryder forgery. *Golden Twilight (The White Horse)*. Oil/resin on paper glued to twill canvas glued to plain canvas, 7 x 12″. Harvard University Art Museums (Fogg Art Museum), Cambridge, Mass.

Fig. 11–3. Albert Pinkham Ryder. *Weir's Orchard*. Middle or late 1890s. Oil on canvas, 17⅛ x 21″. Wadsworth Atheneum, Hartford, Conn. The Ella Gallup Sumner and Mary Catlin Sumner Collection. Photograph: Sandak, Inc., Stamford, Conn., 1961

models became easier. His pictures could be seen increasingly in galleries and public collections, and knowledge of Ryder's technique, described in detail, could be gained from the text of Sherman's book of 1920.

Although Sherman appears to have sold some Ryder forgeries, he set himself up as an expert who could discern such forgeries.[8] He felt that a practiced eye (his own) could easily detect spurious Ryders, and at the end of his Ryder volume he printed a list of what he believed were genuine works. Unfortunately, this includes several paintings now regarded as forgeries, including a few in his own collection. In the mid-1930s, in turn, Sherman took it upon himself to denounce the forged Ryders handled by the dealer Frederic Newlin Price and reproduced in his book *Ryder, a Study of Appreciation* (1932).[9] Price, president of the Ferargil Galleries, New York, had acquired in 1924 a collection of genuine Ryders assembled by Dr. A. T. Sanden, including *Weir's Orchard* (fig. 11–3) and *The Windmill* (fig. 11–4), and made these the basis of his dealing in works by the artist.[10] Exactly when Price began to sell forgeries is unknown, but a number of questionable works credited to his gallery were published in his 1932 volume.

The forgery issue came to a head in 1935, when Price arranged a Ryder exhibition at the very prestigious Kleemann Galleries, New York. Twenty-six oils were

Fig. 11–4. Albert Pinkham Ryder. *The Windmill* (*The Old Mill*). 1890s and later. Oil on canvas, 16 x 14″. Private collection. Photograph: The Metropolitan Museum of Art, 1918

placed on view between October 16 and November 2. When Lloyd Goodrich, then a thirty-eight-year-old research curator at the Whitney Museum of American Art, visited the show, he was deeply troubled. After looking at the works carefully, he came to the conclusion that at least a third of them were not authentic,[11] and it struck him as probably the most serious case of forgery in American art.[12] With the backing of Juliana Force, the museum's director, he proceeded to ask Price if he could borrow the paintings after the exhibition so that he could examine them thoroughly. Price agreed, little knowing what the results would be.

For this study, Goodrich enlisted the help of the paintings conservator Sheldon Keck and the curator of paintings John I. H. Baur, both of the Brooklyn Museum. They arranged for the pictures to be taken to the museum and examined in the laboratory there. (The Whitney Museum did not have a laboratory.)[13] The group began with the suspicion that many so-called Ryders were not by Ryder. Accordingly, they made an objective examination of the works from several points of view: using ultraviolet light, infrared photography, low-power microscopy, high-power microscopy, and X-ray photography (radiographs).[14] Radiographs proved to be the most useful, showing that authentic Ryders possessed distinctive technical characteristics.

Fig. 11–5. X-ray radiograph of *The Forest of Arden*. RA

Starting by making X-ray radiographs (fig. 11–5) of works with an unimpeachable history, Goodrich and his colleagues found evidence of a remarkable depth of pigment and concluded that Ryder had executed his paintings slowly, almost by trial and error. As Goodrich observed: "Ryder worked long over his pictures, building them up in layer upon layer of pigments and glazes, often modifying the forms. Hence in his radiographs the forms do not visualize sharply, the edges are often blurred, and few details are clear. The effect is rather like a composite photograph. But the radiographs almost always show the main area of white lead and of translucent pigments, the former relatively dense and visualizing as almost pure white, the latter dark. Thus they usually reveal the general structure of Ryder's compositions and the way they were built up."[15] By contrast, radiographs of the paintings that the team finally decided were forgeries were very different. Because such works were painted thinly and directly, not laboriously built up over time, "Radiographs . . . usually show little more than a heavy blank undersurface, thinly painted over. Even when some of the composition visualizes, the thin direct technique can be distinguished from Ryder's rich and complicated processes."[16]

Fig. 11–6. X-ray radiograph of Ryder forgery, *Moonlit Cove*, present location unknown, showing painting by another artist underneath a typical Ryder subject. RA

One of the by-products of the radiographic study was the discovery of alien imagery underneath paintings allegedly by Ryder. Latter-day forgers generally utilized old stretchers and canvas in order to simulate materials of Ryder's time, and thus it was not unusual for the team to find evidence of work by another artist beneath the surface (fig. 11–6). Of course, as Goodrich pointed out, any painter might use another's previously painted canvas for reasons of economy, but as of 1951 he had "never found a genuine Ryder with a picture by another artist underneath." Subsequently Keck found several authentic Ryders that had been done on top of canvases with previous work on them, presumably by other artists.[17]

If Goodrich was distressed by the Kleemann Galleries show arranged by Price, he was thoroughly dismayed by that dealer's 1932 volume on the artist, which he described as "the most horrible, ghastly writing about an artist that ever happened." Moreover, Goodrich estimated that forty to fifty per cent of the works listed by Price were not by Ryder and concluded that the book "reproduces the largest collection of forgeries that exists."[18]

Price had had his young assistant Maynard Walker (who later operated his own

Fig. 11–7. Albert Pinkham Ryder. *Moonlight (Marine, Moonlight)*. 1890s. Oil on wood panel, 11⅜ x 12″. The Brooklyn Museum. Gift of Mr. and Mrs. Solton Engel. Photograph: The Metropolitan Museum of Art, 1918

gallery) prepare a list of known Ryders for publication. Price possessed a group of photographs of the pictures he had sold through the gallery, and other pictures as well, and turned these over to Walker, who innocently created the list which has served to confuse rather than inform students of Ryder's work.[19]

Objective examination of the kind conducted by Goodrich, Keck, and Baur is only one means of ferreting out forgeries. Goodrich's awareness of the limitations of the scientific approach is expressed in these remarks: "The determination of a picture's authenticity or falsity is a matter of balancing many different kinds of evidence—old records, history, style, technique. Thorough gathering and study of all these different kinds of evidence is our only way of straightening out the confusion caused by forgers, and restoring the life work of a great artist."[20] In the spirit of this belief, the following paragraphs will present a series of observations, guidelines, and words of caution in the hope that they will help readers discern the difference between the forged and the genuine.

Sherman, Price, and other dealers who sold forged Ryders often argued for the authenticity of particular paintings by calling upon "experts" who had known Ryder and who were willing to write testimonials. Ordinarily, one would expect to trust these individuals, but for unknown reasons, they agreed to authenticate paintings that are now thought to be forgeries.

Forged or spurious pedigrees also appear from time to time. Dealers, owners, or "experts" have fabricated histories of particular paintings—histories which are,

however, difficult to prove false. Too, the stamp of Ryder's dealer Cottier & Co. has been duplicated and applied to the backs of known forgeries.[21]

A painting allegedly by Ryder on canvas or wood panel dating from his lifetime, of course, does not prove authenticity. As mentioned earlier, Ryder's paintings were forged while he was alive; and modern forgers may acquire a worthless painting on old canvas or panel and paint a "Ryder" on top of it. As to materials, a careful forger can easily apply pigments similar to those that Ryder employed. Few new pigments have come into use today that were not available in Ryder's time; indeed, usable paint tubes from the earlier part of this century can sometimes still be found. Thus, the age or apparent age of materials is not a solid criterion on which to base a case for or against a Ryder painting.

Cracks are characteristic of almost every authentic Ryder painting, and many such fissures are severe. Resulting from a premature aging process, aggravated by his painting over areas not completely dry, they appeared in some of his works even during his lifetime (fig. 11–7). Forgers quickly learned how to simulate the crackle pattern of a typical Ryder painting (fig. 11–8), the physical effect of apparent age being duplicated quite rapidly by rolling the work, baking it, or both; at times the "cracks" were even painted in with a thin brush.

With regard to signatures, there is no certainty in this area. Ryder did not usually sign his work, and often forged signatures appear on spurious examples. To complicate the matter, Ryder signatures were sometimes placed on unsigned but authentic works by Ryder.[22] Thus signatures are virtually useless as a criterion for the authenticity of Ryder paintings.

The appearance of a reproduction in a book, museum catalogue, or magazine of a work alleged to be by Ryder is, of course, no guarantee of authenticity. Because of the proliferation of forgeries and the uncertain state of connoisseurship in the early years, reproductions of forged works are found fairly often. Some were intended to deceive; others appeared innocently. Even in recent scholarship, forged paintings are occasionally reproduced by otherwise responsible writers.

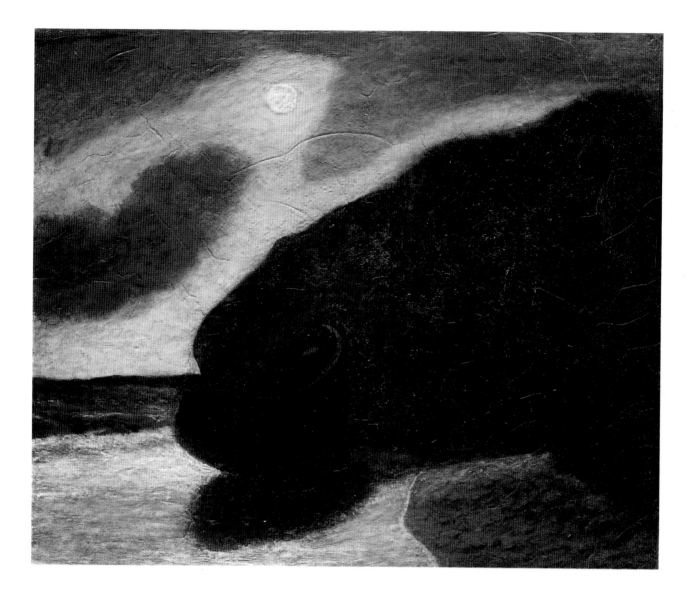

Fig. 11–9. Albert Pinkham Ryder. *Moonlit Cove*. Early to middle 1880s. Oil on canvas, 14⅛ x 17⅛". The Phillips Collection, Washington, D.C. Photograph: The Metropolitan Museum of Art, 1918

It appears that there are few solid criteria by which to judge a painting alleged to be by Ryder. The ultimate test is whether the work looks like a Ryder; in other words, visual discrimination plays a central role. For this purpose—following the example of the great German connoisseur Max J. Friedländer—a body of paintings assuredly by the artist (and not significantly retouched or altered by another) must be studied in order to discover those formal and technical qualities that are uniquely his and no one else's; then the supplicant work must be evaluated against these distinctive traits. In Ryder's case, what are these traits?

A striking feature of most authentic Ryder designs is the interlocking of solids and voids, or figure and ground, a characteristic particularly evident in *Siegfried and the Rhine Maidens* (plate 10) and *Moonlit Cove* (fig. 11–9). In an authentic Ryder painting, the background is rarely "neutral" or inert, but most often is an active compositional force with an identity of its own which interacts with the shapes of the main subject matter. As a result, Ryder's works tend to have an "all-over" two-dimensional integrity or integration, in addition to whatever illusionistic depth he may have chosen to convey. There is, in fact, a tense interaction between three-dimensionality or spatiality, on the one hand, and the two-dimensional iden-

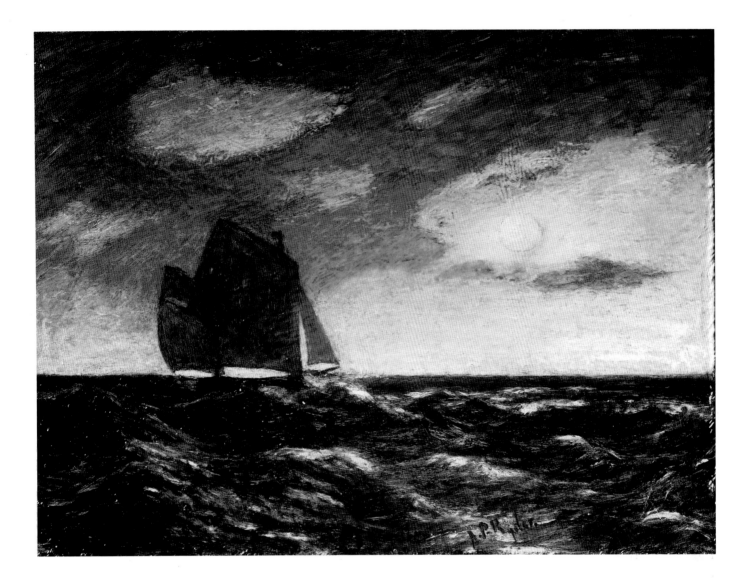

Fig. 11–10. Albert Pinkham Ryder. *Moonlight on the Sea*. Early 1890s. Oil on wood panel, 11½ x 15⅞". Wichita (Kan.) Art Museum. Roland P. Murdock Collection

tity of the surface which Ryder continually acknowledges and respects.

Ryder was most thoughtful and careful in placing his subject within the two-dimensional rectangular (or square) borders of his painting, not allowing the subject's scale to dominate or take away from the inherent strength of the background areas. (See *Moonlight on the Sea* [fig. 11–10].) Thus, from a two-dimensional standpoint there is no "dead" space in a Ryder painting. In this mode of composition, Ryder found it necessary to continually refine positive and negative shapes. His paintings frequently have fairly soft contours or outlines, but this comes as much from his method of working as it does from his moody impressionism. In continually working over his paintings, Ryder not only created telling silhouettes, eloquent in their contours, but also viewed these shapes in relation to the character and force of his background areas. Thus, he not only drew the object, but also conceived of it in relation to negative spaces whose contours equally required articulation and definition.

Ryder worked in a fairly low-keyed tonality, from the middle range of the value scale down to deep darks and mysterious shadows, with only a few highlights. His was a somber palette akin to the French Barbizon School and the American

Fig. 11–11. Albert Pinkham Ryder. Detail of *Constance*, water at lower left. Middle 1880s–middle 1890s and later. Oil on canvas. Museum of Fine Arts, Boston. Photograph by Lloyd Goodrich, 1947: RA

Tonalist painters, usually with a rich vibrancy of warm coloration. In the realm of tone, Ryder's paintings hold together in a highly integrated fashion. It is difficult to verbalize about successful tonal or value relationships in his paintings because the phenomenon exists so much on a visual plane; however, in works ranging from *Joan of Arc* (fig. 8–4) to *Jonah* (plate 7), one can say that each value is considered in relation to every other, with variation and contrast playing a part, but with no tone or value inappropriately jumping out or crying for attention. The overall balance between values is thus a prominent feature in an authentic work by Ryder; and such tonal qualities interact, as well, with his compositions to form a total unity operating on several different levels at the same time.

As to color, Ryder was viewed as a sublime colorist by many of his contemporaries, but there are few chromatic contrasts in his work, nor do his hues have much intensity. Building up his paintings with glazes, layer over layer, many times over, Ryder created a Rembrandt-like glow, and there is no way that direct painting can duplicate this effect. The result, in Ryder's case, was a low-keyed radiant color scheme, characterized by an impalpable sense of mystery. For each painting, in turn, there was a dominant color tone, with variations within a few basic hues. The "key" of his pictures might vary, but his watchword was simplicity of color choice, accented from time to time with bright warm tones or milky white highlights.

Ryder painted with a confident stroke, much in the nineteenth-century tradition which revived the painterly approach of the Old Masters (a detail from *Constance* is reproduced as fig. 11–11). His handling of pigment was not linear but free and fluid (fig. 11–12), and in his sketches (see fig. 11–13) his confidence and assurance are quite remarkable. As Ryder gradually brought his paintings closer to completion, his brushwork became more controlled and refined, though a kind of bold sketchiness is usually evident, if not in the final layers, in the underlayers. In his

Fig. 11–12. Albert Pinkham Ryder. *The Equestrian*. Early 1880s. Oil on canvas, 9 x 12″. Portland (Ore.) Art Museum. Bequest of Winslow B. Ayer

most finished works, Ryder often used very delicate parallel strokes, following the modeling or contours of his subject matter, and in these there is always a sense of control and refinement.

Although by the standards of his day, his draftsmanship was sometimes crude, even primitive and clumsy at times, as in *The Grazing Horse* (fig. 11–14) and *The Lovers* (fig. 11–15), in *The Lone Horseman* (fig. 11–16) and *Diana* (fig. 11–17), he was capable of defining accurately the main outlines and silhouettes of his subjects. Ryder was not naturally fluent in drawing and obviously had to work hard to accomplish his representational goals; but when he did so, his results were commendable.

Fig. 11–13. Albert Pinkham Ryder. *Landscape Sketch*. c. 1888. Oil on canvas, 5¾ x 7¼″. Private collection, New York City

Fig. 11–14. Albert Pinkham Ryder. *The Grazing Horse*. Middle 1870s. Oil on canvas, 10¼ x 14¼". The Brooklyn Museum. Graham School of Design

Fig. 11–15. Albert Pinkham Ryder. *The Lovers (Saint Agnes' Eve)*. c. 1880. Oil on canvas, 11½ x 8¼". Vassar College Art Gallery, Poughkeepsie, N.Y. Gift of Mrs. Lloyd Williams, 1940. Photograph: The Metropolitan Museum of Art, 1918

Fig. 11–16. Albert Pinkham Ryder. *The Lone Horseman*. Early 1880s. Oil on academy board, 8 x 14½". Private collection

To summarize, Ryder's paintings represent an integrated unity of formal elements, an integration, however, that is found on several levels. For him, formal balance in a two-dimensional sense, involving the unifying of figure and ground, was combined with tonal control and harmony which was complementary to his designs. The unity of Ryder's works was further enhanced by his choice of an essentially simple vocabulary, a minimum number of shapes and tones which he related to each other in a comprehensible way. In addition to these elements, Ryder's color, like that of the Old Masters, essentially embellished and enriched an underlying tonal framework.

Authenticating Ryder paintings and detecting forgeries is a difficult, though not impossible, task. Despite the criteria just outlined, there are no hard and fast rules, no scientific certainty even with analytical methods currently in use.

Almost as troublesome as the forgeries are the unauthorized additions to, and changes in, Ryder's paintings made not only by "restorers," but also by not so-well-meaning friends who may have distorted his original intentions. Prime examples in question are *Macbeth and the Witches*, *The Tempest*, *The Lorelei*, and *The Race Track*. At least two of these paintings, and probably others, appear to have been worked on by Louise Fitzpatrick. As mentioned in chapter 9, she was an amateur artist of no particular distinction who closely echoed Ryder's style in her independent paintings. With her direct knowledge of Ryder's technique, she was able to approximate, but not equal, his luminous skies and deep shadows, his lonely seascapes and poetic figures (fig. 9–9).

Such works, painted under her own name, are harmless enough in themselves. But distressing is the report from the painter Philip Evergood (citing information he received from Louise Fitzpatrick) that not only did she set up Ryder's palette for him and steady his hand in old age, but also that "he would ask her to paint on his pictures for him, telling her just what colors to use, how to put them on."[23] We will never know how much "help" Louise Fitzpatrick gave Ryder by actually working on his paintings, but if he was as feeble as Evergood indicated, then Ryder and Louise Fitzpatrick, separately or together, may have altered some of the works that remained in his possession in his final years. It is impossible to be certain which works may have been involved.

There were additional problems after Ryder's death in 1917. Charles Melville Dewey obtained a group of Ryder paintings, including some that were unfinished, and upon the urging of the deceased artist's friends, gave several of these to Louise Fitzpatrick, to whom such works evidently had been promised.[24] Both Dewey and Fitzpatrick, it appears, were directly responsible for changes in some of Ryder's paintings—alterations that were intended to improve their salability.

One documented case is *The Tempest* (fig. 11–18; plate 13), left unfinished at Ryder's death. It had been commissioned many years before by Colonel C. E. S. Wood, but Ryder had never quite succeeded in completing the painting. Frederic Fairchild Sherman said he saw the work just after Ryder's death and remarked that it was essentially unformed and bore little resemblance, at that time, to the painting we know today: it "was simply a canvas loaded with pigment in vain attempts to get it into a pictorial condition satisfactory to the painter. It revealed no evidence of any picture whatever. . . ."[25] Walter Pach told of visiting Ryder's studio and viewing the work, almost black from numerous repaintings, but with a garish white chalk outline that he had drawn of the figure of Prospero in an effort to revise and perfect the canvas.[26] Louise Fitzpatrick, who had corresponded with Wood early in March, 1918, offered to restore *The Tempest* and *The Lorelei*, believing "both of them . . . can be brought out very fine."[27] After some weeks, Wood apparently agreed to have her treat *The Tempest*, for she wrote him in the middle of April: "Will work very carefully on Tempest as if Ryder was right here. Somehow, I feel that he is."[28] Her "restoration" must have been completed by August, because on the 24th, the dealer Robert C. Vose spoke of it in a letter to Bryson Burroughs, curator at the Metropolitan Museum of Art.[29]

Sherman asserted later: "The picture now on the canvas is to the best of my belief more a work of the restorer than anything of Ryder's. . . ."[30] Kenneth Hayes

Fig. 11–17. Albert Pinkham Ryder. *Diana.* Late 1870s. Oil on leather, 28⅛ x 20″. The Chrysler Museum, Norfolk, Va. Gift of Walter P. Chrysler, Jr.

133

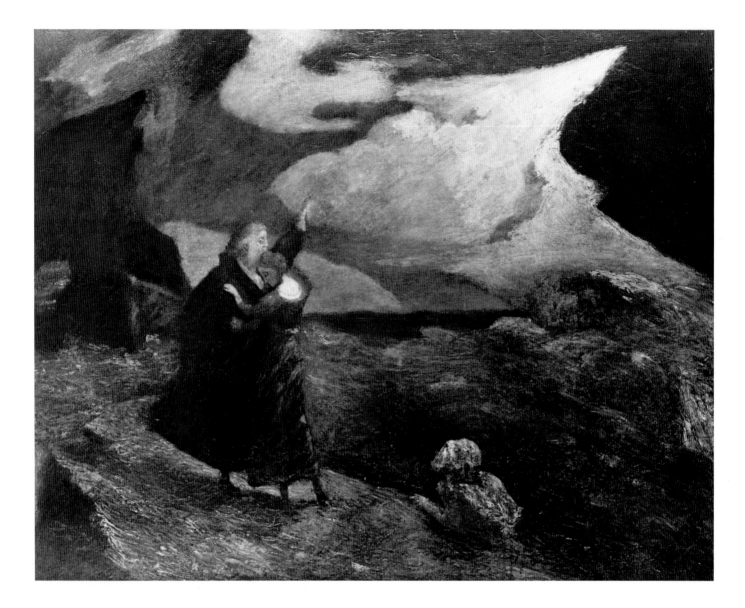

Miller, in the same vein, recalled the "extensive restoration" the painting had undergone between the time he first saw it and its later, presumably present, state. An X-ray radiograph of the two central figures, Prospero and Miranda, shows a very different foundation, much more fluid and convincing than what we see today and surely close to Ryder's original intentions (fig. 11–19). In any case, the present appearance of *The Tempest* is certainly far less than we would expect from the artist. Spatially, the work is disjointed, especially in the middle ground and background; the values do not hold together; and the cloud at the upper right is too bright and massive, almost like a rock, lacking in luminosity and transparency. Overall, the painting has an unpleasant oily surface, and Ryder's sensitive touch has been replaced, in many areas, by a rather coarse handling of pigment.

The Lorelei (fig. 11–20; plate 14) is another work that, according to written sources, may have been worked on by Louise Fitzpatrick. Ryder must have considered it unfinished at the time of his death because he was never satisfied with the figure of the Lorelei, which he kept removing and replacing. Fitzpatrick told, in a letter to Colonel Wood, of Ryder's troubles with the painting: "I lived in memory of

134

Fig. 11–18. Albert Pinkham Ryder. *The Tempest*. 1890s and later. Reworked after the artist's death. Oil on canvas, 27¾ x 35″. The Detroit Institute of Arts. Gift of Dexter M. Ferry, Jr.

Fig. 11–19. X-ray radiograph of the figures of Prospero and Miranda, *The Tempest*. RA

the last supreme efforts of Ryder's agony when he created a most wonderful picture; no, it was more than a picture. It was a 'little world all to itself.' I begged him to leave it so. But alas, in the making of the picture, the varnish, the oils, the wax[,] the heat, and his fear that it would not dry made him dig into it, and then the work of undoing started and it was put aside. He could no longer stand the strain of even speaking about it."[31]

Believing Wood wanted her to restore the painting, even though it had been promised to Helen Ladd Corbett, she "carefully made out the form of the 'Lorelie' [*sic*] and the man and boat and a few lights on the water right below the rock near the boat in water color." This she did because she "remembered how [the painting] was." But when she told J. Alden Weir of her work on *The Lorelei*, he became angry and said she shouldn't have done it; so she removed the water-color additions.[32] Yet in an undated (c. 1918) letter to Wood the matter of restoration was raised again, for she wrote: "I will restore the 'Lorelei' as he [Ryder] would have had me do, if I feel I can know that soul to soul in love of truth and justice to his friends I can still fulfil [*sic*] his wish towards them."[33] It is possible that new restoration work went for-

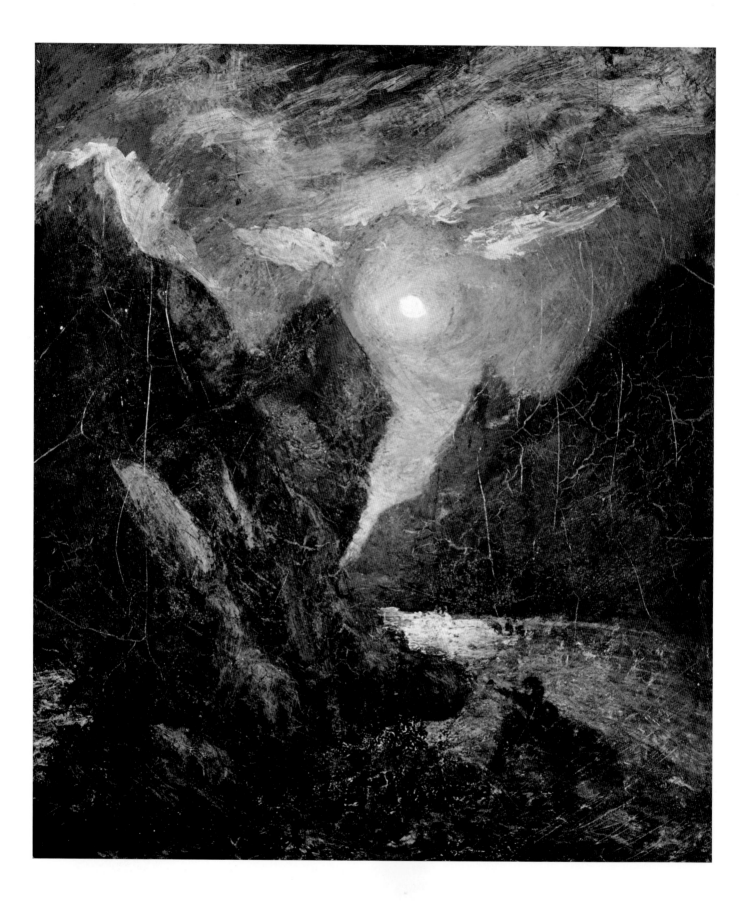

Fig. 11–20. Albert Pinkham Ryder. *The Lorelei*.
Early to middle 1890s and later. Oil on canvas,
22½ x 19″. Private collection

Fig. 11–21. Albert Pinkham Ryder. *Noli me Tangere (Christ and Mary)*. Late 1880s. Reworked after the artist's death. Oil on canvas mounted on wood panel, 14½ x 17½". The Carnegie Museum of Art, Pittsburgh; Purchase, 1943. Photograph, Peter A. Juley & Son: RA

ward because Robert Vose asked Wood, in a letter of October 2, 1918, how it came out.[34] However, we have no early photographic or verbal records of the painting, so we cannot determine how much she did, or whether she touched the painting at all.

Charles Melville Dewey, as already mentioned, came into possession of a number of the artist's works including some that were unfinished. Early reports suggest that Dewey generously applied his own brush to them, no doubt in an effort to get them into salable condition. Most troubling are the remarks of the dealer Albert Milch, who inspected the so-called Ryders in Dewey's possession at the time of his death in 1937. Having also seen these works in Dewey's studio a few weeks after

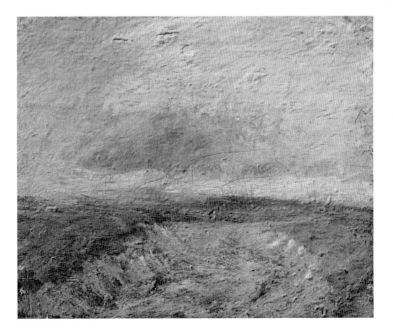

Fig. 11–22. Albert Pinkham Ryder. *The Canal (Essex Canal)*. 1890s? Reworked after the artist's death? Oil on canvas mounted on wood panel, 16½ x 20½". The Art Institute of Chicago. Photograph: The Metropolitan Museum of Art, 1918

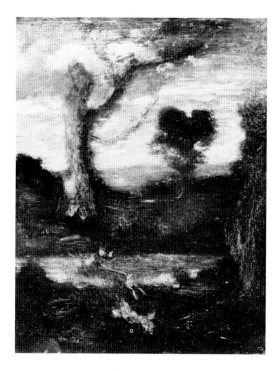

Fig. 11–23. Albert Pinkham Ryder. *Diana's Hunt*. 1890s. Reworked after the artist's death? Oil on canvas, 18 x 14″. The Newark (N. J.) Museum. Purchased 1955 Wallace M. Scudder Fund. Photograph: The Metropolitan Museum of Art, 1918

Fig. 11–24. Albert Pinkham Ryder. *The Race Track (Death on a Pale Horse; The Reverse)*. Late 1880s–early 1890s. Oil on canvas, 28¼ x 35¼″. The Cleveland Museum of Art. Photograph: The Metropolitan Museum of Art, 1918

Ryder passed away, Milch concluded that they had been painted on by Dewey—and noticeably changed in the process. According to Milch, *Noli me Tangere* (fig. 11–21) was originally "very gray and subtle and a fine piece of painting."[35] Today that can hardly be said of the work, for the drawing is tentative, sketchy, even at times crude; and the figures float like cutouts against a pasteboard backdrop that only vaguely reflects a characteristic Ryder design.

Milch raised similar questions about *The Canal (Essex Canal)* (fig. 11–22), once owned by Dewey,[36] which in its present state is somewhat different from any known work by Ryder, suggesting that Dewey may have repainted or "completed" an unfinished canvas after the artist's death. A similar fate might have befallen *Diana's Hunt* (fig. 11–23), a painting that looks like a Ryder design but has strangely undefined animals and curious horizontal strokes in the sky that are uncharacteristic of Ryder. About this painting Sherman said it was "one of those left unfinished at Ryder's death and touched up by Charles Melville Dewey."[37] We have, however, no proof of Dewey's additions, and thus the work may simply be unfinished.

Louise Fitzpatrick and Charles Melville Dewey seem to have been two instigators of change in Ryder's work, but they appear not to have been alone. Having no known connection to Fitzpatrick or Dewey are two other major works by Ryder that have also suffered at the hands of a restorer who did more than restore: *Macbeth and the Witches* and *The Race Track*. Both had been owned by Dr. A. T. Sanden, who acquired the paintings from the artist during his lifetime and lent them to the memorial exhibition in 1918. In 1924, the Sanden Collection, including these paintings, was sold to Price, proprietor of the Ferargil Galleries, and a comparison of photographs of the two works made in 1918 (figs. 11–24 and 11–25) and later ones (plates 11 and 15) shows that noticeable alterations in tone, drawing, and brushwork were made. Price is known to have employed Horatio Walker, the painter and friend of Ryder whose style was not unlike his, to restore gallery pictures, and he is the most likely author of these changes.[38]

Whoever was responsible, the adjustments in *Macbeth and the Witches* have

Fig. 11–25. Albert Pinkham Ryder. *Macbeth and the Witches*. Middle 1890s and later. Oil on canvas, 28¼ x 35¾″. The Phillips Collection, Washington, D. C. Photograph: The Metropolitan Museum of Art, 1918

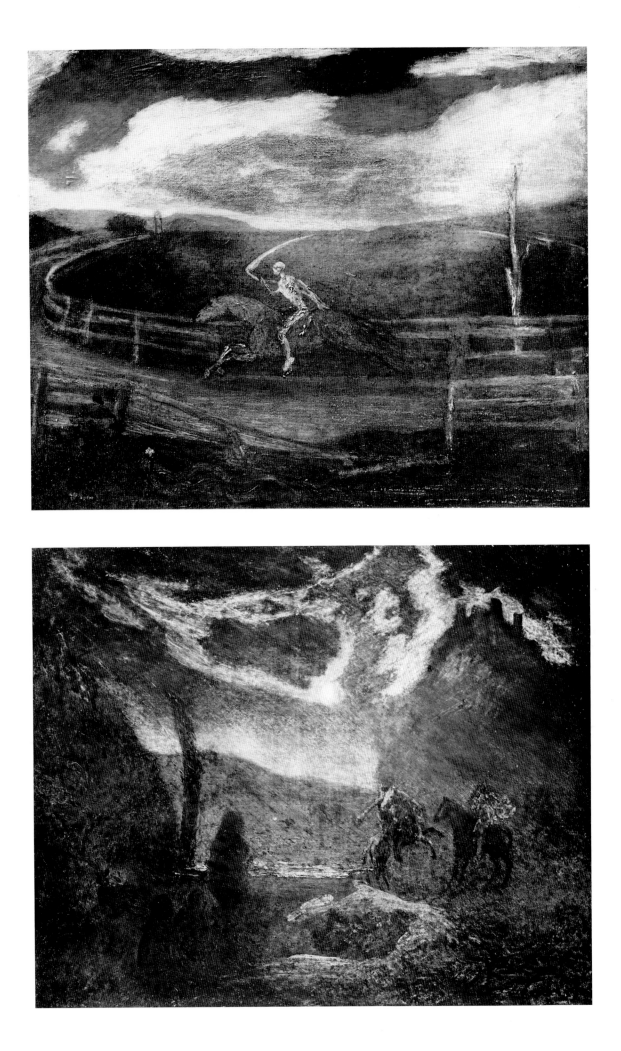

distorted Ryder's original intentions. Although the composition remains essentially unaltered, the sky has been repainted, its contours softened and modified, contrasts reduced, and new shapes added. In the center, above the distant hills, a whole new cloud form has been invented, perhaps in the misguided belief that Ryder would have wanted it there. Other additions are the rocky outcropping at the left and the backlighting that sets off the contours of the witches, almost in the manner of 1930s cinematography. The whole painting has thus been altered to make it conform to what Ryder was expected to be rather than what he was: an often tentative, experimental artist who left his works in various unfinished or unrealized states.[39]

Changes in *The Race Track* are less radical but just as disturbing, because it is one of Ryder's great masterpieces. Comparing the 1918 photograph with the one after restoration, alterations are quite apparent: contrasts have been reduced; Ryder's searching, sensitive brushstrokes in the clouds have been smoothed out; the rail fence has been darkened to make a more forceful silhouette against the track; and the twisting form of the snake in the foreground has been lightened. The restorer, very likely Walker, may have felt qualified to "complete" what he viewed as merely tentative and searching efforts by his distinguished fellow artist.

Is there any generalization that can be offered about why and how these disturbing and irreversible alterations were made? It is impossible, of course, to probe the minds of those responsible, but a major cause seems to have been commercial gain: the desire of the owner, or seller, to reap financial rewards from the sale of Ryders at a time when his prices had risen into four and five figures. Correspondence by and about dealers who handled Ryder's work suggests that they expected a great increase in demand for and continuing upward trend in it. Restorers, in turn, altered or completed works by Ryder in accordance with the taste of the conservative art market of the late teens and early twenties, softening, sentimentalizing, and ignoring the qualities of primitive directness that permeate many of Ryder's genuine works, but which may not have endeared him to the middle-of-the-road tastes of the time that still cherished Inness, Blakelock, and Fuller.

This chapter has suggested that what we see in Ryder's oeuvre today must be approached with a great deal of caution and skepticism. Not only do the many forgeries cloud his authentic identity, but also other artists' additions to, and completing of, his genuine paintings distort his intentions. Besides, there is the troubling physical disintegration of Ryder's work caused by his own technical ignorance. Paintings that were once impressive have now darkened, some almost beyond recognition, as in *The Lovers*; and in certain cases, as in *The Curfew Hour* (fig. 8–2), the pigment layer has separated into islands, with ever-widening cracks that render the surface almost unintelligible (fig. 4–18). And those paintings that still have not fully dried often reveal an underlayer oozing up through the cracks.

In the end, we must admit that the physical evidence of Ryder's creative output today is not what his contemporaries saw in the 1870s, 1880s, and 1890s. Partly because of his own technical ineptitude or indifference, or both, and partly because his works and what they stand for fell prey to those driven by greed, Ryder's oeuvre can no longer be taken at face value. This situation is obviously frustrating to anyone who wishes to understand and appreciate his achievement, but it is too late to do much about the physical state of his paintings.[40] The only way in which we can rectify his image is to select from all the works ascribed to Ryder examples that appear to be genuine, and without marked alterations by later hands, and set them aside to contemplate, study, and admire.

Afterword

THE ONE GREAT REGRET I have is that Lloyd Goodrich, coauthor of this book, did not live to see it in print. He did, however, complete the majority of his manuscript a little over a month before he died. He had carried his discussion of Ryder's life and art well into the artist's old age, and he had outlined the remaining material he wanted to cover. He had also hoped to write a chapter on Ryder's forgeries, but, sadly, death prevented him from doing so.

Lloyd did not write concluding remarks or collaborate with me in this. But on the subject he had definite ideas, which he voiced throughout his earlier writings, published and unpublished, and—just as important—shared with me in conversation. I would, therefore, like to close this book by combining my views with Lloyd's on Ryder's significance and place in the history of art.

Although Ryder's work is very different from that of Homer and Eakins, both realists, its quality is certainly equal to theirs. Quality, of course, is difficult to measure and even harder to talk about. But Ryder shares with both of these painters an intense involvement with his subjects, a mastery of color and design, and an artistic inventiveness that was not satisfied to repeat itself in one canvas after another. In relation to some of his contemporaries such as George Fuller and Homer Martin, Ryder was distinguished by his ability to grow and develop. While these painters certainly possessed considerable talent, they were more traditional—less

ambitious, one might say—in the artistic tasks they set for themselves. True, Ryder's earlier works looked like theirs at the beginning, but eventually he turned to more difficult, challenging subjects, fraught with universal human significance, such as *Jonah*, *The Flying Dutchman*, and *Siegfried and the Rhine Maidens*. And although he may not have been uniformly successful in every work, his successes vastly outnumber his failures.

There were, of course, artists in his own time such as John La Farge, Elihu Vedder, and Robert Loftin Newman who dealt with romantic, poetic, and even visionary subjects. But Ryder's art, as Lloyd pointed out in his unpublished notes quoted here throughout, makes "that of most other American romanticists of his time seem literary, over-intellectualized, cooked up. . . . Compared to most romantics, Ryder seems much more *queer*, original, individual—more a real visionary, with an extraordinarily personal vision; entirely sincere, more sincere and genuine than the others—an inhabitant of the strange world of fantasy, one who actually lived there, knew it as an inhabitant."

Ryder's great strength lay in his fertile pictorial imagination, his continuing ability to conceive fresh visions in each of his paintings. He seemed not to have been bound by repetitions or formulae but, rather, constantly to have created new visual schemes from deep within his own soul, a vocabulary appropriate to the message he wished to convey. Although his art was rooted in existing conventions, he moved away from them to great imaginative extremes. As Lloyd has written: "His art is literally a dream world. . . . His images were not copied from nature, but were produced by the unconscious mind, which molded the stuff of memory and fantasy. In his mind reality went through a long process of distillation, emerging as something purely subjective."

Ryder's imagination, however, was tempered not only by his experience of nature, but also by an exceptional feeling for pictorial construction which anticipates twentieth-century abstraction. As Lloyd noted about the "rightness" of Ryder's work: "It must have been purely instinctive—no one could have reasoned out his designs. They were arrived at by an intuitive, deeply sensuous instinct for form and its relations, for design." For him, Ryder was "the most purely plastic artist that America had produced. Not just the partial art-sense that others had—in some, color sensuousness, in others a sense of drawing—but the complete plastic harmony, the melody. . . . " He went on to praise "the fatness of his forms—their plastic richness. The rich texture of every element in his pictures—form, color, tone, pigment."

Literary, musical, and religious allusions that were so important to Ryder are lost on many people today. Yet we can still empathize with his profound emotional response to such subjects and, in turn, appreciate his great skill in conveying his feelings about them in compelling visual forms. These traits, together with Ryder's personal conviction and creative inventiveness, make him an outstanding artist. Being absolutely devoted to his own mission in art, he created paintings that satisfied himself above all. In his courageous individualism he was a true romantic; but in his isolated pursuit of his goals, no matter what the cost, he was also characteristically modern. Thus, for most of our century, not only Ryder's style, but also his personality—his legend—have been a source of inspiration to those artists sympathetic to him. From Marsden Hartley to Thomas Hart Benton, from Arthur Dove to Jackson Pollock and beyond, he remains alive—his dream transformed, but still vital—Albert Pinkham Ryder, a true American genius.

THE PLATES

Plate 1. The Barnyard

The Barnyard is an excellent example of Ryder's early work in the manner of the Barbizon School, following the methods of pastoral painting practiced in France by Jean-Baptiste-Camille Corot, Théodore Rousseau, and Charles Daubigny. The painting is much indebted to this tradition in its humble, rural subject matter—complete with thatched cottage, horse and wagon, and roosters in the foreground. The luminous, dark tonalities, suffused with browns and ochers, are reminiscent of Barbizon painting as well. Recent studies, such as that by Peter Bermingham, have shown that the Barbizon idiom was prevalent in America in the later nineteenth century;[1] and from our vantage point in history, we can see that Ryder's work of the 1870s belongs squarely in that tradition.

There are those who would claim that Ryder was an entirely self-taught genius, oblivious to the major currents of European art. It pleased certain critics of the 1920s and 1930s to make a case for the home-grown American prodigy; and, for some, Ryder fit this mold—or could easily be forced into it. Recent thinking on this subject, however, takes another view, seeing Ryder's work as a part of an international, cosmopolitan tradition, albeit somewhat delayed, that found expression in the United States.

In *The Barnyard*, Ryder turned the Barbizon manner to his own ends: he simplified his pictorial language into essential planes and masses, eliminating many of the sentimental trappings so often found in the work of the French Barbizon painters. Moreover, he flattened his images so that his painting operates as a two-dimensional pattern as much as it does three-dimensionally. Particularly noticeable is Ryder's tendency to treat tangible forms and their "background" as equal pictorial weights, balancing one another in an overall compositional pattern. Ryder was to develop and perfect this characteristic in subsequent paintings of the 1880s and 1890s, when his compositions were masterfully balanced as two-dimensional entities.

The Barnyard has an unimpeachable history, something that is always a pleasure to see in Ryder paintings. Records of the work reach back at least to 1915, the year it was sold at auction from the collection of Ichabod T. Williams, a New York lumber merchant. The painting was described fully in the auction catalogue, with the note that it was acquired by Williams from the late Daniel Cottier. This history offers an extra measure of security, as Cottier was Ryder's friend and dealer, and any painting from his collection is one that we would expect to be genuine. M. Knoedler & Co. was the high bidder, paying $1,400 for the work, a respectable price in that era. *The Barnyard* found its way, in 1919, to Duncan Phillips, who bought it for his gallery in Washington, D.C. The painting achieved notoriety in the following year when it was stolen on its way from Washington to an exhibition at the Century Club, New York. It was hidden from sight until its recovery in 1926. Subsequently, Phillips exchanged this work and another Ryder for the large *Macbeth and the Witches* (plate 15). Then *The Barnyard* was purchased by Dr. C. J. Robertson, who later sold it to a New York dealer, from whom it was acquired in 1957 by the Munson-Williams-Proctor Institute Museum of Art.[2]

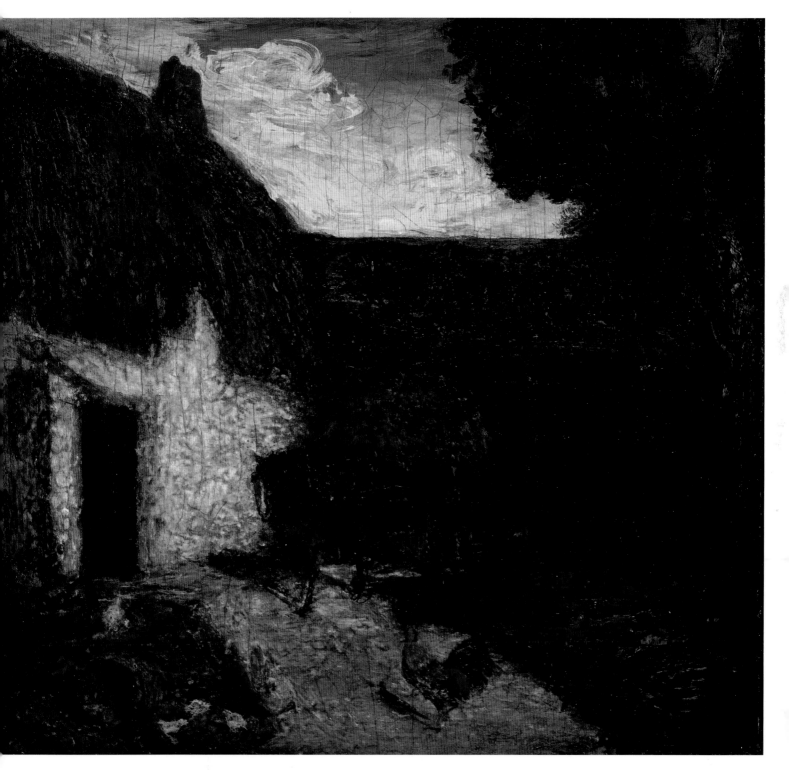

Plate 1. *The Barnyard*. Early to middle 1870s. Oil on wood panel, 11⅝ x 12¼″. Munson-Williams-Proctor Institute Museum of Art, Utica, N.Y.

Plate 2. The Lover's Boat (Moonlight on the Waters)

One of the freshest and best-preserved paintings in Ryder's oeuvre, this small panel had already found a buyer (the Reverend N. W. Conkling) by 1881, the year in which it was exhibited at the Society of American Artists. Instead of a title,[1] the catalogue printed a poem composed by Ryder (later, he wrote several variants):

> *In splendor rare, the moon,*
> *In full-orbed splendor,*
> *On sea and darkness making light,*
> *While windy spaces and night,*
> *In all vastness, did make*
> *With cattled [sic, read castled] hill and lake,*
> *A scene grand and lovely.*
> *Then, gliding above the*
> *Dark water, a lover's boat,*
> *In quiet beauty, did float*
> *Upon the scene, mingling shadows*
> *Into the deeper shadows*
> *Of sky and land reflected.[2]*

That Ryder felt the poem was a necessary adjunct to the painting tells us a great deal: for him, a painting should embody poetic sentiments, or even be the equivalent of a poem. In this case, Ryder's verse not only offers a description of his subject, but also serves as a poetic accompaniment to the painting, articulating and augmenting its meaning.[3]

Into this nocturnal setting Ryder introduced a single bark, exotic in shape, that moves slowly from a protected cove toward the open sea. The sky, in turn, is punctuated by an enormous full moon whose lunar glow permeates the fleecy clouds nearby. At the left, a pair of tall trees, with soft Corot-like leafage, frames the scene and adds to its quiescent pastoral atmosphere. Ryder combined all of these elements to convey the tender lyricism of the lover's romantic departure into an unspecified realm. But because the poetic content of Ryder's painting is so subtle and impalpable, it is impossible to translate it into prose.

For *The Lover's Boat*, Ryder chose a nearly square panel, a format that, as art historian William H. Gerdts has pointed out, seems to lend itself to flat, two-dimensional treatment.[4] Such an approach is evident in this painting: there is little substance to its few elementary forms, which are broadly brushed rather than modeled illusionistically, in order to stress flatness. Ryder further emphasized the surface by allowing much of the wood panel's color and grain to show through. By this means he not only established the painting's basic reddish brown tone, but also asserted obviously flat, tactile identity.

In his arrangement of two-dimensional shapes that tend to lie on the surface of the painting, Ryder demonstrated, in this fairly early work, his consummate skill as a designer. He had undoubtedly learned important lessons from Japanese art in the course of his own decorative work, but at this point in his career he was now ready to apply them to easel painting. The result in *The Lover's Boat* is a tightly ordered composition that is satisfying in itself; but the work also resonates with poetic sentiment, an increasingly important goal for the painter as his art developed in the 1880s.

The painting was sold at the estate auction sale of Mrs. Conkling in 1905. In that year, it entered the collection of E. B. Greenshields, of Montreal, where it remained until 1917. It passed through the hands of several dealers and collectors before it was acquired, in 1956, by its present owner, a private collector.

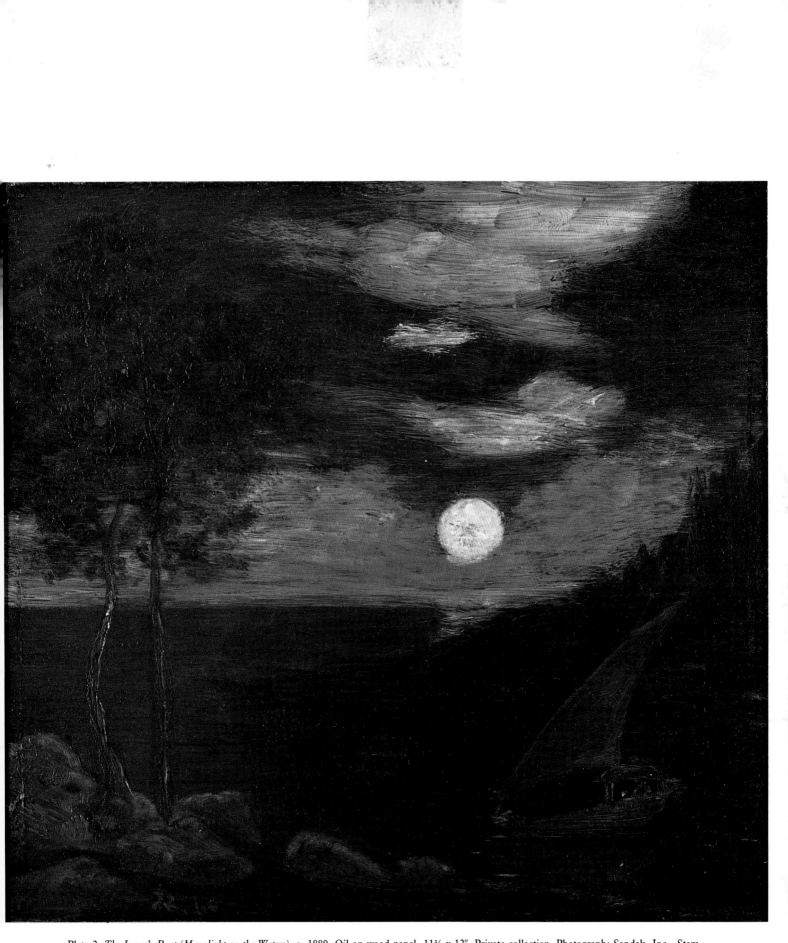

Plate 2. *The Lover's Boat (Moonlight on the Waters)*. c. 1880. Oil on wood panel, 11⅜ x 12″. Private collection. Photograph: Sandak, Inc., Stamford, Conn. 1961

Plate 3. Pegasus

Pegasus, or *The Poet on Pegasus Entering the Realm of the Muses,* was painted for the editor, critic, and poet Charles de Kay, who gave it the longer title.[1] The painting was underway at least as early as 1883, a writer for the *Studio* reported,[2] and it seems to have been finished by 1887, for that date is inscribed on the back, though not in Ryder's hand. The subject was appropriate to De Kay, and especially to Ryder, because the latter frequently likened painting to poetry and wrote verse himself.

In ancient mythology, Pegasus, a winged horse who sprang from the blood of the slain Medusa, helped the Greek hero Bellerophon in his struggle with the Chimaera. Before flying to heaven, Pegasus created, by a blow from his hoof, the fountain of the Muses on Mount Helicon. Thus he was originally associated with the arts, among which poetry may be counted. In postclassical times, however, Pegasus, ridden by a poet, became a more specific symbol for poetic inspiration and fancy, and it is in this later manner that Ryder portrayed Pegasus. The traditional gathering of the Muses, however, remains part of Ryder's imagery, and in the picture Pegasus and the poet enter their domain.

No particular locale is suggested; the mountainous setting could be any of several places where the Muses gathered. Nor are all of the nine Muses present. For Ryder, three—two seated and one standing—were enough to convey his message. Physical deterioration of the painting makes it difficult to identify them or their attributes precisely. But it appears that the seated maiden on the left, studiously examining a book, is Clio, muse of history, and that her counterpart on the right, holding a lyre, is Erato, muse of lyric and love poetry. The identity of the standing figure is less certain because her attribute, a small book or tablet in her right hand, is difficult to discern; but in all likelihood she is Calliope, muse of epic poetry. Alert and erect, she extends her arm to greet the mounted poet, while her sister Muses remain absorbed in thought. Both Pegasus and his rider are animated in gesture and expression, and show joy in this inspirational encounter.

As an artist who identified with poetry, Ryder obviously cherished this magical moment and employed all his skill to translate it into visual terms. The symmetrical composition, broad and simple in its few choice elements, suggests classical calm and regulates and contains the spirited movement of the poet and Pegasus. The Muses, in turn, are grand and dignified in conception, recalling figures from sixteenth-century Venetian painting, particularly Titian's. Like Titian, too, is Ryder's subtle, resonant coloring, achieved through repeated glazing of warm tones and ochers over cooler greenish browns.

In *Pegasus,* as suggested earlier, Ryder celebrated the triumph of poetry and poetic sensibility. He believed fervently in the link between painting and poetry, deriving the greatest pleasure from hearing his works described as "poems in paint."[3] Although *Pegasus* was commissioned by Charles de Kay, himself a man of letters, it was just as much a statement of Ryder's concerns at a time when he was coming into artistic maturity. This was when he was producing such works as *The Temple of the Mind* (plate 5), *The Little Maid of Arcady* (fig. 5–1), and *Perrette* (fig. 4–14), re-creations of poetic sentiment on canvas that helped him make his mark as one of the most imaginative painters America had yet produced.

Pegasus passed from De Kay to the collection of the architect Stanford White, a friend of both De Kay and Ryder. The painting was sold at auction in 1907, after White's death, and purchased by J. R. Andrews of Bath, Maine, who lent it to the Armory Show of 1913. After his death, it was sold at auction again, in 1916, this time to collector Alexander Morten, who paid $2,500 for it. With Morten's death, the painting went on the auction block in 1919, the successful bidder being the dealer William Macbeth, who paid $4,400 on behalf of the Worcester Art Museum. It was one of the earliest purchases of a Ryder by a museum outside New York.

Plate 3. *Pegasus* (*The Poet on Pegasus Entering the Realm of the Muses*). Early to middle 1880s. Oil on wood panel, 12 x 11⅜″. Worcester (Mass.) Art Museum

Plate 4. The Toilers of the Sea

Ryder's *The Toilers of the Sea*, a small, luminous painting on a wood panel, represents a lone sailboat, tossed by white-capped waves, making its way across the sea. Above and to the left, a full moon with a radiant halo illuminates the scene; and close by, a few clouds, glowing with their own inner light, hang motionless in the sky. Within the protective shell of the boat may be seen the vague huddled forms of two sailors but it is the striking silhouettes of the vessel, surrounding waves, moon, and cloud forms that convey the painting's main message. The work closely resembles similar ones by Ryder's near contemporary Jules Dupré, and thus there is a strong possibility that the American succumbed to the influence of the frenchman's paintings.

The Toilers of the Sea, already owned by T. C. Williams, was first exhibited in 1884 under the auspices of the Society of American Artists, but without a title. (Later, but within Ryder's lifetime, the painting was titled *The Toilers of the Sea*, the name of a Victor Hugo novel of 1866.)[1] Ryder's own four-line poem, published in the exhibition catalogue (lines of which, in the artist's hand, appear on a label on the back), speaks of this subject: "'Neath the shifting skies, / O'er the billowy foam, / The hardy fisher flies / To his island home." The painting, of course, need not be taken literally as an illustration of the poem; rather, Ryder's verse should be seen as a kind of suggestive accompaniment to the painting, which has a distinct life of its own.

Having intently studied ships and the sea for much of his life, Ryder brought the essence of his experience to bear on this image. Unlike his contemporaries Winslow Homer and Thomas Eakins, who also painted boats, he avoided the particular in favor of the general and the universal. By refining and flattening his shapes to their most essential form, perhaps under the influence of Japanese art, Ryder created a painting that is both decorative in pattern and expressive in its impact.

Ryder's nonliteral, generalized treatment in paintings of this kind invites them to be viewed as expressions of metaphorical content. As art historian Elizabeth Johns has written, such works, "which show a lone boat ploughing into the space of a wide, empty sea, the entire space presided over by a moon whose position stabilizes the picture space and whose radiance affects both boat and sea, would seem to point to his sense of individual life in these terms of journey."[2] That individual, of course, could easily be Ryder himself, who may have romantically projected his own lonely passage through life onto this haunting image. Whether the painting was intended to be an autobiographical or a cosmic statement matters little: Ryder's handling of the boat traversing the sea allows us to read whatever we like into the painting; in a very modern sense, it becomes a mirror for the emotions we bring to it, and its meaning is largely relative to the observer's sensations and values.

The Toilers of the Sea was acquired by the Metropolitan Museum of Art in 1915 at the Ichabod T. Williams sale (Williams had bought it from Cottier & Co.). Its purchase and display by such an esteemed institution secured for Ryder recognition of his achievements from admiring artists and laymen alike. Indeed, *The Toilers of the Sea* epitomized the essential Ryder. For example, Marsden Hartley, an emerging modernist who came under the older artist's influence in 1909, wrote of his response to his first Ryder: "A marine of rarest grandeur and sublimity, incredibly small in size, incredibly large in its emotion—just a sky and a single vessel in sail across a conquering sea. Ryder is, I think, the special messenger of the sea's beauty, the confidant of its majesties, its hauteurs, its supremacies."[3] Ryder's growing popularity, to which the Metropolitan Museum of Art's purchase contributed, brought an onslaught of forgeries—few at first, but then in rapidly growing numbers after Ryder's death. Unfortunately, *The Toilers of the Sea* was often the primary focus of the forgers, and numerous spurious variants have flooded the market over the years. Yet the formal and expressive integrity of the original is so great that it can never be debased by imitation; no matter how hard they may try, forgers cannot re-create Ryder's genius.

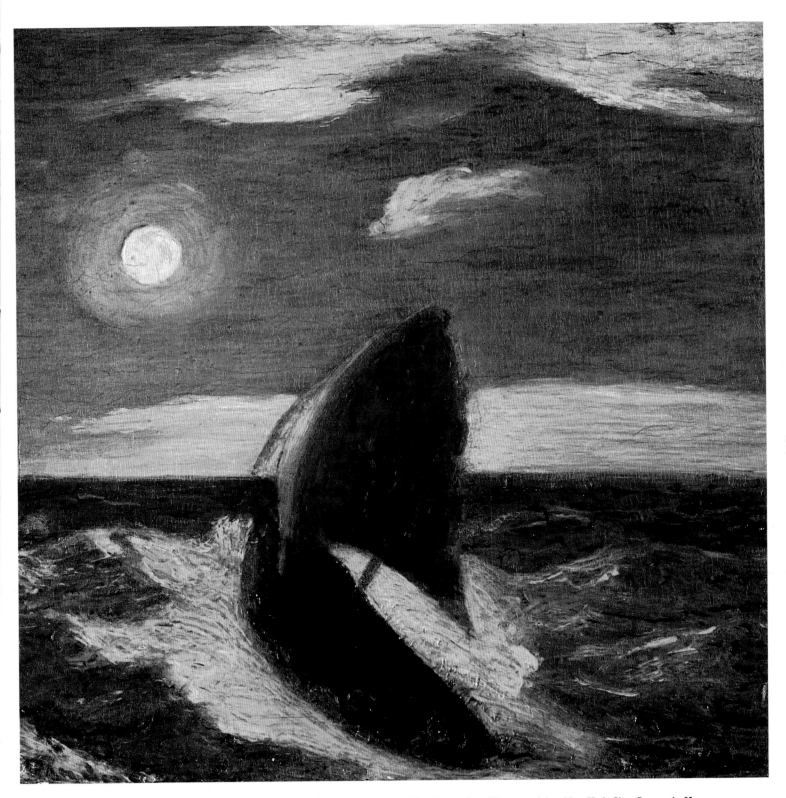

Plate 4. *The Toilers of the Sea*. c. 1883–84. Oil on wood panel, 11½ x 12″. The Metropolitan Museum of Art, New York City. George A. Hearn Fund, 1915

Plate 5. The Temple of the Mind

Plate 5A. Albert Pinkham Ryder. *The Temple of the Mind.* c. 1883–85. Illustration from Clarence Cook, *Art and Artists of Our Time,* vol. 3 (New York, 1888)

The Temple of the Mind was completed and delivered to Thomas B. Clarke in 1885. This was an important transaction for the thirty-eight-year old painter: the work was his most ambitious to date, and Clarke was then the most prominent collector of American art. Apparently Clarke held *The Temple of the Mind* in high esteem, because Ryder wrote to thank him "for all those nice sentiments"[1] he must have expressed to the painter orally or in a letter. The work was a critical success, evoking lavish praise when it was first exhibited in 1888 and for years afterward. In 1890, for example, Charles de Kay declared that it was "as beautiful in thought as the finest work of the kind during the Middle Ages, and lovely in color as nothing else. It is a picture steeped in faery, and may be taken as one of the greatest achievements American painting has yet shown."[2]

Ryder painted *The Temple of the Mind* at the time when he was attaining artistic maturity, when he had left behind decorative work, inspired by the Japanese, to find hiw own personal language. Harold W. Bromhead, Ryder's dealer-friend, who had interviewed him and had an intimate knowledge of his oeuvre, reported around 1901 that this painting "cost him the most thought and the most work of any of his works," and concluded that it was his "masterpiece."[3]

The Temple of the Mind was inspired by, but does not literally illustrate, Edgar Allan Poe's "The Haunted Palace." First published in the Baltimore *American Museum* in April, 1839, the poem was next incorporated into Poe's story, "The Fall of the House of Usher," published later that year. In this tale, the rhymed lines were recited to the music of a guitar by Roderick Usher, who tells of an ancient "stately palace," decorated with "banners yellow, glorious, golden," and governed by Porphyrogene, whose "wit and wisdom" were celebrated by a "troup of Echoes." This happy state of affairs, however, is not to last:

> But evil things, in robes of sorrow,
> Assailed the monarch's high estate;
> (Ah, let us mourn, for never morrow
> Shall dawn upon him, desolate!)
> And, round about his home, the glory
> That blushed and bloomed
> Is but a dim-remembered story
> Of the old time entombed.
>
> And travellers now within that valley,
> Through the red-litten windows, see
> Vast forms that move fantastically
> To a discordant melody;
> While, like a rapid ghastly river,
> Through the pale door,
> A hideous throng rush out forever,
> And laugh—but smile no more.[4]

The expulsion of the forces of reason by their opposite, the poem's central theme, is not an abstract concept, but a reflection of Roderick's troubled mind. As the poet himself confessed: "By *The Haunted Palace* I mean to imply a mind haunted by phantoms—a disordered brain."[5]

Ryder distilled the poem's meaning and cast it in different symbols of his own choosing. In place of Poe's "troop of Echoes," three Graces have been expelled from the palace; and the gaily decorated edifice, which serves as the focus of the poem's activity, has become a more sober building secondary to the landscape. In a letter, Ryder explained the allegorical language he created for *The Temple of the Mind:*

> The finer attributes of the mind are pictured by three graces who stand in the centre of the picture: where their shadows from the moonlight fall toward the spectator.
>
> They are waiting for a weeping love to join them.
>
> On the left is a Temple where a cloven footed faun dances up the steps snapping his fingers in fiendish glee at having dethroned the erstwhile ruling graces: on the right a splashing fountain.[6]

The Graces' monumental forms dominate the center foreground, their silhouettes speaking eloquently, as do their expressions and gestures, of wonderment and fear. Huddled together, they watch the lively faun perform his bewitching dance, while a diminutive cupid, signifying love, makes his way toward them. These figures act out their drama between the temple at the left and a giant weeping willow at the right; and behind them stretches a body of water that melts into a series of distant rolling hills. The silvery light of the moon casts a melancholy spell over the entire scene.

Without doubt, Ryder's goal was to re-create, with brush and pigment, the poetic sensation that Poe's "Haunted Palace" generated within his imagination. Some of his visual vocabulary was his own invention, but some of it must have been taken from artistic sources that were easily available to him. Art historian Robert Pincus-Witten has observed that the three Graces, cupid, and satyr "derive from a general array of classical models," ranging from the Elgin marbles to Antonio Canova, either originals or popularized versions of them.[7] The pastoral poetry of Ryder's landscape, in turn, has often been compared to Corot, but the stress on architectural elements resembles Claude Lorrain and Nicolas Poussin as well. This is not to say that Ryder copied literally any of these artists (his only direct borrowing was the fountain, from a photograph of one in Florence)[8]; instead, he brought together elements of their pictorial vocabularies to serve his personal ends. The final product is distinctly Ryder's own, but nonetheless the painting suggests tradition and age, and this undoubtedly contributed to its great appeal.

The Temple of the Mind was the first painting by Ryder ever to be reproduced in a book. It appeared, with brief comments, in Clarence Cook's *Art and Artists of Our Time* (New York 1888) (plate 5A) in a form slightly different from what we see today, owing to changes

Plate 5. *The Temple of the Mind*. c. 1883–85. Oil on canvas mounted on wood panel, 17¾ x 16″. Albright-Knox Art Gallery, Buffalo, N.Y. Gift of R. B. Angus, 1918

Ryder made after 1890. The foliage at the right of the water was initially fuller and rounder, Ryder later smoothing it out; and the trees were made more homogeneous and softer in contour. But even more radical changes, not intended by Ryder, have taken place since the work left his studio. With age it has darkened to a point where it is literally a shadow of its former self, and the enchanting subtlety of light and color, once so appealing to critics, has been lost. Today, the dominant tone of *The Temple of the Mind* is subdued green, shading off to deeper, almost blackish green, tan, and dark brown. Because the painting has darkened, the figures are difficult to discern, and the surface has been disfigured by deep cracks, especially in the heavily brushed areas. It is one of the tragedies of American art that Ryder was not more skilled in the use of his materials.

The painting was sold by Clarke at auction in 1899, fetching $2,250, then a remarkably high price for a Ryder. By 1901, it had passed into the collection of R. B. Angus, of Montreal, who lent it to the Metropolitan Museum of Art in 1918, and then decided to donate it to the Albright (now Albright-Knox) Art Gallery in that year. When John Gellatly, a passionate collector of American art (who wanted to add this work to his other Ryders), heard of the gift, he immediately wrote Cornelia B. Sage, director of the museum, proposing a generous exchange, subject to approval by Angus: ten American paintings, including four of his Ryders, and $15,000 to Angus to be distributed to war charities of his choice.[9] Although Angus had no objections, Gellatly's plan was rejected, so the painting remained in Buffalo and is one of the museum's great treasures.

Plate 6. *Christ Appearing to Mary*

Christ Appearing to Mary, like *The Temple of the Mind* (plate 5), was painted for Thomas B. Clarke, the noted collector and patron of American art. Ryder spoke of what he had accomplished in this "Religious picture" in an 1885 letter to Clarke,[1] so we must assume that it was executed in the early 1880s, probably after his European trip of 1882. Whether Clarke proposed the subject or Ryder chose it is not known, but just before or soon after executing this canvas, he painted another of the same subject, entitled *Resurrection* (figs. 4–9 and 4–10).

The painting illustrates the New Testament story, told in John, chapter 20, in which Mary Magdalen comes to the sepulcher, finds it empty, and then encounters Christ whom she does not recognize at first:

> She, supposing him to be the gardener, saith unto him, Sir, if thou have borne him hence, tell me where thou hast laid him, and I will take him away.
> Jesus saith unto her, Mary. She turned herself, and saith unto him, Rabboni; which is to say, Master.
> Jesus saith unto her, Touch me not; for I am not yet ascended to my Father; but go to my brethren, and say unto them, I ascend unto my Father, and your Father; and to my God, and your God.

Ryder depicted the climactic moment when Mary recognizes Christ, falls to her knees, and holds out her hands in a gesture that combines surprise and reverence. Christ, standing erect, arches His body slightly away from her, signifying with His tense position and outstretched right arm that she is not to touch Him ("*Noli me tangere*"). Ryder placed his figures at a suitable distance from each other—not too close or too far—to create a psychological separation appropriate to the event. Mary and Christ incline their heads toward each other, and she looks devoutly at Him; yet He looks downward, eyes almost closed, suggesting a powerful spiritual presence not fully accessible to her.

The artist has created a believable setting that enhances the significance of this miraculous event. The time is daybreak, suggested by a luminous strip of sky just above the horizon. Mary and Christ are portrayed in the Biblical robes commonly found in nineteenth-century religious paintings, the colors being blue and white, respectively, following traditional usage. Ryder's handling of these colors, and those of the landscape, gives the painting an exceptional richness of surface, suggesting crushed jewels. Like Titian, whose paintings undoubtedly influenced him, Ryder applied layer after layer of pigment, often quite thinly, so as to let the underbody show through in varying degrees. In this way, he created an effect of vibrant yet subtle coloration that enhances the painting's spiritual content.

To gain the desired results, Ryder diligently altered and refined *Christ Appearing to Mary.* X-ray radiographs show that Christ's left hand (to our right) was originally raised and that the gently rolling contour of the hills once dipped more steeply, well below his Head. The painting seems to have retained most of the luminosity that inspired that words "mystical and beautiful in color," written in 1888 by the critic of the *Art Amateur* in response to that year's showing of the work at the National Academy of Design.[2] The critic of the *New York Times* not only praised the color as "marvelous," but also lauded Ryder's general treatment of the subject: "Mary kneels with her hands uplifted in surprise and Jesus stands fronting the spectator, expressing with one hand the command not to touch Him and with the other pointing upward. The sky and gnarled trees in the background are particularly beautiful. The light hair and forked beard of Christ, His bare gashed side and ample draperies, and the pale face of Mary, are all of a piece in this remarkable work of art. The drawing of the hands of Mary has been severely criticized, but the impression of the whole picture is very deep, very serious, very genuine." The same critic saw in Ryder "a bold return to a subject the old masters used to treat. . . ."[3] Another critic noted, in the same vein, that this was "a picture which in tone and color approaches the works of certain of the old masters."[4]

The remarks just quoted underline Ryder's ties not only with traditional styles (sixteenth-century Venetian influence is pronounced), but also with a long-dormant current of religious painting in America. Although such subjects were not unheard of later in the nineteenth century—John La Farge and Robert Loftin Newman had also painted Christ appearing to Mary at the sepulcher—Ryder's effort to embody genuine religious feeling in painting was unusual in his time. Soon after completing *Christ Appearing to Mary* and the closely related *Resurrection,* he turned again, and with great conviction, to religious painting in *The Story of the Cross* (fig. 4–11) and *Jonah* (plate 7), both executed before 1890.

Thomas B. Clarke sold *Christ Appearing to Mary* at auction in 1899, the buyer being Cottier & Co. It was subsequently purchased for William M. Ladd by Colonel C. E. S. Wood, both Ryder enthusiasts of Portland, Oregon. In 1919, ownership passed to John Gellatly, another great admirer of Ryder's work, who considered *Christ Appearing to Mary* his favorite canvas. It was included in his generous gift to what was then known as the National Gallery of Art (National Collection of Fine Arts, renamed the National Museum of American Art).

Plate 6. *Christ Appearing to Mary.* Middle 1880s. Oil on canvas mounted on fiberboard, 14¼ x 17¼″. National Museum of American Art, Smithsonian Institution, Washington, D.C. Gift of John Gellatly

Plate 7. Jonah

Ryder took as his central theme for *Jonah* the best-known episode in the life of the rebellious Old Testament prophet whom God had ordered to go to the great city of Nineveh and cry out against its evil ways. Disobeying the divine command, Jonah took ship for Tarshish; but during the voyage, God sent a fierce storm that threatened to wreck the vessel and destroy its occupants. Discovering that Jonah had provoked God's wrath, the seamen and travelers reluctantly cast him into the sea. There, a "great fish," or whale, appointed by God, prepared to swallow the intransigent Jonah. To complete the story, which is not told in its entirety in the painting, the prophet is indeed swallowed, prays to God and repents, and is freed from the belly of the whale after three days and three nights. From this time onward, he will do God's work.

Jonah, one of Ryder's earliest commissions, was painted for Thomas B. Clarke, a pioneering collector of American art. From a Ryder letter to Clarke, we know he was working on the painting in 1885,[1] but by 1890 ownership had passed to another prominent New York collector, R. H. Halstead. A wood engraving of *Jonah* plate 7A published in the *Century Magazine* in that year shows the painting in an early form, very different from its present appearance.[2] The painting evidently was in a state of flux even at the time Elbridge Kingsley was preparing to make the engraving, for he reported: "The phases and the changes that this painting went through during my intimacy with the artist were a little short of marvellous. The main points of interest would move all over the canvas, according as the stimulating influences of the color accidents would appeal to Ryder's imagination for the moment."[3] A photograph of a chalk drawing that survived in the Kingsley papers, possibly done as a guide, in reverse, for the engraver, shows one of these stages; see plate 7B.) Finally, it was agreed that Ryder would have to call a halt so that Kingsley could cut the block, and Ryder painted in the sail, Kenneth Hayes Miller reported, "to please the engraver."[4] He later removed the sail and flash of lightning at the upper left, raised Jonah's arms out of the water, moved the whale up and to the right, and redrew the waves and clouds. All these changes made the painting more powerful and appealing as a unified visual statement. At some point following these revisions, the painting was acquired by

Colonel C. E. S. Wood of Portland, Oregon, for $500.

In the painting as it exists today, the boat, wildly tilted and bent by the onslaught of the turbulent waves, dominates the composition. Within it are found the huddled, shadowy figures of its inhabitants, almost expressionistic in their gestures of exclamation and wide-eyed terror. Just below the bow of the boat, Jonah flails about in the water, arms outstretched and head cocked back, eyes fixed in fright and mouth agape, in fearful anticipation of his fate. The menacing whale approaches from the right, with bulging eyes staring fiercely at the helpless form of Jonah struggling in the sea. In the upper register, God is shown as a bearded old man offering a gesture of benediction with His left hand, holding an orb in His right, and surrounded by radiant golden clouds whose winglike shapes add authority to His figure. He leans slightly to the left and almost looks askance, with a sense of concern about the dramatic turmoil He has initiated below.

Ryder's sweeping curvilinear design and sharp contrasts of light and shade bring the entire surface of the canvas to life. These moving, swelling rhythms, rising and building upon each other, are further articulated by Ryder's active brushwork, which corresponds to the flowing rhythms of the sea. Because these strokes are heavily built up on the surface of the painting, they become a tactile equivalent of the waves themselves. Yet all of this turmoil is brought under formal control, for patterns of light and shade are beautifully interlocked to form a harmonious composition that works effectively in two dimensions, with only a suggestion of space offered by the overlapping forms, stacked vertically from top to bottom.

The message of *Jonah* reaches us as much through formal means as through narrative conventions. True, the image of God and the human subjects convey their message through facial expressions and dramatic gestures (and the whale echoes some of these), but the emotional significance of the event is also embedded in the totality of the picture's arrangement. Thus, viewed abstractly, the agitated, swirling rhythms of the sea, the radiant yet otherworldly light, and the somber olive and brown tonality speak eloquently of this momentous episode that terrifies Jonah and threatens to extinguish his life. The visual agitation of the canvas becomes a symbol for the prophet's emotional turmoil.

Plate 7A. Albert Pinkham Ryder. *Jonah*. 1890 or before. Wood engraving, 5⅛ x 6⅞", of the painting. Published in *The Century Magazine*, June, 1890

Plate 7B. Albert Pinkham Ryder. *Jonah*. 1890 or before. Chalk drawing, 4⅝ x 5⅜" (now lost), for or related to the painting. Photograph: Forbes Library, Northampton, Mass.

Plate 7. *Jonah*. Middle 1880s to 1890 and later. Oil on canvas, 27¼ x 34⅜". National Museum of American Art, Smithsonian Institution, Washington, D.C. Gift of John Gellatly

Ryder's *Jonah* testifies to God's omnipotence in human affairs, reaffirming his active presence in the nineteenth century, an age increasingly threatened by materialism and a host of secular concerns. *Jonah* bears witness less to a particular theological creed than to the general value of spirituality; this is expressed not only in the specific narrative subject from the Bible, but also in the cosmic, otherworldly visual language that Ryder chose as a medium for his ideas. Seen in a larger context, *Jonah* belongs to the international resurgence of interest in things spiritual and immaterial that reached its apex in the 1890s. It is hard to say just how conscious of this development Ryder may have been, but nevertheless in *Jonah* he belonged to his time.

The painting has inspired more comment than any other by Ryder, and some consider it his greatest masterpiece. Except for *Jo-*

nah, as art historian Abraham Davidson observed, there is "nothing in nineteenth-century American painting that can be called visionary, in the mystical dreamlike sense, that contains at the same time as much awesome grandeur."[5] The magnitude of Ryder's conception, his soaring imagination, inspired Colonel Wood, one-time owner of *Jonah*, to celebrate Ryder in a letter to his friend and fellow collector John Gellatly as "a unique and impressive figure—single and alone in style and technique. . . . "[6] Even though he felt strongly about Ryder and *Jonah*, Wood decided to part with the painting, selling it to Gellatly in 1919 for the handsome sum of $22,000, with the earnest hope than it would go to a museum.[7] Happily, *Jonah* found its way to the National Gallery of Art (now the National Museum of American Art), as part of the Gellatly bequest.

Plate 8. Constance

In 1889 a critic wrote of seeing *Constance* in the possession of "the gentleman who had long ordered it."[1] But Ryder apparently reclaimed the painting, for he explained to the art critic of the Chicago *Times-Herald:* "It was finished once, but I scraped it out last month to change the shadow under the boat. . . . You can't get the tone without working a thing over and over."[2] The buyer, Sir William Van Horne, of Montreal, must have been disappointed because he would have to wait even longer to claim the painting, which was first recorded in 1905 as being permanently in his hands. He paid $1,300 for it. After his death *Constance* went to his widow; it was acquired by the Museum of Fine Arts, Boston, in 1945.

The subject was suggested by "The Man of Law's Tale" from Chaucer's *Canterbury Tales.* In this story, Chaucer told of Constance, virtuous daughter of the Roman emperor, who weds the sultan of Syria, a pagan who becomes a Christian for her sake. The sultan's mother, angered by this religious conversion, kills her son and sets his bride adrift in a boat without a rudder. Eventually Constance is washed ashore in Northumberland, England, where, after being cleared of a false murder charge, she marries Alla, the king of Northumberland, and bears him a son. In a jealous rage, Constance's new and treacherous mother-in-law manages to set her adrift, this time with her child, in a large, open boat without sail or oars. She drifts on the open sea for two years until she finally lands at Rome, where her husband Alla (who in the meantime has killed his mother) accidentally finds her and their son. In this second, seemingly hopeless episode at sea, pictured by Ryder, the abandoned pair survives because God miraculously intervenes to protect and guide them. As Chaucer observed:

> God liste to shewe his wonderful myracle
> In hire, for we sholde seen his myghty werkis.
> Crist, which that is to every harm triacle [remedy],
> By certeine meenes ofte, as knowen clerkis,
> Dooth thyng for certein ende that ful derk is
> To mannes wit, that for oure ignorance
> Ne konne noght knowe his prudent purveiance.
> Now sith she was nat at the feeste yslawe,
> Who kepte hire fro the drenchyng in the see?
> Who kepte Jonas in the fisshes mawe,
> Til he was spouted up at Nynyvee?
> Wel may men knowe it was no wight but He
> That kepte peple Ebrayk from hir drenchynge,
> With drye feet thurgh-out the see passynge.
> Who bad the foure spirites of tempest,
> That power han tanoyen lond and see,
> Bothe north and south, and also west and est,
> Anoyeth neither see, ne land, ne tree?
> Soothly the comandour of that was He
> That fro the tempest ay this womman kepte
> As wel when she wook as whan she slepte.
> Where myghte this womman mete and drynke have,

> Thre yeer and moore? how lasteth hire vitaille?
> Who fedde the Egypcien Marie in the cave,
> Or in desert? No wight but Crist, *sanz faille.*
> Fyve thousand folk it was as greet mervaille
> With loves fyve, and fisshes two, to feede.
> God sente his foyson [plenty] at hir grete neede.[3]

Ryder did not merely portray the Christian moral of the tale, but sought also to convey something beyond that, a more universal message embodying several layers of meaning. As Lloyd Goodrich explained: "He was one of the few religious painters of modern times in whom one feels not mere conformity but profound personal emotion."[4] The emotion, deeply poetic and evocative, is embedded in part in the sturdy podlike boat, sheltering mother and son. On a calm sea, under the dim, delicate light of the moon filtering through fleecy clouds, they drift quietly, in loneliness and isolation. Constance, chin propped in her right hand, looks soulfully upward, as if hoping for divine help; her infant son, nestled close beside her, stares straight ahead. These human expressions, however, contribute a relatively small part of the picture's message; counting far more are the simple, elemental shapes that constitute the painting. In the words of the critic Roger Fry: "The actual forms are almost childishly simple, but they have a mass and content essential to the effect they produce."[5] Color, too, plays a central role, hinting at a believable reality, yet speaking of the timeless mystery of the event. As Goodrich wrote in his unpublished notes:

> The picture has extraordinary depth and richness of color. Not variety or range, but depth and richness. This is achieved by the quality of the color itself, by its transparency and depth, due to the rich glazing technique used; and also by the sensitive relations between the colors, and the relations between lights and darks. . . . The clear parts of the sky are entirely translucent; one has the feeling of looking into depth, like looking through water at a white sandy bottom. . . . A tremendous sense of peace, of calm, of serenity, combined with a sense of infinite space, vastness, loneliness. All of this is harmonious with the whole theme of the picture; two human beings adrift on the limitless sea, but under divine protection. . . . The sea is also painted in deep glazes, prevailingly deep blue-green. The accents of reflected moonlight are painted in touches of opaque light warm green and sometimes yellowish-gold. These touches are on top of the deep glazed blue-green, and the play between the light opaque touches and the deep glazes produces an extraordinary sense of depth and liquidness, the great depth and liquidness of the sea, and of its sparkling, jewelled surface. I know of few paintings in which the essential liquid quality of the sea is so richly expressed."[6]

In *Constance,* Ryder depicted a lone boat under a moonlit sky, not

Plate 8. *Constance*. Middle 1880s–middle 1890s and later. Oil on canvas, 28¼ x 36″. Museum of Fine Arts, Boston. Photograph: Sandak, Inc., Stamford, Conn., 1961

just as the literal setting for Chaucer's episode, but also, as in his secular marines, as a symbol for man's isolation, his solitary journey through life. It seems, however, that the images in question may also be read as projections of Ryder's own feelings and concerns. Like the ubiquitous sailing crafts in his marines, and particularly like Constance in her abandoned boat, Ryder himself may have felt innocent and pure, yet isolated and alone in society. Writing about Constance "adrift at sea with her new-born babe," art historian Richard Braddock asked: "Was this symbolic of Ryder, sensitive to beauty, living alone in the Gilded Age?"[7] In this light, the painting may also be seen as a wish-fulfilling prophecy for Ryder, whose faith in God would carry him through the trials of being an artist, little recognized by his contemporaries and praised only by a few who understood and valued his contribution.

Plate 9. The Flying Dutchman

First exhibited in 1887, *The Flying Dutchman* was based on a popular legend known in various forms during the nineteenth century,[1] most notably Richard Wagner's celebrated opera *Der fliegende Holländer* (performed in New York in 1877). According to this legend, a Dutchman, Philip Vanderdecken, was condemned to sail forever in a phantom ship unless released from this curse by finding a maiden who would be faithful to him until death. He is allowed to go ashore to search for his true love every seven years, and on one such excursion he meets and falls in love with Senta, who has already imagined her own love for the legendary Dutchman. Not believing her dream would ever come true, she promised herself to Erik the hunter. When the Dutchman hears Erik reminding Senta of their own betrothal, he believes he has been betrayed and begins to sail away. To prove that she truly loves the Dutchman, Senta hurls herself from the cliffs into the sea and dies, and with this the phantom ship sinks and the transfigured pair floats upward to the heavens.

Ryder portrayed not the happy ending but an earlier unresolved moment of tension and mystery when Vanderdecken is alone, threatened by eternal doom, before Senta's love saves him. In a poem Ryder wrote to accompany the picture, which was bought by the noted collector John Gellatly in 1897, a deeply pessimistic note is struck:

Who hath seen the Phantom Ship,
Her lordly rise and lowly dip,
Careering o'er the lonesome main
No port shall know her keel again.
But how about that hopeless soul
Doomed forever on that ship to roll,
Doth grief claim her despairing own
And reason hath it ever flown
Or in the loneliness around
Is a sort of joy found
And one wild ecstasy into another flow
As onward that fateful ship doth go.
But no, Hark! Help! Help Vanderdecken cries,
Help; Help, on the ship it flies;
Ah, woe is in that awful sight,
The sailor finds there eternal night,
'Neath the waters he shall ever sleep
And Ocean will the secret keep[2]

Sails taut with wind, the ghostly ship plies the sea at the upper left, and in the foreground a bark with a torn sail is tossed by angry waves. Within, the mariners (especially the old man at the right) express terror and surprise, for the sight of the Flying Dutchman's vessel is an evil omen.

As in *Jonah* (plate 7), Ryder infuses the painting with dynamic, kinetic movement; but *The Flying Dutchman* is much more sensuous in its hot colors and radiant, glowing surface. Goodrich described Ryder's masterful handling of color in his unpublished notes: "The whole sky is warm golden, with tones of red and orange. A long diagonal cloud across the sky, running from behind the ship up towards the right corner, lit below by the sun; the cloud is light warm brownish gold. The flying ship is much the same color as the sky and clouds, which adds to its phantasmal effect, its sense of hallucination. . . . The further sea is warm, lit by the sinking sun. But the near sea is cold darkish grays with cold light-colored foam, giving an effect of the coldness and menace of the water."[3] Ryder, of course, was not using color for its own sake but in concert with his turbulent design to orchestrate the emotional significance of the scene: a moment of high drama in itself, but also anticipating the heated feelings that will be displayed when the wandering Dutchman consummates his meeting with the loving Senta. Moreover, the warm, glowing light in the painting, which we may initially link with the setting sun, actually transcends the natural and becomes a visionary light, shining from within. It is light created and manipulated by the artist, above and beyond specific time, signifying something permanent and eternal. Everything in the painting is bathed in it and becomes part of it, man and nature merged as one. This fusion, so popular among Romantic painters, recalls J. M. W. Turner especially, a comparison that was made as early as 1896 by the critic of the *New York Times*, who spoke of the "Turneresque sky and sea" of *The Flying Dutchman*.[4]

The painting ranks with *Jonah* as one of Ryder's greatest. Although its condition has deteriorated, like so many of his other works, that it had entered James Inglis's collection by 1890, then Gellatly's (and from him to the National Gallery of Art, now the National Museum of American Art), meant that it was not subject to tampering by unqualified hands or even Ryder's own later "improvements."

Plate 9. *The Flying Dutchman*. Middle to late 1880s and later. Oil on canvas, 14¼ x 17¼". National Museum of American Art, Smithsonian Institution, Washington D.C. Gift of John Gellatly

Plate 10. Siegfried and the Rhine Maidens

When Ryder heard Richard Wagner's opera *Götterdämmerung (The Twilight of the Gods)* in 1888, during its New York premiere, he was immediately moved to paint *Siegfried and the Rhine Maidens*. He did so in a forty-eight-hour frenzy of creative activity without eating or sleeping.[1] The resulting canvas, much reworked afterward, is one of his masterpieces. Selecting his subject from the third act of the opera, Ryder chose to portray Siegfried, a knight in armor, riding along a river bank beside a giant gnarled oak; below and to the left the three maidens rise up from the river Rhine. According to legend, they beg Siegfried to return the magic ring, but, despite their angry threats and warnings of the ring's curse, he refuses to give it up. Steadfastly proceeding to the castles of the Gibichungs, Siegfried is murdered by Hagen, the Gibichung Gunther's half brother.

In the libretto corresponding to the scene in Ryder's painting, the maidens' encounter with the knight, we read:

The three Rhine-Nymphs.
.
The Sun-god
sendeth rays of splendor;
night reigns in the waters.
Once did they beam,
when, brave and bright,
our father's gold yet in them glittered.
Rhine gold!
clearest gold!
how brightly once thou streamedst,
beauteous star of waters.
Fair Sun-god,
send to us the hero
who again our gold will give us!
If it were ours
thine ardent eye
no more should we long for with envy.
Rhine gold!
clearest gold!
How gladly wouldst stream then,
glorious star of waters.
(Siegfried's horn is heard on the heights.)

Woglinda.
I hear his horn!

Wellgunda.
The hero comes.[2]

It is not clear whether Ryder shows us the moment of surprise that causes Siegfried's charger to shy and the maidens to shrink away, or whether they have delivered their dire warning and have begun to withdraw, leaving Siegfried to ride on to his tragic destiny. In any case, to those who know the opera, the message is clear: it is an episode of high drama, full of tension and portending doom.

The painting reveals deeper space and more "theatrical" lighting than any other work of its kind by Ryder, in this possibly reflecting the stage-setting he witnessed at the 1888 performance of the opera. As art historian Diane Chalmers Johnson has suggested, he may have been directly influenced by the New York adaptation of the Viennese Josef Hoffmann's original set designs or illustrations of them published in *Scribner's* in 1887.[3] Different from the opera, however, was Ryder's placing of Siegfried on a mount, instead of on foot, and his creation of the imposing windswept tree that dominates the composition. That tree and several smaller ones to the right not only establish a natural setting, but their writhing branches also symbolically amplify the message of anguish and conflict acted out nearby. The angry sky, eerie moonlight, and greenish bronze tonality contribute to the total expressive effect, as well.

The whole is an imaginative creation issuing from Ryder's mind, a result of his desire to embody in shape and color the emotional significance of the scene. As a by-product of this effort, Ryder achieved a remarkable integration of formal elements in which the rhythmic patterns of trees and sky, earth and water, human and animal are all merged as equals. The abstract value of this treatment was recognized and admired early in the twentieth century by critics sympathetic to modern art, such as Charles Caffin, who wrote: "The patterning of the tree-forms, the massing of light and shade, and, most of all the coloring, have been arbitrarily assembled for the purpose of expressing the painter's own emotional conception."[4] But a deeper message may be found in the artist's interlocking of every possible element, animate and inanimate. As art historian Abraham Davidson has pointed out, Wagnerian subjects allowed Ryder to "frame his conception of man as part of the wider rhythms of nature, a nature that could be for him sometimes turbulent and menacing, sometimes calm and benign."[5] It is the former, not the latter, aspect that Ryder stressed in *Siegfried*, presenting both a vibrant drama and a dynamic pictorial field whose energy approaches *Jonah* (plate 7) and *The Flying Dutchman* (plate 9).

The painting was lent by its owner, R. H. Halstead, to an exhibition at the New York Athletic Club in 1891, where it was hailed as one of Ryder's "recent triumphs in mystery and mastery of color."[6] By 1902, *Siegfried* had entered the collection of the railroad magnate Sir William Van Horne, of Montreal, who owned other important Ryders, and it was frequently exhibited and reproduced during the artist's lifetime, thus contributing to his growing reputation. The painting remained in Van Horne's family until 1946, when it was purchased by the National Gallery of Art (now the National Museum of American Art) for the sum of $23,500.

Plate 10. *Siegfried and the Rhine Maidens*. c. 1888–91. Oil on canvas, 19⅞ x 20½". National Gallery of Art, Washington, D.C. Andrew W. Mellon Collection

Plate 11. The Race Track

The Race Track, also known as *Death on a Pale Horse* or *The Reverse*, is Ryder's most haunting visionary painting. The work represents his immediate personal response to a tragic event that took place in New York City in 1888. As Ryder told the story, one of the waiters at the Hotel Albert, operated by his brother William, had saved $500 and, convinced that betting was "an easy way to make money," told the painter that he had wagered the entire sum on Hanover to win the Brooklyn Handicap. "The next day," Ryder recalled, "the race was run and . . . Hanover came in third [actually, he was second]. I was immediately reminded that my friend the waiter had lost all his money. That dwelt in my mind, as for some reason it impressed me very much, so much so that I went around to my brother's hotel for breakfast the next morning, and was shocked to find my waiter friend had shot himself the evening before. This fact formed a cloud over my mind that I could not throw off, and 'The Race Track' is the result."[1] In the ensuing painting, which he worked on for years, Ryder was obviously concerned not with the outcome of the specific race, but with a set of symbols that would express his anguish about his waiter-friend's suicide. His creation of *The Race Track* may have been a catharsis, a ritual lifting of the emotional burden caused by his friend's tragic demise. But in the process of responding in this personal way, Ryder created something universal, a ghostly image of the Grim Reaper who will gallop around the track for all time. Harold Bromhead, a Cottier employee, observed in notes after chatting with Ryder around 1901 that "the presiding genius of it all is Death, Death to the finer instincts. Death wins the race, always."[2] The subject and its treatment inspired the critic Roger Fry to assert that Ryder shared with Edgar Allan Poe "the quality of lyrical *macabre*, though Ryder's [images] have not the perversity of Poe's inventions."[3]

To present death allegorically, Ryder employed the popular image known since the Middle Ages of a cadaver mounted on a horse, carrying a scythe, the instrument of his grim harvest. A giant snake, undoubtedly signifying evil, writhes in the foreground. To the right, a blasted tree stands alone, suggesting death and desolation. Even the rider moves clockwise around the racecourse, contrary to the usual American practice. This gives a dual meaning to one of the painting's alternate titles, *The Reverse*, which also signifies the waiter's change in fortune. The allegorical images and symbols just cited are merged into a landscape offering vestiges of reality that Ryder would have known from attending races:[4] a dirt track flanked by wooden rail fences and a winning post in the far distance. The gloomy, threatening sky may also reflect the weather conditions for the race in which Hanover was beaten: the *New York Times* reported that the day of the Brooklyn Handicap—May 15, 1888—was unseasonably cold and gray, and the track was muddy because it had rained that morning.[5] A comparable atmosphere pervades the painting, perhaps a result of Ryder's reading the newspaper account of the race on the following day, though in any event he probably would have invented such gloomy weather to establish a mood of despair and loneliness. Whether it is day or night cannot be determined. When asked which it was, Ryder replied, "I hadn't thought about it."[6]

The mixture of the real and the imagined suggests the language of a dream, a realm of fantasy comparable to certain works by fin-de-siècle artists of Europe, such as Arnold Böcklin, who essayed similar macabre themes, though Ryder was probably unaware of them. The ghostly, supernatural quality of the work, so different from Ryder's major literary and operatic paintings, is enhanced by the thin, transparent application of pigment and the softly glowing sky. The colors are subdued, muted, lightly glazed, and they reminded Lloyd Goodrich of "Rembrandt, Tintoretto, Titian (in his sober moments), even something of El Greco."[7] Today, these hues are no doubt duller and darker than they were originally, the result of aging and additions to the canvas made after Ryder's death (see chapter 11) that toned down the general effect, especially the "fine passages of loveliest green" observed by Bromhead.[8]

The Race Track was sold to Mr. and Mrs. Louis Lehmaier before 1906, but was back in Ryder's studio again in 1909 or 1910. By 1913, it was owned by Dr. A. T. Sanden, who possessed an impressive group of Ryders and who lent the work to the Metropolitan Museum of Art between 1918 and 1924. It was purchased by the Cleveland Museum of Art in 1928 for $12,000. In 1910, Ryder had agreed to sell the picture to one of the Museum's trustees, Ralph M. Coe, for $1,000, but would not let him take it away because it was "not finished."[9] Coe would not accept the prospect of a long delay, so he did not obtain the picture.

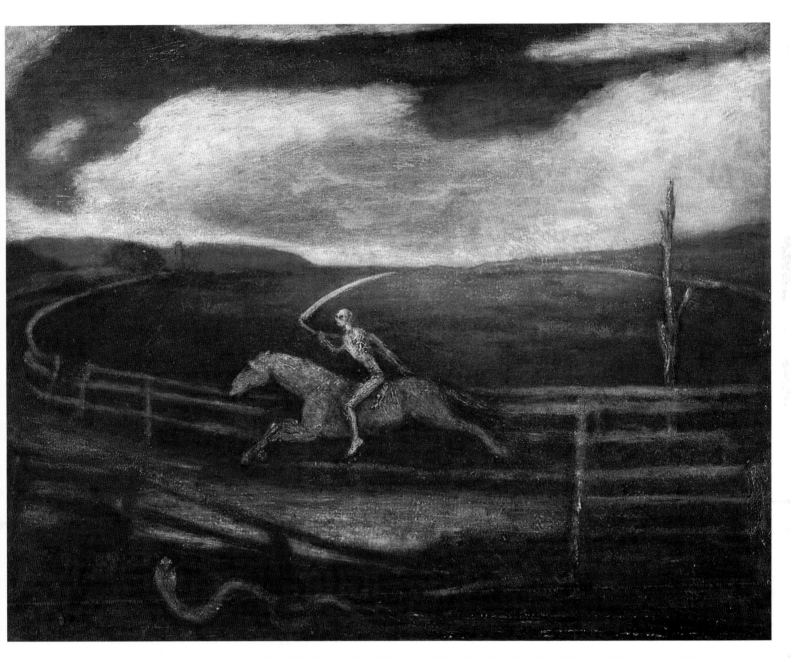

Plate 11. *The Race Track (Death on a Pale Horse; The Reverse)*. Late 1880s–early 1890s. Reworked after the artist's death. Oil on canvas, 28¼ x 35¼". The Cleveland Museum of Art. J. H. Wade Collection. Photograph: Sandak, Inc., Stamford, Conn., 1961

Plate 12. The Forest of Arden

The Forest of Arden is one of the last, perhaps the very last, of Ryder's important paintings devoted to literary, operatic, and religious subjects. Purchased by Dr. A. T. Sanden, a friend and dedicated collector of Ryder's work, it was probably started sometime in the 1890s. Ryder expressed the hope, in an 1897 letter to Sylvia Warner, widow of his sculptor-friend Olin L. Warner, that the painting would be "fully as beautiful as any preceding work of mine,"[1] and in that year, according to the critic Sadakichi Hartmann, it was "finished."[2] As art historian Doreen Bolger Burke has pointed out, autoradiographs of the painting show that Ryder made some changes in the process of completing the work: "The head of the figure on the left was brought closer to that of the figure on the right; the sky, originally clear, was broken into clouds, and the tree seems to have been made shorter and thicker and some of its foliage and branches painted over."[3]

The painting was inspired by Shakespeare's play *As You Like It*, act I, scene 1. Ryder's title, *The Forest of Arden*, refers to the idyllic pastoral setting into which the deposed Duke Frederick has retreated, far from the cares of the court. There he and "many young gentlemen . . . fleet the time carelessly" like those who lived in the golden age.[4] Although an actual Forest of Arden existed on the Continent (the Ardennes), and in England (in Warwickshire), Shakespeare's forest is an unspecified realm, perhaps based on reality, but largely a product of the playwright's imagination. Ryder's canvas is dominated by the vision of this peaceful site; only at the far left can a pair of figures be seen, and they barely intrude on what is essentially a landscape painting. Their identity is uncertain. In Shakespeare's play, Rosalind, the duke's daughter, and her cousin Celia journey to the Forest of Arden, the former disguised as a man and the latter as a country maid, so as not to reveal their rank. Traditionally, the pair in the painting have been identified as Rosalind and Celia, but, as Burke points out, they could be Rosalind and Orlando, who love each other, or possibly Celia and Orlando's brother Oliver, also lovers. In any case, two of the main characters enter from the left, the latter gesturing in the direction of the landscape and the other, hands clasped, looking demurely downward.

Some critics have objected to the human element in this painting. Roger Fry, for example, wrote: "One might perhaps wish the lovers away. Mr. Ryder has not quite the power to people his own landscape, and after all—for romanticism is the most egotistic effort of the imagination—we each want the Forest of Arden for our own loves."[5] But the couple fulfill an essential role in directing our atten-

tion to the landscape. As with donor figures in Northern Renaissance religious works, we enter the domain of the painting through them, merging with and savoring the landscape in our imagination. Yet this sylvan retreat, as pictured by Ryder, has a substantial reality, and it will come as no surprise, therefore, to learn that he often went to Bronx Park to fix the landscape in his memory. In the process of painting, however, Ryder reshaped the whole, filtering it through his psyche, so that the final result is a poetic distillation of the essential feeling of this idyllic realm.

Lloyd Goodrich responded eloquently, in his unpublished notes, to *The Forest of Arden*, which he believed was "one of the greatest landscapes of the nineteenth century in any country." Writing in 1947, he observed:

> The picture has extraordinary substance and mass. One feels that it is the result of a process akin to sculpture or bas-relief; that each form has been built up as solidly as a sculptor builds his forms. In this picture there is none of the somewhat tentative, hesitating character of some of Ryder's early landscapes. One feels that the forms must have been fairly clear in his mind from an early stage, and that everything he did to the picture added to the substance and the strength of the forms. Note how entirely unobvious the design is. For example, the placing of the two figures at the extreme left edge and near the bottom corner; yet they are absolutely right in composition. The lines of the stream, the dead tree, the more distant trees, the distant hills, the clouds, are all beautifully felt in their relation one to another; yet there is not an obvious line in them; they are all filled with Ryder's peculiar intense individuality, his sense of form so unlike that of anyone else, so pure a production of his own vision and his own sense of design.[6]

Although, as already noted, Ryder made some minor alterations as he completed *The Forest of Arden*, the painting seems not to have been tampered with by others or excessively worked over by the artist himself. Photographic reproductions dating from 1908 show it essentially in its present form, except that pronounced cracks have developed since that time. So, in its passage from Dr. Sanden in 1924 through the hands of several dealers and collectors, to the Metropolitan Museum of Art in 1960, the gift of Stephen C. Clark, this painting by Ryder has survived better than most.

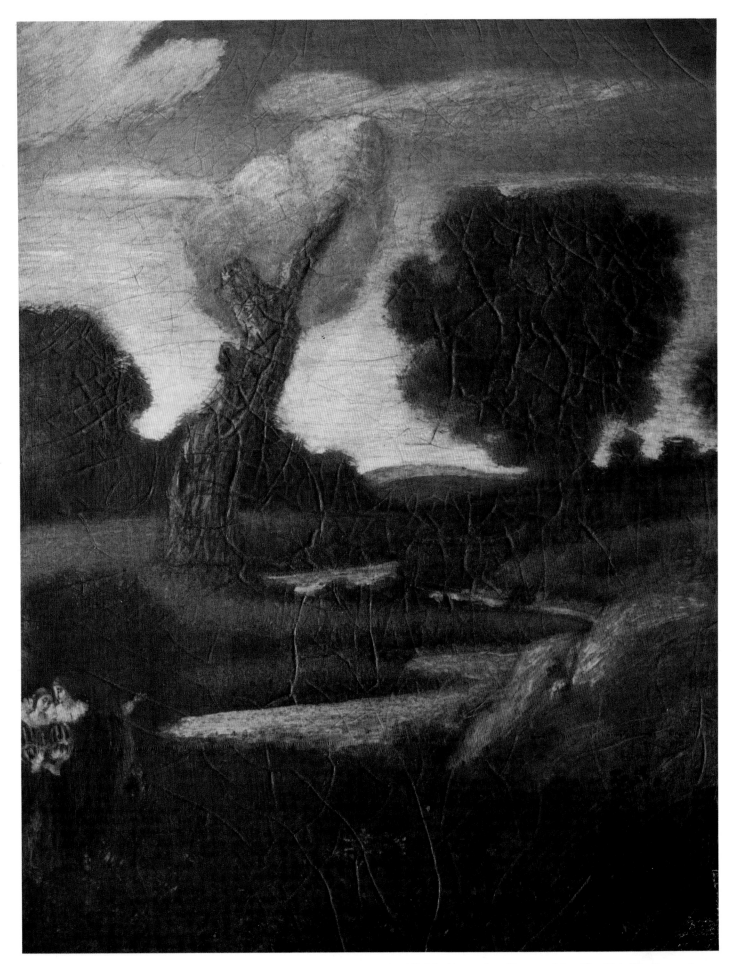

Plate 12. *The Forest of Arden*. Late 1880s, 1890s, and later. Oil on canvas, 19 x 15″. The Metropolitan Museum of Art, New York City, Bequest of Stephen C. Clark, 1960

Plate 13. The Tempest

Ryder's *The Tempest*, probably begun in the late 1880s, was first exhibited in 1892. At that time it was praised by the critic of the *New York Times* because it was "magnificently composed" and because the figures were "remarkable for drawing as well as color."[1] The painting appealed to the Portland, Oregon, collector Colonel C. E. S. Wood, who saw it in Ryder's studio, bought and paid for it, but had to wait until the artist's death in 1917 to take possession, for even after decades of work, Ryder could not bear to let it go.

Turning to Act I, scene 2, of Shakespeare's play, Ryder chose as his setting the enchanted island to which the scholar-magician Prospero, the deposed duke of Milan, and his beautiful daughter Miranda have been exiled and abandoned by Prospero's evil younger brother Antonio and his confederate, King Alonso of Naples. Living in a half-mythical world, populated by spirits such as the gentle Ariel and the subhuman monster Caliban, Prospero comes to possess magical powers. By these means, he commands a tumultuous storm that threatens to destroy a ship carrying the treacherous conspirators who had driven him and his daughter away. Miranda, frightened and concerned for the travelers' safety (the ship bears her future love Ferdinand and Alonso's brother Sebastian), throws her arms around the imposing figure of Prospero, while the grotesque Caliban, the embodiment of evil, looks on from the right. Shakespeare has her say:

> If by your art, my dearest father, you have
> Put the wild waters in this roar, allay them.
> The sky, it seems, would pour down stinking pitch,
> But that the sea, mounting to the welkin's cheek,
> Dashes the fire out. O, I have suffered
> With those that I saw suffer: a brave vessel,
> Who had no doubt some noble creature in her,
> Dash'd all to pieces. O, the cry did knock
> Against my very heart. Poor souls, they perish'd.[2]

Prospero explains to her that the guilty occupants of the wrecked ship will not come to harm, for upon the island they will have an opportunity to repent. In the end, they do so: Prospero is reconciled to his brother and returns to Milan where he is reinstated as duke, and Miranda and Ferdinand marry.

In *The Tempest*, as in *Jonah* (plate 7) and *The Flying Dutchman* (plate 9), Ryder selected a moment fraught with tension and uncertainty, before the narrative reaches its happy resolution. Ryder unites the sky, sea, and rocky landscape with the figures to express the inner meaning of Shakespeare's scene. Unlike the stagelike settings of the large *Macbeth and the Witches* (plate 15) and *Siegfried and the Rhine Maidens* (plate 10), *The Tempest* offers a visionary spectacle, something generalized from the deepest reaches of Ryder's imagination, yet somehow appropriate to the play. As his dealer-friend Harold Bromhead wrote in his private notes after interviewing Ryder around 1901, "Nearly always reserved, here Ryder has let himself go, and steps forward and cracks the whip to the Pegasus of his fancy. With a theme so purely whimsical no necessity to be restricted by ordinary conditions. Unreal, Yes; so is Shakespeare's comedy. Theatrical; in an ideal sense, yes. Here we see Ryder at his full speed and how finely he has his flying steeds under control and in hand. . . . Generally using his instrument at half swell, R. has here pulled out all the stops, and we have the thunder of his diapason."

Bromhead also remarked on Ryder's treatment of "Ariel swimming into the sky" and "the wrecked vessel,"[3] but no such elements are visible in the painting today, or in any of the earliest known photographs, which date from just after Ryder's death. Furthermore, X-ray radiographs show that the figures of Prospero and Miranda (fig. 11–19) and certain parts of the landscape were once more elaborate and expressive than they now appear. This evidence, combined with our knowledge that the painting was "restored" (we believe considerably reworked) by Louise Fitzpatrick, Ryder's friend and student, suggests that at present *The Tempest* is different from what it was earlier in Ryder's creative lifetime (see chapter 11). At one point it must have been remarkable in color, as the *New York Times* reported in 1892, but Ryder's continual and obsessive reworking of the canvas undoubtedly damaged it aesthetically as well as physically. As Colonel Wood wrote to Lloyd Goodrich in 1939, "When I bought the Tempest it was as vivid as a Monticelli but more gem like and through twenty years I saw it become lower in tone and more subtle[,] more imaginative."[4] Photographer Alice Boughton, who made Ryder's portrait when he was about fifty-five, and his young admirer Walter Pach, a painter and critic, both reported that the painting was black, or nearly so, when they saw it in his studio.[5]

The composition and the general tonal scheme of this painting seem to have remained essentially intact, but the color, drawing, and brushwork appear to have been altered significantly beyond where Ryder might have carried them. Yet *The Tempest* still speaks, however haltingly, of Ryder's grand intentions, an ambitious work, the artistic challenge of which seems to have frustrated and, in the end, paralyzed him.

Wood, as noted above, finally got the painting after Ryder's death. It was sold in Wood's estate auction in 1946, and then entered the collection of Chester J. Robertson. The Detroit Institute of Arts received *The Tempest* as the gift of Dexter M. Ferry, Jr., in 1950.

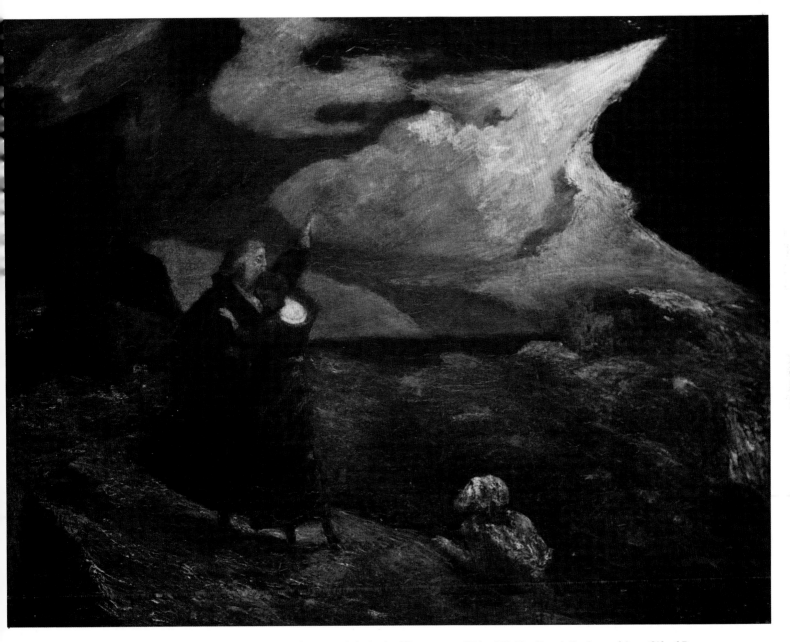

Plate 13. *The Tempest*. 1890s and later. Reworked after the artist's death. Oil on canvas, 27¾ x 35″. The Detroit Institute of Arts. Gift of Dexter M. Ferry, Jr. Photograph: Sandak, Inc., Stamford, Conn., 1961

Plate 14. The Lorelei

Ryder's painting takes its title from the celebrated precipitous rock rising above the Rhine near Saint Goar, in Germany, and from the legendary blond-haired siren, of the same name, who inhabited it. The Lorelei posed a threat to mariners because, sitting upon the rock in the evening, she would sing an enchanting song and lure them to their destruction. Heinrich Heine drew upon this legend in his set of poems called *The Homecoming (Die Heimkehr)* (1823–24). Heine's verses on the Lorelei served as the lyric for Franz Liszt's well-known song, which reads, in part:

> And yonder sits a maiden,
> Of wondrous beauty rare;
> With gold and with jewels sparkling,
> She combs her golden hair.
> With comb of bright gold she combs it,
> And sings with mournful sigh;
> A song of enchanting power,
> A magic melody,
> A magic melody.
>
> A boatman in frail bark gliding,
> Bewilder'd by love's sweet pain;
> He sees not the rocky ledges
> His eyes on the height,
> on the height remain.
>
> The billows surrounding, engulf him,
> Both bark and boatman are gone!
>
> This sorrow by her charmed singing
> The Lorely,
> The Lorely hath done. . . . [1]

In Ryder's painting, the scene takes place at night; it is obviously not Heine's "fading day." While a boatman is dimly visible in the right foreground and the menacing form of the rock rises at the left, the Lorelei is nowhere to be seen: over the years, Ryder repeatedly added and removed her, and when he died—the painting was still with him—she had not been painted back in.

The painting, commissioned for $300 by Mrs. Helen Ladd Corbett of Portland, Oregon, with Colonel C. E. S. Wood of that city acting as agent, was probably begun in the early or middle 1890s. Although Ryder wrote fellow painter J. Alden Weir in 1896 that he had "finished" *The Lorelei*,[2] he continued to work on it for most of the remainder of his life. In 1899 he promised Wood that he would "someday get the Lorelei," but explained that he would have to keep

on working for "it is only now that I am convinced that a moonlight rare and pale will be the most beautiful and positive treatment of the subject."[3] Two years later, when Ryder was still struggling with the painting, Colonel Wood wrote him a scolding letter, in which he said: "Mrs. Corbett would gladly save you from cooking or washing to get the Lorelei."[4]

Ryder's frustration with the placement of the Lorelei, mentioned in his letters, was chronicled vividly by the critic Sadakichi Hartmann, who had come to know him well: "How often she has changed since I first became acquainted with her! She is going through a whole cycle of evolution. Now large, now small, now emerging from the rock, now sinking back into it, almost vanishing at times, coming forth again, changing her position, drapery, expression, color of her hair, a hundred times. And the rock itself shifts its outline in every direction, moves upward and downwards in perspective views, recedes far into the landscape and comes right near to the spectator's vision." Hartmann tried to persuade Ryder to leave well enough alone, but the artist would argue that there was still something else he could do.[5] Ryder's longtime friend and neighbor Charles Fitzpatrick stated: "His Lorelei picture gave him more hard work than any picture he had. . . . If we heard a rasping sound on the floor (and it was always at night) we knew he was rubbing down the Lorelei."[6] Only on the day of Ryder's funeral was Wood notified that he would finally receive his painting: J. Alden Weir wrote that he had claimed it, and another work due to him, the week before.[7] (Wood gave *The Lorelei* to his stepdaughter Mrs. James [Katherine] Caldwell, from whom it was acquired by its present owner, a private collector.)

The colors of *The Lorelei*, unusually cool, prompted his dealer-friend Harold Bromhead to remark on the "wonderful tones of blue and tender mystery and romance, a harmony of blues."[8] The general design, on the other hand, is quite characteristic of Ryder, especially his later work, in its dramatic diagonal contrasts and bold, vigorous drawing. Art historian Diane Chalmers Johnson has argued that Ryder borrowed his composition—two opposed rocky peaks framing a cloudy sky and moon—from an engraving after J. M. W. Turner that was used to illustrate "Lord Ullin's Daughter" in an edition of Thomas Campbell's poems published in London in 1837.[9] This is a plausible suggestion, although Ryder did not copy the illustration literally and could easily have invented the design independently.

After Ryder's death, additions to the unfinished *Lorelei*, it was reported, were made by Louise Fitzpatrick, his friend and student (see chapter 11), in the belief that she knew the artist's intentions. In any case, the painting has unquestionably suffered as a result of Ryder's inadequate knowledge of technique; it had to undergo conservation treatment three times—in 1947, 1957, and 1975—but none of these efforts was able to return the painting to its original condition.[10]

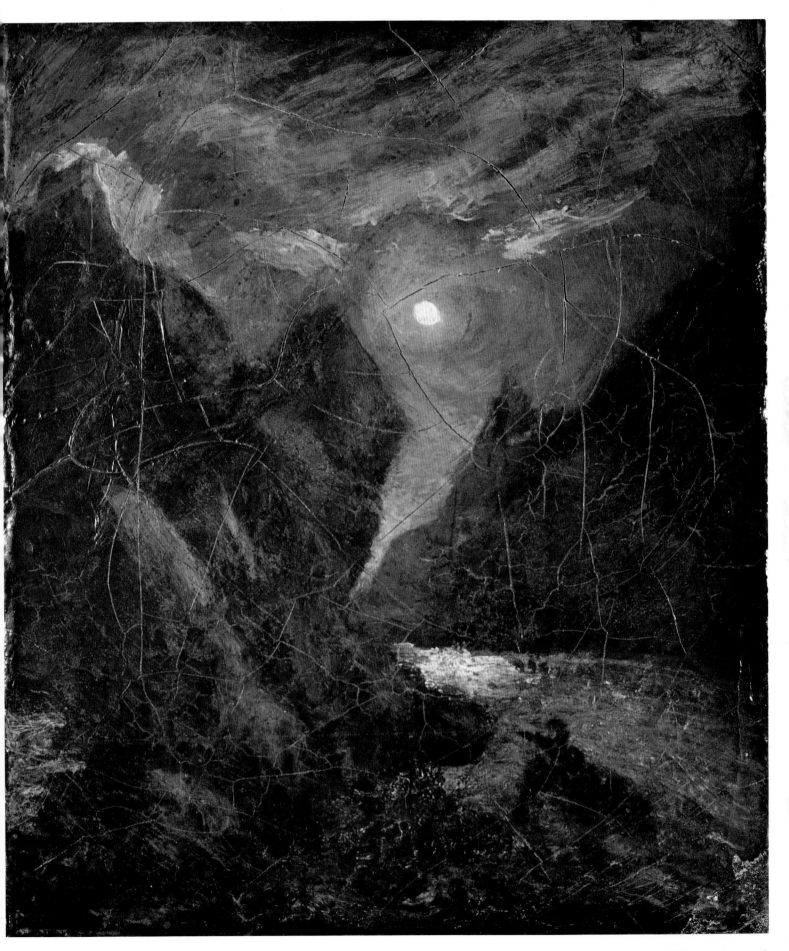

Plate 14. *The Lorelei*. Early to middle 1890s and later. Oil on canvas, 22½ x 19". Private collection. Photograph: Sheldon Keck, 1972 171

Plate 15. Macbeth and the Witches

Macbeth and the Witches in the Phillips Collection is the second painting of this subject that Ryder executed. The first, in the Art Museum, Princeton University, dating from the early 1880s, is smaller and more decorative in treatment. The Phillips painting, probably begun in the late 1890s and worked over for many years afterward, is more fully realized and compelling in its dramatic message. Taking his subject from act I, scene 3, of Shakespeare's play, Ryder portrayed the startling encounter of Macbeth and Banquo, victorious generals serving King Duncan I of Scotland, with three strange creatures in female garb who loom up out of the shadows. The two riders, crossing a lonely heath, respond to the apparition:

Macbeth. So foul and fair a day I have not seen.
Banquo. How far is't call'd to Forres? What are these
So wither'd and so wild in their attire,
That look not like the inhabitants o' the earth,
And yet are on't? Live you? or are you aught
That man may question? You seem to understand me,
By each at once her choppy finger laying
Upon her skinny lips: you should be women,
And yet your beards forbid me to interpret
That you are so.
Macbeth. Speak, if you can: what are you?[1]

The witches offer a fateful prophecy that Macbeth will become the next king of Scotland, and foretell that, in time, Banquo's heirs will reign. As the play unfolds after this event, Macbeth ambitiously seeks and gains the throne through treachery and the murder of Duncan; and, in the end, after undergoing doubts and delusions, Macbeth himself is decapitated.

The site for Macbeth's and Banquo's meeting with the witches is a desolate heath, dimly lit by a golden moon. Behind them stands a distant castle, high on a mountaintop; in the center, a moonstruck body of water and rolling hills beyond it; and to the left, behind the witches, a dead tree and a steep, mountainous incline. Above, an apocalyptic sky, recalling El Greco, glows with luminescent clouds. Save for the sky, all is dark and shadowy: a penumbral setting appropriate to this episode in Shakespeare's play.

Although *Macbeth and the Witches* was a product of Ryder's imagination, it is anchored, more than *Jonah* (plate 7) or *The Flying Dutchman* (plate 9), in the experience of reality. The threatening clouds, their edges etched with light, could be from one of his nocturnal marines, moody paintings distilled from his memories of the real. By the same token, Macbeth's and Banquo's startled horses are drawn accurately and expressively, their positions orchestrating their riders' emotions of surprise and shock. The dark, haunting forms of the witches, themselves apparitions, seem convincing, even though only their backs are seen. This is not the event as it might have occurred on stage, but a dramatic reconstruction in Ryder's mind's eye, a portrayal of the inner reality of Shakespeare's intent. The critic Royal Cortissoz praised Ryder's "spiritual insight into the core of the drama" and lauded his grasp of essentials: "We behold his vision as in a flash between thunder-claps; it goes as swiftly as it comes . . . we feel for a moment as we sometimes feel in life, as if we had imagined the thing which we had seen."[2]

Ryder's aim was to show Macbeth and the witches in a mysterious nocturnal setting, but the painting, as he worked over it, apparently became far darker than he had originally intended. It was one of those works Ryder could not "finish" or easily part with. A reporter stated in 1906 that it had already been in his studio for seven years,[3] and his letters to the collector Dr. A. T. Sanden, who purchased it, indicate that he was still working on *Macbeth* between 1905 and 1913.[4] In the latter year, the artist J. Alden Weir wrote their common friend Colonel C. E. S. Wood: "It grows darker all the time. At one time it was very fine."[5] Ryder's obsessive desire to improve the painting, combined with his faulty technical procedures, no doubt contributed to the darkening process. But the work was also heavily restored and partially repainted (see chapter 11), and thus what we see today bears only a partial resemblance to Ryder's original efforts.

As part of the Sanden collection, the painting was purchased in 1924 by Frederic Newlin Price of the Ferargil Galleries, New York. In 1928 and 1930 it was sold to collectors who could not pay in full. Duncan Phillips purchased it in 1940 for the Phillips Memorial Collection in partial exchange for *The Barnyard* (plate 1) and the smaller version of *Macbeth and the Witches* (fig. 6–15).

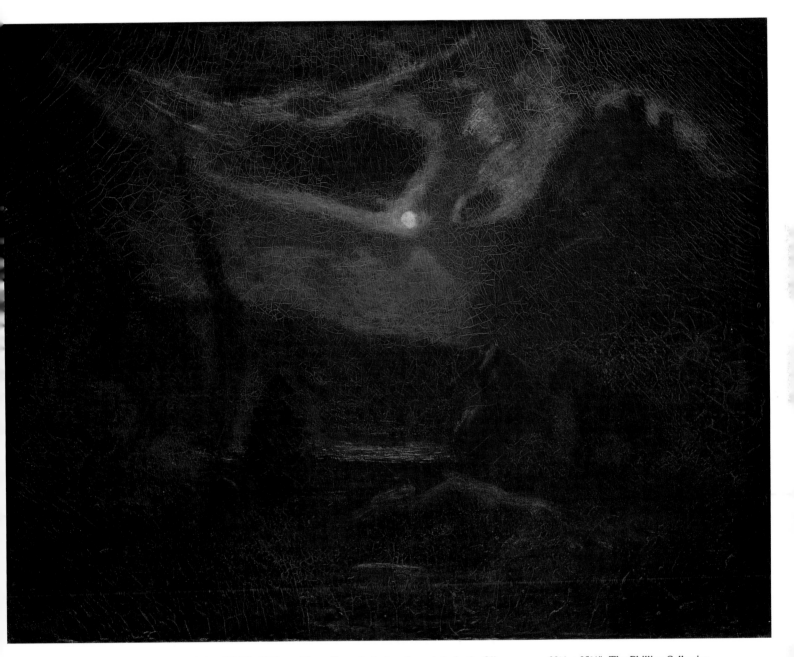

Plate 15. *Macbeth and the Witches*. Middle 1890s and later. Reworked after the artist's death. Oil on canvas, 28¼ x 35¾". The Phillips Collection, Washington, D.C.

NOTES

Abbreviations used in the notes

AAA Archives of American Art, Smithsonian Institution, Washington, D.C.

ELC Philip Evergood–Harold O. Love collection of Ryder materials (see chapter 1, note 7, for details)

FFSC Frederic Fairchild Sherman's collection of Ryder research materials

RA Lloyd Goodrich–Albert P. Ryder Archive, University of Delaware Library, University of Delaware, Newark

Plate 1. *The Barnyard*

1. Peter Bermingham, *American Art in the Barbizon Mood* (exhibition catalogue), National Collection of Fine Arts, Washington, D.C., January 23–April 20, 1975.
2. The histories of the fifteen paintings reproduced in color with facing page essays were taken from Lloyd Goodrich's unpublished draft entries for the Ryder catalogue raisonné, RA, expanded and updated by William Innes Homer on the basis of the current curatorial or collector's files for each work.

Plate 2. *The Lover's Boat (Moonlight on the Waters)*

1. The painting has also been referred to as *The Smugglers* and *Smugglers' Cove*, but these titles are obviously incorrect in the light of Ryder's poem accompanying the picture. I have adopted the singular, rather than the plural, of "lovers" because that is how it is stated in the poem.
2. Ryder complained about the careless printing of this poem in a letter to collector John Gellatly, June 8, 1897, AAA.
3. The relation of Ryder's poetry to his painting is discussed at the beginning of chapter 5.
4. William H. Gerdts, "The Square Format and Proto-Modernism in American Painting," *Arts* 50 (June, 1976): 73.

Plate 3. *Pegasus*

1. Henry Eckford [Charles de Kay], "A Modern Colorist: Albert Pinkham Ryder," *Century Magazine* 40 (June, 1890): 258.
2. "Studio Notes," *Studio* 1 (April 14, 1883): 139.
3. Ryder to Wood, October 2, 1899, Katherine Caldwell, Berkeley, Calif.

Plate 4. *The Toilers of the Sea*

1. For a full discussion of the connection to Hugo, see Doreen Bolger Burke, *American Paintings in the Metropolitan Museum of Art*, vol. 3 (New York, 1980), pp. 15–16.
2. Elizabeth Johns, "Albert Pinkham Ryder: Some Thoughts on His Subject Matter," *Arts* 54 (November, 1979): 170.
3. Marsden Hartley, "Albert P. Ryder," *Seven Arts* 2 (May, 1917): 94.

Plate 5. *The Temple of the Mind*

1. Ryder to Clarke, undated [1885], Thomas B. Clarke Papers, AAA.
2. Eckford [De Kay], "Modern Colorist," p. 259.
3. "Rough Notes Made By H. W. Bromhead, about 1901, for a proposed article in *The Studio* upon the works on which Ryder was then engaged," typescript, FFSC, RA. (See Appendix 4.)
4. Edgar Allan Poe, "The Fall of the House of Usher," *Burton's Gentleman's Magazine, and American Monthly Review,* September, 1839. pp. 148–49.
5. Edgar Allan Poe to R. W. Griswold, March 29, 1841, published in James A. Harrison, ed., *Life and Letters of Edgar Allan Poe,* vol. 2 (New York, [1902–3]), pp. 83–84.
6. Ryder to Dr. John Pickard, November 3, 1907, Dr. John Pickard Papers, AAA, published in Allen Weller, "An Unpublished Letter by Albert P. Ryder," *Art in America* 27 (April, 1939): 102.
7. Robert Pincus-Witten, "On Target: Symbolist Roots of American Abstraction," *Arts* 50 (April, 1976): 85.

8. Miller, interview with Goodrich, June 26, 1947, typescript, RA. (See Appendix 4.)
9. John Gellatly to Cornelia (Quinton) Sage, March 9, 1918, Archives, Albright-Knox Art Gallery, Buffalo, N.Y.

Plate 6. *Christ Appearing to Mary*

1. Ryder to Clarke, undated [1885], Thomas B. Clarke Papers.
2. "The Gallery: The National Academy of Design," *Art Amateur* 18 (May, 1888): 132.
3. "The Spring Academy," *New York Times*, March 31, 1888.
4. "The Academy Exhibition," *Harper's Weekly*, April 7, 1888, p. 250.

Plate 7. *Jonah*

1. Ryder to Clarke, April 7 [1885], Thomas B. Clarke Papers.
2. Eckford [De Kay], "Modern Colorist," p. 256.
3. Elbridge Kingsley, "Autobiography," undated typescript, Forbes Library, Northampton, Mass., p. 185.
4. A.B.L. [Aline B. Louchheim], "Ryder Seen by Marsden Hartley, Walt Kuhn, Yasuo Kuniyoshi, Reginald Marsh, Kenneth Hayes Miller," *Art News* 46 (November, 1947): 30.
5. Abraham H. Davidson, *The Eccentrics and Other Visionary Painters* (New York, 1978), p. 141.
6. Wood to Gellatly, November 22, 1919, AAA.
7. Wood to Gellatly, October 15, 1919, AAA.

Plate 8. *Constance*

1. "The Critic" [Alfred Trumble?], "Albert P. Ryder," *Art Collector* 9 (December 1, 1898): 37.
2. "Genius in Hiding," Chicago *Times-Herald*[?], [date ?] offprint or tearsheet designated, in print, "[From the Times-Herald, Chicago, March 24, '69]," ELC, RA. Internal evidence suggests that the article was written in the mid-1890s. A search of the newspaper's archives, however, has not revealed the article or its date.
3. Arthur Gilman, ed., *The Poetical Works of Geoffrey Chaucer*, vol. 1 (Boston, [1879]), pp. 186–87.
4. Lloyd Goodrich, "Realism and Romanticism in Homer, Eakins, and Ryder," *Art Quarterly* 12 (1949): 27.
5. Roger E. Fry, "The Art of Albert P. Ryder," *Burlington Magazine* 13 (April, 1908): 63.
6. Goodrich, unpublished catalogue entry for *Constance*.
7. Richard Braddock, "The Literary World of Albert Pinkham Ryder," *Gazette des beaux-arts*, 6th ser., 33 (January, 1948): 50.

Plate 9. *The Flying Dutchman*

1. The best-known of these, prior to Richard Wagner, was Frederick Marryat's novel *The Phantom Ship* (1839).
2. Ryder enclosed this poem with a letter to John Gellatly, June 8, 1897, AAA. A revised version, dated July 20, 1909, AAA, sent to Gellatly for a tablet to accompany the painting, is printed in Appendix 3.
3. Goodrich, unpublished catalogue entry for *The Flying Dutchman*.
4. "Art at the Lotos Club," *New York Times*, December 26, 1896.

Plate 10. *Siegfried and the Rhine Maidens*

1. This story was told by Elliott Daingerfield, "Albert Pinkham Ryder, Artist and Dreamer," *Scribner's Magazine* 63 (March, 1918): 380.
2. Richard Wagner, *Götterdämmerung (The Dusk of the Gods)* (New York[?], 1883[?]), p. 17.
3. Diane Chalmers Johnson, "Art, Nature, and Imagination in the Paintings of Albert Pinkham Ryder: Visual Sources" (paper delivered at the Seventy-second Annual Meeting of the College Art Association of America, Toronto, Canada, February 23, 1984).
4. Charles Caffin, *The Story of American Painting* (New York, 1907), p. 216.

5. Davidson, *Eccentrics and Other Visionary Painters*, p. 141.
6. "Art Notes," *New York Times*, April 7, 1891.

Plate 11. *The Race Track*

1. Frederic Fairchild Sherman, *Albert Pinkham Ryder* (New York, 1920), pp. 47–48.
2. "Rough Notes Made By H. W. Bromhead."
3. Fry, "Art of Albert P. Ryder," p. 64.
4. Sadakichi Hartmann reported that Ryder "went quite frequently to the racetrack." ("The Story of an American Painter," typescript [1926], Library, Metropolitan Museum of Art, N.Y., p. 14).
5. "The Bard Beats Hanover," *New York Times*, May 16, 1888.
6. Miller, interview with Goodrich, June 26, 1947.
7. Goodrich, unpublished catalogue entry for *The Race Track*.
8. "Rough Notes Made By H. W. Bromhead."
9. Henry Sayles Francis to Lloyd Goodrich, July 24, 1947, RA, reports on this incident.

Plate 12. *The Forest of Arden*

1. Ryder to Mrs. Olin (Sylvia) Warner, October 12, 1897, Olin Warner Papers, AAA.
2. Sadakichi Hartmann, *A History of American Art* (Boston, 1902), p. 83.
3. Burke, *American Paintings*, p. 24. For a discussion of autoradiography, see my chapter 11, note 16.
4. William Aldis Wright, ed., *Shakespeare Select Plays: "As You Like It"* (Oxford, England, 1884).
5. Fry, "Art of Albert P. Ryder," p. 64.
6. Goodrich, unpublished catalogue entry for *The Forest of Arden*.

Plate 13. *The Tempest*

1. "New Paintings by Americans," *New York Times*, March 21, 1892.
2. William Aldis Wright, ed., *Shakespeare Select Plays: "The Tempest"* (Oxford, England, 1876).
3. "Rough Notes Made By H. W. Bromhead."
4. Wood to Goodrich, May 14, 1939, RA.
5. Alice Boughton, *Photographing the Famous* (New York, 1928), p. 74; and Walter Pach, *Queer Thing, Painting* (New York and London, 1938), p. 62.

Plate 14. *The Lorelei*

1. Franz Liszt, *The Most Favorite Songs. By Franz Liszt* (New York, [1876]), no. 5 ("The Loreley" ["Die Lorelei"]).
2. Ryder to Weir, undated [1896], J. Alden Weir, Manuscript Collection, Brigham Young University Library, Provo, Utah.
3. Ryder to Wood, October 2, 1899, Katherine Caldwell.
4. Cited in Dorothy Weir Young, *The Life and Letters of J. Alden Weir* (New Haven, Conn., 1960), p. 215.
5. Hartmann, "American Painter," p. 9.
6. Charles Fitzpatrick, "Albert Pinkham Ryder," undated typescript, ELC, RA, published by Kendall Taylor in "Ryder Remembered," *Archives of American Art Journal* 24 (1984): 9.
7. Weir to Wood, March 30, 1917, cited in Young, *J. Alden Weir*, p. 256.
8. "Rough Notes Made By H. W. Bromhead."
9. Johnson, "Art, Nature, and Imagination."
10. Information from Sheldon Keck, who furnished the treatment.

Plate 15. *Macbeth and the Witches*

1. W. G. Clark and W. A. Wright, eds., *Shakespeare Select Plays: "Macbeth"* (Oxford, England, 1878).
2. Royal Cortissoz, *American Artists* (New York and London, 1923), p. 99.
3. "Albert Pinkham Ryder—A Poe of the Brush," *New York Press*, December 16, 1906.
4. These letters are dated June 9, 1905; November 14, 1906; April 15, 1907; April 16, 1908; February 28, 1910; and August 5, 1913, photostats, RA.
5. Cited in Young, *J. Alden Weir*, p. 244.

Albert P. Ryder: His Technical Procedures

By Sheldon Keck

RYDER LEFT US almost no literature descriptive of his materials and techniques. He had many friends and admirers: artists, connoisseurs, collectors, art dealers and critics, who often visited him. The evidence available from their published accounts, while generally illuminating, is vague concerning his technical practices. On the subject of color for instance, glowing color, vibrancy of the color surface, and richness of color are frequently mentioned, but only four or five pigments are given their identifying nomenclature.[1] It is only through analytical study of his paintings that we may eventually gather more facts of his procedures.[2]

In the matter of supports there is evidence from museum and exhibition catalogues that Ryder painted in oil on canvas, wood, at times cigarbox lids, composition board, and also the unusual support of gilded leather, some for decorative folding screens which he was apparently commissioned to paint for Cottier & Co. The strongest factor which we may extrapolate from contemporary statements, almost all of which were recorded after he became a recluse, is Ryder's incredible ill-treatment of his own work, a perhaps unconscious but equally nonselective habit of abuse.

In 1905 Miss Adelaide Samson interviewed Ryder for *Broadway Magazine* on his philosophy of life and art. It would almost appear that she had transcribed his story shorthand since on publication, the article entitled "Paragraphs from the Studio of a Recluse" was printed with Ryder as the author.[3] Of the ten paragraphs, three shed light on his practice and techniques.

Imitation is not inspiration, and inspiration only can give birth to a work of art. . . . In pure perfection of technique, coloring and composition, the art that has already been achieved may be imitated, but never surpassed. Modern art must strike out from the old and assert its individual right to live through Twentieth Century impressionism and interpretation. The new is not revealed to those whose eyes are fastened in worship upon the old. The artist of to-day must work with his face turned toward the dawn, steadfastly believing that his dream will come true before the setting of the sun.

When my father placed a box of colors and brushes in my hands, and I stood before my easel with its square of stretched canvas, I realized that I had in my possession the wherewith to create a masterpiece that would live throughout the coming ages. The great masters had no more. I at once proceeded to study the works of the great to discover how best to achieve immortality with a square of canvas and a box of colors.

Nature is a teacher who never deceives. When I grew weary with the futile struggle to imitate the canvases of the past, I went out into the fields, determined to serve nature as faithfully as I had served art. In my desire to be accurate I became lost in a maze of detail. Try as I would, my colors were not those of nature. My leaves were infinitely below the standard of a leaf, my finest strokes were coarse and crude. The old scene presented itself one day before my eyes framed in an opening between two trees. It stood out like a painted canvas—the deep blue of the midday sky—a solitary tree, brilliant with the green of early summer, a foundation of brown earth and gnarled roots. There was no detail to vex the eye. Three solid masses of form and color—sky, foliage and earth—the whole bathed in an atmosphere of golden luminosity. I threw my brushes aside; they were too small for the work in hand. I squeezed out big chunks of pure, moist color and taking my palette knife, I laid on blue, green, white and brown in great sweeping strokes. As I worked I saw that it was good and clean and strong. I saw nature springing into life upon my dead canvas. It was better than nature, for it was vibrating with the thrill of a new creation. Exultantly I painted until the sun sank below the horizon, then I raced around the fields like a colt let loose, and literally bellowed for joy.

This landscape was painted in the direct "alla prima" or "peindre au premier coup" technique. The direct technique was accomplished with a palette knife or brush by the French Impressionists and many American painters in the second half of the nineteenth century. Ryder appears to have continued to employ the technique until the late 1870s. According to Goodrich the paintings of the 1870s were pastoral in nature, mainly landscapes and rural scenes with farms, figures, horses, and cattle reminiscent of New Bedford's countryside.[4]

One paragraph from "Paragraphs from the Studio of a Recluse" dealing with the artist's procedure relates quite definitely to a change in Ryder's technique which occurred in the early 1880s.

The canvas I began ten years ago I shall perhaps complete to-day or to-morrow. It has been ripening under the sunlight of the years that come and go. It is not that a canvas should be worked at. It is a wise artist who knows when to cry "halt" in his composition, but it should be pondered over in his heart and worked out with prayer and fasting.[5]

His friend, Walter Pach, painter and writer on art, sheds further light on the development of Ryder's processes and technique. Pach writes in his book, *Queer Thing, Painting*, of his "happy acquaintance [with Ryder] covering the last eight years of his life."[6] He believed that Ryder had surprising memories of the great masters in the museums of Europe and that these played "a constant part in his thinking." On one occasion Pach stopped to say good-bye to Ryder as he was sailing that evening for Italy. As Pach proceeded downstairs to leave, Ryder rushed after him calling: "Oh, I was forgetting to tell you to give my love to that Rembrandt in the Pitti Palace."[7]

In spite of a consensus among his friends, asserted by Charles de Kay, that on his trip to Europe in 1882 Ryder showed little liking for travel, exhibited a strong dislike for hurry, and gave small attention to the great paintings in the old galleries,[8] Pach was convinced his tour abroad remained in Ryder's memory and that vivid recollections of what he found stimulating influenced the form and design of his pictures. He cites Ryder's change of composition in *The Temple of the Mind* (plate 5), which at a late stage in the work had a bridge leading from the temple to the opposite margin of the painting. Ryder explained to Pach how this placement of the bridge suggested to him that "once a person had crossed that bridge, he could never return." Then he went on to say: "It was a pretty allegory, but that bridge with its horizontal line never seemed to suit the picture. I wanted an upright and thought a fountain might give it. I remembered a fountain I had seen in Florence and put that in, which is what you see today."[9]

In an article published in 1911, Walter Pach writes: "According to his own statement, Mr. Ryder uses no sketches from nature, but lays the picture in according to what he feels to be its needs. Then follows a process of small or large changes that frequently extends over a period of years. The position of clouds in a sky, the contour of a hill, or the movement of a figure undergoes infinite modifications until the stability and harmony of masses is attained that the artist's astonishing sense of their beauty demands. 'I work altogether from my feeling for these things, I have no rule. And I think it is better to get the design first before I try for the color. It would be wasted, much of the time, when I have to change things about.'"[10]

This brief description of Ryder's procedure in painting agrees with Lloyd Goodrich's view that "Ryder's technique was more complex than was usual in his time."[11] Instead of continuing with his initial solid alla prima technique, Ryder appears to have chosen in the early 1880s the traditional system abandoned by painters in the second half of the nineteenth century, a technique of underpainting, overpainting, scumbling, and glazing. This traditional "indirect" method, passed down through the centuries since Jan van Eyck perfected oil painting in the third decade of the fifteenth century, theoretically simplifies the problems of nature's intricacy. It offers a systematic approach to representing the visible world by separating the artist's working order into: first, *outline* (drawing); second, *light and shade* (form); and third, *coloring* (hue differentiations).

The term *indirect* is a twentieth-century invention used to distinguish the technique introduced by van Eyck from the alla prima method used by painters of the late nineteenth and early twentieth centuries. To the painters of the sixteenth, seventeenth, eighteenth, and early nineteenth centuries the only technique for oil painting was that of van Eyck and his European followers. Although it varied widely among generations and areas, there was no other oil technique. In a sense it followed the earlier technique of egg tempera which also used drawing and underpainting as described by Cennino Cennini. For convenience, we will continue to call the traditional Eyckian technique the indirect technique of painting in oil.

The first element, *outline*, is related to the cartoon employed in fresco painting and to the term "sketch," which Pach had in mind when he wrote: "Ryder uses no sketches from nature." Ryder had no need to produce a sketch from nature, for in the indirect technique he could, if he wished, outline his subject on his primed canvas, panel, or other support, before the underpainting or "deadcoloring" which follows. The outline could be in pencil, conté crayon, or thinned paint applied with a pointed sable brush. This would then be deadcolored to produce form and relief. On drying of the deadcoloring, the coloring was added with opaque, translucent, and transparent colors to complete the painting.

We know that Ryder outlined some of his subjects since the outlining can clearly be seen in *The Dancing Dryads* (fig. 2–19), *Pegasus* (plate 3), and *The Shepherdess* (fig. 6–18).

In 1868, Ryder's friend and informal tutor, William E. Marshall, owned a treatise by John Burnet entitled *Practical Hints on Light and Shade in Painting*, published in London in 1864. It was illustrated with examples of the works of great masters of the Italian, Flemish and Dutch Schools. Light and shade refers to the second fundamental element in the indirect system, namely that of form and relief. Marshall, who lent the treatise to Ryder, had studied in Paris with Thomas Couture. Couture painted in the indirect tech-

Fig. K–1. Albert Pinkham Ryder. *Landscape.* c. 1897–98. Oil on canvas, 9½ × 14″. The Metropolitan Museum of Art, New York. Gift of Frederick Kuhne, 1952. Photograph: Rainford, 1947

Fig. K–2. Albert Pinkham Ryder. Detail of *Moonlit Cove.* Early to middle 1880s. Oil on canvas, 14⅛ x 17⅛″. The Phillips Collection, Washington, D.C. Photograph: Sheldon Keck, 1961

nique and Marshall seems to have adopted the method for his portraits (see fig. 2–3) since it is well suited to that type of painting. There is no doubt in my mind that this treatise combined with Ryder's travels abroad in 1877, and more especially in 1882, influenced him to try to create his pictures in the traditional indirect system.

Precisely when Ryder began to experiment with the indirect traditional method of painting cannot be infallibly determined. It may have occurred in the late 1870s. For example, one of his relatively naturalistic landscapes, entitled *The Curfew Hour* (fig. 4–18), first exhibited in 1882, shows characteristics of a picture painted in the indirect technique. Displayed in the Metropolitan's "Loan Exhibition of the Works of Albert P. Ryder" in 1918, a year after the artist's death, a photograph made at that time (see fig. 8–2) shows narrow traction cracks in the large hill at the right, the largest of which appears to be extruding outward small lumps of paint. In the lower half of the right-hand area, narrow smaller traction cracks are seen; their apertures are white against the dark gray of the photograph. In 1935, Lloyd Goodrich noted that "serious cracks had appeared," and in 1938 he wrote: "The cracks are very bad, especially in the hill at the upper right and center, where the top layer of paint has contracted into islands, wrinkled in texture, [and is] separated by great wide areas of a transparent glossy substance which looks like varnish. Through this transparent substance can be seen other paint below the surface. The effect is that of a scum of paint floating on a liquid."[12]

From his own experience Ryder must have been aware that some colors dried more quickly than others. For instance, flake white, umbers, and Prussian blue are *rapid driers* while ivory black, lamp black, and Van Dyke brown are among the *very slow driers.* Between these extremes are other pigments in oil rated as *average driers* and *slow driers.*[13] A reasonably thick, even coating of a rapid drier over an underlayer of rich slow drier can, within a few months, pro-

mote cracking in the upper coat of paint due to contraction as it dries. A 1947 photograph of Ryder's *Landscape* (fig. K–1) clearly exhibits such traction cracks. At times the sluggish underlayer of not yet dried paint extrudes up out of the cracks as glossy globules. Such a globule can be seen slightly magnified in the sky of Ryder's *Moonlit Cove* (fig. K–2).

An oil painting dries by a chemical process, namely oxidation of the oil molecules comprising its medium, not by evaporation of water as in watercolor or gouache. Oxygen from the air combines with the oil increasing its weight while it is also releasing certain volatile by-products of the oxidation, thus losing some of its weight. Simultaneously polymerization joins chains of molecules together increasing the viscosity of the oil. This process of drying is exceedingly slow. Oxidation begins at the paint surface and proceeds inward, its progress dependent on the thickness of the paint and on the various drying rates contributed by the pigments employed in the paint. The presence of sunlight accelerates the drying.

Shortly after application, under normal circumstances, the paint surface usually reaches in two or three days what is called the initial set and in a day reaches tacky set, followed in another day or two by tack-free set. At this point, the paint layer has reached its maximum weight increase which gradually diminishes over a period of weeks or months. Be-

cause of weight loss during this period, occasioned by the departure of gaseous by-products, the paint film tends to shrink unless it has a firm attachment to its substrate of primed canvas or panel. Traction cracks may well appear in time, especially in the heavy thick layers of paint so often seen in Ryder's work. A. P. Laurie states that: "The complete oxidation of an oil film is a very slow process, a film four hundred years old gives reactions which show it is not yet complete."[14]

Today *The Curfew Hour* is over a century old (see fig. 4–18). The degree of contraction and wrinkling of the pictorial layer has increased. A large irregular canal of dark brown glossy substance spreads from the lower left edge of the picture diagonally upward toward the right where it joins the exposed matter on the hill which Goodrich noted in 1938; it also travels horizontally across the foreground. As a result, the cows in the lower left and the lower foreground to the right have contracted and wrinkled.

In all probability the glossy substance is a glaze composed of oil varnish and bitumen which Ryder applied over much of the underpainting of the composition. He proceeded to cover this glaze by repainting the subject with relatively lean paint. Because of poor adherence to the glaze, the lean paint tended to contract on drying and tear away from its substrate with simultaneous wrinkling of its surface. In addition, it appears that the glaze, which is thermoplastic (that is, softens in warm temperatures and hardens in cool ones), has been flowing slowly toward the bottom of the painting.

The Barnyard (plate 1), painted on wood, has much in common with *The Curfew Hour*. The painting appears to have been executed in Ryder's indirect technique, with layer upon layer of thick, rich paint smoothly applied over each other and showing corrugations in the paint surface. Recently cleaned and restored, it seems to be well preserved though dark in tone.

Related to *The Curfew Hour* and *The Barnyard* is the painting *In the Stable* (fig. 6–9). Traction cracks are extensive; surface paint has contracted into countless dark islands over almost the entire scene. Except for the white horse and part of the stableman's figure, crackle extends throughout the painting with shriveling of the surface in varying degrees. Under low-power magnification the islands show multiple blister bubbles and pinholes, minute craterlike formations indicative of volatile material in the structure of the paint surface (fig. K–3). The continuous glossy layer beneath is reddish in portions and yellowish elsewhere. A photograph taken in 1918 (fig. K–3A) shows details no longer visible in 1967 when the painting was examined before conservation treatment.

Two of these three paintings would seem to have been painted experimentally by Ryder in the indirect system. The third, *The Barnyard*, may have been painted in the alla

Fig. K–3. Albert Pinkham Ryder. Detail of *In the Stable*. Early to middle 1870s. Oil on canvas, 21 x 32″. National Museum of American Art, Smithsonian Institution, Washington, D.C. Gift of John Gellatly. Photograph: Sheldon Keck, 1967

prima technique avoiding the damage found in *The Curfew Hour* and *In the Stable*. Neither of these latter showed any disfigurement until long after Ryder's death.

Among the works of the 1880s which appear to be in Ryder's indirect technique are four marine paintings all nearly square and all on wood. Of these *The Lover's Boat*, or *Moonlight on the Waters* (fig. 6–15), is a fluid, quickly brushed painting, dramatic in its high contrast of light and dark, quite different in his handling of paint from the scenes of the 1870s. It is well preserved and does not show the buildup of underpaint as do his later indirect constructions.

Another sea subject exhibited in the National Academy in 1884 is *The Waste of Waters Is Their Field* (fig. 4–5), painted for Daniel Cottier. Though freely brushed and with strong contrast, it has faded due to photochemical reaction from exposure to direct sunlight. It is more heavily painted with thicker undercoats than *The Lover's Boat*, as is revealed where small chips of paint have flaked at the edge of the panel.

Characteristic of Ryder's indirect technique, *The Toilers of the Sea* (plate 4) has rich slow-drying layers of underpainting which exhibit gradual gravitational flow toward the bottom edge of the picture, even overflowing the rabbet of the frame. This does not appear to have affected the continuity of the surface with disfiguring cracks, although Goodrich in

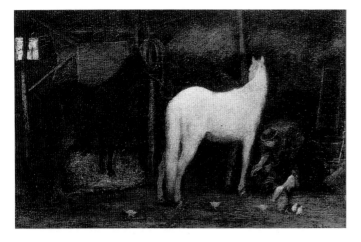

Fig. K–3A. Albert Pinkham Ryder. *In the Stable*. National Museum of American Art. Photograph: The Metropolitan Museum of Art, 1918

1938 had observed changes, "particularly in the dark areas of the boat and sail which had settled below the level of the surrounding lighter paint areas."[15] The artist's signature at the bottom left is already obscured by the outward deformation of the surface paint along the bottom, due to downward flow of the underpaint.

Moonlight Marine (fig. 4–6) also suffers construction problems similar to those found in *Toilers of the Sea*. Below its top paint layer, which now presents an irregular pattern of traction cracks, rich plastic underlayers of paint have gradually moved downward to form a bulge of thicker paint at the bottom, also overflowing the rabbet of the frame. Goodrich studied and compared a series of photographs of the paintings taken in 1908, 1918, 1930, and 1934 and found differences in each largely due to the "serious sagging of the paint."[16] Two figures and the diagonal spar of the mainsail had completely disappeared. The painting seems to have been restored in or before 1930, altering its appearance with even more repainting, reglazing, and changes in outline. The Metropolitan Museum of Art attempted with doubtful success to have the picture restored to its original semblance. Goodrich concluded that because of the numerous changes the painting had undergone it no longer was the picture Ryder had finished.

Any painting on panel or canvas subjected to this kind of gravitational flow of rich undried underlayers of paint measures considerably less in thickness from front to back in the upper area of the picture and greater in thickness in the lower area, even though when originally painted the thickness was relatively equal throughout its entire plane.

Unfortunately, Ryder's ignorance of the distinction between lean and rich paint and of the order in which they may be safely applied in painting where layers of underpainting and overpainting are required was largely the cause of serious damage to many of his pictures executed in the indirect technique. For instance, in Ryder's painting, *The Lorelei* (plate 14), the paint thickness ranges from ⅛ inch in the up-

per area to ¼ inch below. There is also a noticeable sagging of the paint toward the bottom with a bulge at the rabbet of the frame.

Sadakichi Hartmann, well-known art critic, was among the first to interview Ryder after he had become a recluse. He visited Ryder at his studio living quarters where the artist showed him ten or more half-finished paintings which were "lying about in every possible position." Hartmann admitted he was "carried away into a fairyland of imaginative landscapes, ultramarine skies and seas, and mellow, yellowish lights." From the account, Ryder must have painted on one or more of the pictures while they conversed. Although troubled by Ryder's technique, Hartmann was obviously impressed with the poetic sentiment and originality. He wrote: "Ryder is a chiaroscurist, an *ideal* black-and-white artist, with a special aptitude for moonlight effects. His technique, reminding me somehow of Blake's wood-cuts, is quite his own. The heavy 'loading' of his canvases, the muddy, rather monotonous brushwork (holding the brush at the middle of the handle and hesitatingly dragging it across the canvas), the constant using of strong contrasts of dark and light colors, and the lavish pouring of varnish over the canvas while he paints to realize lustre, depth and mystery."[17]

Later in the article Hartmann comments: "Some artists accuse him of being dependent on the old masters. Probably they are right; everyone must get his inspirations somewhere, it really matters little how. True, Ryder's pictures are somewhat like old masters'; yet they rather look like old pictures in general, than resemble any particular master, and, therefore, this medieval appearance indicates no imitative, but, on the contrary, a creative faculty."[18]

In time Hartmann became deeply involved with Ryder and his approach to painting. He spent many hours in Ryder's studio, often at night when the artist painted by the light of a single globeless gas jet. Hartmann wrote a typescript of these visits entitled "The Story of an American Painter" which never reached publication.[19] The following is an excerpt: "I have read in some handbook that varnishing should not be done in a temperature below seventy degrees Fahrenheit. If this be true—Ryder did not mind painting in cold weather without a fire and windows wide open—his canvases can not fare well. And in fact they do not, as many of his patrons have found out. There occur not only extensive crackings but regular varnish slides, moving lava-like through the surface, and here and there pieces the size of small coins deliberately fall out. A humorous incident is reported to have happened to his 'Flight into Egypt' which represents a pilgrim in Oriental drapery and an extremely tall lady with a wee bit of an infant on a mule, passing a signpost which resembles a cross. The head of the infant suddenly began to move and wiggle downwards to abdominal regions where it remained as far as I know until the days of restoration (as told by Gellatly). Ryder apparently

did not mind such trifles, perhaps he was so absorbed in the main issues of his work, that he could not concentrate on minor happenings and necessities."

Arthur B. Davies, a romantic painter with an artistic kinship to Ryder and an active organizer of the celebrated Armory Show of 1913, was a friend who frequently called on Ryder at his lodgings. On one visit, Ryder in some distress asked Davies how he kept his paint on his canvas, since at times Ryder's paint would drip down from his canvas and dry on his easel in blobs. Davies replied that in his own work he used very little paint, only enough to cover the canvas, thus avoiding the problem Ryder was having.[20]

A friend and admirer of Ryder was Kenneth Hayes Miller, artist and instructor at the Art Students League in New York, twenty-nine years younger than Ryder. Miller began his training under John Henry Twachtman and H. Siddons Mowbray at the League and later at the Chase School. In 1900 a visit abroad provided him an opportunity for intensive study of the Renaissance masters. He became deeply interested in the indirect technical procedures of Titian, Tintoretto, and Veronese. In his teaching at the League, Miller passed on to his students his knowledge of the indirect technique. His own paintings were very carefully crafted in that technique, composed only of thin layers of paint well modeled in form and gently and translucently colored. About 1909 he befriended Ryder and visited him regularly until the artist's death.

Lloyd Goodrich, a friend of Kenneth Hayes Miller, interviewed him in 1938 and again in 1940 for the research on Ryder and his work. We are fortunate to have Goodrich's transcript's of their conversations, excerpts from which shed some light on Ryder's use of the indirect technique. Miller stated that Ryder did most of his underpainting at night by gaslight and that he finished the overpainting by daylight. He was also of the opinion, confirming Pach's statement, that Ryder did not make drawings. According to Miller, Ryder's method was essentially black and white followed by the "play of transparent, semi-transparent, and opaque [color] tones." Ryder never lost sight of the fact that "paint should be transparent." He once said to Miller, "I have so much enjoyment underneath."

Goodrich also reported that Miller commented to Ryder, "I have known you all this time, and I have never seen your palette." Ryder laughed and picked up a small canvas and turned it over, "showing a little speck of white and another of black": "This is my palette.[21]"

Miller confirmed that Ryder loved to show his pictures which were piled around his studio and often got damaged. He would wash them "with a wet cloth to bring out their depth and transparency" for his visitors.[22] On evaporation, the water could definitely cause blanching of the paint and glazes. In the interviews, Miller admitted to Goodrich that Ryder really had no knowledge of correct painting methods, that he simply painted as he wanted to. Miller had also realized for some time that Ryder was not originating anymore, but merely working over his old pictures, and sometimes hurting them.[23] Ryder told him he "used to be able to 'strike a picture in' but not now."[24] Apparently the emotions which inspired him to produce his greatest works in the decades starting in 1880 and 1890 no longer touched him.

Ryder sometimes added wax to his paint, according to Miller, and when reproached for adding too much, Ryder replied, "But I only used one candle."[25] Manufacturers of artist's paints have added beeswax or aluminum and zinc stearates or palmitates to stabilize the suspension of pigments in the oil and to impart a desirable short or buttery consistency in the paint.[26] Although the presence of wax has been reported in some paintings by Ryder, to my knowledge the specific type of wax has not yet been identified nor has its ratio to the oil content.

Miller was disturbed by Ryder's habit of laying a picture flat, pouring varnish on it, then "tipping it this way and that" until the varnish was spread over the entire surface. On some, he would paint over the varnish when tacky or into the varnish while it was still wet, confirming what Hartmann had already mentioned.[27]

In 1930, William H. Hyde, who had been a student with Ryder at the National Academy of Design, published an article on Ryder with references to his method of working. Hyde wrote: "I don't think he ever used a model and rarely sketched from nature. He evolved everything from his inner consciousness. But I have seen him looking through a portfolio of engravings and reproductions and I thought at the time that he got suggestions from them. I remember asking him if he thought it wrong to use photographs in paintings, and he said: 'I don't think it is wrong, but it will spoil your painting.' " In the same article Hyde reported: "Ryder had a funny, tentative way of working, and a picture might start as a daylighted landscape and end as a night scene. I have often seen him glaze a whole picture with Prussian blue, and then paint over it again.... I saw Ryder paint *Macbeth and the Witches* (plate 15), several of his moonlit water scenes, and the *Death on a White Horse* (plate 11). He never was much of a draftsman and he had great difficulty with his figures, but he never failed to throw over everything he did the charm of his own poetic feeling.... They [his young contemporaries] all felt that he was a single-minded artist who had no thought but to do his best."[28]

On several of his trips to England he traveled aboard the ship commanded by his friend Captain John Robinson. Robinson was an amateur artist who often watched Ryder at work on the ocean voyage: he even wrote an article on him in 1925. On one trip Ryder had with him his painting, *The Temple of the Mind* (plate 5), upon which he continued to

Fig. K–4. Albert Pinkham Ryder. Detail of *King Cophetua and the Beggar Maid*. Early 1890s and later. Oil on canvas, 24½ x 18″. National Museum of American Art, Smithsonian Institution, Washington, D.C. Gift of John Gellatly. Photograph: Sheldon Keck, 1967

Fig. K–4A. Albert Pinkham Ryder. Detail of *King Cophetua and the Beggar Maid*. National Museum of American Art. Photograph: Sheldon Keck, 1967

paint in his cabin. Robinson wrote: "One day, in the course of a talk, he told me that he sometimes used pure alcohol as a medium dilutent more especially in the commencement of a picture. It worked smoothly and with transparency, he said. It is reasonable to suppose that the use of this spirit will account for some of his earlier works showing many cracks. My reason for making this statement was that after Ryder had told me, I used it myself on a picture I was painting. I found that the paint went on very 'slick' and smooth; but whether I used too much I cannot say, but after a few years the picture cracked in all sorts of ways. I have it now by me. I think that shortly afterwards he abandoned the use of alcohol as a medium. . . .

"*The Temple of the Mind* was painted on a thick panel. I found he had commenced another picture on the back of the panel. 'Well, Ryder, you cannot exhibit two sides at once,' I said. 'No,' he replied, 'I mean to have the panel split so as to make two separate paintings.' Whether he had this done I never knew."[29]

One of Ryder's most sincere and generous friends was J. Alden Weir, who wrote in a letter to his wife, January, 1912: "How strange it must seem that although in the same town, I see very little of old friends. Pinky never comes to see me. I go when I can to see the old chap, but I suppose his night

marauds put him out of commission. He looks better than he has looked in years but does not seem to get to work. Every time I go he washes out his canvases with kerosene and they are black as your hat. I think if he would take a new canvas he would probably do something, but I don't think he worries much."[30] William Homer, who has seen *The Lovers* at Vassar College, recently told me that it is virtually black.

The evidence we have received from those who knew Ryder and spent much time with him, in particular Walter Pach, Sadakichi Hartmann, and Kenneth Hayes Miller, affirms the conclusion that Ryder first worked in alla prima and later changed to the indirect technique of painting. At times he may have mixed the two techniques in one picture. When either of these techniques is employed by artists who know the correct application of paint, it is not easy to distinguish between the direct and indirect techniques. Unfortunately, Ryder's handling of the indirect technique ignored the necessity for applications of *lean* paint when layering and instead improperly applied layer after layer of rich paint, sometimes over a period of years. Henry C. White in "A Call upon Albert P. Ryder" wrote: "When his mood impelled he scraped, glazed, scumbled and made the wildest experiments, simply to produce a fine bit of tone or beautiful col-

or. It was an emotional process that often disregarded sound technique, working over a surface not completely dry, piling layer upon layer of paint using too much medium or varnish.[31]

All oil paintings on canvas, wood, or composition board are affected by exposure to chemical, physical, and biological environmental agents of deterioration. Natural aging, promoted by joint action of many, though not necessarily all, of these agents is a gradual alteration involving changes in the physical and chemical properties of the painting's components. It is characterized by color and volumetric changes, loss of cohesive and adhesive strength, embrittlement and cracking of paint and ground. Ryder's paintings are no exception to natural aging.

Over the years 1880 to 1900 when he painted his most profound and dramatic subjects, Ryder's procedures with the indirect technique were inconsistent and varied widely. Some pictures in this group, such as *The Flying Dutchman* (plate 9) and *Siegfried and the Rhine Maidens* (plate 10), have survived reasonably intact, while others, such as *King Cophetua and the Beggar Maid* (figs. 4–12, K–4, and K–4A), and the *Temple of the Mind* (plate 5) have suffered excessive deterioration.

Many of Ryder's paintings in the indirect technique exhibit what the insurance companies have labeled "inherent vice," namely, components that are chemically unstable or incompatible. The pigment asphaltum of bitumen which frequently occurs in Ryder's pictures, prevents the oil with which it is mixed from drying, thus encouraging plastic flow. He never understood that certain pigments interact with each other: for example, Emerald green is rapidly ruined by Cadmium yellow; indigo is unsafe when mixed with white lead. He failed to realize that fugitive pigments fade, leaving behind only the permanent color with which they had been mixed. A large number of Ryder's paintings are candidates for "inherent vice" classification. *The Curfew Hour* is a prime example.

One of Ryder's best-preserved pictures is *The Dead Bird* (fig. 3–6), painted in the indirect technique on a cigarbox lid. The wood support is stained a deep warm transparent mahogany tone. In many areas the dark wood grain has been permitted to show through the cool impasto pattern of the white to gray scumbled background in the center of which lies the dead bird. The bird is underpainted with scaled tones of white to umber, over which a glaze of raw sienna has been applied. The painting shows no cracks. Similarly, *The Lover's Boat* has withstood the action of time, because it too has not been painted with successive loaded layers of paint.

Since 1936 my wife, Caroline, and I have examined and treated thirty-seven paintings by Ryder. Our purpose has been to preserve them if possible from further deterioration and with minimal intervention restore them to their original appearance. Almost all of these paintings had been previous-ly structurally treated (e.g., paint had readhered, or the painting had been lined with extra canvas or even transferred to another support) and restored, sometimes excessively. We sought to remove safely later overpainting and to reveal the original paint and glazes.

Our work from 1965 through 1968 was devoted in large part to the treatment of thirteen Ryder paintings belonging to the National Collection of Fine Arts (now the National Museum of American Art). Treatment of these paintings made us well aware that the structural fragility of Ryder's pictures was due to thermoplastic underlayers of nondrying matter such as bitumen, sealed in linseed oil and varnish mixed with very slow drying pigments.

After completing our preservation of the thirteen paintings in 1968, we offered suggestions to the curator of the collection for the environmental maintenance of the Ryders. We emphasized that, except for those few pictures which were thinly painted and despite our efforts to retard and diminish the action, Ryder's materials were subject to perennial plastic flow, therefore the following advices:

1. When the paintings are placed in storage, they be kept face up.

2. Under all circumstances they be kept cool, about 40° Fahrenheit in storage and on exhibition.

3. The paintings not be traveled or lent except in compliance with the conditions stated in (2) above.

4. If possible, arrangements be made to exhibit these paintings to the public flat, in glasstop cases kept cool inside.

5. If (4) is not feasible, we suggest a method of vertical hanging be constructed so that during twelve of every twenty-four hours each painting is hung upside down while the public is not in the building.

Ryder's indifference to sound technical procedures and his careless abuse and misuse of the products of his brush leave us with an inheritance which too often has little or no relation to his initial designs. In the history of art, this kind of misfortune does not exclusively apply to Ryder, however; in few other instances has the final inheritance shown itself in such extremes of physical and chemical travesty. Few of his paintings had a fighting chance for survival as initially constructed; therefore, bear in mind that the larger proportion of Ryders we see are sadly muddied mockeries, but that occasionally we are privileged to behold works such as *The Flying Dutchman, Siegfried and the Rhine Maidens,* and others which allow us a glimpse of Ryder's unique quality of artistic imagination. In these paintings he lived up to his statement: "It is a wise artist who knows when to cry 'halt' in his composition."

MAJOR ENVIRONMENTAL AGENTS
OF DETERIORATION

CHEMICAL ↔ PHYSICAL ↔ BIOLOGICAL

CHEMICAL	PHYSICAL	BIOLOGICAL
Oxygen	Radiant energy	Vegetation
	sunlight	algae
Ozone	ultraviolet	fungi
	infrared	lichens
Carbon dioxide		plant roots
	Heat (high)	
Sulfur dioxide		Insects
	Cold (frost)	ants
Hydrogen sulfide	cycling of	moths
	heat and cold	silverfish
Acids, alkalies,		termites
salts	Abrasives	wood beetles
airborne or	dirt, soil particles	
in solution	airborne dust	Rodents
	and smoke	
Water		Man
ground waters	Water	
cleaning solutions	liquid	
Organic solvents	vapor	
	cycling of	
	relative humidity	
	Matter in motion	
	mechanical stress	
	impact shock	
	wave or mechanical	
	vibrations	

Arrows indicate collaborative and simultaneous roles of various agents. Photochemical and electrochemical actions result from collaborations of physical and chemical agents. Biological agents use physical-chemical means to ingest and digest matter.

Natural aging promoted by the joint action of many, though not necessarily all, of the environmental agents is a gradual alteration involving changes in the properties and chemical state of materials. It is characterized by color and volumetric changes, loss in cohesive and adhesive strength and embrittlement.

EVIDENCES OF DETERIORATION IN PAINTINGS

Deterioration is the result of environmental agents and properties inherent in the object. The alteration may be directly or indirectly related to the agent that caused it; for instance, shrinkage of a wood support may directly cause flaking and paint loss, but a change in atmospheric relative humidity (the indirect cause of the flaking) was responsible for the contraction of the wood. We are concerned here with evidence visible to the eye or with slight magnification, since deterioration can also be indicated by other means. We look for evidence in the separate strata starting from the surface. By relating the deterioration to what caused it we can better attempt to prevent or correct it.

1. Varnish Film

Bloom	: bluish haze and loss of transparency
Discoloration	: change to yellow-brown color
Blanching	: opaque, chalky-white appearance
Cracking, crazing	: embrittlement and shrinkage of film
Dullness	: loss of gloss and reduction of transparency
Pulverization	: blanched, powdery surface from abrasion
Scratch	: form of deep abrasion
Cleavage	: separation from paint and lack of transparency

Varnish can affect paint beneath by contraction on drying resulting in stress on weak paint film.

2. Paint Film

Wrinkling	: expansion in drying
Drying cracks	: traction crackle from shrinkage in drying
Sagging, stream lines	: plastic flow and distortion of paint
Sinking in	: (French "embu") dullness, loss of gloss, depth, and transparency

Blanching	: chalky appearance of paint from loss of medium due to extreme "sinking in" or to leaching of medium by solvents
Efflorescence	: of soluble salts or waxy materials from paint
Color change	: fading, darkening, yellowing, stain
Pentimenti	: increasing visibility of changes in design by artist
Abrasion	: loss of paint from surface due to rubbing or solvent action
Blisters	: bubbled appearance usually caused by excessive heat (not same as buckled cleavage)
Scratch, dent	: deep mechanical abrasion or depression
Grime, dirt	: may be on surface or embedded (penetrated) in paint
Interlayer cleavage	: loss of adhesion between paint layers

3. Paint and Ground

Age cracks	: cracks penetrating paint and ground from mechanical stress, shrinkage of medium with age and embrittlement
Defects in plane	: cupping, curling, dent, bulge
Cleavage	: flat or blind cleavage, cupped cleavage, buckled cleavage (cleavage pockets), loss of adhesion between strata
Flaking, chipping	: paint and/or ground loss
Staining	: discoloration of ground usually by infusing liquids

4. Support

Embrittlement	: loss of tensile strength
Distortion of plane	: warp, draw, dent, bulge
Rupture or puncture	: tear, split
Insect damage	: wood-eating beetles and other insects

NOTES

1. Ultramarine (Sadakichi Hartmann, "A Visit to A. P. Ryder!", *Art News* 1 [March, 1897]:2); Prussian blue (William H. Hyde, "Albert P. Ryder as I Knew Him," *Arts* [May, 1930]:598); Cerulean blue (Sadakichi Hartmann, "The Story of an American Painter" [1926], typescript, Library, Metropolitan Museum of Art); Malachite (ibid.).
2. Such a study on a number of Ryder paintings involving autoradiography, pigment and medium identification, and normal radiography, is currently underway courtesy of a collaboration between Dr. Elizabeth Broun, Acting Director and Chief Curator of the National Museum of American Art, and the staff members of the Conservation Analytical Laboratory of the Smithsonian Institution. The paintings being analyzed are from the most important and largest collection of Ryder's work, that of the National Museum of American Art.
3. Ryder wrote Dr. John Pickard in 1907: "In the paragraphs from a studio you will find what is practically an interview by Miss Adelaide Samson, now Mrs. Maundy: it was done from memory: and gives a wrong impression in the instance of copying old masters: otherwise quite correct." *Art in America* 27 (April, 1939): 102.
4. Lloyd Goodrich, *Albert P. Ryder* (New York, 1959), p. 14.
5. Albert Pinkham Ryder, "Paragraphs from the Studio of a Recluse," *Broadway Magazine* 14 (September, 1905).
6. Walter Pach, *Queer Thing, Painting* (New York and London, 1938), p. 58.
7. Ibid., p. 60.
8. Charles de Kay, "A Modern Colorist: Albert Pinkham Ryder," *Century Magazine* 40 (June, 1890): 252.
9. Walter Pach, *Queer Thing, Painting*, p. 60.
10. Walter Pach, "On Albert P. Ryder," *Scribner's Magazine* 49 (January, 1911): 126–27.
11. Chapter 4 of this book.
12. Lloyd Goodrich quoted in Doreen Bolger Burke, *American Paintings in the Metropolitan Museum of Art*, vol. 3 (New York, 1980), p. 12.
13. Ralph Mayer, *The Artist's Handbook of Material and Techniques*, 3rd ed. (New York, 1970), p. 14.
14. A. P. Laurie, *The Painter's Methods and Materials* (Philadelphia, n. d.), pp. 128–29.
15. Lloyd Goodrich quoted in Doreen Bolger Burke, *American Paintings in the Metropolitan Museum of Art*, vol. 3 (New York, 1980), p. 14.
16. Ibid. p. 18.
17. Hartmann, "A Visit to A. P. Ryder!", p. 2.
18. Ibid. p. 2.
19. Hartmann, "The Story of an American Painter."
20. G. B. Hollister, "Albert P. Ryder as Remembered by Arthur B. Davies," unpublished typescript (1920), RA.
21. Kenneth Hayes Miller, interview with Lloyd Goodrich, typescript, June 15, 1938. RA. There is no record Ryder ever owned a customary oval palette with a thumbhole.
22. Ibid.
23. Ibid.
24. Miller, interview with Goodrich, manuscript, February 1, 1940, RA.
25. Ibid.
26. Mayer, p. 145.
27. Miller, interview with Goodrich, manuscript, February 1, 1940.
28. Hyde, "Albert Ryder as I Knew Him," p. 598.
29. John Robinson, "Personal Reminiscences of Albert Pinkham Ryder," *Art in America* 13 (June, 1925): 183. Ryder did indeed have the two paintings sawn apart; *The Temple of the Mind* (plate 5), now in the Albright-Knox Art Gallery, and *Moonlight* (fig. 9–1) at the National Museum of American Art have each been cradled to reduce warping of the wood.
30. Weir to his wife, cited in Dorothy Weir Young, *The Life and Letters of J. Alden Weir* (New Haven, Conn., 1960), p. 241.
31. Henry C. White, "A Call upon Albert P. Ryder," typescript, RA.

APPENDIX 1

"Paragraphs from the Studio of a Recluse"

"Paragraphs from the Studio of a Recluse" is Ryder's only published statement of any length. It was a record, from memory, of an interview by Adelaide Louise Samson for *Broadway Magazine* published in September, 1905. The florid style of the language suggests that Samson may have taken some liberties in writing down Ryder's remarks, but the artist himself pronounced the interview accurate, except "in the instance of copying old masters." (Ryder to Dr. John Pickard, November 3, 1907, Dr. John Pickard Papers, AAA.)

The artist should not sacrifice his ideals to a landlord and a costly studio. A rain-tight roof, frugal living, a box of colors and God's sunlight through clear windows keep the soul attuned and the body vigorous for one's daily work. The artist should once and forever emancipate himself from the bondage of appearances and the unpardonable sin of expending on ignoble aims the precious ointment that should serve only to nourish the lamp burning before the tabernacle of his muse.

I have two windows in my workshop that look out upon an old garden whose great trees thrust their green-laden branches over the casement sills, filtering a network of light and shadow on the bare boards of my floor. Beyond the low roof tops of neighboring houses sweeps the eternal firmament with its ever-changing panorama of mystery and beauty. I would not exchange these two windows for a palace with less a vision than this old garden with its whispering leafage—nature's tender gift to the least of her little ones.

Imitation is not inspiration, and inspiration only can give birth to a work of art. The least of a man's original emanation is better than the best of a borrowed thought. In pure perfection of technique, coloring and composition, the art that has already been achieved may be imitated, but never surpassed. Modern art must strike out from the old and assert its individual right to live through Twentieth Century impressionism and interpretation. The new is not revealed to those whose eyes are fastened in worship upon the old. The artist of to-day must work with his face turned toward the dawn, steadfastly believing that his dream will come true before the setting of the sun.

When my father placed a box of colors and brushes in my hands, and I stood before my easel with its square of stretched canvas, I realized that I had in my possession the wherewith to create a masterpiece that would live throughout the coming ages. The great masters had no more. I at once proceeded to study the works of the great to discover how best to achieve immortality with a square of canvas and a box of colors.

Nature is a teacher who never deceives. When I grew weary with the futile struggle to imitate the canvases of the past, I went out into the fields, determined to serve nature as faithfully as I had served art. In my desire to be accurate I became lost in a maze of detail. Try as I would, my colors were not those of nature. My leaves were infinitely below the standard of a leaf, my finest strokes were coarse and crude. The old scene presented itself one day before my eyes framed in an opening between two trees. It stood out like a painted canvas— the deep blue of a midday sky—a solitary tree, brilliant with the green of early summer, a foundation of brown earth and gnarled roots. There was no detail to vex the eye. Three solid masses of form and color—sky, foliage and earth—the whole bathed in an atmosphere of golden luminosity. I threw my brushes aside; they were too small for the work in hand. I squeezed out big chunks of pure, moist color and taking my palette knife, I laid on blue, green, white and brown in great sweeping strokes. As I worked I saw that it was good and clean and strong. I saw nature springing into life upon my dead canvas. It was better than nature, for it was vibrating with the thrill of a new creation. Exultantly I painted until the sun sank below the horizon, then I raced around the fields like a colt let loose, and literally bellowed for joy.

It is the first vision that counts. The artist has only to remain true to his dream and it will possess his work in such a manner that it will resemble the work of no other man—for no two visions are alike, and those who reach the heights have all toiled up the steep mountains by a different route. To each has been revealed a different panorama.

The artist should fear to become the slave of detail. He should strive to express his thought and not the surface of it. What avails a storm cloud accurate in form and color if the storm is not therein? A daub of white will serve as a robe to Miranda if one feels the shrinking timidity of the young maiden as the heavens pour down upon her their vials of wrath.

Art is long. The artist must buckle himself with infinite patience. His ears must be deaf to the clamor of insistent friends who would quicken his pace. His eyes must see naught but the vision beyond. He must await the season of fruitage without haste, without worldly ambitions, without vexation of spirit. An inspiration is no more than a seed that must be planted and nourished. It gives growth as it grows to the artist, only as he watches and waits with his highest effort.

The canvas I began ten years ago I shall perhaps complete to-day or to-morrow. It has been ripening under the sunlight of the years that come and go. It is not that a canvas should be worked at. It is a wise artist who knows when to cry "halt" in his composition, but it should be pondered over in his heart and worked out with prayer and fasting.

The artist needs but a roof, a crust of bread and his easel, and all the rest God gives him in abundance. He must live to paint and not paint to live. He cannot be a good fellow; he is rarely a wealthy man, and upon the potboiler is inscribed the epitaph of his art.

A Selection of Ryder's Letters

Although Ryder spent much more time painting than writing letters, a surprising number of his letters and cards have survived, two hundred in all. Undoubtedly some are lost, but those we have tell us a great deal about his personality, attitudes, and thought processes. (Unfortunately, replies to his letters have not been found.)

Ryder wrote to people from various walks of life—artists and collectors, many of whom were his friends, critics, dealers, and professional colleagues. These letters, on the whole, do not reveal a great deal about his views about art. In reading them, one can piece together something of his aesthetic credo, though this is by deduction rather than from an abundance of evidence. Occasionally, in writing to his clients, Ryder would talk about the progress of this or that picture, the struggles that he was undergoing in completing it, and his general method of conceiving a work of art. But he did not use his letters in a major way to philosophize or to develop his theories of art.

His letters to his close friends are filled with tender emotion, and there is often a note of chivalrous, poetic sentiment in them. Ryder would frequently accompany his letters with poems on the occasion of friends' weddings or the marriage of one of their children. His language is usually direct and straightforward, though at times he would drift into poetic vagueness and suggest rather than articulate his meanings clearly.

Although Ryder's popular image is that of an artist who shunned public attention, in his later letters we find a fair number of references to publicity about his works in one publication or another. He was obviously involved in the process of giving information, including photographs, to critics and journalists and seemed to enjoy doing so.

The following letters, each quoted in its entirety, were selected because they reveal various interesting facets of the man and his art. Persons and locations not mentioned in the text are identified here, where possible. His original spelling, spacing, and punctuation have been retained exactly as they appear in the letters. Necessary elements of punctuation have been inserted in brackets only when they have been urgently needed to clarify Ryder's meaning.

Abbreviations used in the letters

AAA Archives of American Art, Smithsonian
 Institution, Washington, D.C.
ELC Philip Evergood–Harold O. Love collection
 of Ryder materials (see chapter 1, note 7,
 for details)
FFSC Frederic Fairchild Sherman's collection of
 Ryder research materials
RA Lloyd Goodrich–Albert P. Ryder Archive,
 University of Delaware Library, University of Delaware,
 Newark

Harold Bromhead was an employee of Cottier & Co., of London and New York, Ryder's first dealer. The tone of Ryder's letters to Bromhead suggests that a warm friendship had developed between the two men. Ryder felt special affection for the Bromheads' daughter Elsie. [Typed copies, FFSC, RA. Location of originals unknown.]

308 W. 15th St.
Aug. 2d. 1901

My dear Bromhead,
 I feel I must encourage you a little in regard to the work coming along.
 I am bending all efforts that they may be ready this month; fortunately I have fine energy just now and will be able to work nights if necessary.
 I feel if I am able to carry out this plan that it should be fairly good time; in light of the difficult problems, and the fact that I lost both the Lorelei and the Passing Song but have them under way again; I am treating the Lorelei in a way that I think will give you pleasure; I will not describe, but haste all the more that you may see for yourself.
 I have put this matter first, but my real pleasure was to hear from you and your family, and that I could have given pleasure to your dear little angel of a girl, you are most fortunate; and I am pleased that I could have come in touch with your happiness by my little call before you left.
 I appreciate the honor from you and Mr Thomson and I sincerely hope my work will be up to expectations; it may be interesting to you to know that the treatment I am adopting for the pictures is in a measure a kind of revelation for method to introduce in some stage of my future work.
 So another link in the chain of good fortune from the pleasure and honor of your acquaintance.
 Mrs. Gellatly's Uncle a Mr. Rogers, locomotive builder has died and left her and other relatives $25000 each and $5000000 or more to the Metropolitan Museum.
 Some of the heirs are to make a contest; but the opinion seems to be that it will be a hard will to break as he copied it from one that successfully stood a contest in the courts.
 I have'nt much news from the store as I have been so closely occupied here, and so desperate for time that it has seemed almost impossible to get up there.

I wish it had been so that you could have been around in the doing of the work; on second thoughts I take it back as the heat has been pitiless, and I wish you every thing good instead.

Lloyd Williams asked me to go over with him, to "Merrie England." Two invitations to go to Portland, Or. and one to visit in the woods of Maine.

Now I must wish you the best of health for your family and yourself. I hope some day to have an encore of my pleasant call in 52d St.

And with a promise again to do all thats possible for me.

> *I am Yours Faithfully*
> *Albert P. Ryder*

P. S. If Weir should drop in on you tell him I meant to have him down the evening of his sailing but found that by Saturday night which was the impression with me for his going aboard he was already on the Broad Atlantic.

> *308 W. 15th St.*
> *Oct. 12, 1901*

My dear Friend,

 Harold W. Bromhead

Your letter was of the greatest possible cheer to me, coming as it did, when my eyes were plaguing me quite severely; and when I was inclined to be nervous about the time and becoming conscious of the possible disappointment as to the hopes I had raised by my letter: my eyes started on the rampage directly after I had written you, and with me it is a particularly dangerous matter; as if I do not indulge them there is a great possibility of little ulcers coming on the eye itself; I need say no more to explain how serious a trouble of that nature has to be taken.

I was so pleased with your sentiments and your correct attitude toward the combination of Pegasus and those dependent on him that I would have written immediately if it had been possible; or if I had not felt I must give up everything that risked an aggravation to my trouble.

You must not be too much concerned as I will soon be all right and I am just now thinking that possibly my new glasses are not just the thing.

Now to the more cheerful phases of our acquaintance; and particularly to the pleasure of seeing you domiciled here for a little while as of late, with your dear family around you; which is as it should be; and as you mention the benefit of their previous visit; it is always so: a complete change of that nature is of incalculable good to everyone often felt for years afterward.

I would like to have answered more fully your exceedingly kind letter and gone more into details of subjects that interest

us; but am fain, in the sense of Locke and Dr. Johnson, to be content with best wishes for Mrs. B. and little Elsie and yourself;—a pleasant voyage, and to assure you that I am hopeful; concerning my own affairs.

> *Affec. Yours*
> *Albert P. Ryder.*

P.S. Of course I feel very kindly to Mr. T. and have great esteem for his qualities.

> *308 W. 15th St,*
> *Mch. 20, 1903*

My dear Bromhead

I was very pleased to get your letter with the news of it.

It is very gallant to Elsie to write as you do; and feel quite sure it will be for the best.

I was in hopes to have sent you some messages by Mr. Hart; but he was very busy to the last minute, and I have been writing you ever since, to convey my good wishes in your change, and in general I shall of course miss your connection with Cottier & Co; but as you are happy not to say fortunate to be with such a famous house, and as friendship has nothing to do with this or that connection, and as you think it possible that you may be here at times, why there is nothing to do but rejoice when you rejoice: understanding of course that there are regrets in all changes.

The Magazine of Art has a distinct loss in Mr. Thompson, it had become a very much improved publication, and he is a man I have great admiration for.

It probably would have been better to have tried to get photographs of pictures already made; but I look on all these matters as for the best when the best has been done.

All though things have'nt materialized yet it is not because I have held the honor lightly, but more because I have, There have been accidents & c. and a fault, I sometimes think, the smallest thing I do: it is as if my life depended on it: and then the great shadow, always, of the impossible and the unattainable.

It may please you to hear what Bauer [Theodore Baur] has to say of the Passing Song.

I take it for granted he means that if they did not know the origin, that if someone was to take it to Germany, that they would write essays about it and poetry, speculate as to its meaning, and altogether be in a great state over it.

Mrs. Bromhead and yourself have my kindest and best wishes, and with love to little Elsie sweetheart, and she may be pleased with her new playmate—

> *Affec Yours*
> *Albert Ryder*

A pioneering collector of American art, Thomas B. Clarke was Ryder's first major patron. These letters document Ryder's excited response to Clarke's interest in, and purchase of, his work. [Thomas B. Clarke Papers, AAA.]

Apr. 7 [1885]

My dear Mr. Clarke

Many thanks for your kind remembrance of the fourth hundred for the Temple of the Mind.

So sorry not to have seen you as I think you may have brought it personally.

I am in ecstasys over my Jonah: such a lovely turmoil of boiling water and everything

Dont you think we should try and get it in the A.A.A.

If I get the scheme of color that haunts me: I think you will be delighted with it.

> *Good Bye*
> *till I see you*

> *Sincerely yours*
> *A. P. Ryder—*

[1885]

My Dear Mr. Clarke.

Many Thanks for the fifth hundred but so many more for all those nice sentiments.

I find myself so childish in a way. I am so upset with a little appreciation that I can hardly be quiet to acknowledge the source.

Everybody is very nice I must say: but you have such a happy confidence and courage that it counts tremendously in nerving a man and and [sic] bringing out his endeavors.

I was saying to Mr. Inglis only the other day that you are one of the few who have the passion of a collector; that of course brings its own joy.

But I also wish you the honor that belongs to one who has made such an impression on the art impulse of the country.

I think you can hardly realize how much it means.

For a long time I have observed a marked change in the attitude not only of the press but also of collectors toward the possibilities of something being done here, amongst us: to you much of this credit belongs: and I am so happy to be identified with your mission and that, with the two chief efforts of my ambition: I cannot but feel someway that in both the Temple and the Religious picture I have gone a little higher up on the Mountain and can see other peaks shining along the horizon: and although I suppose their are conditions that make perhaps what I cannot do again, in your selections yet I know you will wish as I hope, to keep the banner forward and in other things justify your faith and appreciation.

With great respect and appreciation.

To *I am yours affectionately*
T. B. Clarke Esq. *Albert P. Ryder*

Charles de Kay was the first critic who consistently and enthusiastically offered friendly encouragement to Ryder. Together with his brother-in-law Richard Watson Gilder and sister Helena de Kay Gilder, equally Ryder's friends, he interested others in Ryder's work. These two letters from Europe, written in 1882, along with one to William R. Mead penned at the same time, are primary documents of Ryder's summer travels of that year. [The undated (May, 1882) letter exists in a photographic copy, RA. Location of the original is unknown. The letter of July 5 (1882) is from a manuscript copy made by Mrs. John (Phyllis de Kay) Wheelock, daughter of Charles de Kay, RA. Location of original unknown.]

[May, 1882]
3 St. James Terrace
Regents Park.
N. W.
London.
Eng.

My Dear
de Kay,

I hope this finds you well along with your book.

If you find enclosed properly expresses the appreciation you know I must have for Miss Howe's more than kind consideration, will you kindly direct it to her.

I think of you nearly every day: and I wish you were here I think I wrote you about visiting Exeter and all these places. Since then I have been to Leicester, saw the Prince and Princess of Wales: took a run from there to Coventry, a delightful old place, so splendid and old that it is moldy—

There is an old Alms House for seven old women that is perfect in its old architecture, a picturesque paved close, with these funny timbers let in with the plaster

I want to visit these places again and have all the time I want.

We went to a circus at the Coventry fair; Entrance two pence On a platform the stars were hopping about and cutting capers before the performance began.

Reminding me of Brownings lines that begin "Come trip and skip Elvire."

Pushed on next morning to Stratford on Avon: what a delightful place.

Fine view of the castle at Warwick on our return.

Unfortunately it was not open for us to see.

If you have had patience to get this far and forgive me I promise not to write on such paper again,

Cottier and I will hunt up Homer Martin after our travels so probably will have a message for you.

I have got my money from Scotland.

I laid out Mrs. Moores card: but must have mislaid it—

Will call on her if I can find address. Presume there will be some way in Paris for these things.

<div align="right">

Good Bye
With True Affection
Albert P Ryder

</div>

[Across side and top of page]

I remember very kindly the Berdans and Miss Lazarus and all those friends. Do not forget the two Mr. Wards. I can't Enumerate all, so will finish [illegible words]. Yours [?]— Good Night What a host of letters I have got to write

[Across side of another page]

I shall write Mr. and Mrs. Gilder and your Mother. Please remember me.

<div align="right">

Farewell

</div>

Peggy Cottier says it is easy to write to Mr. de Kay.

[Upside down on bottom of first page]

I am sealing this in the fields at West Drayton. "Hark I hear the Cuckoo."

<div align="right">

At Sea
Between Gibraltar
and Tangiers

</div>

5th of July [1882]
My Dear DeK

How did you spend the fourth: I passed it on the way between Cadiz and Gibraltar

And am now making with several others including Cottier and Warner a mixed crew or lot of passengers of Moorish, Spanish French, English, Greek Scotch and Americans

There is a Moorish lady who spends most of her time trying to cover her face and has succeeded at last by lying down and covering herself completely. Our Captain is in a great State he has lost three hours towing the bark Accadia out of Gibraltar and now finds he has lent his keys to a Clerk who took them in shore.

I wish you could see the lovely mountains that tower on the Afric coast it would do your poetic soul good, a lovely vapour closes around them and passing over their brow is a lovely cloud between the sight and them giving an indescribable charm to their beauty—Cool and lovely is the air after the hot arid plains of Spain I am quite surfeited with travel and would like to be home again: this small shaky boat makes it almost impossible to write so will stop now and finish after seeing Tangiers Good Bye just now

Back again to Gibraltar after rubbing shoulders with yellow Moors and red Moors and black a moors I guess you will think this letter has a nice kaliedescopic look, I broke my Stylo Pen and have now bought an ink pencil you wet the writing and it turns into ink. Cottier is all the time insisting it

is ink already and is quite amazed at my always speaking about wetting I tell him that it is what the man showed me to do.

I am now aboard the Caldera bound for Marseilles where we expect to bring up Tuesday morning today being Sunday

My trip so far from London has cost me 250 dollars and I have 150 left.

Cottier says I will have to write for money oweing me 150 in New York on the last picture I painted

Write me if Mrs. Moore should be away from Paris if it would do to leave a note for her when I get there: we want to work Rome Naples, Venice, home by way of Switzerland and Germany. Cottier will help me out till we get to London: he doesn't cease to wonder at my seeing so much on a few months work last winter: he says I will have to walk home &c.

We were asking about the Museum at Marseilles. The Captain says Yes it is a fine museum but, there is nothing in it:

<div align="right">

Monday

</div>

148 miles yet from Marseilles: yesterday they were agoing to have us in to night at 10 o clock: we have concluded that they always do it in the same time but always thinking they are agoing to make some phenomenal run and fetch the night before or something.

Warner is just shouting over the Cover "If you want to know where we are Ryder we are just off Barcelona about to round the point into the Gulf of Lyons.["]

I fear there is a lingering joke behind as I have shown a great need of Geographical knowledge during our travels although it was my favorite study at school

[sketch of figures walking and riding donkeys]

Here we are Setting out to climb Gibraltar, Warner's Cuddy was great for rolling!

I wish I had Cottier's knack for writing there's hardly an incident he cannot raise the laugh on: from my burning the umbrellas from taking to smoking Vesuvious as he terms it to our traveling by excursion tickets and generally paying over again.

He wrote to Inglis not to worry as we took our whisky neat in a tropical sun with our over coats on

He was reading his letter to me and it was as good as a comedy or burlesque rather Every once in a while he would say let me see: forgot what I wrote there[.] he thinks people should copy their letters after first writing them

He is rather badly stuck here on the ship as no one speaks English except one passenger from Gibraltar. He tries hard to talk though, and tries to ask the Engineer about things breaking down: by dropping his shoulders and making his arms collapse. But it is no go, parlez vous broken French and English only go a little way—

Oh—I forgot a Tuscan who is on his way home to take his

homesick brother & sister in law and family we go and make him a visit every day, and listen to his pigeon English: he makes us laugh quite often; we have one man in irons tonight: he is the policeman of the ship strange to say, the row was over the cooks boy who tantalized him into kicking him and then the Gravy man sallied up and called him a beggar and tweaked his nose and then a free fight and now the feet in irons

Good night
Charlie

Tomorrow morning Marseilles

If you think well that I should write Mrs. Moore if I should miss her in Paris will you answer and give address: if you too have lost the address I suppose I can get it from Sargent or some book in Paris

Remember me to your Mother and sisters and write me if Miss Howe's picture went straight,

I shall be glad to see you once more and all kind friends—

I think I will be benefitted by seeing so much

Cottier has come and joined in writing and is going ahead like a steam engine

Cottier sends his kind regards and hopes you dont miss me too much and we will be full of stories when we get home

Warner says write we are now full of fleas and will be full of stories after—

Give my love to Lohengrin van Cleef and tell him that I miss the Herald very much—

We met Chase, Vinton, Blum and Lundgren in Paris bound for Spain—Or as they call each other Blum Tony and Lundgren Blum–also R. Gifford

Give my love to Eaton[,] White, Weir and everybody

Wishing for the time to roll around when I can take you by the hand, not forgetting Gilder

I remain
affectionately
Yours
Albert P. Ryder
3 St James Terrace
Regents Park
London West

John Gellatly was an important collector of American art who owned a sizable group of Ryder paintings. In these letters, the artist deals with a variety of artistic concerns. [AAA.]

308 W. 15th St
June 8 1897

Dear Mr. Gellatly

I hope Mrs. Gellatly and yourself will find the enclosed verses of the "Flying Dutchman" up to your expectations.

I am pleased to have the opportunity to tell you how much I enjoyed my evening with yourselves and your collection, which is formed with a good deal of feeling and judgment.

I have a memory of something oriental of your rich rooms and the little Japanese.

In fact I feel as if I had been away and come back again.

Yours Sincerely
Albert P. Ryder

P.S.—If you should have the verses inscribed on a tablet as you thought of doing, you had best make sure that the carver has them correctly lettered; For with the exception of the Century Magazine I have never had a poem faithfully rendered.

And in one of the Societys catalogues most lugubrious mistakes were made.

As "Castled Hill and Lake" were printed, cattled hill and lake, and other blunders, making one wish he had never courted the gentle muse.

308 W. 15th St
Aug. 24.1905

Dear Mr. Gellatly:

Thank you for your remembrance; and of course the information is inspiring of the gallery and the pleasure Mrs. Gellatly and yourself expect in the Beggar Maid picture

Consider this an acknowledgement of your note: and within two weeks I will reply directly to your letter

I have had considerable trouble with my eyes, and although better I can not tell just how they will stand a continuous strain till I make a trial.

Of course there has been no time when I would not have been pleased to see everything finished; and ideals realized.

As I understand the trouble of my eyes, it is due to a strain, and they exact a fair chance to get right again and are doing as well as I could expect.

I realize from your point of view that you have been patient and deserve credit for it.

Although I may have seemed indifferent; tis only seeming.

Assure Mrs. Gellatly for me I value her esteem; and I hope it will be earned by the finished picture: I have a fancy that she understands possibly better than you or me the meaning of such a work and the difficulties and also the limitations pertaining to it.

More Anon,
Very Sincerely,
Albert P Ryder

308 W. 15th St
Nov. 20, 1905

Dear Mr. Gellatly

The time is at hand for your gallery in your new house to be completed: I hope both will be entirely to your liking.

As to your picture The fact must be realized that it must be all felt out again.

Can you wait? or do you wish to wait?

If you have the patience, and the desire to do so: I shall of course do all in my power to make it as good as before. Contrary: if you are tired of it all, I will cheerfully return your retaining fee.

Allow me to say that I cannot in any sense accept a defensive position in the matter.

The commission when taken was a compliment to you.

The disastrous effort to finish it in a certain time was your suggestion: and I assure you the loss of all the previous work on it is by no means a light one.

However I take it all lightly; as the fates decried it so.

If you decide to wait you will sadly have to wait as my obligations in other directions are really greater than in your case.

If not: as I have said, I will cheerfully refund the $200—Two hundred dollars.

Now all this is written with the best feeling: and whichever way you decide; will also be accepted with the best feeling

With best wishes to Mrs. Gellatly and yourself and much pleasure to you in your new home.

I am Very Sincerely Yours
Albert P. Ryder

308 W. 16th St
Mch. 26. 1910

My dear Mr. Gellatly

I spent a delightful evening Thursday.

Mr. Arthur Beaupré was kind enough to play some selections from Chopin. And Miss Inez Sanden played a beautiful composition of Schumans beautifully.

Mr. Beaupré has a great love for pictures: and is anxious particularly to see the "Flying Dutchman["] I told him I was sure you would be pleased to show him your gallery.

While not a professional musician he plays with rare feeling and appreciation and brings the same qualities into the picture world, making of course a great pleasure in the showing of them.

I promised to write you: although I told him I did not think it necessary as you were generous in showing your things

Mr. Hartley a young painter was here yesterday to get your address which I gave him.

He thought a line too would help him: I told him it wasn't necessary as you had promised Mrs. Fitzpatrick to show him your treasures: I did not know that you had been told by her that I would probably do so.

So a gracious duty is twice performed in one note

I have been trying to write you of my change of address:—have been unsettled ever since moving and am still: but of course must be soon.

Will let you know just as soon as it happens.

You and Mrs. Gellatly, pray pardon seeming neglect although I have notified no one as yet.

Best Wishes: and was pleased to hear from you through Mrs. Fitzpatrick.

Albert P. Ryder.

In his letter to the Montreal collector E. B. Greenshields, Ryder speaks of the purchase and delivery of *The Sentimental Journey* (fig. 8–5). [RA.]

[1889]
52 E 11th St
Hotel St Stephen

My Dear Mr. Greenshields

I take pleasure in shipping your picture today; hoping you will be as pleased as when you saw it here; I have no doubt you will be more so; when you get it home with your other treasures; as my work always looks better away from the Studio.

Both pictures I consider two of my best.

The Sentimental Journey you will remember was given up by Mr. Inglis in order you might have it; and [Frederick S.] Church in speaking of the Joan of Arc considered that and one other picture the two best in the Prize Fund Exhibition of 87 I think it was. So I think we have good authorities with us in our selections.

Hoping Mrs. Greenshields will be pleased with the new purchase, and with kind remembrances and particularly our little daughter and also other friends.

I am Yours
Affectionately
Albert P. Ryder

P.S. Where I have so many good friends among you I do not like to specially mention one, so that is the reason I do not mention names more than I do, but perhaps in consideration of recent honors it might be kind to let Mr. Van Horn and

Mr. Popham know that they are specially remembered to-
day—So Good Bye once more.

The little strips of wood may be kept around the edge of the
picture as they fill up the rabbit in the frame nicely.

Oliver says the moonlight does not need lining in back, had
better not be: at least at present.

The tone of this letter to the New York art dealer William Macbeth, who
had begun to handle his work, is unusually forceful for Ryder. He objects
strongly to Macbeth's plan to restore one of his paintings. [From a photo-
graphic copy of the letter, RA. Location of original unknown.]

 308 W. 16th St.
 Nov. 9. 1911.

My Dear Mr. Macbeth:

Your favor of the sixth at hand this a.m., you say nothing
will be done to mar my beautiful color: and then you say the
old varnish will be removed: that you cannot do without in-
juring the picture seriously; all it needs is to be washed and a
thin coat of varnish if you like.

How Mr. Cottier was amused at the cleaned Corot's that
had been painted some years, made to look as if they were
painted yesterday. I refer you to the verdict in the English
Courts sustaining Whistlers contention that a man did not
wholly own a picture by simply buying it.

Ergo, I have a right to protect my picture from the vandal-
ism of cleaning, if it needed it I would not say a word. I had
a good look at the picture and I assure you that no picture is
in a better state of color; and if only washed and thinly var-
nished will look as it did when just finished.

It is appalling this craze for clean looking pictures. Nature
isn't clean, but it is the right matter in the right place, to
paraphrase Faraday [Michael Faraday, English physicist
and chemist].

I can't remember that the picture was ever varnished.
Heed what I say.

 Truly yours.
 Albert P. Ryder.

In these drafts of letters to the widow of his teacher William E. Marshall,
Ryder sheds a great deal of light on what he saw in Marshall and reveals his
high opinion of his work. [ELC, RA.]

 [1906]

Dear Mrs. Marshall:

I have just learned of your sad loss: and of mine in my
talented and gifted master William Edgar Marshall.

I have often wished I could have been a pupil of his
charming personality: but I do not believe it possible that
there should be another: so perfect a gentleman.

No one but Shakspere or Burns could picture his manliness
and gentleness and giving of himself to others.

Of his art, that the French Government should purchase
and place in its school his two masterpieces of Washington
and Lincoln is the highest possible endorsement: [the follow-
ing words were crossed out] enhanced by the fact that their
author was living.

"But Departed, for the Artist never dies."

You are more blessed than many: in the comfort of your
husbands genius which remains to the world: may all that is
possible be combined to solace your affliction; and the Divine
comfort[?] be with you.

[after first paragraph and across side of page]
*just on the eve of my intended visit in response to your kind
invitation I having learned you were in the city*

 308 W. 15th St.
 July 22. 1909

Dear Mrs. Marshall:

The Durand portrait is in my mind; and I can see it as
clearly or more so than any portrait I have ever seen; the
thoughtful brow, the serious but not stern face, a man typical
of the time when it was painted.

I think it one of the best portraits.

The fact that I can recall it so vividly, is one of the best
proofs of its excellence.

Never have I seen the man behind the face so well done.

In fact I think if it could be placed in company with the
finest portraits of any period the Durand would have to be
acknowledged the superior in point of the soul showing in the
portrait.

Nor is it strange it should be so: great as Rembrandt and
the others are; they were painters and delighted in painting:
Marshall's gift for portraiture was more phenomenal; keener
in his insight into the character of his sitter in the Durand
portrait, making him live as Shakspere would have done in a
word portrait.

It is convincing: one feels in its presence, here is the man.

 Yours very Truly
 Albert P. Ryder.

William R. Mead was a partner in the architectural firm of McKim, Mead, and White. Ryder's cordial, chatty letter to Mead, describing his May, 1882, stay in England, suggests that he knew the architect well. The letter is of special interest because records of Ryder's travels are extremely rare. [From a photographic copy of the letter, RA. Original in the J. Alden Weir Manuscript Collection, Brigham Young University Library]

[Mailed May 27, 1882]
3 St James Terrace
Regents Park.
London.
N.W.

[To William R. Mead]

I hope this reaches you before you leave for this side: I intended seeing you all before I came away but I was rushed up to the last minute finishing a picture or rather two pictures at seven o'clock the previous evening to sailing which hour was 1/2 past 7 in the morning.

I hope you have as lovely a trip as we very smooth and delightful weather.

fearful lot of gambling they even wagered amount taken for benevolent fund: one old jew named something or other I thought I could recall it: amused us immensely, the least chink of money woke him up amazingly. And anybody matching had him peering over their shoulder in no time eager for a chance I will see if I can draw his face. [sketch]

I have just seen the Derby. found it very interesting—took a bus at Piccadilly and drove over Blackfriars Bridge—soon gaining the picturesque lanes that lead to Epsom: I suppose you know of so I will not attempt to describe it: the innumerable breakdowns and capsizes.

Returned with a drunken driver and a lead mare who can kick for a prize and will travel better over the traces than in them—

She kicked off both hind shoes within the first mile from Epsom came near breaking the heads of a dozen pedestrians: in fact they only escaped by a miracle as the way is so narrow that they have to crowd pretty close.

My adventures ended with them at Serberton [Surbiton] where the driver started down a long and steep hill, about the length of Wall St. I should think on a good run with no brake I suspected mischief and watched the horses narrowly to see if they were equal to the speed of the accelerating bus, meantime the guard was merrily winding the horn which soon changed to cries of alarm as the Bus went faster and faster meantime the kicker had been led behind and the great pace made her yank the stable man through the Bus door, first the leader down then the off Pole and at the bottom of the hill all in a kicking pile together. I didn't think one would be able to stand on their legs but apparently a few scratches was all the mischief: but [written across side of page:] they had kicked off all the whiffletrees so they hitched up by fastening to the

steps of the Bus and as the same man was again to drive I bid farewell to [written across top, and upside down across bottom and side of previous page:] my English cousins and left them in a compound row with a policeman and a man who had called him and another who had helped rescue the horses and wanted pay or drink money. I took the train home reaching here about 11. I am curious to know how they got along I bought a paper yesterday giving an account of a bus accident thinking it might be that one but it turned out to be another so I suppose naturally I was disappointed not hearing some melancholy news of the Royal Oak [words illegible] of London. [written across sides and upside down on top of first page:]

I would write your brother if I knew his first name Won't you kindly let me have it as curiously enough I do not think I ever heard it called. Remember me to him and White and McKim and [George W.] Maynard and Weir and Lathrop and Warner and everybody have got to write Brown as I did not have time to see him although I do not suppose it really necessary

Good Bye Ryder

Wish I had taken another sheet.

I have got to after all. Be sure and hunt me up it will give you no great trouble and if it is nearer to enquire in city go to 32 Argyll St. West, Cottier's London office.

Have been to Exeter—Saulisbury and Sherborne—splendid old doorway at latter place in the old cathedral: Ethelbald and Ethelbert brothers of King Alfred are buried there: but I suppose I am telling you what you know better than I.

Expect to go to Spain Monday: by way of Paris.

Will write everybody in turn tell Warner he is a Snoozer not to have been over by this time besides his burly form would be good target for the Spanish Stiletto.

Tell St. Gaudens to take things easy and to learn to smoke: Tell the brother St. G. to take a wife and raise a cousin for his little nephew.

You are so busy that if you just answer with a postal card it will do: I commenced writing you last week but my Stylograph gave out.

How is Eaton tell him he will soon hear from me: Shall write Weir next: as this letter will do for your brother too and White.

England is beautiful. I feel it is not fair to give you so much to read so will stop short.

Good Bye
Not forgetting anybody
Sincerely Yours
Albert P. Ryder
32 Argyll St
London
West

Kenneth Hayes Miller, a noted teacher and painter, had been a young admirer of Ryder and began to cultivate his friendship in 1909. A proposed visit of Miller and his cousin Rhoda Dunn, a poet who admired Ryder's verses, is the subject of this letter. [Kenneth Hayes Miller Papers, AAA.]

<div align="right">

308 W. 16th St.
Apr. 20. 1910.

</div>

My Dear Kenneth Miller:

I have been trying to write you for a week, so as to give you as much time as possible, and not to be too near the eleventh hour of your leaving the city. However I hope you and Mrs. Dunn will be able to make a day for your expected call.

I would like to have been in better order for so sweet a lady but I will at least be able to spread a rug and keep the writer of "the Aeronauts" out of the dust which I feared if you took me unawares.

I think you misunderstood when I said not to bring the gifted lady into this dusty place.

I didn't mean you were not to come, but to wait until I could clear a space and as I have just said spread a rug down.

So if you can come do so: and it will give me great pleasure to thank the giver of sweet praise, which was very acceptable to one, who has had little, yet more than he realized through a certain reticence in believing: as Chas De Kay said, didn't I publish one of your poems: I answered I didn't think you meant it.

<div align="right">

Affec. Albert Ryder.

</div>

P.S.

I would like to have written Mrs. Dunn as well; but the promise of a written verse will be kept: as they have been used more as a mark of honor to friendly friends, and an appreciation of kind sympathy: although many of the deserving still are on the list.

<div align="right">

To be remembered.
Sincerely Albert P. Ryder
Try to let me know the day & hour

</div>

The Chicago poet and critic Harriet Monroe had visited Ryder in his New York studio. We do not know how close their relationship was, but it is clear from this letter that Ryder admired her and wished to cultivate her good will. Ryder's own poetic sensitivities undoubtedly made him especially responsive to her verse. [University of Chicago Library.]

<div align="right">

[1892–93]
60 E. 11th St.

</div>

Dear Miss Monroe,
Many many thanks for your kind remembrance.

I should have acknowledged sooner if I had not been called away to bring home my Father who was stricken at Fal-

mouth: but who I am happy to say has miraculously recovered

I was, and am, astonished, and delighted with your wonderful ode.

It begins in a most inspirational, and I may say colourful way. rising in most eloquent strains as you proceed.

Almost anywhere one may choose a passage on opening the book, as an instance of sustained eloquence and beauty.

I think this, among many, very beautiful "O strange, divine surprise out of the dark man strives to rise["] and so on.

I think all the lines that lend themselves to song exceedingly musical and brilliant.

I should have liked so much to have heard them rendered under Thomas' direction.

Mr. Weir requested me to convey his appreciation also; and to give remembrance to you.

With kindest regards to your sister and yourself, again thanking you for the joyous surprise of the ode and the hopeful promise that I may see you again.

<div align="right">

Believe me
Most sincerely
Yours
Albert P. Ryder

</div>

"Columbia, my country, dost thou hear?
Very beautiful all [written at an angle]
 and praise"
Long hid from Human Awe"

This letter to Alexander Morten, a collector of Ryder's paintings, is a unique document because Ryder speaks of the problem of forgeries and also authenticates the works Morten owned in 1915. It is the only known letter of its kind. [Typed copy, AAA. Location of original unknown.]

Alexander Morten Esq.,
141 East 21st St.,
(New York City)

<div align="right">

November 1915.

</div>

Dear Mr. Morten:—

As you are aware, I rarely sign my paintings, having always felt that they spoke for themselves: but in view of the value you place on your collection and of the fact that your collection contains, I believe, many more paintings by my brush than are in any other collection and particularly because, I am sorry to say, a great many spurious Ryders have lately come into the market, I gladly, at your suggestion, write to state that I am personally familiar with every one of your fourteen paintings by me now hanging in your house and described below and hereby attest their authenticity as having been painted by me.

<div align="right">

Yours faithfully,
Albert P. Ryder.

</div>

Witness: Kenneth Hayes Miller.

THE HUNTER'S REST. 14 x 24.

Horse in center with saddle and bridle, the hunter seated at foot of big tree with his three dogs. In the background waning light in sky and heavy clouds.

PLODDING HOMEWARD. 10 x 16.

Peasant driving horse and wagon in the gloaming (with the moon rising over hills)

THE LOVERS. 10 x 6–1/4.

Two young lovers with a dog at the foot of each. Time, Evening. Background: a richly wooded park.

THE PASSING SONG. 8 x 4–1/2.

In the foreground a woman with a lyre in her left hand; and a wine-glass in her right. In the background, a man in a red shirt sailing a boat with one sail.

PAINTING. 10 x 27–1/2.

Ship at anchor. Two seamen crossing the sand from the boat to their cottage under the rocks, each carrying a bundle and a dog separating the two.

PAINTING ON GOLD LEATHER. 8–1/2 x 26.

A gondolier, or ferryman, punting large boat with an awning in stern in which are seated two (?) people: the destination apparently being a tower or small castle in the upper left-hand corner.

LARGE LANDSCAPE. 12 x 16.

Pond. In immediate right foreground a tree; and heavy woods in the background to the right.

HUNTER AND DOG. 9–1/2 x 12.

Hunter, mounted on horseback. (original being my friend J. Alden Weir). This figure occupies the center of the landscape. In the foreground, to the right, his dog, a pointer: farther back three or four large trees: and to the left a sheet of water.

SMALL LANDSCAPE. 9 x 9–1/2.

The central feature being a large tree: in the foreground a rough landscape; in the background, water and sky.

DIANA PAINTED ON GOLD LEATHER. 20 x 29.

Diana is represented nude to the waist: on the right a spotted dog: in the background and to the left a heavy tree under which the figure of Diana is seated; and to the right, water and sky.

PAINTING. MOONLIGHT. 14–1/2 x 17–1/2.

In the foreground, water; and to the right, beach. In the center, a black boat pulled up towards heavy rocks running from right into center of picture and out to sea: the moon, at full, breaking through heavy clouds, makes a very dramatic night scene.

THE CANAL. 23–1/2 x 17–1/2.

Hills topped by a cloudy sky in the background; in the center a sheet of water, down which, on the right, two horses are towing an indistinct object.

SKETCH. 7 x 5–1/2.

A Tree.

SKETCH. 8 x 11–1/4.

Woman with child in her arms on horse. Evening. Big tree on right. Painted on cigar box: piece of bottom broken off and missing.

Note. As a personal friend of both Mr. Ryder and Mr. Morten, and knowing intimately each of the pictures described above, and which are hanging in Mr. Morten's house, I gladly attest the accuracy of the foregoing descriptions and statements, and Mr. Ryder's signature.

Kenneth Hayes Miller.

Dr. John Pickard, professor of Classical Archaeology and the History of Art at the University of Missouri, in preparation for a course on American painting, wrote a select group of American artists in 1907 to ask them to provide information about their lives and work. Ryder's letter was written in reply to that request. It offers much essential information about his paintings, their owners, and the circumstances under which they were created. [Dr. John Pickard Papers, AAA.]

305 W. 15th St
Nov. 3. 1907.

Dear Mr. Pickard:

I am highly honored by your request.

I send the accompanying magazine article in the hope it may be of some use to you.

In the paragraphs from a studio you will find what is practically an interview by Miss Adelaide Samson, now Mrs. Maundy: it was done from memory: and gives a wrong impression in the instance of copying old masters: otherwise quite correct.

I have never had any photographs made from my works personally.

The pictures in the accompanying article I fancy are made from photos—furnished by the owners.

Mr. Gellatly has a fine one of the "Flying Dutchman" which he owns address 34 W. 57th St New York City

Sir William Van Horne, and E. B. Greenshields addresses are Montreal Ca. I am sure they would be equally delighted and honored by a request from you as from the magazine.

Mrs O. L. Warners daughter Rosalie, informed me she had attended a lecture given by one of our artists, I think at

Barnard College, and he showed an Oriental Camp which must have been furnished by N. E. Montross, Art dealer of 5th Ave & 35th St. N. Y. City as he bought it from me.

It may interest you to hear of his remarks: I understood Miss Warner to say that he spoke of the poetry of my works as a distinguishing feature: in this connection perhaps it may be of some value to you to quote from Jeannette Gilder; in reference to a visit to my studio which after mentioning: she added that she would rather have the work from as "they were poems made with a brush."

Miss Gilder founder of the Critic.

The Temple of the Mind belongs to R. B. Angus of Montreal Ca.

The theme is Poes Haunted Palace.

The N. Y. Times had a very excellent illustration of it, at the time of the Clark [Thomas B. Clarke] Sale in which it was sold.

The finer attributes of the mind are pictured by three graces who stand in the centre of the picture: where their shadows from the moonlight fall toward the spectator.

They are waiting for a weeping love to join them

On the left is a Temple where a cloven footed faun dances up the steps snapping his fingers in fiendish glee at having dethroned the erstwhile ruling graces: on the right a splashing fountain.

I saw the picture in the Cottier gallery after the sale: it seemed to have a chrystalline purity: if so it is of course a new quality.

Mr Chas. De Kay had a picture of Mrs. R. W. Gilders, called the passing song reproduced in colors.

My Jonah is in C. E. S. Woods collection in Portland Ore. An attempt was made by Mr. Cortizzos [Royal Cortissoz] of the N. Y. Tribune to get a photograph for his paper in an article on the Buffalo Ex. He considered the result did not do justice to the picture so did not use it as he informed me he should not do in that contingency.

The photographer may have been handicapped by conditions incidental to the galleries.

Chas. E. Ladd firm of Ladd & Tilton, Bankers Portland Oregon: has a Desdemona: I think he would be pleased to send you a photograph.

William Ladd, same firm, has a "Christ appearing to Mary"

Mrs. Helen Ladd Corbett has my Story of the Cross: I would not advise troubling a lady in such a matter however.

I think the easiest way if you are pleased with the pictures in the magazine. is to write to the owners of them: they have shown by their response to the magazine: that it is agreeable to them to have their pictures honored: and as I said before, prima facie evidence suggests that they have the photographs.

Very Sincerely
Albert P. Ryder

A collector of Ryder's works, Dr. A. T. Sanden was one of the artist's closest and most loyal friends. He and his wife often had Ryder to dinner at their home in New York City and invited him to visit them at their summer residence in Goshen, New York. The tone and content of Ryder's letters to Sanden suggests that he was thoroughly relaxed and comfortable with him and his family. The number of Ryder letters to Sanden is the largest to any individual recipient. [From photostats of the letters, RA. Location of originals unknown.]

My Dear Dr Sanden

I hope the cards have bridged the time till now; and served as a reminder that you were in my thoughts.

I have planned to do my writing at night seemingly a natural time for correspondence but by so doing I am away behind; this being my only letter except to my Father.

The fact is I have been so fatigued and nervous when night came that I was almost compelled to wait for another day: having been this summer as in the preceeding two rather down with a played out feeling; but less so this year; and begin to feel alive again and stirring for the work, which slow to be sure but surely I believe is coming as I would wish.

I like my slow dreamy way with a picture fancying thereby they have a charm peculiar or like self creation.

If the moonlight goes forward, a few more paintings will I believe make it fine.

And the Macbeth also, but more slowly of course, I believe will grow in grandeur and soon have a light and charm that I wish to be in it.

Anyway I hope to show in the work more than by words my appreciation of your kind thoughtfulness and generous advance of money on the pictures while going on.

In fact I hope to excel anything previous to this, and I can see a possibility of so doing as the work advances.

When to days painting drys I look for much from the next one.

I have had two invitations for the summer; one to visit Madrid and see the Velasques exhibition; and incidentally take in Venice and Vienna: and the other to go out over the C.P.R. and make a visit to Portland Or.

Tempting; but I do not regret as I think I have learned a little by experiments which I hope will come out in your pictures as well as others later on.

I had an invitation for an illustrated notice in the July Critic; but I had no photographs.

Perhaps they will ask again when I have the Macbeth finished; anyway I will have them photographed when ready and they will be handy for anything of that kind.

A lot about myself; but I sincerely hope you are finding all you anticipated from the summer and your delightful place by the waters and near the shadow of the mountains: that you will all be refreshed and strengthened for the winter your

*friends and acquaintances, and not forgetting your right bower
with the fishing rods.*

*May your photographs be lucky and your fish big and the
biggest: and try catch a great big one and if it should be that
you shall find the need of patience with the pictures it will be
that it will be rewarded to the uttermost for the "accomplish-
ments of his youth remain and I believe a little something
gained as well to and by your sincere friend; who repeats that
by his work more than by his words hopes to show his sincere
appreciation of all your kindness and sympathy [no close quote]*

<div align="right">

*Affec. Yours
Albert P. Ryder
308 W. 15th St
Sat.
Aug 12.
99.*

</div>

<div align="right">

New York Sep. 26 1900

</div>

My Dear Dr. Sanden

*I have hardly the heart to write you; I have had such a
melancholy summer that I am almost tempted to wait until
your return to tell you; fancying you have something in com-
mon with myself: and not thinking strange of such a lapse,
taking it for granted there is sufficient reason*

*I have written and not sent; they all read so melancholy; I
always try so much to express my appreciation of friendship;
especially as I feel a bit lacking in intercourse, through diffi-
dence and a natural silentness, that I am especially pleased by
letter to show my regard for the few friends I have and with
the pen am free from that restraint.*

*However it would be a pity to be put in an indifferent light
to so kind a patron; so I have to tell you of the loss of my
Father and that I have been so miserable from it, and am
only just coming to myself. Of course there are many palliat-
ing circumstances; his quite extreme age and the knowledge he
wanted for nothing, and that I could be with him and see him
quite himself for the last time,*

*And last year he expressed a wish that I could be with him
when he died and it seemed as if my going was just timed to
his desire.*

*Now for yourself I hope you have had your anticipated
pleasures in Onawa [Maine] and a renewal of all your de-
lights in the place; and the rest of your happy family theirs
also.*

*I doubt not you have all been very happy and that Mistress
Inez has grown so I will hardly know her, and sun browned
as the "Little Maid of Arcadie"*

*In fact I fancy you all will have tan to spare; and be in
the height of fashion with it. So adieu. with affectionate re-
membrance of your kindness in all relations[?]*

<div align="right">

*Very Sincerely
A. P. Ryder*

</div>

<div align="right">

*308 W. 15th St
Sep. 2d 1901*

</div>

My Dear Dr. Sanden

*I drop you a line to let you know that your letter was very
welcome and very much appreciated.*

*As usual with your expressions it had the charm of fraterni-
ty and personality.*

*I feel badly that it is so long in being answered although I
have made attempts and beginnings.*

I presume it is the housekeeping thats the baleful cause.

*I get so nervous from the time it takes, and hurried also by
it; hoping all the time to find some way of simplifying, or by
method make it unfelt.*

*I tell Mrs. Fitzpatrick that it reminds me of ropewalking,
although very often it is a Johnny Cake walk literally.*

*You were very kind to hope for my good health; and I
have been able to work harder this summer than usual, but it
has not counted much as I have had to undo most of it.*

*Still that is not unusual. I have known Matthew Maris to
work many a picture slowly up to where everyone was
charmed with it, and then as slowly it would go again back
to nothing.*

*I am now anxious to have the pictures ready for the article;
and realize that I am way behind; especially must it look so
to English people, where they are used to rapid results.*

*Sir John Millais in his last exhibition, repainted all his pre
raphaelite pictures when he got them up to London and then
had to paint them all back again when their owners objected.*

*I was not wise to accept anything of the kind except in my
own time: feeling it a serious matter.*

however the best I can is all that I can do.

*I cannot encourage you very greatly yet, except that the
Macbeth will of course have to be ready almost as soon as the
others for the article, I shall probably make it the last as I
want it to have all the study possible: also I have refused all
the last commissions offered that I may fulfill my obligations:
then I shall probably go back to my early ways absorbing na-
ture whenever I feel like going out and keeping fresh always.*

*Weir was speaking of it this past year; kindly remarking
that I painted with so much feeling exquisite—he called it,
that he thought I got so I could'nt see by hammering away all
the time.*

*I was very pleased over the gold medal to Weir and
Walker.*

*It is so late, or early in the morning rather that this time I
shall have to make my good wishes to all in one expression of
best wishes to little Miss Sanden and all.*

<div align="right">

Affec. Ryder

</div>

My Dear Dr Sanden:

The day for your letter has come around; I was waiting partly for a visit from Adelaide Louise Samson assist. Editress of the Broadway Magazine.

The visit was in relation to an article that, Mr. J. G. French has written about my work: Miss Samson says it is very touchingly written, and she wanted to see about some illustrations.

I want your little ["]Gay Head" picture if possible to go in; that is if it can be done without too much inconvenience to yourself; she said she would write you about it; it is not a matter that you must feel as if you should take a lot of trouble about: just answer as you feel.

I took a little over a week after you went away to trolley excursions in Long Island and the last day walked my old seven miles: and the following week found my eyes had come pretty near all right; and that I stored up a lot of vitality.

Felt almost too good; have lapsed since; so shall have to do more of it, fortunately it will be a great help to the work, so will not be a waste of time.

Montross called this afternoon; sails for Europe Tuesday, so you have set the fashion; He told me that Evans had bought the Hamilton Bruce moonlight of Inglis, or to use his words "That was a fine moonlight Evans bought of Inglis."

He looked at your two pictures, Macbeth and the moonlight landscape, speaking of the Macbeth he said you have that in fine shape I should think you could keep it: I told him that was what I was doing.

Now I hope you are all in the good shape you spoke of in your letter: Mrs Sanden improving, or quite herself by this time, Inez and yourself looked splendid the day you went away, Arthur [Beaupré] must be with you by this time and of course in fine shape.

Mrs Flint I hope is well again, as your news was very encouraging; in fact I think you said she was quite recovered; and Mrs Davis is glad to be in Maine again mainly because its Maine.

Lil's [illegible word] Miss Bessie that was is [sic] near you; my hearty compliments to the young matron and her other half. And Allen, I guess it has been too cold for much stretching of lengths under the trees.

Others you must pass the good will to as space is filling up; and the hour is getting late.

You wrote a beautiful letter this trip: and was very much appreciated as you always do.

I should think plenty of fresh butter would be good for Mrs. Sanden. And "grub that makes the butterfly". pardon my suggestions; but I really think there is a great deal in these little things.

I am in hopes soon to get out to Rahway [New Jersey] for my call on Mrs Carlberg and your niece.

I hope they are keeping well for your sake and their own sakes.

Now for very best wishes for Mrs. Sanden and Inez and Arthur and yourself.

And believe me Affec yours, and conscious that you deserve the best: as Weir says, "Dr Sanden must be a fine man the way he has been so thoughtful of you."

Albert P. Ryder
308 W. 15th St
June 9 1905

308 W. 15th St.
Jan 11. 1907

My Dear Dr. Sanden:

It was my plan to write you early in the week hoping to say that I would come up tomorrow on one of the "splendid trains" you were kind enough to specify.

My heart answers your kind and hospitable wish: but when it comes to say that I will come on a special day I get very nervous: although I am a great deal better than at any time since my illness, I am not sure enough of myself yet: to say I will be up such a day and such a train; that's why I am writing at the eleventh hour.

If things had gone as I planned I would have surprised you the day before Christmas and I told Fitzpatrick Sunday night before New Years I thought I would go up and see you Monday; and hunt up "Broadacres"

They thought I had done so: The little girl saw me at the window last Sunday and said when did you get back?

I know how you feel, the same as Mrs. Carlberg feels about me visiting her and not receiving her hospitality: and as Weir feels about his places in the country

I don't know anyone I would rather visit or that it would be easier to visit: but I can't see any way just now than to run up some day and take Pot Luck with you: see your place which I know must be very beautiful and congratulate Mrs Sanden on having everything on almost two places and joy with Arthur over the farm, and with yourself over everything in particular and Inez over everything in general

I meant to have had this in Goshen tonight: but a knock on my door and their stood Henry P. Wolcott, a fellow student in the Academy; who I hadn't seen in twenty five years, and mentioned in the article in the press [sic, read The Press] which I will mail tomorrow: right after him came Mr. [Harrison] Morris Editor the "Ladies Home Journal["] and was head of the Staff of the Philadelphia Academy for a number of years

Mr Morris had never seen the Macbeth: Wolcott spoke of something he liked in the picture: Yes he answered and you see imagination in it: and rarely you see that in pictures.

I would have sent the paper [the Press article] before but hoped to have the pleasure of bringing it up long before this

They had seen it at Newark and Miss Blenda said they thought it very nice: too gossipy I think.

Mrs Carlberg sent me a loaf of Rye Bread just before Christmas by her charming daughter and a sweet little lady from Pratt institute.

Weir brought me a roast Partridge Christmas morn; the combination was fine. When you go hunting again: get one of Mrs. Carlbergs loaves and you will have a new sensation as Sandens would say

I havent got down to see them yet.

Have written one letter and will write another tomorrow as I must get started with the work.

And then will go down, and up to see you very soon
Love to all.

 Affec. Ryder.

 Feb. 7. 1907.
 308 W. 15th St.

My Dear Dr. Sanden:

Thanks for your kind remembrance and nice letter; letters are not necessarily long to be nice and should not cost too much effort: except occasionally to make the recipient secure in his friendship or rather to give the assurance of it.

My how fine it must be at Broadacres now.

The friends from Maine must feel not only at home in feeling which Mrs. Sanden and yourself know so well how to give, or is so natural to you: but their eyes must feel at home as they wander over the snowy scape; how pure it must look: a veritable "mantle of snow" and as light and feathery as a quilt of down.

Weir wanted me to go up to the Hotel at Wyndham [Windham, Conn.] make a fire in the Studio there and paint snow scenes from the windows.

He has a house [?] sled at Branchville; lights a kerosene lamp for heat and has his oxen dray him over the country.

He had a pair once that would travel like horses. And a man would have to trot to keep up with their walk.

Mrs. Sanden must feel happy looking out of the window: when she thinks of the dirty snow in the streets of New York.

Arthur must be having a rest: no digging when the snow is down.

A story for Mrs. Sanden:—Scene.—East side drug store Ave A.

Enter lady who asks for talc powder—Clerk.—Mennen's? Lady—No. Vimmens. Clerk—scented. Lady—No. I will fetch it myself.

Remembrances to all

 Affec. Ryder.

Read at your leisure

 308 W. 15th St.
 Mch. 16 1907.

My Dear Dr. Sanden:

So sorry to hear you have been so ill: I had misgivings: probably due to your remark about taking salacelate or salacylic.

There is no doubt that uric acid affects the blood in such a way that one is susceptible to a draft and more easily chilled.

It is more than thoughtful and very kind of you to remember me when you are feeling so badly.

Again I think many of our ills come from exhausting ourselves we do not always know it: for instance New Years Eve I called at the Weirs: the next morning Weir was around: they thought I would be ill, I looked so tired they said.

I am escaping prostration: but for a little while I have got to be careful.

Three years ago I was getting along nicely: just going only to the steamer to see some friends off laid me low: I said then I would never run that risk again.

I write all this as a sort of advice. don't do as I do but as I tell you. See P. S.

I think we are a good deal alike temperamentally hopeful, sanguine, and the traits that go with such a disposition:

but we must be careful. it is wrong to run the risk of illness at any time.

I have of course written and spoken in good faith about coming up and made sure plans for last Saturday: even telling my dairyman that I was going up to Goshen—but I went up to the New Gallery at request of Mrs. Ford who had asked me twice: and walked home: I saw it would never do just then to undertake the Goshen jaunt.

It will have to be as soon as I am able we will both be all right when we can perspire: I sweat to night bringing home my milk from Jefferson Market Two quarts of sweet milk and two quarts of butter milk: "get the habit" of butter milk" [sic]: they claim all sorts of good from it: this will be all you will care to read at once.

"Broadacres" will be equally beautiful at all times and under all phases: Mrs. Sanden must forgive me, or rather realize that it has been impossible to make the visit yet: If you are indoors keep in and bask in the sun.

Kindest memories to Mrs. S. and Inez. Good wishes to Arthur and Beaupré: I will hope hard for you to mend quick.

 Affec yours Ryder.

P. S. "Dont do as I do but as I tell you" a celebrated N. Y. physicians remark to Mike the Ice Cream Man at a reception, who had just said: Dr. I notice you eat all the things I have always understood were injurious.

So I do but I like them like everybody else, Dont Etc—

My Dear Dr. Sanden:

I was pleased to hear everything was well with you; and especially that Mrs. Sanden could send you good word of herself.

When I think of you I see the long green hill almost mountain over Arden Dairy way: I think you told me it belonged to Harriman: and then I think of Schilling's [Alexander Shilling] picture that you have with the green hill.

And then I see the bluer mountains: stretching along the horison: I do not think you could have picked a more beautiful site for your home if you had had a year to search for it: Every window of your house with a beautiful view; inspiring indeed.

To look over so much ground and feel you possess it.

To view such a panorama of views and feel that they are yours too.

I suppose you are having a little welcome rain as we had last night and to day With the wind you should have it too.

I was over to see Mrs. Marshall yesterday afternoon and she has a beautiful Water Spaniel she found homeless—She went to the Society that issues licenses, and no one had reported the loss: so I suppose she could give it away & she says she can not keep it as she has all she can attend to in her cats.

Mr. Marshall, my master, has left some fine portraits, and a beautiful twilight landscape.

His portrait of Asher B. Durand and his mother are worthy of any museum in the world.

Such an insight into character.

So true in color.

I think he was the greatest portraitist that ever lived.

What a woman can do with a room is marvelous. he used to have a place not much better kept than mine

Now there is a piano and order reigns: and comfortable chairs are around, prints hung up. and the window at the top of the stairs have plants and two easy chairs vis a vis where callers can rest if there is no one in.

Best wishes to all.

Inez and Arthur a message to Mrs Sanden when you are writing.

May you prosper and all good luck come your way and to those around you

Affec Yours
A. P. Ryder.

My Dear Dr. Sanden:

I have had a slight set back in the shape of inflamed eyes, which were very painful: but fortunately have mended quite rapidly.—"Man proposes—. ["]

Still there will be some progress in the Mill: nothing like what I had hoped for though.

So it goes; all for the best probably. I have always believed the fatality in making pictures is part of the process that develops what they are: and in working on the Old Mill to day:—I think it is coming a little grander: if so it will prove my axiom.

And perhaps when they are both done you will have gained something in the way of experience: that will be a lesson in patience in the School of Existence: that will be of great value. to your character.

I often think of Bruce in hiding in the loft of a peasants cottage: watching a spider swing at the end of its spun beginning of its web land at the 100th effort to reach the anchoring beam and then busily spin the remaining bit.

Bruce took heart again; rallied the Scots, and led them to a magnificent victory.

Or as Tom Robinson used to say:—Trouble; trouble is what we want.

Fortunately so far: I have been able to keep superior to afflictions.

And as I have often told a friend:—Discouragement is a luxury I cannot afford to indulge in.

Your Aug. favor is duly recorded.

The Sept. C[urrent]. Literature has not appeared yet.

Ask Mrs. Sanden to put up with a brief remembrance as I must keep on the safe side of the eyesight: you both know what I would say and all the others must accept the old omnibus of good wishes.

I hope and am sure you have had a good time. Adios as they say in Spain

Affec. Ryder.

My Dear Dr. and Mrs. Sanden:

I thought I would surely be up this evening: it is so pleasant to be wanted and after the last pleasant visit.

I have learned not to make my fire till I have done my errands: was so near the Fitzpatricks dropped in there and heard the little girl play or practice the Ave Maria, and a beautiful composition from Menndelsohn, and some other charming classic: all sweet melodies.

The little thing really made some fine music, quite a treat.

Has quite a little power. Then my fire and then my dinner: and then a sweet dose in my chair and then a look at my watch and found I had hardly time to get ready.

Soon I will be up. I wish the Doctor could have waited last Monday and looked at the Macbeth with Mr. Miller.

He thinks it is grander than ever: and I was so pleased to hear that his cousin [Rhoda Dunn] who wrote me a beautiful letter about the published poem thought as highly of it as ever: I thought the surprise, not knowing I had written anything, might have given an impression that would temper somewhat: On the contrary it seems that if I never wrote anything else that the verse would stamp me or give me a name as a great poet.

The cousin is a very gifted writer: having poems in the Atlantic: so I suppose I shall have to be reconciled.

I am to have a visit from them very soon.

I think I will stop right here: perhaps I might not have written so much complimentary appreciation and so much that is personal to myself.

It will have to go now, blots and scratches which no other matches.

I want to see your settled home; I am sure you will be very happy in it.

Especially as you have been so long without a local habitation.

And your nice things altogether once more.

Regards to Inez and Gracie and Arthur S. and Arthur B.

And the Newark friends I hope I will soon be able to appear there once more.

> *Au Revoir*
> *And Best Wishes.*
> *Affec Yours*
> *Albert P. Ryder.*

Excuse this blot [written in an arc around a blot at bottom of the page].

May 17, 1912

> *308 W. 16th St.*
> *New York City*

My Dear Dr. Sanden:

Your well expressed note of the 16th at hand, and its enclosure duly recorded:

A severe cold from sleeping in my chair to expedite clearing for the janitors tub and his plumbers, broke up only last night, but I seem to be better for it; and thanks to Mrs. Fitzpatrick, have found that Rikers expectorant is a splendid adjunct to my royal cure, although I found said cold very stubborn and began taking my own cure at night as well as morning and am sure that fact added very much to the cure,

still I must say the Riker medicine was very beneficial as I had at times a very hard and irritating cough which the expectorant soothed

So do not forget that the Riker preparation is fine for bronchial trouble which I think my cold partook of.

Bought a large bottle of it last night and have not broached it yet: so you must admit it is a good medicine that cures whether you take it not [sic].

I am confident you are having a real good time; and it will soon be warm now.

Lumley brought a good sized water color to the Fitzpatricks for you, a view on the Loire. The river flowing through a wooded country. with figures. very pleasing in tone.

I was in hopes to have been up once more before you left; and was quite lonesome over it.

I hope Mrs Sanden will keep well in the beautiful summer coming and will eat something when she is hungry, no matter how little a glass of milk for instance. Inez also and yourself, Beaupre looked so husky that he may do as he pleases.

A remembrance to Mrs. Flint and Bessie that was and is, although a Mrs. and others that I have met.

Tell Jack he is not forgotten–He also is to eat when he is hungry.

We are all to give thanks that we can eat and have something to eat, and are far away from floods–

> *Amen.*
> *Good night, good rest and*
> *a bright morning.*
> *affec Yours.*
> *A. P. Ryder*

> *308 W. 16th St.*

My Dear Dr. Sanden:

I intended writing you last evg. but the heat and persapiration affected my eyes a little so thought I had better put off.

Thanks for your letter and enclosed which is duly recorded.

You were right about Woodrow Wilson I remember you mentioning his qualifications for a candidate some time back when candidates were first being mentioned; how right you were.

Your mention of Cleveland suggests that Wilson will have a strong republican vote as well.

The Times had a most eulogistic editorial on the nomination I expect as you to vote for Wilson after quite an absence from the polls.

It is a delight to vote for a candidate who does not look on the office as a prize in a political juggling match.

As the Times said the party has gone back to its era of dignified candidates.

So far I have seen no disparaging of the man. I see Taft and his allies are beginning to read his books to find something to influence prejudice him with certain classes who might be sensitive to some of his statements I doubt if an honest expression gives the offence they long long [sic] to find.

I gave your message to the Fitz's they were of course pleased and reciprocate your good will they have a nice little flat now at 31 Bank St. Mr. F. has had quite a lot of business from old and new customers.

With great pleasure I accept the good wishes of the family.

You will have to pardon any more as it is to difficult to write any more, with the sweat of my brow ste[a]ming over my glasses

> *Affec. yours*
> *Albert P. Ryder*
> *The same to all the family.*
> *July 7, 1912*

This letter to "Mr. Tack," probably the painter and teacher Augustus Vincent Tack, was Ryder's response to an invitation honoring the dealer William Macbeth. It shows both how carefully he guarded his privacy—and protected his fragile eyesight—and how cordial and courteous he was in doing so. [Macbeth Gallery Papers, AAA.]

> *308 W. 15th St.*
> *Apr. 15. 1909.*

Dear Mr. Tack:

I am pleased honored and gratified with your invitation to join in the "personal compliment" and appreciation to Mr. W$^{\underline{m}}$ Macbeth for what he has done for American Art; and with your wording of same.

Would have answered last evening but for a pain in my eyes from visiting the American Art Galleries: I have to be very careful as lights on these occasions including dinners and very often visits to friends of an evening bring on quite a severe inflamation.

However as it is a life long affliction, I am used to it and take it as a matter of course.

I will take some means to honor Mr. Macbeth on the day of Saturday the 17th.

You and Mr. Hawthorne and Mr Doughterty [sic] will please accept my regrets, and the congenial souls gathered with you Saturday night.

Hail to Macbeth, and a' who honor him.

> *Loyally yours.*
> *Albert P. Ryder.*

Mrs. Schuyler (Mariana Griswold) Van Rensselaer is best known as an architectural critic, but she also wrote exhibition reviews and essays about painters and sculptors. She was a member of the circle of Richard Watson Gilder, editor of *Scribner's Monthly* and the *Century*, and she wrote favorably about Ryder. In this cordial letter, Ryder expressed his sincere gratitude to her for her remarks. It is regrettable that the more detailed letter he decided not to send has never been found. [Library, Metropolitan Museum of Art, New York.]

> *[late 1883–early 1884]*
> *Benedick Bld*
> *80 E. Washington Sq—*

My Dear Mrs. Van Renssellaer

I wrote you the other day or rather a week or two ago speaking of some work I was doing; but I felt afterwards that I had spoken too strongly of what I had tried to do and what I had accomplished: so I did not send it.

Also about Philadelphia, just as I was to send, Mr. de Kay thought he had a sure opportunity for my picture so I was obliged to alter my plans.

I have since sold to Mr. Williams—

So you won't think me careless of your request—

I felt you were tired and busy that day in the library so I could not well say to you how pleased I was with your Fuller article; and how glad so appreciative a person as yourself could have held up the mirror to Mr. Fullers heart or rather his soul and give that glimpse, to a remarkable genius, that comes more often after death than to—you can imagine what I was about to say: it slipped from me even in the writing

My mother was telling me to day she had seen that a Mr and Mrs Van Renssellaer had gone abroad: in one way I hope it was not you—forgive the two l's I have put in your name I see from one of your letters that there is but one; I felt my conscience earlier but of course kept on until I could stand it no longer—

We shall see many of Mr. Cottiers pictures in the Loan collection I hope.

What a pity the Sower could not have been shown as well; as I believe the committee asked for it from the purchaser

In the other letter I spoke of wishing to see if you felt that I had accomplished my desires in the little picture of the two lovers that I am doing—Florizel and Perdita, from Shaksperes "Winters Tale". In good time I shall know.

Pray do not trouble to answer, as I know how precious is every word from your pen, to yourself and the cause in which it is employed.

> *[across side of page:]*
> *Sincerely and appreciatively yours*
> *Albert P. Ryder*

Many thanks for my name in the C[entury].

Sylvia Warner was the widow of Ryder's close friend, the sculptor Olin L. Warner, who died unexpectedly at the age of fifty-two. Afterward, Ryder continued to maintain a warm and cordial friendship with Sylvia, pouring out his feelings to her more freely than to anyone else. She and her daughters, Rosalie and Frances, were like a family to Ryder. [Olin Warner Papers, AAA.]

<div align="right">

308 W. 15th St
June 2d 1897
</div>

Dear Mrs. Warner

Your kind note of the 31st seems in one way not to call for an answer, but I would like to assure you that I am quite willing you should plan for me as you think best.

The last two days I have mended a great deal, and have done considerable work

I have a picture Flight into Egypt begun for you already; but of course you shall have the say as to what you would like.

The picture you mention I am free with but I feel I can do better for you

Yourself and Miss Bloodgood will be welcome whenever it suits you to call

The Weirs will have me dine with them Thursday or Friday. They will get away shortly; possibly Saturday.

Kind greetings to Rosalie Frances and yourself.

<div align="right">

Very Sincerely
Albert P. Ryder.
</div>

P.S.

I have delayed visiting until I could get over a little anscious spell which is all gone now; and I hope to take advantage of your permission to call very soon.

I realize that this letter is in a certain sense superfluous but I hope you will permit it as an indulgence to brush away a little diffidence in my calling to see you.

<div align="right">

Sincerely
Albert Ryder.
</div>

Encore I have a feeling as if my troubles were pretty much over.

<div align="right">

Oct. 12. 1897
</div>

Dear Mrs. Warner,

I hope this will have a more cheerful sense.

My work is going tolerably well and your request to see it is not unheeded, nor Miss Bloodgoods commission.

I have every faith that my forest of Arden, will be fully as beautiful as any preceding work of mine; Bronx Park has helped me wonderfully, and I would have gone out to day for that breezy agitation of nature that is so beautiful. But the rain has spoiled my plans.

I sincerely wish the picture was for you; but it will not be my fault if I do not succeed equally well with your commission.

I was at a dinner last night given by Knoedler to Swan an English Artist, who with Mrs. Weeks one of our Artists abroad are here to be judges on awards at the Pittsburg Exhibition.

Julian Weir, Chase and Caffin were the other artists present. Mr. Inglis sat next to me.

It was a very enjoyable affair.

My tribulations have done me good; which is the best use to make of them.

I hope always to retain your friendship not through sympathy for weakness, but from what I can do in my art work.

I long to realize in myself that comraderie that is so beautiful in Julian Weir and yourself; and which I think is the secret of your charming letters. Pardon me for mentioning Weir first; it seemed to give permission for the saying.

I hope it will not be unpleasant for you to hear that I am sure that your letters have done me a world of good in contact with the world.

With a bright hope of fulfilling in my art what is expected of me, an honest desire to see you and your children in the blessing of God. And my usual remembrance of Rosalie and Frances.

<div align="right">

I am in friendship
Yours
Albert P. Ryder
308 W. 15th St.
</div>

<div align="right">

[Postmarked New York, Sept. 24 '98]
</div>

Dear Mrs. Warner

I am back to my barracks strengthened and benefitted in many ways by my visit.

You have an unusual power in lifting one up to endeavor and effort; as I am sure others feel your elevating influence, I hope it will not read as something sentimental.

As usual with me the retrospective pleasure of my stay is most refreshing and delightful.

It is impossible for you to realize how much I have brought back with me in my impressions of Point Pleasant [New Jersey].

Your little nest in the trees the air and charm you and your birdlings gave the scene.

And the unobtrusive kindness and friendship of the community that surround you there.

It is nearer Arcadia than anything I have ever known.

To cap all my pleasures in my ride back, for the first time I felt there was poetry in modern travel; the galloping of the train, the bustling stations, the flying views, the signals cautiously set for following trains.

A crippled employee climbing the signal station stairs to labor adapted to his wounded life, somehow struck me as romantic

Mellowed by your kind thought, refreshed by your efforts for my enjoyment and benefit: I am sure in my work will come a reflex of it all.

So rest assured your kindness will bear fruit and I hope you will think with me that it is not sentimental to appreciate fully a kindness and benefit though the giver make not much of it.

Hoping to see you and Rosalie and Frances soon after your return.

<div align="right">

You have always
The best wishes
and more of
Albert P. Ryder.

</div>

P. S. I meant to have mentioned to you that at [Miss] Kibbe's request I recited the verse on the trees, and after, noticed that I had not said you, where you thought ye would be more perfect; as I said it quite naturally, I have no doubt your criticism was just and good, will write you another copy if agreeable to you.

<div align="right">

308 W. 15th St
Apr. 3. 1900

</div>

Dear Mrs. Warner

Your kind invitation came to hand this evening; having through some blunder been placed in a box next door.

I was pleased indeed to get it for its own sake, and because I had been a bit worried to day; thinking perhaps, as I had not room in the card I mailed you Friday to mention the possible invitation you might have thought me careless: whereas I was really on my way to your house to thank you for the pleasure I had in the commission of delivering your note to Mr. Wood and the possible pleasure of being with the company you mentioned.

When I suddenly changed my mind; from the fact that I had a serious cold Sunday previous, and thinking of Rosalie and Frances, although I did not consider in any sense there was any danger, I thought better to wait and see or be sure that it was only an ordinary cold; which it turned out to be. You were very kind to realize that I was "fretting and stewing over the Lorelei and others."

The slowness of the pictures does not affect me; but the realization that they are wanted and that they must be done.

I have been working very hard, gaining only by inches, and waiting for the light of heaven as you so charmingly described it to come into the Lorelei; and hoping it might be finished while Mr. Wood is here.

The season is flying and Mr. Gollatly wants his King and Beggar Maid and as you say the others.

However everything comes to the patient artist.

Sometimes I think that is all there is to it: trying waiting and persisting.

Mr. Inglis was very pleased with your remembrance.

Au Revoir—Hoping to see you all Thursday, and your permission to say that your friendship and the liking of Rosalie and Frances are among my most precious possessions

<div align="right">

[across side of page:]
Very Sincerely
Albert P. Ryder

</div>

J. Alden Weir and Ryder were very different in personality, but they became fast friends. In many respects, Weir was like a brother to him, sometimes helping him financially; and his family, like the Warners, treated him as one of their own. The warmth of Ryder's feelings for the Weirs is fully evident in these letters. [J. Alden Weir Manuscript Collection, Brigham Young University Library.]

<div align="right">

308 W. 15th St.
Nov. 8. 19.2

</div>

My Dear Julian

A brief note to show my appreciation of my pleasant visit to your farm, and to thank Mrs. Weir and yourself for your kind efforts to make my stay agreeable and the pleasure it was to see and the beauty in thinking of, the lovely affection of your children to yourselves and to each other.

I hope your impulse is still strong; for your work so near a happy completion; it pained me to think you must stop and be bothered about getting me to the train: as it was not necessary.

Have written Mr. Wood of your summers work, quite a catalogue, and your masterly portrait; and the wonderful truth, and last but not least, the rapid execution of it.

Please find P. O. order for ten dollars your kind and timely loan.

If agreeable to you to fee the maids of your household for me will reimburse you Almost had N. P. over it.

Great night election night, all but the horrible explosion of fireworks. the thirteenth victim died in hospital Thursday; I was quite near it on 23d St. So. side of Square; but did not know of its serious nature till late in the evening.

Was up to the haberdashers to find what you paid for sundries, but could not find out.

Do let me know.

They are shooting deer on Long Island, eighty so yesterday, four days allowed only; still what an army, there must be with the high population hereabouts.

Let me be a stimulus to you with my good wishes: it often goes a long way in making stimulus: and the fine weather now. a sort of combination; propitious skies, and good wishes.

Please do not think of your health, my bane, you are in splendid trim.

With a doff of the hat to Mrs Weir, Caro, Dorothy and Cora, and a ranch of affection for yourself and all that good wishing can imply for you all.

<div align="right">

Affec. Ryder
[across side of page:]
Paul feeling of a rock to see if its real
after they get scarce in B. regards to him.
[sketch]

</div>

My Dear Julian,

I will just acknowledge your letter now and write Friday again; as I am a bit bewildered as to say just the day I could leave now.

My laundry is out; but it is doubtful if I can get it before Saturday night.

I tried to write you last night but my eyes became inflamed and I had to stop.

Perhaps it is fairer to let you name another day or perhaps as I cannot leave Saturday you would have arranged events at Windham [Conn.] wherein it would be inconvenient to have me.

You mustn't think I would have any feeling if you should have to change your mind.

I will take this up to the G.C. Station in hopes it may find a train to Windham and you would get it in the morning

I am very pleased to hear your good news of the Woods; and equally sorry to know that you have been miserable: I hope you are yourself again.

Many thanks for your enclosed remembrance, I hope it will be only for a little while.

There must be something doing at 308 W. 15th St before a great while; meanwhile I shall not allow myself to worry too much.

Perhaps it is just as well to philosophise together;—I think I do not indulge myself sufficiently in work more suited to my moods: I know I sometimes lose a whole day trying to get to work on a picture that I think I should be doing; when I might have struck out another canvass or carried some other one along: I think I shall have to do that.

Kindest regards to Mrs Weir and Caro and Dorothy and Cora and yourself.

Of course your kind care is very comforting: and melts the hard spots of the heart: I regret our relations are so one sided; and that I have'nt even brightness as a palliating virtue.

As I am, I am
Yours Affec.
Albert P. Ryder
Sep. 23 [1903]

Sep. 22. 1904

My Dear Julian,

Received your kind letter and note. And got out my "Royal Coach" to answer.

There is a question apparently at the end of the note that I cant make out although I have just reread it again. probably means why didn't you tell me when you could come? As an Irishman would say you can guess eggs if you see shells. tell that to Paul.

Dr. Sanden is due the first, and I shall have to be here till he arrives anyway.

I think you had better give up any visit this year; although I am very grateful to you for your kind interest: I am getting stronger gradually; but my legs are quite weak yet: who would think ones limbs had so much to do with painting?

Inglis is due Saturday. Wood says I have been wanting to write to you and to Weir for a long time, but have found it simply impossible to get the time.

Hassam has been here for about six weeks and is still with us.

He has been to the sea coast and painted really some very beautiful pictures, some of which I think he will sell here.

I dont suppose you will see old Weir, you are such a town mouse and he is such a country mouse, but if you do, give him my love and tell him ["]I am going to write."

Sep. 1st 1904

With kindest regards to Mrs. Weir, Caro, Dorothy and Cora, and with an affectionate greeting to yourself.

That the fish will thrive, and there will be no more 25 lb. turtles. Almost a Sea Monster wasn't it.

That your work will answer.

And your farms too. And haystacks grow, and rocks disappear, and everything be as you wish.

308 W 15.
As ever yours
A. P. Ryder

308 W. 16th St

16 x 2 = 32 theres your 3 □ 2 + 6 = 8 theres your 8 □
0 for the middle number gives you 308.

My Dear Julian:

I was and am very pleased over your letter and I will be in from 9 until 3 P.M. beginning on the 14th of Aug. which is a day before the actual week from the date of your letter.

I am very happy over your notices kindly mailed to me by the Carneigie Institute.

Mr Kenneth Miller was remarking to me about the notices you are having these days referring generally to them as being in the vein of genuine appreciation and understanding of your art.

He is a strong admirer of your work.

Well, I don't believe you have lost any time by the forced let up in your work: I have no doubt your eyes are always open to the beauties around you; and what we cannot remember, has affected us as the Scotch womans bleaching: the parson came upon her in the mids't of it and knowing of her constant attendance at Church began to ask her about his last sermon. The poor old woman could remember nothing.

Well he said surely you remember the text. No. What good does it do you to go to church? She picked up a bucket of water and dashed it over the cloth, and asked if it looked any whiter; it did not, and the woman replied when it has been saturated sufficiently it will come perfectly white.

You will not be very exhilarated by what I have done; but "alls well that ends well.["]

Dont ask me to write anymore to day. like staying in the cage, I want to get out, and need to, although a great deal later, have had a close call, with the gout or one of the Fifty Kinds of Rheumatism. In my shoulder to day and "Wiehawken" will cure it.

Kindest regards to all the family.

> *Affec. Albt Ryder*
> *Aug 11. 1911*

It would be a good story to say she threw the bucket of water over the minister.

> *308 W. 16th St*
> *Dec. 25. 1911.*

My Dear Julian:

I was very sorry to miss your call; but am glad you met Mrs Eversfield who is very charming with her "seventy five years young".

And I was delighted to hear her agreeable impression of yourself: which was all I thought it would be if she ever had the good fortune to meet you.

Many Thanks for your note the check and kindness of your call.

I hope the check is from Mr. Morten as I cannot allow you to forestall any payments.

My regrets that the kind invitation of Mrs Weir and the young ladies was unanswered; I never thought it would be so: I was very tired and nervous at the time I received it: on account of the condition of my room: The which I will explain when I see you and the wherefore.

Then when I tried to find it, I could not discover it and had not made a note of the number and could not remember the crossing St. of Park Ave.

I hope they have forgiven the episode and could wish it were forgotten, will try to call at the studio Thursday.

This is a bare acknowledgment, as I had to have my walk to day: which I felt less than for two or three years: and came home much benefitted.

It is now nearly Four in the morning owing to my midnight supper and a long letter to Peggy.

> *Au Revoir.*
> *Affec.*
> *A. P. Ryder*

Mrs. Lloyd (Peggy) Williams, whom Ryder called "Peddlums," was one of the daughters of Ryder's dealer Daniel Cottier. After his death in 1891, Ryder kept up his friendship not only with Cottier's widow but especially with Peggy, who eventually married Lloyd Williams, son of the collector Ichabod T. Williams. Judging from Ryder's playful, witty remarks, he must have been entirely at ease with her, perhaps viewing her almost as the daughter he never had. [From photographic copies of the letters, RA. Location of originals unknown.]

> *308 W. 16th St*
> *Dec 26. 1910*

Dearest Peddlums & Lloyd

Received your announcement of home coming this P.M. in shape of very pretty engraved cards analagous to the Birmingham pictures that the famous pen maker of that place induced Turner to take for a picture.

"I saw three ships go sailing by Christmas Day in the morning."

Had a card from Mrs. Cottier & Willie—Very pleased indeed.

Hope to see you very soon; and hear all about them and other friends mutual, the Capt. and all.

Love to the children and your selves[.] Please tell Mrs Field I got their card a very pretty one and I was very pleased.

> *Affec Yours.*
> *A. P.*
> *Ryder*

> *308 W. 16th St. N.Y.*
> *Dec. 25. 1911.*

You see I am leaving room for all I can say on this sheet of foolscap which perhaps may turn out not so foolish but fairly interesting and now I must read your Mothers Christmas Card before I go much further to get the whole feeling which was written in the gentle tender friendly way, that only Mrs. Cottier, and her daughter Margaret McLean Williams can write, I am just back from my walk, my nerve cure I call I call it, and am very pleased that I took it so well; being the full distance I take these days, three miles the round walk and have taken to writing this to you immediately: and am quite fresh.

Isn't it about time I mentioned who I am writing to. To My Dearest Peddlums, who is living on partridge at the Partridge Inn and to her "Dear Hubby" Dearest Lloyd, and to her Dearest daughter Marion who has a great deal of her grand-mother's natural goodness sweetness, and loveliness, my

people often spoke of Mrs. Cottiers being such a pretty sweet woman. and to the other Dearest daughter Margaret who can say, why it is Uncle Pinky! as sweet as any echo from a placid lake, and Dear manly little Dugs who is the host of goodness and whose Dear Mother does not let forget Uncle Pinky or Marion or Margaret as well also.

Yes I got your more than friendly card from Belgrade, which at first I thought was from the classic other side; I was really in hopes to have answered and was thinking of coming up to see you when along came your "Partridge Inn" letter.

I may as well say here one reason that helps to make it hard to write; you have heard of the inspectors that go around where three or more families live in a house and lodge violations against the landlord if things are not just so; I have told Mr. Cagney, mine, that I would have no feeling if he should tell me to move:

He told me not to move till he told me to and has given me an extra coal bin to put things in: since he told me of the liability to be penalized to the amount of over a hundred dollars it has kept me quite nervous so much so that sometimes I haven't answered knocks on the door.

A dear English Lady, 75 years young is my next door neighbor Mrs. Eversfield, her son Dr. Frank Eversfield is a clever physician She was telling him she thought I looked feeble, after observation he told his mother he did not think so but that I looked not sufficiently nourished: he found out by accident that I was cooking meat and vegetables and as consumed the same stock replenished from time to time; he told his mother to tell me that by and bye I would be good for nothing, I thought I had discovered something clever, and as I had consulted my butcher about it and was saving so much time in cooking and always seemed satisfied as to hunger was quite proud, but in truth was wondering why I seemed so dead and alive, inert and so forth now I go out nearly every night for a midnight supper and am much better.

If I can find out how to fix my room I hope I will be able to write the Captain and a great many others that ought to hear from me.

Remember me kindly to the mother and tell her how pleased I have been with her annual remembrances that are very comforting, and Ella and Willie, and the Robinson family.

Love to Lloyd and all the family; heaps to all of you. draw on your imagination for all I would like to say. Many thanks for your pretty card and [across right side of page:] *for your pretty check.*

[Across left side of page:] *Good night—Good morning— au Revoir "All the world loves a lover" half the world loves an artist, the other half a poet—signs are good I will be called both. Dearest Peddlums good morning.*

[Across side of first page:] *From Your Dear Uncle Ryder.*

*308 W. 16th St
July 13, 1912
New York*

*My dearest Peddlums & Lloyd
So pleased to hear from you;
I promised Willie McGuire some time ago to write you when he came down to see me after hearing from you: he seemed anxious to see your wishes carried out: it seems next to impossible; it will take too long to explain now.*

We have had a drop of 10 degrees in thermometer. Not so cool or refreshing as the sound of Poland Spring but not so bad.

My eyes have plagued me a little, cold probably as I have been sleeping cold especially toward morning. but they are much better to day.

Give my very best wishes to your mother.

I am glad you understand about the writing, I wish everybody did; I think the sort of pressure I am under is somewhat the cause, keeping me close to being nervous

Sep. 27,

It seems ridiculous to finish out so old a beginning—but the above explains as far as it goes &c and so on my eyes were quite bad at the time why I did not finish this at the time; they are a great deal better now[.] Kenneth Miller was in to day, and thought he had not seen me looking so well since he had known me, about three or four years, I am better than I have been for a long time[.] I wish I could know if you would get this before you leave.

I suppose you have seen the Captain ere this, I wish I could have got a word of remembrance to him and his children.

I received your thoughtful card with the statue and Edinburgh Castle and your nice line of remembrance.

Tell your mother she is not forgotten; if I sent a line every time for "Auld Lang Syne" they would be many,

My Love to Willie, My Dearest Peddlums if still in Dear Old London or on the sea or here with your loving family[.] you are close to the heart of your Uncle by time and feeling, all of you.

*Now Good Night
Sleep Tight,
Good wishes, right
good wishes
and remembrances for you all
Your Ucle [sic] Pinky
A. P. Ryder
308 W. 16th St.*

308 W. 16th, St.
Aug. 29. 1913.

Dearest Peddlums:

I hope you get this before you embark for this side.

Nothing but a cold in my eyes is the reason for this ungallant and seeming heartlessness of the lateness of this reply to your kind thought from Dinard.

It looks a breezy place a cool place a nice place but I do not see any of the nice people you speak of and as I have no magnifying glass I will take your word as to their desirability as townspeople.

The conditions of writing this letter speak for how much I think of little Peggy, her Dear Mother, her children and Capt. Robinson and his own Reine and Cottier and happy Johnson and anyone that remembers your patriarchal Unclets.

Of course you are not charged with these remembrances any one you see there is a profuce store sent to draw upon.

Now for a happy voyage to New York and do let me know when you arrive; as I cannot see you and your precious ones too soon.

My eyes are getting better and are a great deal so compared to what they have been; and a sight of you and your little family will make a complete cure.

> *Au Revoir,*
> *Bon Voyage.*
> *Delightful days*
> *The Ocean be at its best*
> *Pleasant companions*
> *The winds blow soft.*
> *And Psycopathic greetings*
> *Come on the air to you*
> *All the way.*
> *Best wishes*
> *Yours as ever*
> *And more so*
> *Your old friend*
> *Your good friend*
> *"Pinklets"*

[sketch of a bird carrying a letter]

Ryder wrote Colonel Charles Erskine Scott Wood, a Portland, Oregon, poet and lawyer, not only as a collector of his work but also as a good friend. Wood had promoted the sale of Ryder's paintings among his colleagues and associates in Portland, particularly the Ladd family. Because of Wood's poetic accomplishments, he must have been especially attuned to Ryder's verbal as well as his painterly skills. [The March 4 (1896) letter is in C. E. S. Wood Collection, The Huntington Library, San Marino, Calif. The October 2, 1899, letter is owned by Katherine Caldwell. The February 9, 1906, letter is in the ELC, RA.]

Wed. March 4. [1896]

Dear Brother Wood

I have written you before but did not send as it was in one of those enthusiastic veins I get in when I am delighted with my work and reading over sounds as if your trumpeter was dead and buried long ago.

I have gained every day on Desdemona *since you left and it is now nearly ready.*

If Charly Ladd and yourself liked it before you will be more than charmed with it now from my point of view.

It is very near my ideal and you know what that is.

I am anxious you should see the flesh quality: I am greatly mistaken if it is not very beautiful: a charming kind of warmth yet rare and pale. Altogether it seems to me very strong and very delicate which I think you will agree with me is most desirable in a Shakspeare Subject.

I prefer to write Charly Ladd just when it is ready. I shall try for next Monday but shall claim the limit the 15th if necessary.

Called on Mrs Wood and Miss Failing [?] Sunday evening: but was unfortunate in finding them out; will probably call to day again.

Remember me to Tom Wood: I hope he is not too lonesome for New York: tell him it is not what it is cracked up to be.

I get faint heart when I try to mention others than Charly Ladd but you can say a word for me to anyone that cares.

Miss Monroe was very charmed with Tempest—

Affec. Ryder

Addenda

I feel I must add a word in praise of Warner's panel; he has made a most delightful nude bas-relief; nothing could be more beautiful; which I begged him to keep; such lovely and spirited modeling.

I heard from Mrs. Warner that he had droped it: I think he ought to be called the nood for doing it.

The Reverend Referendum

I feel I must drop you a line to at least keep alive a last ray of hope that I trust lingers with you yet, that you will some day get the Lorelei and that like many things in life it may not be so late as to give no pleasure: it should not be so with pictures; for the patience to keep on and the possibility of retaining interest in the endeavor long sustained should be encouraged in proportion to our reverence and esteem or understanding of the gift that makes art and the makers thereof possible.

It was not till this spring that I felt the witching maiden was placed where she should be.

It is only now that I am convinced that a moonlight rare and pale will be the most beautiful and positive treatment of the subject.

An ounce of poetry added to a picture is worth many pounds of paint literally; and truly with the doing and undoing of an hundred pictures to obtain.

Again one who paints not by rule but by inner promptings is thereby more or less a stranger to his talent whatever it may be; but there is a compensation in sometimes going "a mountain in a night." So we will hope for the night, and a day added may make a picture that is a song in paint to paraphrase Miss Jeannette Gilder who was kind enough to say my pictures were poems in paint.

I am content now with the picture and am willing to finish it in its present phase.

So perhaps you will have for a little longer Faith, which I am sure you have almost lost, Hope, and charity which I am sure are yours always by divine right and endowment.

And I can safely promise you that one work at least with faith liveth.

[not signed]

Dear Brother Wood

I have felt like, and intended, writing you for a long time.

I got everything before Christmas Day.

Splendid apples, do. Wine do. Segars.

Please give my thanks to Mrs. Corbett and accept yours.

Had a nice visit from Catlin: I hope he told you how the Tempest looked to him; he also brought me a nice basket of assorted fruit.

I told him I would rather you would sign the refusal offer for the stock; as it was only fair to you not yet being earned.

I am getting the Lorelei into shape. I think she was too perpendicular on the rock, reclining, more as I have her now, seems to help the feeling of the picture very much: of such little things painted dreams are made of.

The Tempest seems to want but little; but oh how much this little may be; however I really believe if anything happened to me, if the blue of the sky in upper left hand corner was matched it would be about as valuable as finished.

judging from the work of Millet and others, it is so nice in color and other good things.

My fault is: I cannot, some way, go at a picture cold; I have to have a feeling for it: perhaps I shall better some.

I asked Catlin to speak to you about an injunction on the Copyright Office at Washington, to restrain them from giving copyrights on my works except to me or by my consent.

From Confucious to Wood; it seems self evident, or common Law that a person should not be oblidged to copyright everything to protect it or to save his rights:

Please tend to it as soon as you can as I want to head off somebody I suspect

To be paid for as a service rendered.

You will be an advocate for me who has so many faults; that he forgives almost anything to others.

*Very Sincerely
Your Friend
Albert P. Ryder
308 W. 15th St.*

Ryder's Poems

Ryder considered himself a poet as well as a painter. His verse, discussed at the beginning of chapter 5, was written in the spirit of the English Romantic poets, though without their skill. He often sent handwritten copies of his poems, and would occasionally recite them, to his close friends. In the case of "The Voice of the Forest," published in the New York *Evening Sun*, May 6, 1909, he mailed offprints augmented with personal dedications to the recipient and, at times, corrections in his own hand.

Sometimes Ryder would compose a poem to accompany—on a plaque or in an exhibition catalogue—one of his own paintings: for example, *The Lover's Boat* (plate 2), *The Toilers of the Sea* (plate 4), *The Flying Dutchman* (plate 9), *Joan of Arc* (fig. 8–4), and *Passing Song* (fig. 8–3). On most other occasions his poems functioned as independent literary efforts. We have no idea how many verses Ryder composed—many are undoubtedly lost—but of the sixteen extant examples, five (cited above) relate to his paintings, and the remainder have a life of their own. Of the latter group, the last three reproduced were written as private tributes to the recipient and probably were not designed for wider circulation.

It is virtually impossible to date Ryder's poems, for he rarely gave any clues about when he wrote them. The first five, however, relating to his own paintings, have been arranged according to the order of execution of each painted work.

There are often several different versions of Ryder's poems. Those that seem earliest and most directly expressive of his thought, prior to later revisions, were chosen. The poems have been printed without correcting Ryder's spelling or punctuation.

The Lover's Boat

In splendor rose the moon
In full orbed splendor soon
On sea and darkness making light
While windy spaces and night
In all vastness did make
With castled hill and lake
A scene grand and lovely.
Then gliding above the
Dark waters a lovers boat
In quiet beauty did float
Upon the scene,

And the moons fair light did screen
Mingling shadows
Into the deeper shadows
Of sky and land reflected.

[From an undated manuscript dedicated to Alexander Shilling, in the Lloyd Goodrich–Albert P. Ryder Archive, University of Delaware Library, University of Delaware, Newark (hereafter abbreviated RA). This version differs slightly from the one published in the Society of American Artists exhibition catalogue, 1881, cited in the essay accompanying the full-page color plate.]

The Toilers of the Sea

'Neath the shifting skies,
O'er the billowy foam,
The hardy fisher flies
To his island home.

[From the catalogue of the Seventh Annual Exhibition of the Society of American Artists, New York, May 26–June 21, 1884.]

Joan of Arc

On a rude, mossy throne
Made by nature in the stone
Joan sits, and her eyes far away
Rest upon the mountains gray
And far beyond the moving clouds
That wrap the sky in vaprous shrouds

Visions she sees
And voices come to her on the breeze
With a nation's trouble she's opprest
And noble thoughts inspire her breast
Oh gentle maid and can it be
Thou wilts do more than chivalry
And thy weak arm shall strike the blow
That hurls the invading conqueror low.
Who knows what God knows
His hand he never shows
Yet miracles with less are wrought
Even with a thought.

[From an undated manuscript in the Philip Evergood–Harold O. Love collection of Ryder materials, RA (see chapter 1, note 7 for details).]

The Flying Dutchman

Who hath seen the "Phantom Ship"?
Her lordly rise and lowly dip;
Careering o'er the lonesome main
No port shall know her keel again.
Pity the hapless soul,
Doomed forever on that ship to roll!
Doth grief claim her despairing own?
And reason hath it ever flown?
Or in the loneliness around
Is a strange joy found,
And one wild ecstasy into another flow
As onward that fateful ship doth go?

But no: Hark! Help! Help! Vanderdecken cries,
Help! Help! on the ship it flies;
Ah! woe is in that phantom sight,
The sailor finds there eternal night,
'Neath the waters he shall ever sleep.
And ocean will the secret keep.

[From a letter to Mr. and Mrs. John Gellatly, July 20, 1909, Archives of American Art, Smithsonian Institution, Washington, D.C. (hereafter abbreviated AAA). The earlier (1897) version is printed in the essay accompanying the full-page color plate (plate 9).]

The Passing Song

By a deep flowing river
Theres a maiden pale,
And her ruby lips quiver
A song on the gale
A wild note of longing
Entrancing to hear
A wild song of longing
Falls sad on the ear.
Adown the same river
A youth floats along
And the lifting waves shiver
As he echoes her song
Nearer still nearer
His frail bark does glide
Will he shape his course to her
And remain by her side
Alas there is no rudder
To the ship that he sails
The maiden doth shudder
Blow seaward the gales
Sweeter and fainter the song cometh back
And her brain it will bother
And her heart it will wrack
And then she'll grow paler
With this fond memory
Paler and paler
And then she will die

[From an undated manuscript in the Evergood-Love collection, RA.]

Voice of the Night Wind

The wind, the wind, the wind,
That am I that am I
My unseen wanderings
Who can pursue, who comprehend?
Soft as a panther treads
When moving for its prey
I fly over beds of sweet roses

Fig. P–1. "Voice of the Night Wind," Ryder's manuscript for the poem.
Evergood-Love collection, RA

And violets pale,
Till disturbed within their slumbers
They bend from my gay caress,
Only to lift their heads again
And send the aroma of sweet perfumes
To call me yet again
Ere I pass away
 For I am the wind, the wind, the wind,
I'll away, I'll away and seize upon the giants of the forest
And shake them to their roots
And make them tremble to their sap.
 For I'm the wind, the wind, the wind
I'll away, I'll away to where
Maidens are sighing for fond lovers
And softly coo and woo
And whisper in their ears
Making their hearts throb
Their bosoms rise
Till I seem hardly from without

Almost within the voice of their souls illusion
What lover would not give his all for this
To kiss those rosy cheeks
Those dewy lids that luscious mouth
So wantonly to lift those woven tresses
And breathe upon those rounded bosoms

But I'm the wind, the wind, the wind
I'll away to gloomy pools profound
And stir the silence
Of their reflective depths
With rippling laughter
At my wanton freaks.
And my fantastic wanderings
Who can pursue who comprehend

[From an undated manuscript in the Evergood-Love collection, RA (fig. P–1).]

Spirit of the Flowers

What radiant passing is this
That gilds the sphere with summer bliss
And calls a race of gentle wonders
All born in beauteous splendours
To gem the warm zone of the world
And as in tender sheen unfurled
Raying with sweet light the earth
All lovely like the tender birth
Of dawn in early rays or light
Or lustrous or luminous or bright
As stars or moon or milky way of night

Tis the spirit of the flowers
Soul of the sunny hours
Her lightend way winging
Birds and insects singing
Her graceful weight scarce bending
The slender vine thats lending
Support to her
To breathe within the petal of the flower
Its perfume sweet of her
Fragrant breath
 Sweet spirit of the sunny air
Sweet radiant fair
Shall our entranced delight
In thy delicious joys sigh for a good night
Thou wilt say when Novembers gloomy
Wings smother the feeding springs
That nurse thy lovely flowers
Or wilt thou come again
When weeping April sends her rain
Fairy messenger to call
The blushing forms all
Spring like a throne of joy
To seat thy reign
Yes thou wilt come again
And crowding butterflies
Shall claim thee for kindred
And yield glowing obedience
To thy fairy reign.

[From an undated manuscript in the Evergood-Love collection, RA.]

The Voice of the Forest

Oh ye beautiful trees of the forest
Grandest and most eloquent daughters
From the fertile womb of earth:
When first ye spring from her
An infants puny foot
Could spurn ye to the ground
So insignificant ye are;
Yet ye spread your huge limbs
Mightier than the brawny giants of Gath!
How strong! How Beautiful! How wonderful ye are

Yet ye talk only in whispers
Uttering sighs continually
Like melancholy lovers,
Yet I understand thy language
Oh voices of sympathy,
I will draw near to thee
For thou can'st not to me
And embrace thy rugged stems
In all the transports of affection,
Stoop and kiss my brow
With thy cooling leaves
Oh ye beautiful creations of the forest.

[Accompanied a letter to Dr. A. T. Sanden, August, 1911, photo-stat, RA.]

The Awakening.

When Phoebe in the eastern ray
Fades early in the morning
With faintest tinge the breaking day
So tenderly adorning

Then restless herds demand their care
And musically lowing
Sniff scented gales of fragrant air
From dewey pastures blowing

Then on the rosy morning high
The hamlet smoke ascends
A curling tinge upon the sky
A charm to nature lends

At intervals a note is heard
A hail to the budding dawn
Another and another bird
Chirp a welcome to the morn

Tremulously the world awakes
To a harmony of trills
Till one eager bird slakes
Its burning soul in gushing rills

Of song, so loud so clear,
So joyously profound,
That aught else far and near
Seems lost or mute in this
 firmament of sound

One shepherdess of all the rest
Leading their flocks through daisy
 snow or morning dew
To the hills fair crest
In beauteous grace seemeth all
 the view

So is there always one,
One gem of purest ray to find
One moon; one sun;
One yet of nobler mind.

[From an undated letter to Dr. A. T. Sanden, photostat, RA.]

[Untitled]

These tended flocks and pastures green
Although the Sun falls fair along
Far brighter in my memory beam
["seems" inserted in margin]
For then I stray in love and song
 Ah well [?] the day
 And happy happy dreams

And well I know these sylvan bowers
That range so wide around
These scented gales of fragrant flowers
Remind of hallowed ground

For in other days
 There were pleasant hours

But now alas, no more can be
Our wanderings in the sunny gleams
Ah then what sorrow else for me
Thou vented grief in tearful streams
 The long long day
 So sad to be.

Where yon tree in sunlight stands
There us'd to be our trysting place
There met our hearts in trembling hands
There drooping 'fore my earnest face
 Eyes fell [?] the day
 That kissed the summer lands

But now alas no more shall know
Familiar paths our lingering feet
Alas! Alas! tears shall flow
For memories now but ghostly sweet
 This weary day
 Has griefs enough.

Just over yonder there the place
A sad sad bower of willow trees
Where leafy memories to call her face
Light hover in the summer breeze [haze?]
 The live long day
 In the lonely place

And when A reverie appears
Her face with same sweet smile of old
Then ah then I lay me down in tears
And sigh for cold cold death to fold
In embrace of years
 This weary day
 Has gloomy fears

And when And when sad beguiling
I wake from dreams to conscious day
Then ah then as her spirit [vision] smiling
I would resolve in dreams away
 In dreams away
 I would resolve in dreams away

[From an undated manuscript in the Evergood-Love collection, RA.]

215

To An Orchid

Oh beauteous flower,
Angel of the Floral kind
How shall I praise thee?
Sustained on thy arbor stem
Thou imbibst the air
And dost radiate it to a hue
Breath of my love
A poets ecstasy
I see thee, as man first saw thee,
A cool light in all the wood
Displayed in thy element.

[From a manuscript dedicated to Mrs. A. T. Sanden, December 24, 1908, photostat, RA.]

[Untitled]

From afar, from afar
From brass trumpets of war
Comes adown the gale
An echoing wail
Passing on a summer zephyr by
Coming again never
Out into the infinite sky
Like a dying shriek into eternity.

Nearer comes, nearer comes
A roll of drums
While a fifes shrilly cry
Dies: passes by to die
Into immensity.

See way up the street
The twinkle of their feet
A dark mass swaying
Bands playing
A Dirge

A Dirge
A Dirge.
Nearer coming nearer coming
With mournful drumming
Arms trailing
Fifes wailing
Steel gleaming
Sunlight streaming
A dark mass swaying
Bands playing
A Dirge.
Drawing near drawing near
Falls the silent tear
Runs through the frame a chill
As they climb the hill

Now bursts the awful chime
As they advance in line
Shoulder to shoulder
As they sway together
As they vibrate together

And the rustling of their feet
Through the stony street
Gives an impressive chill
Moving with perfect drill
Beats the throbbing heart
As they pass in part
To their beating drum
And their shrieking fife
Gives our blood a start
As they come as they come
With departed fife
And beat of muffled drum.

Then wail the shrieking fife
Roll the muffled drum
Halpines★ in the higher life
His remains come

Their impressive tread
Wakes a responsive dread
As their rustling feet
Beat the dusty street
Like withered leaves across moors
In chill November hours

Rustle their muffled tread
O'er the street so dread
 They pass beneath the hill
With their perfect drill
Leaving us a chill

As when water still
 Closes o'er a corpse
On the dread sea
 And the burier walks
Close again to me

Now bursts the awful chime
 As they pass away in line
 Swaying together
 Vibrating together
Now sounds the awful music
Strains the ear not to lose it
Sound it loud and high
Into the infinite sky

Roll the muffled drum
 Wail the shrieking fife
Halpines in his home
 Only his remains come

To the grave To the grave
 Halpine brave has gone
With sound of fife and drum
And Veterans every one
And we hold the breath
 In the presence of death
And we hold the breath
 For men who faced death
 Veterans every one.

Now bursts the awful chime
As they pass in line
Shoulder to shoulder
As they sway together
 As they vibrate together

With music weird and strange
 As sounds that range
Along the billowy shore
When storm rules the hour
 Alas! Alas!

 As they pass
 As they pass

 Wakes within the brain
 Oh so dull a pain
 Wakes within the frame
 Both a chill and pain
 Oh so dull a pain

 And we hold the breath
 For men who face death
 On the hill and plain
 In the bullets rain

 They seem not honourers of dead
 With their awful tread
 But to carry a victim slain
 Leaving us such pain
 As they pass
 As they pass

 With sorrow in their hearts
 A funeral step their parts
 With bowed head
 And muffled tread

 With air profound
 Shadows clinging to the ground
 Arms gleaming
 Sunlight streaming

 With music weird and strange
 As sounds that range
 Along the billowy shore
 When storm rules the hour—
 They have passed
 They have passed.

[From an undated manuscript in the Evergood-Love collection, RA.]

*Probably a reference to Charles Graham Halpine (1829–1868), an Irish-born American editor and poet, who rose to the rank of brigadier general in the Civil War. He wrote war poetry under the pseudonym of Miles O'Reilly. Halpine died at thirty-nine, having inadvertently given himself an overdose of chloroform which he used to relieve his insomnia.

[Untitled]

Lightly o'er the meadow land
Wailing o'er the shelving strand
Hides it in some shady dell
Or in some caverned well,
Ah tell me, who can tell.
The mist soft molded to the cape
Rises lightly on the morning air
And shifts with every breeze its varying shape
But always graceful and forever fair.
The thought fits to the parent mind
And lightly floats, away
But varies to each 'centric kind
That grasp it on its way.
Passed beyond recall the thought
Makes forward free as air
On what eternal mission fraught
Its end, oh tell me where.

[From an undated letter to Mr. and Mrs. J. Alden Weir, J. Alden Weir Papers, Harold B. Lee Library, Brigham Young University, Provo, Utah.]

Lines Addressed to a Maiden by Request

I look upon thy youth fair maiden,
I look upon thy youth, and fancy laden,
—Would that I a fairy were
That with magic wand I could deter
All evil chance, and span thy coming years,
All sorrows wrought by rain of tears,
With a rainbow bright:
That thy feet, made joyously light,
May tread thy glowing arc of days.
May such sorrows as all must feel
Come to thee as tears that steal,
In sleep, from the peaceful lid away,
Leaving no trace in the morning ray,
As an opal, from the dark,
 Shines still brighter rays.

[From a letter to Olin L. Warner, Christmas, 1875, Olin L. Warner Papers, AAA.]

[Untitled]

They lived the life of angels
For they worshipped each other as angels
From their coming steps and their going steps
Arose the fragrance of flowers
And they respired the aroma of their odors
Each sought to forestall the other
With little acts of tenderness
And with the intuitiveness of inspiration
Which is love they penetrated
To the wishes of the inner soul
And delighted by the wonder of their perceptions
In love morning succeeds morning
One day another day varied only
By increasing love increasing tenderness
Her steps were too pure to touch the dust
He lifted her in and out of conveyances
And over obstacles that destroy
The grace and harmony of womans movements
And each day she seemed lighter
Because he grew stronger[,] erect and beautiful
Breathing and living in this
Exquisite atmosphere of the affections

[From an undated letter to Frances (Warner) and Ralph McElfresh, RA.]

Untitled

A bit of gold in woven wire
A song of impassioned fire
A fluttering of autumn leaves
A trembling when a maiden grieves
A tiny throat a storm of sound
A following silence quite profound
Does it think of liberty.
Liberty, Liberty, give to me
Sweet, Sweet Sweet
Lib Lib Lib Liberty
It calls, it sings my bright blue sky
My nest. My Home. Open my cage
 that I may fly
Oh give give me ere I die
Liberty Liberty
Sweet Sweet Sweet
Lib Lib Lib Liberty.

[From an undated letter to Cora Weir, private collection.]

Interviews and Reminiscences

The following interviews and personal reminiscences are mainly from the Lloyd Goodrich–Albert P. Ryder Archive, in the University of Delaware Library, University of Delaware, Newark [RA]. Although they have been drawn upon intermittently in the text of this book, they deserve to be published in their entirety.

The author of these notes was Harold W. Bromhead, an employee of Cottier & Co., Ryder's dealer, in 1901. Apparently he had hoped to write an article on Ryder for the English art journal *The Studio*, but nothing came of this plan. In 1919, when Bromhead was working for his family's art gallery in London, he sent these notes to Frederic Fairchild Sherman, author of the first book on Ryder. Because they offered so much new firsthand material about Ryder, Sherman printed a fragmentary digest of their contents in *Art in America* (October, 1937); but the complete notes were never published. [RA]

"Rough Notes Made By H. W. Bromhead, about 1901, for a proposed article in *The Studio* upon the works on which Ryder was then engaged"

ALBERT P. RYDER

Now 53 and complains that he is still too young.
Now engaged upon:—

Lorelei. Moonlight scene on Rhine. Spirit lying on a high rock singing to the man in the boat. Rushing river with vapour rising, wonderful tones of blue and tender mystery and romance, a harmony of blues. For Mrs. Corbett. (Portland, Ore.)

Macbeth and the Witches. (Hail Thane of Cawdor!)
Has treated Macbeth before but a much smaller picture and a different point in the tragedy. This and Jonah and The Tempest his three largest pictures. In this picture another note is struck, another emphasis given. Deep, thrilling, and tragic, the night is stormy. Rain falls like a veil over the figures from clouds overhead, while in the distance the moon emerges between the clouds, and her light penetrates through the landscape. In a lonely glen at the foot of a towering crag the witches await Macbeth and his companion. Silent, gaunt and tremendous, the chief witch stands erect while her companions crouch in the shadow. The two horsemen have emerged from a narrow gorge on the right at the bottom of a lofty cliff on which far away remote is perched a rambling castle with frowning battlements in the moonlight, dominating the landscape and from its very secrecy making the loneliness more impressive. The scene is fit. The atmosphere seems to quiver with a sense of the weird and the dreadful. The suddenness of the encounter is shown by the restiveness of the riders' steeds which rear upon their haunches. Again another harmony of colours and masterly handling of moonlight. The faint purplish tinge of the hill in the middle distance suggests the Scottish heather even in the moonlight. The composition so adequate, so finely balanced. The note of dramatic terror so piercing, so enthralling. Marvellous the inspiration Ryder finds in Shakespeare.

Genius of the Race Track. Death on horseback wielding a scythe riding around a race course. Choosing from medieval precedent, R. prefers Death as a cadaver rather than a conventional skeleton. This powerful allegory suggested by an incident from real life and has a certain Holbein strain. A poor waiter in Brooklyn inspired by the success of others on the track slaved for years to get $500. On the first race he lost it and blew out his brains. This sounds as if the picture were didactic, but it is not, only allegorical. It preaches no sermon but only illustrates a poetic idea. Absurd to compare, but contrast occurs with Mr. Frith's "Derby Day." The course may be bright, mirth and jollity abound, but the presiding genius of it all is Death, Death to the finer instincts. Death wins the race, always. Some such idea as this the painting conveys. The action of the horse and impressions of speed very fine. The horse and rider are in the full middle of the picture, sweeping around to the winning post on the left. There are no spectators, for this jockey is unseen. Into the landscape and the sky the painter has put all his tenderest melancholy and most poetic sympathy The fence of the track is broken away in the immediate foreground and a snake is writhing away from the horseman's track. Fine passages of loveliest green and a superb sweep to the track. Romantic sky.
Reserve [*sic*, read Reverse].

The Passing Song. Very small, not sufficiently advanced to photograph.
A perfect gem of composition. Illustration of unrequited love. The concentrated feeling in this small canvas. The maid who sang and the youth whose boat had no rudder.

The Tempest. (Illustrate) for Mrs. Wood, Portland, Ore. Nearly always reserved, here Ryder has let himself go, and steps forward and cracks the whip to the Pegasus of his fancy. With a theme so purely whimsical no necessity to be restricted by ordinary conditions. Unreal, Yes; so is Shakespeare's comedy. Theatrical; in an ideal sense, yes. Here we see Ryder at his full speed and how finely he has his flying steeds under control and in hand. Actors are inspired by the picture. Generally using his instrument at half swell, R. has here pulled out all the stops, and we have the thunder of his diapason. The result is tremendous; everything tells. Prospero and Miranda, Caliban, Ariel, the wrecked vessel, the heaving and yeasty sea. And then the colour! The last vivid flash of the lightning in which Prospero holds up his hand to tell Caliban to end the storm. This is the point where we are introduced to the scene. Caliban an uncouth monster. The grace of Miranda, the beauty of her, the dignity of Prospero. Ariel swimming into the sky. The power of it, the grasp the sympathetic insight into Shakespeare. The Shakespearean flavour of pleasant large-hearted half-serious comedy.

The Flying Dutchman. For Mr. Gellatly. Ryder is proud of its pure tonality, says the key is as high as the paint will go. cf. Inglis's Monticelli.

Temple of the Mind, R. B. Angus, Montreal.
His masterpiece, cost him the most thought and the most work of any of his works. The beautiful temple-alabaster covered with moss. The foul satyr has driven out the lovely graces, even love himself, and dances with resounding hoofs over the beautiful marble floors built, alas! for other occupants.

RYDER HIMSELF

The idealist. Artistic hermit. The poet. Reserved, shy and sensitive as a gazelle.
Fine in colour as Monticelli and not so monotonous, more sane. Does not exhibit for the reason he quaintly gives that some of his brother artists did not like it. Not even represented at the Paris Exposition.
Master of the sky, especially of the moonlit sky, Wanders whole nights from dusk to dawn.
Never much heard of, for the reason of the smallness of his output. Has an audience fit though few, indeed more concentrated in devotion and admiration in proportion to its restricted circle. Of commendable patience. His works cannot be got and very rarely seen. Commissioned years ahead. Demand exceeds supply. Now 53, and complains that he is too young to do his best work yet. Spirit of other worldliness. Century article Eckford. Segantini[1] much in common with Ryder.

A young painter who admired Ryder, Salvator Anthony Guarino, visited the artist in 1907. He presented his recollections of that event in this essay written on February 22, 1919, apparently at the painter Alexander Shilling's request, for Frederic Fairchild Sherman, who was preparing his book on Ryder. Particularly telling are Ryder's views on the deterioration of works of art—especially in reference to his own. [Frederic Fairchild Sherman's collection of Ryder research materials, RA]

"A Visit to Albert P. Ryder"
by Salvator Anthony Guarino, February 22, 1919

It was on a drizzly November night in 1907 that I found my way to the "Palace of Dreams" where the master reigned and Gustave Cimiotti was with me.

I shall always remember the quaint red house way over on the west side and the stout old "biddy" who instructed that we go "two flights up in the rear."

Knocking at his door was no easy task. Somehow I was under the impression that our reception could hardly be pleasant hence the great sigh of relief when the door was opened a few inches and Ryder's impressive countenance appeared in the dimly lighted opening. A gruff "who do you want?" & I sailed in telling our hope that he might receive us as young painters who deeply believed in his work.

"Come in" he slowly answered.

Shall I ever forget the square room fairly littered with every imaginable thing from onions to bedroom slippers and the old white bust of someone or other wearing a hat that cast a deep black shadow over its eyes?

A great big carved chair was there too and the master hastily sought a dust rag that I might be properly enthroned. I felt keenly flattered when he told me that Sir William Van Horne used the same seat when he visited the studio.

It took a long time to get the master interested. He seemed very shy or diffident. It was only after he was convinced that our visit was not one of simple curiosity but prompted by the most sincere affection for the man and his work that he became more at ease. He timidly asked if we wished to see some of his unfinished "children" (as he termed his pictures). Of course our "yes" could not have been more emphatic.

There was, I think, in Albert P. Ryder an over accentuated sense of jealousy in reference to his pictures. From every hidden corner he pulled one out and having passed a large wet sponge over its surface he would place it under the solitary gas jet for us to see. It was under these circumstances that I was given the joy of seeing his

"King Lear" "Macbeth and the Witches" a little "moonlight" with a horse & cart lately sold at the Morten sale—the famous "Passing Song" of which he recited the quaint & tragic poem that the picture illustrates.

Albert Ryder spoke at length of his critics. "They say I cannot paint, that I fuss away like a child and that my efforts are puny etc. but they forget that tho' I stumble along I do get to where I want to go. "Besides" he added, *"I would not be Ryder if I painted like someone else."*

And to my question as to whether the cracking of his pictures ever bothered him he answered, *"When a thing has the elements of beauty from the beginning it cannot be destroyed. Take for instance Greek sculpture—the Venus de Milo I might say—ages & men have ravaged it—its arms & nose have been knocked off but still it remains a thing of beauty because beauty was with it from the beginning; so why worry about my children?"*

Coming from any other painter this assertion might have been considered sheer conceit but from the lips of the master it sounded like a very simple & everlasting law.

He had no use for dealers or individuals who had the hobby of restoring pictures and was very positive that his work must live or die as it was created.

Albert Ryder spoke also of the hurry of his patrons. One, Sir William Van Horne, paid for a picture some ten years before but had been unable to get the master to part with it. "Whenever he comes here he keeps on asking for his picture, but he can't have it until I am through with it—masterpieces are not created in a day or a year!"

It was long after midnight when we decided to go—as I closed the door behind me I caught a last glimpse of the Giant standing near the hatted bust of the someone or other I did not know.

The following reminiscences of Ryder's friend Arthur B. Davies were recorded by G. B. Hollister of Corning, New York, an art collector and glass manufacturer. Davies had spoken with Hollister and his wife in their home in October, 1920, and at that time or some later date Hollister wrote down Davies's remarks. Davies's comments on Ryder's technique are especially interesting. [RA]

"Albert P. Ryder
as remembered by
Arthur B. Davies"

In October of 1920 Davies while visiting us in Corning, N. Y. knowing that my wife and I were interested in the work of Ryder, and because the artistic kinship between them was so marked, they both being dreamers romantics the acquaintance blossomed into warm friendship.

Davies, as a young man, became acquainted with Ryder intimately and became greatly attracted to him. Davies fell into the habit of visiting Ryder in his lodging on a street way down town in New York. Ryder, he said, lived the life of a recluse, in quarters disorderly and untidy in the extreme. He would not allow anyone to clean or arrange his things. Clothes, old battered furniture, canvasses and priceless pictures were all thrown together so that [there] was barely enough room left in which to turn around. In such surroundings his cooking simple as it was, was done by himself with great irregularity. "Ryder did not encourage visitors," said Davies and, "I think he had few friends."

There were times when he was desperately poor and even found it difficult to buy the art material he needed for his work. At such times he would saw out a piece from the headboard of an old walnut bed and on it paint a picture.

The self portrait which is in the writers collection was painted on such a board—[2]

On one occasion Davies entered Ryder's cluttered studio, a kettle was bubbling in the fireplace, with some concocktion whether to paint with or to eat, he did not know but he found Ryder pacing up & down pulling his long gray beard and exclaiming over & over again. "She's an orchid. She's an orchid." It seems that he had been talking about a little timid old maid school teacher who roomed below him and who had appealed to him because some spiritual quality which Davies said he himself recognized in her. Ryder had been disappointed in love several times. People had "interfered" it was said. However in this case Ryder had just given the little school teacher one of his paintings. "Just handed it over" said Davies. A rather touching tribute it seemed.

On one dark night Davies met his friend way up Broadway in bed room slippers. He had come out to study the November sky, and in this Ryder was doing nothing unusual for he frequently stayed out all night observing the changing subtle light effects in the clouds & sky. The results of such observations are of course noticeable in many of his pictures.

One of the unfortunate features of Ryder's technic in painting was his habit of overloading his canvasses with paint. Coat after coat would be added for building up the body of the paint, or pictures which had been set aside were later changed by repainting to give some new effect. While this technic gave his work a quality which enhanced the subtle effects he was trying to produce, the results in other[s] introduced new difficulties. The paint

in some of these pictures had a tendency to wrinkle while drying and in others marked cracks have developed. Davies related that Ryder came to him one day in great distress to ask what he (Davies) did "to keep the paint on his canvas." Ryder stated that his paint at times would drip down & dry on his easel in blobs. Davies told him that in his own painting he used very little paint, barely enough to cover the canvas, which avoided the trouble Ryder was having. Davies classed Ryder as a great artist and his estimates of the status & value of some of his latter paintings was interesting. Among others Ryder's "Jonah" was among them. The Jonah had been out for some time changing hands owners [sic] and at an increased price with each change. The owner at that time was Mr. John Gellatly of New York who was said to have paid $25,000 for it. Davies was an excellent critic of pictures and a keen judge of their values. He said about this picture ["]$25,000 was no price for it that painting is worth $100,000 easily. There is only one Jonah"!

Then there was the case of another [of] Ryder's pictures The Temple of the Mind[.] [end of essay]

A sculptor who had attended the National Academy of Design with Ryder, James E. Kelly, apparently wrote this essay for publication in *Scribner's* (the title of the magazine appears in the upper left-hand corner of each page of the typescript), but it was not published there or, as far as we can tell, anywhere else. Composed sometime after Ryder's death in 1917, it gives a candid, close-up view of the artist's behavior, especially in his early years. [RA]

"Albert Pinkham Ryder"

by James E. Kelly

My earliest recollection of the artist Ryder was at the old Academy of Design at 23rd St. and 4th Ave. I do not recall our first meeting, and never saw him at work, as I was in the third alcove and he in the first. His character was like his own pictures—you gradually found yourself in a delightful atmosphere created by his winning personality. That made the beginning so indefinite; yet as time passed this attraction seemed to grow without one being able to put the cause of it into words.

He was somewhat taller than I, and wore a slouch hat. His hair was light brown and straight; a high, delicately modeled forehead, very fair, almost pearly in effect. Ryder's eyes were inclined to be blue–lustrous, with a frank, confiding look like a fine child; nose straight and crisply moulded, with sensitive nostrils. His face was pale, without much color, covered with a light, flossy beard, as though it had its own way. At that time he was very neat, with a New England regard for the proprieties; but what made Ryder was his sweet, refined voice and gentle smile.

Meeting in the alcove, he invited William Carroll, another student, and myself down to his room, southwest corner of 9th St. and Broadway, to see his pictures. He led us up a dark stairway to a little room in the rear facing 9th St., and the light was fading as he started to show his paintings. I must say that I did not understand them, and it was many years before I could. But Ryder's personality and earnestness made me try. The other student, a breezy Texan, seemed to look upon them as a huge joke, while Carroll was enthusiastic over them from the first.

He must have felt my sympathy and liking for him, because he routed around in corners and showed me everything in the room. Then, going to a closet he began pulling out more, finally bringing out a fair-sized picture representing a stretch of moorland. Enthusing over this, I said, "That ghostly figure in the distance adds to its desolation." "A figure!" he said, "What figure?" "There!" I answered, pointing towards it. Stooping down, he examined it closely, and rubbing it with his finger said, "Why, that's not a figure—it's a drop of candle grease!"

But I held my ground and answered, "Well, if it's not a figure, it ought to be one, because it adds to the weirdness of the scene—that lone figure crossing the moor. Now if you will take out the candle grease and paint in the figure it suggests, that will improve it." Ryder studied it and musingly said, "I see what you mean, and will do that." Then Carroll began to talk of his color and tone; and I felt that I was complimenting him by saying I thought his work resembled Boughton's. "Yes," he said, "some people seem to think so, but I have more gold in mine."

He seemed to appreciate our praises, and do not think he had received many at that time. Yet in spite of all his gentleness and suavity, one could feel the resolute confidence and high moral courage of the man. After leaving, as we stood on the corner, the Texan jumped darkey fashion, and giving a hearty laugh, said, "He's crazy—he should have a keeper." I remarked that he was a nice fellow but a little queer, while Carroll was deeply impressed and glorified him. We were all young, but Car-

roll seemed to look farther into the future. The Texan went back and began to paint short-horned steers for the cattle barons, which so impressed them that they backed him. He received the appointment to paint the Governors for the State Capitol, through which he achieved wealth and local fame.

After that, our friendship was continued by chance meetings. I heard that Daniel Cottier, the Scotch art dealer on 5th Ave. at 20th St., had taken up Ryder and was bringing his work before the public. His prices began to be quoted among the leading painters, and some of his pictures were engraved by Kingsley, which was a distinction of itself. I can recall THE FLYING DUTCHMAN and JONAH AND THE WHALE, both published in the Century. He soon won a distinct position in the art world.

Some time after, I met Ryder in front of the old Scribner building opposite Astor Place, carrying a large board under his arm, and asked "Where are you going with that plank?" He turned it around—on the other side he had painted one of his masterpieces, and replied, "I've a frame in my room, but this is too large to fit it, so I'm going around to a carpenter's and get him to saw it off." We then began to talk on subjects of mutual interest, not of pictures; he generally talked of old friends and old times.

One bright fall morning I was walking down the east path in Central Park leading to the Arsenal. A little above the bridge at 65th St., some sheets of paper blew in front of me and across the lawn. Looking to see where they came from, I saw Ryder sitting on a bench, where he had been writing. He hailed me in his usual cheery way and said, "I'm sitting on my manuscript, so can't get up lest the rest blow away." I went over to the grass, gathered up the stray leaves and handed them to him. He said he was up there writing poetry, which he liked to do, as he could write better with nature in front of him, which was rather singular, as he always declared that he could paint better away from nature.

We had quite a talk, but as usual his personality dominated. It never struck me to ask what he was writing about, any more than to ask him to show me his pictures. If I had not come along, I suppose that he would have let his notes blow away without thinking to put his other sheets in his pocket and go after them! As years rolled on, he began to lose his natty appearance and became quite unkempt; his flossy beard became thick and matted, and his cheeks grew quite full, but their color was better. His fine features had lost a little of their edge, but his lovely eyes kept their youthful luster; his voice retained its mellow charm and he never lost his courtly manner. After Cottier, with his rugged Scotch moral courage, gave Ryder his start and sounded the "view hollow," the whole pack of art dealers and collectors started after him

in full cry, while he—roused from his dreams like a startled stag—fled, seeking on every side for refuge, as that one in Sir Edwin Landseer's noble painting, THE SANCTUARY.

Meanwhile I had moved to 344 West 14th St., and in my walks up 8th Ave., across the southwest corner of 15th St., I met Ryder, who had been marketing for breakfast. Greeting me as usual, we stopped there in the spring sunshine, and he dropped into his accustomed train of inquiry for old friends. I looked him over and marked the changes since we first met and he had achieved fame. He wore an old weather-beaten derby hat perched on top of his head as though someone had placed it there; his hair was scraggly, his mustache longer and his beard matted, as if he had given it a twist. Ryder's fine features had become intensified with age, but he still retained the bright eyes and the smile of youth.

He wore a night shirt instead of the conventional one, with a china button at the neck—no collar and a well-worn sack coat; his trousers hung low at the hips. His right arm balanced several bundles of kindling wood, which gave out a rather pungent odor of pitch pine and the tar rope around them; in his left hand he carried a large china pitcher almost full of milk. Over his arm was a large wicker basket containing packages of cereals and other foodstuffs; under the same arm, partly covered with yellow straw, was a large twist loaf, its ends sticking out fore and aft. That meeting was the forerunner of regular ones, with little variations.

Sometimes he balanced a higher pile of wood bundles, and at other times had a bigger load of cereals. We never inspired any art talks in each other—it was all good fellowship. He said that he had hired a studio at 308 West 15th St., where I called once; it was an old-time tenement house, but neatly kept, and the stairs were comfortably carpeted. His room was one flight up in the rear. Ryder was either out, or did not care to answer my knock. I shortly after moved from the neighborhood, but Carroll kept up our intercourse by delivering mutual messages and furnishing details of his observations. Carroll gave me the following description of Ryder's studio:

"I met Ryder about half a block from his house. Although I had been invited several times, I never succeeded in entering—he had a trick of ignoring the knock; but that time I said that I would like to see his works, so he took me to his studio. Entering the room, a conspicuously large table was crowded to its full extent; on the floor was a mound of cereal boxes and milk cans—it looked like a junk shop. After seating me in a large chair, he reached up to the shelves or racks and showed me one of his few large paintings.

"He dusted it, and in spite of its dark tone, its beautiful color and rich golden glow showed through, even in

the dim light of the room. He also let me look at his smaller pictures, which he was more accustomed to paint. The room was in a large, comfortable tenement. You could forget the condition of the room amid the many interesting works, and I could not help feeling impressed by being surrounded by so many masterpieces. It was a studio where the man was completely bound up in his work.

"Near the entrance was a cylinder stove, used for cooking as well as heating; his coffee was excellent, and he was hospitality itself—after you were admitted. He then entertained me with stories of his struggles, telling me how he had to wait for recognition of some of his noted works. I remember an incident of his early career; standing in front of the William Schaus gallery, Broadway and 8th St., seeing Ryder come out, I asked him 'What luck?' He had a small picture in his hand, which he had painted on the cover of a cigar box. He said that Schaus received it with such words of contempt, and insult that I will not repeat them here. But in spite of them, Ryder smiled confidently, and in a few years those pictures were valued at thousands.

"He liked to paint on cigar boxes, for the golden tones of the cedar, which glowed through his backgrounds. An association of art dealers and collectors published a magazine in the interests of the trade, and used to have a monthly dinner—a most exclusive affair in art circles. Ryder showed me an elaborate invitation and said, "I did not want to go. As Macbeth said, I do not care for such things, so I sent a poem, ON A HYACINTHE, instead." It was read by the chairman and received with applause; later it was published in the Art Magazine, which seemed to please him very much.

I met Ryder again one morning on 14th St., and he invited me to have a sandwich and a glass of old ale in a tavern corner of 13th St. and 7th Ave., frequented by sailors, principally from England on account of the Cunard and Scotch lines near the foot of the street. The place had assumed an English tavern type, and had a back room characteristic of the English Public House, such as Dickens would describe, with pictures of the Heenan and Sayres fight, and of racing horses, such as Dexter in Harness, all of which appealed to Ryder's bohemianism.

In the course of our conversation I said I had noticed a great sale in the American Art Galleries, and that some of his pictures had sold for four figures; and congratulated him. When I read the item about it to him, Ryder never showed any enthusiasm, but simply said, "I think the man got a bargain, as a picture of mine sold for four figures in England—I think it is a good investment he has made." "I saw a very fine picture of yours, THE FLYING DUTCHMAN," I continued; did you sell that?"

"Yes," he replied, "a man with a very prominent name saw it in my studio and said, 'Send this to me for a month, and if I get to like it, I will buy it for Two Thousand Dollars.' He took it away, and I forgot all about it; but meeting him one day he said, 'Ryder, take back that picture, I—I don't understand it, and don't like it enough to buy it.' I took it back and sent it to the Academy, and about a week after. . . . " Then he went on munching his sardine sandwich as if that finished it.

I said, "You needn't tell me the rest, Ryder. I read in all the papers about the great sensation of the year—THE FLYING DUTCHMAN, by Albert Pinkham Ryder—sold the first night." "Yes," he answered, "the man I have just told you about called on me a few days later and said, 'Ryder, I made a mistake. Who bought that picture?' I told him, and he remarked, 'I'm going to see the present owner.' It cost him more than double what he offered at first, and is now held at much more than double."

He told me once that on the street he met Macbeth, who asked, "How is it, Ryder, that I have to go to England to get any of your pictures?" He had a great habit, when he did not answer a question, of shaking his head and smiling. "Well, I can't paint unless I am in the mood—you know that, Macbeth; but the next painting I'll not forget to show you. You know that dealers will insist on offering me money—I don't need money," with his usual gurgle and laugh. The great value of his pictures is that he only painted a limited number.

For a change, we would at times patronize one of the few oyster saloons then remaining in Greenwich Village—a triangular, two-story wooden structure in the south angle of 8th Ave. and Horatio St. A sign read, OYSTERS IN EVERY STYLE; also a painted sign, CODFISH SANDWICHES, FIVE CENTS; OYSTERS AND CLAMS ONE CENT APIECE. At a window on the 8th Ave. side was a shelf on which were salt, paper [sic], vinegar and catsup. Inside was the proprietor, known as "Captain," whose glazed cap was perched on the top of his grizzled head. His face was lean, seamed and weather-beaten, and a sailor-like chin piece decorated his chin.

That he loved art, and had bled for it, was proven by the tattooed emblems on his huge, sinewy hands, as he dealt out oysters on the half shell to a crowd of fellows. Except at the doorway, the building was surrounded by mounds of baskets full of oysters. Inside, facing the window where the Captain stood, was a small counter with an oyster block, and the rest of the end was lined with oysters or shells. Along each side of the room were benches on which customers sat.

The cooking was done at the point of the angle, and was presided over by Mrs. Captain, a motherly woman, and her pretty daughter; they served raw and cooked oysters, hot codfish sandwiches and tea. Sometimes we

would plunge and order lobster. At that time Ryder assumed a more eccentric costume; he wore a Turkish fez with a tassel, but being an old landmark, nothing was ever said to him. In fact the neighbors appreciated him; I have heard them say when he entered, "There's Ryder, the great painter—he gets thousands of dollars for his pictures." The place was a resort for theater parties, people returning from picnics and family gatherings of the villagers.

Whenever he met me he would call me Kelly, and would then apologize and say it was on account of the similarity of names, and the old Academy days. Another phase of his character was his affection for a favorite niece who had just died. I met him as he was returning from her funeral, on which occasion he observed all the proprieties, wearing a plain frock coat and high silk hat.

He said he had two studios, one to work in and the other in which to receive, the latter in a modern studio building on 14th St. I called on him once there. It was not as picturesque as the other, but neat, with a sofa, chair and easel. Then I missed his kind, good face, heard that he was ill and had left the city to be cared for by friends. His death was announced on March 28, 1917—another great loss!

When Ryder came to the Academy he used to join a party which met in the coat room, among them Brush, Bliss, Denslow, Baker, the Hyde brothers, Raye and occasionally Thayer—not forgetting Joe Evans. One day Church came in with his usual breezy western swagger. Ryder said, "How do you do, Mr. Church." Church drawled out, "Ryder—it's you're the Mister, as the great painter. I am only Church, the student!"

Shortly after that he had an attack of typhoid fever. Denslow told us in the Academy; so Church, Denslow and myself did what we could to comfort Ryder in his sickness. When I called one day after his recovery, he said, "I appreciate the kindness of you boys, especially Wallie Denslow. I feel that I owe you something; then, pointing to some of his paintings on cigar boxes, he said, "I give that to Denslow, that to Church—and that to you." We were all glad to hear this, but Denslow and myself went into newspaper work and lost all track of the artistic; and when we returned in a few years, we realized what we had lost through our negligence.

When I told this to Macbeth, he said, "I wish you had them now—I would give thousands of dollars for them." So much for neglecting an opportunity. Ryder told me that he had studied painting under Marshall, the engraver. W. H. Shelton said that he knew Ryder very well—that he did not understand the value of money. He was careless of his checks and left them lying about his room; when he died they found several of them among his effects. . . .

Henry C. White, biographer of Ryder's contemporary the painter Dwight W. Tryon, paid several calls to Ryder in his studio in the late 1890s. Although White and Ryder did not develop a close friendship, White's undated account offers a valuable descriptive vignette of the artist in his working environment. [RA]

"A Call upon Albert P. Ryder"
by Henry C. White

As an admirer of the work of Albert P. Ryder and at the suggestion of a mutual friend, Miss Mary R. Williams, an artist, I called upon him several times during the late nineties at his studio and living apartment in West 15th Street, in New York. It was on the second floor of an old tenement house in a crowded, dingy and down-at-the-heels neighborhood and about the last place in which one would expect to find an artist of Ryder's temperament. His patrons and agents, Cottier & Co., had persuaded him at times to leave his sordid surroundings and had installed him in comfortable quarters in a better locality. But he never stayed more than a week or two and, though grateful for their interest, he was soon back in what was, for him, a congenial environment.

His studio was originally a back bedroom of the tenement and his own bedroom, not more than eight or ten feet square, opened from it. The studio was lighted by two windows overlooking a courtyard draped with clotheslines and washings, and filled with ash barrels, garbage cans and rubbish.

I first called one morning about eleven o'clock. Groping my way along the dark hall, I came to the door of his studio and knocked. There was no response and I knocked again. I waited about five minutes and was on the point of leaving when there were sounds of someone stirring in the bedroom at the right. In a few minutes the door of the studio opened about an inch and an eye peered at me.

I said, "Mr. Ryder I have come to call upon you and see your pictures, if it is convenient for you and I am not intruding." He said, "Wait a minute," and disappeared. In a few minutes he returned and said, "Come in."

He seemed rather heavily built and somewhat above medium height which was accentuated by a long, dark brown bath robe which covered him from his head to his bare feet. With his unkempt hair and beard, I felt for the moment as if I faced a monk of the Middle Ages.

He placed a chair for me in front of his easel, dusted the seat of it and wiped a clean circle on the floor around it. He said little at first and looked at me shyly and rather suspiciously.

The room was about twelve by sixteen feet. Ryder's

easel stood in the space between the two windows at the rear, which faced the South, and the floor about it was cluttered with small canvases, cooking utensils and odds and ends of clothing, leaving a clear space only four or five feet square in front of it. The dust upon the shelf or rest for pictures of the easel was so thick that the forms of paint tubes lying upon it were but dimly recognizable. They must have lain there undisturbed for years.

The ceiling of the room had been papered originally but leaks and dampness had loosened the paper and discolored streamers of it, three or four feet long, hung down like stalactites, interspersed with cobwebs. There was an old-fashioned white marble mantel and fireplace at one side and on the mantel was a plate with a couple of chop bones and a potato which looked as though they had been there for a considerable time. The inner half of the room was piled high with boxes, packing cases and a confused mass of junk, partially obscured in the dim light.

When Ryder saw that I appreciated his work his shyness disappeared and he brought out his pictures to show me. He was quiet and a little reserved but very gentle and kindly, and talked readily of his painting.

One picture that I remember especially was a small oil about 12 by 16 inches, evidently one of his favorites. It was thickly covered with dust. He set it on the floor and got a wash basin of dirty water and a dirty towel and washed it. As soon as it dried, I could see that he had washed it many times before, for the process had taken much of the oil out of the paint and given the picture a beautiful dry, atmospheric quality like a pastel, and a lovely tone.

The subject was a moonlight and the moon had been painted over so many times that it projected a quarter of an inch or more from the canvas like a large white button and seemed ready to drop off, as Ryder scrubbed it, which apparently did not trouble him at all.

Ryder's casual treatment of his picture convinced me that his technical methods were much like those of many other imaginative and creative painters, especially the colorists. When his mood impelled he scraped, glazed, scumbled and made the wildest experiments, simply to produce a fine bit of tone or beautiful color. It was an emotional process that often disregarded sound technique, working over a surface not thoroughly dry, piling layer upon layer of paint and using too much medium or varnish.

The results are shown in some of his pictures which have cracked, blackened or disintegrated, though not always greatly to their detriment for much of their charm often remains, as in one of Ryder's masterpieces, "The Flying Dutchman."

Ryder evidently used his pictures as a school boy does his slate. They were an emotional proving ground, easily erased or sacrificed in the effort to obtain the rarest qualities. He forgot them in the intervals and did not worry about them, or, like Whistler, have sleepless nights. When in the mood he pulled them out, played with them and enjoyed them as a child might play with a handful of jewels or semi-precious stones.

William Gedney Bunce and Ryder were friends and their art had much in common. They once exchanged pictures. Calling on Ryder some time afterward Bunce was disconcerted to discover his own picture, which was painted on a wood panel, lying flat, face upward, on a side table, where Ryder was using it as a place to set his beer mug.

The humor of this appealed to Bunce and he did not resent it for he knew that Ryder would have been quite as likely to use one of his own pictures in the same way.

Ryder was, of course, a good draftsman, but he did not let scientific facts stand in the way of poetry. He painted a number of pictures with a white horse as the principal object in the composition. In working for qualities of color the drawing and anatomy sometimes got out of hand. T. W. Dewing told me that he once said, "Ryder, why do you paint those white horses of yours about fifteen feet long?" "Well," said Ryder, dreamily, "I think they are a little more naive that way."

To return to my call, Ryder showed me other pictures, among them one that appealed so strongly to me that I asked him if he would sell it to me. He seemed pleased that I liked it and, putting it in a good light, he looked long and lovingly at it, seeming for the moment to forget my presence. Finally I gently recalled him to my question. He said, "I am glad you like that picture, and if you will come again next year I think I can let you have it, when I have done the little more it needs. I have only worked on it for about ten years."

In the chaotic world of today the serene decade of the nineties seems remote indeed, but even in that Arcadian era a call upon Ryder was an inspiration. He rose high above his surroundings and one forgot them entirely. He had the simplicity and sweetness of a happy child and in his utter unworldliness and complete detachment from mundane affairs he stood out in vivid contrast to the typical American. Unlike many artists of genius who are jealous of their privacy and who resent intrusion upon their time, Ryder, who had no set hours or routine of work, always seemed glad to have a call from an appreciative visitor. His setting in the slum was his defense. Few but kindred spirits would ever have penetrated it. After a call upon Ryder when I went out into the noise and confusion of the city streets, Ryder strangely seemed the reality and New York the shadow.

Marsden Hartley, a young painter from Maine fascinated by the emerging spirit of modernism in the arts, made his pilgrimage to Ryder's studio in 1909. The artist's integrity and the quality of his work so impressed Hartley during his several visits that, in his later years, when he had achieved considerable fame as an artist he wrote several revealing essays that pay homage to Ryder. The following [c. 1929], one of the most personal, has never been published. [Beinecke Rare Book and Manuscript Library, Yale University, New Haven, Conn.]

"A. P. Ryder: 'The Light That Never Was' "
by Marsden Hartley

In these little pictures of Albert Ryder—and the largest cannot really be called large—is epitomized the drama of the sick soul—the tragic union of love and of death. There is an unceasing passion in them to enter that "other" world—to escape, if possible, from this unceasingly wearisome one. Ryder was moon-ridden—he was obsessed of all the shades of lunar despair and lunar hypocrisy—for the moon has led many a sad poet to perdition by the diabolical gift of hypocrisies she has over[?] them. That is to say the poetic of this epoch. There are of course no moon poets in the 20th Century and cannot possibly be—because the moon has been unveiled and found to be a very vacuous lady. She has been displaced by synthetic planetary effulgence—just as every other quality of life has been supplanted by synthetic veracity—and the truth of yesterday is the ridiculous piece of baggage of today for which no one has practical need or practical use. Ryder's was an ancient soul longing for the ancient illusions—and it is this quality that offers the given beauty to his pictures. No real lover of the realistic fact would be satisfied with Ryder's idea of nature—and he would be inclined to say that Ryder knew little of actual nature & yet nothing that Ryder ever did is devoid of true knowledge of things as they are—nothing that does not prove that he not only saw nature as she was but saw her "in the flesh" so to speak. Ryder held his vision of nature constantly—and when he essayed to arrange the facts of nature he arranged them with imaginative plausibility. He was like Courbet in this—he was steeped in the truths of the physical facts, and he took fewer advantages of nature than a painter like Blakelock whose pictures were so distinctly lunar inventions—full of rhetorical extravagances and rhetorical banalities. Ryder was closer to the poesy of nature even than Corot—he was truer even to the sea—than Courbet—whose passion for dramatization was frequently excessive, and it very frequently happens that Courbet's seas like many of his people—could not move & have the logical being that they are expected to contain. And for all that—Courbet's seas are infinitely superior to the most of Homer's because they express the sense of the natural gigantic force of the sea. I am one who finds Homer's waves to be very pretty things—and I couldn't by any stretch of emotion or thought find the seas of Ryder anything but dramatic entities possessed of the devil and of devilish treacheries. In other words I could trust Ryder's seas to be what the literary imagination expects them to be—namely—dangerous. It would be expected of them that they would swallow ships and care nothing whatsoever for little human fretting souls. The same quality exactly is to be found in Herman Melville's concepts of the sea—and these men are not so far apart in their appreciation of the sea—save that Melville is disconcertingly graphic in his experience of it. He knows what Ryder thought it was, but the knowledge of the one and the thought of the other are of a very similar texture. In the more literary aspects of his creations, Ryder is less convincing—because they are not superior inventions. He is for me, and I have been and still remain an unceasing admirer of this beautiful genius—far and away at his best when he takes an actual observation of nature and renders it in all its poetic terror and its poetic mercilessness. The sense of inviolable immanence is a strong factor in the genius of this New Englander and carries him to one of the highest places in the world of imaginative painting—& places him side by side with Maris and Marées[3]—and it is exactly the same world to which these three imaginatives belong—not too far romantically speaking from the imaginative world of Blake and if Blake had never seen a Flaxman drawing he might have remained still more original for it is in the best designs of Blake that he departs from that school of Rome academism. It is in the tonal scheme that Ryder seems strange to us today, for in his obsession for Rembrandtian unity he stretches the scope of monochrome possibility and makes of it a kind of artifact and the result is—very often if not exactly always—that nature is seen through a superfluous assemblage of false tones. It is not the painting in Ryder's pictures that impress and inspire—it is the truth of the observation of nature and of the right concept of drama of which nature is capable[.] Ryder never could have shown the defect of taste in this regard that his other special disciple has given expression to—for it is in some of the pictures of Elliott Daingerfield that one finds the false comprehension of what Ryder knew and understood so perfectly. Ryder never allowed himself to step over from recognizable drama into unre-

227

cognizable and unplausible melodrama, and very few artists indeed have shown a better sense of design than Ryder has at his best. I remark this particularly and I feel for myself it is perhaps more remarkable because more subtle, less "anthological" so to speak in the little picture called "The Old Mill by Moonlight"—If the cultists were to get on the subject of this picture they might excite themselves sufficiently to prove that it had the constituents of modern mathematics in the esthetic field. They might go so far as to say here is a new word in the language of picture construction and I think this would cover the notion agreeably. Ryder did not wait for design to happen. He did his very last and very best to see that it had all he could make out of it for the idea at hand—and the basic sense of organization of pattern is frequently very poised and right. In the "Macbeth" while it is spectular [sic, read spectacular] it does not give the same sense of finality—not at least as it now exists—restored and varnished out of all plausible import in the Ryder sense of things. This picture was better in its soiled condition as many restored pictures often are—and in Ryder's case the mysterious intention of this particular picture was augmented by its soiled condition for restoration has prettified it out of bounds. I saw this picture myself in Ryder's own apartment something like twenty years ago and I am certain if he saw it today he would certainly scum it over with ashes as he was in the habit of doing from the little heaps that lay around his asthmatic little stove in this most incredible of living quarters known to modern history, so typical of a mystic's blindness to the common things of the day—Ryder lived in the abjectest disorder and dreamers are apt to do this—and he apologized to me when I went to visit him at one time before Ryder had almost fallen into danger of becoming a social cult. I never could understand by what means of persuasion or acquiescence Kenneth Hayes Miller allowed the magnificent Ryder to "dress up" in so commonplace a way as is given in his portrait of him [fig. 7–4]—as the true vision of Ryder was nothing of the sort. This beloved and beautiful "grand old man" obsessed by the moon was habitually clothed in rust-grey clothing—a grey woolly sweater and a grey wool skull-cap or a kind of tam-o-shanter—and of course I am speaking of him as I saw him in periods of cold weather. He was never otherwise habited. But Ryder did have the annual custom of going up Fifth Ave to do what he called "see the pictures" and this was perhaps the greatest event outside of his sense of "love and death" that ever came to him, unless it was possibly his visits to the Fitzpatrick home for it was this fine and devoted family that saw him through many an unfathomable despair. Mrs. Fitzpatrick was a pleasing woman of if I recall correctly, then about in the late forties—and she painted herself & not without a very given talent, though it was

of course very heavily under the impress of Ryder and naturally saturated with the feminine touch. She, too had done a portrait of Ryder but while it was "Rousseau esque" in its naive conception, it certainly had something of Ryder that as I recall made one sort of forgive its lack of documentation and say a polite yes to it. And when I say that Ryder was never otherwise habited than in rust-grey—I speak only of the various times that I was privileged to see him—very often evenings after 9 o'clock when he seemed to be starting his mystical rounds with slow walks up 8th Avenue, hands joined behind his back, eyes fixed upon a world so far from clanging trolleys that he could not possibly have heard their wearisome din. But to return to the portrait of Hayes Miller—there is an intellectual conception there which is justifiable but at the same time it is Ryder "dressed up" and was doubtless the wish of the dear old man himself. And he said to me of the wretched condition of his poor apartment—"I never notice all this disorder until someone comes to see me." So it is I suspect that the gentleman in him rose and he wished to be recorded in his dress clothes and not as the absent one seeking new stratas of lunar desolation. I am glad I have the superb memory of Ryder as he then was in my own beginning period. I am glad that I don't have to ask how he looked or what he said for I see him at this moment, surely twenty years later—hear that gentle, almost hurt voice of his—in which there seemed to be mingled tones of lyric pity and infantile delight, when, out of every word came only its purest meaning devoid of all intellectual or rhetorical excess. For his speech was like his poetry—it had the kinship of "Little lamb who made thee" in it. It was full of manly sweetness if such a thing was possible—and the hardest and harshest of men frequently have these childish reverberations in their voices and you will hear it perhaps best and oftenest in the voices of men who spend much of their time upon the seas. They seem to come on land with a fear of being loud. And this was Ryder's voice—a mixture of daylight simplicity and whispering strength. If there is such a thing as a specific American imagination and we can certainly for ourselves at least assert there is—then Albert Ryder was its first and finest orchestrator. He certainly gave the symphonic touch to it, for every simple experience was a profound one—made profounder and more noble by thinking with unceasing depth of emotion about it. And like all geniuses he has his commercial copyists—for I have recently seen at least one "Ryder" that never once has been gazed upon by those far reaching eyes—never by the slightest chance could it have been so much as touched by him; just as there are already Cézannes, Corots, and we now have multiple Millets, and spurious examples of lesser lights that have never been seen by the eyes that are attributed to them. Such things are often

visible to even the dullest, most insensitive eye. But the seventy or so Ryders that are authentic—are the powerful witness that America will never look upon the like of such a genius again—for that vision has been destroyed forever. Imagination in this sense has been synthesized—properly congealed ossified even to say—and will never appear again for there is no element existing today which can produce it—and even if there be romantic imagination in existence it must necessarily take on the form of this day—which is mechanistic and the vision of course is far more fantastic far more prophetic and far more practical.

Romantic imagination such as Ryder's produced nothing but a vast sense of the pathos[?] of belief in dreams. When Ryder departed the idea departed with him and can never return again and in all probability it shouldn't, but, I repeat, just this quality of Ryder—Melville—Homer Martin & George Fuller—all superb examples of the romantic imagination[;] these are quelled forever by the fierce onslaught of theatricism of the 20th Century which leaves no room for anything but synthetic realization, synthetic falsification.

Like Marsden Hartley, Kenneth Hayes Miller was an admiring young artist who sought out Ryder in his studio in 1909. Not as advanced in his style as Hartley, Miller saw another dimension of the hermit-artist: his ties to the Old Masters. Of the younger artists who cultivated Ryder, Miller was the most persistent and loyal, and he aided the elderly painter in a variety of ways. When Lloyd Goodrich interviewed Miller (his teacher at the Art Students League) in the 1930s and 1940s, he found a rich mine of information. Three of his seven interviews with Miller are published below. [RA]

[Interview with Kenneth Hayes Miller, November 2, 1933]
by Lloyd Goodrich

Miller said (at Katherine's,[4] November 2nd, 1933) that he knew Ryder for seven years, up to the time of his death—got to know him intimately. But none of the people who have written books on Ryder has come to him.

Before he knew Ryder he had admired his work, and used to see him walking around. Once, as Ryder passed, he took off his hat and stood there—"not for the man, but for the art."

One day he went to see him. His studio was in ex-

treme disorder: rubbish was piled up "as high as that" (about waist-high)—everything—"there was some garbage in it." Ryder, he said, could not cope with things; Miller picked up an ashtray with cigarette stubs in it, and said: "He could not cope with that." There were paths through the rubbish, to the door, to the bathroom, a small space around his easel.[5] Ryder picked up a stack of rubbish ("like this"—holding it between his hands, top and bottom) and disclosed a chair; but it had no seat; so he got a cushion with a little frill around it;—"incongruous." Miller sat in the chair; and there being no other chair, Ryder leaned against the rubbish. He wore a nightshirt, which he was tucking into his trousers when he opened the door.

Miller told Ryder how he admired the works of Old Masters in the museum; that Ryder's work was like that of an Old Master; that he had felt impelled to come and tell him.—Here was a man whose work was like that of an Old Master—but *living*. He had come to pay homage. I wonder how Ryder took this? Probably embarrassed.

There was something about Ryder thinking that he must entertain Miller, and offering him tea; and the fuss that went on about making it. (Betts[6] told me this—not Miller.)

Miller said last night that Ryder felt he must entertain Miller, so he told little jokes—stories—and very well—each ending in a little falsetto giggle. While he was talking he became conscious of a cup on the floor—there were many of them—instead of washing a cup he would leave it there, and buy another. He became conscious of this cup on the floor, with the remains of food in it; and leaned over, with difficulty on account of his fatness—picked it up, and put it in another place on the floor—a little more out of sight.

Miller said Ryder was very much afraid of the Board of Health.

The story of the studio & Macbeth—

Of riding on the bus with Miller & Helen[7]—tobacco juice—

Katherine: story about the nymph on the rock.

What Ryder said about his first paintings—his difficulties—how they were solved: what his aunt said.

What he said about the time when he used to be able to strike things right in (was this the way he put it?)

His ideas about art—sentimentality—

Corot—talked about Corot as about a woman he loved—story of what Cottier said about Corot. Maris.

His sex life—had been in love with an opera singer—the male and the female were balanced in him—He was a virgin. Nothing hurt about him.

He used to walk at night.

Painted at night—but only underpainting—colors in daylight.

229

"Conversation with Kenneth Hayes Miller"
by Lloyd Goodrich
June 15, 1938

I saw Miller at Reginald Marsh's place.

I told him that I had some pictures formerly owned by Mrs. Fitzpatrick, and asked him whether I remembered rightly something he told me about taking some doubtful pictures out to Ryder for him to look at when he was with Mrs. Fitzpatrick in Long Island. He said that he remembered once someone bringing a doubtful picture, a terrible thing, for Ryder to look at. (He said that the person who brought it was an "impossible woman" but he did not say whether she was Mrs. Fitzpatrick). He said that Ryder sat and looked at the picture a long time, but all that he said was: "I don't remember painting it."

Alexander Morten, to whom Miller says that he owed much, was offered two Ryders which were doubtful. Miller agreed to take them out to Ryder who was then living with Mrs. Fitzpatrick on Long Island. Ryder did not say whether or not he had painted them. (When Miller told me this story before, I seem to remember that the pictures came from Mrs. Fitzpatrick; that Miller doubted them; that Ryder, being indebted to Mrs. Fitzpatrick, could not say anything about them or possibly that he even signed them. Straighten this out).

Miller spoke again about Ryder's room. He described just the layout of the room, where the windows were, etc. He said that the entire room was filled with rubbish, two or three feet high, with a space about four feet square around the easel, and a few paths through. He said it consisted mostly of old newspapers, but there were also eggshells and other things (when I talked to him before he said: "There was garbage in it, too.") The first time he went to see Ryder, Ryder asked him to sit down, but he saw nothing to sit on. Ryder picked up a large section of the rubbish and underneath was a chair without any seat in it.

Once when Ryder was ill and had to go to a hospital, Weir had his room cleaned out, and among other things had his bed burned. Ryder resented particularly the fact that a little plaster head, a cheap and tawdry thing, had been thrown away. Evidently he saw something beautiful in it. He referred several times to this. He always held it against Weir. (As I remember, Miller told me before that Ryder was heartbroken to find his bed gone; he said: "They've burned my bed!")

After this, Ryder slept on the floor. Miller said later that he sometimes slept on a windowshade stretched on the floor.

Once a pretty young girl, a neighbor of Ryder's, popped her head in the door of the cluttered room and said: "Everything useful?" There was a loaf of bread on the mantlepiece that had been there a year. Some friend of Ryder's (I think Mrs. Fitzpatrick) wanted to paint a still life with a loaf of bread, so Ryder took it to her, and it was useful.

William Macbeth rented a room for Ryder and asked Miller to see that he moved into it. Miller says that Macbeth paid for this all himself, and for no consideration. Miller tried to persuade Ryder to move in, but Ryder would have nothing to do with it. Miller brought the matter up often and with the greatest tact, but as soon as he mentioned the subject Ryder would simply shut up. Finally Miller managed to get him to visit the room. Ryder was delighted with it and began to sleep there and later moved in. But Macbeth had to pay the rent of the room for a year before Ryder was finally induced to move in.

I asked Miller something about Ryder's sex life. He said that he understood that once Ryder had been in love with a singer; everybody said she was an opera singer, but Miller thought probably not a good one. "Quite an unsuitable person," said Miller. To get Ryder over this, Cottier took him to Europe. Afterwards, Ryder seemed completely cured. Miller said he thought Ryder's nature hermaphroditic; that there were elements of both man and woman in him, that he was sufficient unto himself. He said that in this respect he resembled Thomas Mann's idea of Jehovah.

Miller first met Ryder about 1909. At this time Ryder had ceased doing any creative work, was no longer originating pictures, but was working on old pictures. His powers had failed considerably, and the work he did on his old pictures was inferior to what he had done before. He said that at this time Ryder was puttering over his "Macbeth and the Witches." Miller said that after Ryder's death (I think) a great deal of his later painting on "Macbeth and the Witches" was cleaned off. He said that the picture as it came from Ryder's studio was like a blackboard; dark but not black, and somewhat opaque.

I asked Miller about the pot that was supposed to be always cooking on Ryder's stove but he did not seem to remember it. He said that Ryder used to cook coffee, if you could call it coffee. Ryder used to say that sometimes he would go out and get "a good meal—a twenty-cent meal."

When someone said that Ryder had all he needed, that this life was all right for him, Miller said that his powers had failed too early, that he had not got enough vitamins.

He was a big man, with a falsetto laugh or giggle. He loved to tell stories.

Miller told how once he and Ryder and Helen Miller were coming downtown in the "L." Helen was talking to Ryder, but Ryder made no reply; he just listened and

sometimes rolled his eyes, but said nothing. Finally he got up and went to the platform of the train and spat out an enormous quantity of tobacco juice.

Reginald Marsh said that probably Ryder was fundamentally a shy man, and Miller said that was true.

There was a lamp in the hall of Ryder's building, a terrible affair, all decorated, with wires strung with little pink beads. Ryder used to stop whenever he went past it and say, "How pretty."

He loved to show his pictures to people, although he had few visitors. He would clean them off with a wet cloth to bring out their depth and transparency. I suggested that this was probably very bad for them, and Miller said that was true.

He said that Ryder took very little care of the pictures that he spent so much time over. They were piled around his studio, and often they got damaged. He spoke of one picture, I think "Plodding Homeward," reproduced in the early article in the Century Magazine, and said that this was damaged by another picture falling against it. Ryder commenced a copy of it, but Miller said he did not think he ever finished it. (I think I have this story right, but I'm not sure).

One picture, of a king and a beggar, had run down and over the edge of the frame. Ryder cleaned off the top surface, and was delighted with the beauty of what was underneath. Miller said that it was beautiful, but with the beauty of any old, time-worn object.

He spoke always with great feeling of his picture of Desdemona.

Miller never remembers Ryder's going to the Metropolitan Museum. There was a picture of his in the Museum, and Miller tried to induce him to go up there, but he never succeeded. When he went to a dealer's gallery he would look at each picture a long time—too long, Miller said. Then he would point out some tiny part and say that it was well painted.

Once Alexander Morten had a small Ryder photographed and a very fine print made of the photograph, in a special finish. The photograph was shown to Ryder, who looked at it a long time, holding it in his hands. It turned out that he thought it was the original.

He painted a great deal at night, by lamplight. Miller thinks that he painted most of the underpainting of his pictures at night, but finished them by daylight. I asked Miller whether it was true that Ryder's eyes were defective, and he said that he does remember that one of them looked peculiar.

I asked Miller whether he knew of any drawings by Ryder, and he said that he did not think that Ryder did drawings.

The artists whom Ryder particularly admired and whom he talked most of were Corot and Matthew Maris,

especially Corot. Ryder used to tell with great enjoyment a story that Cottier had told him, about someone who asked the owner of a Corot whether, if he was freezing to death, he would not burn the Corot to keep alive; and the owner said that he would have to be pretty cold to do that. I asked Miller whether Ryder ever talked of Monticelli, and he said that perhaps he did, he did not remember.

Aside from Corot and Maris, he talked little about other artists. He never talked about the old masters. Once he said: "They were great painters but we can be artists too," meaning evidently that although the old masters were unexcelled technically, one could be just as true an artist, in a small way.

Ryder once said that he was like an inchworm, feeling his way until he reached the end of the limb and then groping about in space.

Miller once said to him, "I have known you all this time, and I have never seen your palette." Ryder laughed and went over and picked up a tiny canvas, and turned it over, showing a little speck of white and another of black, and said "This is my palette." Miller said that much of his painting was done just in black and white. He intimated that the underpainting was done this way, and afterwards glazed in color. (But I have never found much trace of black in Ryder's work. Perhaps he mixed it with other colors. Or perhaps at this period when Miller knew him and when he was doing little more than putter over his old canvases, he may have used black and white.)

Ryder once said that "most color is too clean." Miller said that this was like a remark of Titian's, which he quoted but which I do not remember exactly.

Miller said that Ryder's method was essentially white on black. It was also the play of transparent, semi-transparent and opaque tones. Ryder never lost sight of the fact that paint should be transparent. He once said to Miller, "I have such enjoyment underneath." (Or something like this.)

Ryder's great interest was in tone. He once said: "Tone is a kind of feeling."

Ryder told of how, when he was trying to get into the school of the National Academy, he had to submit a drawing from the antique. He made a drawing of the cast of a hand and turned it in. It was rejected. William E. Marshall looked at it and said, "That's all right. Just clean it up with an eraser and send it to them." Ryder exclaimed "Can I use an eraser? Then it's all right."

Miller said that Ryder had no knowledge of correct painting methods, that he simply painted the way he wanted to.

He sometimes used wax as a medium, Miller thought too much. When Miller reproached him with this, Ryder said, "But I only used one candle." Miller and Reginald

Marsh said that wax is often used as a medium, but I gather not to the extent that Ryder sometimes did.

Miller said he remembered Ryder showing him a picture, which Miller thought was the darkest picture he had ever seen, but after he had seen it several times he told Ryder that he thought it was the lightest.

When I said I thought Ryder had painted 100 pictures, Miller said he did not think that many.

His talk about art was always quite sentimental; it was all about nature and poetry.

I asked Miller whether Ryder did not enjoy music, but he said that he had not seen any particular signs of it, that Ryder did not talk about music.

He used to speak with much warmth and appreciation of Charles de Kay. He did not mention Cottier much.

Miller said that he thought that Ryder had painted a few pictures that were "right"; and that this quality was so rare that it gave his work great distinction, that it made him one of the foremost artists of his time. He quoted an Italian countess, a woman familiar with great Italian art but knowing nothing of American art, who had gone through our Landscape Exhibition and had been interested in nothing particularly until she got to the Ryders; then she said, "They are like Titian." Miller himself said that in the entire landscape exhibition there were four pictures that were "right"—the four Ryders.

"Notes on Conversation with Kenneth Hayes Miller"
June 26, 1947
by Lloyd Goodrich

Miller told me that he remembers once meeting Ryder down by one of the Hudson River ferries, at a time of day when commuters were hurrying to catch the ferry. Ryder was dressed like a workman, with old shabby clothes and a sweater. Miller stood talking to him, with his hat off in respect to Ryder. Miller said that he himself was fairly neatly dressed, and he wondered what the commuters thought when they saw him talking to someone who looked like a tramp.

I asked him how Ryder usually dressed and he said in the way described, but that when he did get dressed up, he always wore a black frock coat; this was the period when frock coats were still worn. He spoke again of Ryder's studio and the mess it was in, although he did not go into details. However, he did say that the refuse was "this high," holding his hand about three feet off the floor. I asked him where this studio was, and he said that

he believes it was at 308 West 15th Street. (This is the address given in Ryder's three letters to Miss Bloodgood in 1898 and 1900, so Miller's memory is quite exact.) He said that the studio that Macbeth rented for Ryder, and on which Macbeth paid rent for a year before Ryder could be lured into it, was on 14th Street west of 6th Avenue, on the south side of the street. He said that as soon as Ryder saw the place he liked it immediately and moved right in. I asked him if the place became as messy as Ryder's place on 15th Street, and he said no. I asked him what Macbeth's motive was in paying the rent, and he said that it was purely altruistic; that Macbeth was not Ryder's dealer.

I asked him how Ryder managed to live in these years, and he said that his friends were often concerned about this, and that Weir once contributed a painting by Ryder to be sold for Ryder's benefit. He said the price was $1000; that it was a little landscape painted at Weir's place in the country, and of absolutely no value or importance; that Alexander Morten bought it but felt that he was paying a great deal for very little. Later I showed him a photograph of "Weir's Orchard," but he said that it was not the picture; that the picture was upright, as he remembered it, and very small. . . . I mentioned the letter from Ryder to Morten, but he did not remember it. Afterwards I showed him a copy, but he made no comment on it. So I gather that he could not have written the letter and the descriptions, but that Ryder himself probably did so.

He said that the story about Weir cleaning up Ryder's studio when Ryder was in the hospital was hearsay; that it had happened before he knew Ryder. He said that Weir took one look at Ryder's bed and ordered it burnt. Afterwards Ryder used to sleep on a window shade on the floor. He said that what Ryder minded most was that Weir had thrown away a little plaster cast of a classic head, about the size of one's hand, which one could buy for almost nothing. He said that Ryder held this against Weir.

He spoke again of asking Ryder whether he ate well enough, and of Ryder saying that he did, that sometimes he would go out and get "a twenty-cent dinner." Miller said again that this was not as cheap as it sounds, that he remembers when you could get a good dinner for thirty-five cents. He said that Ryder believed in eating oysters.

He told the story about Ryder making another version of a picture that had been damaged. He did not mention the title or subject of the picture, but he said that Ryder used a canvas already painted on, simply marking off a part of it and starting in to paint the picture.

He said that he had never seen Ryder actually start a picture, and does not know how he went about it.

232

He spoke again of how Ryder would sometimes take a painting and hold it flat and pour varnish on it, tipping this way and that so that the varnish would cover it. I asked whether Ryder ever talked about the old masters, such as Titian; and he said that Ryder had said to him, "They were great painters, but one can still be an artist." He said that Ryder often talked of Corot and of Matthew Maris.

He said that he several times went with Ryder to visit the Sandens; that Mrs. Sanden was a very attractive and fine woman. I reminded him of a story about the bet as to whether "The Race Track" was supposed to represent night or day, and he said that Ryder's exact words were "I hadn't thought about it." He went on to say that this was partly Ryder's courtesy, that he hated to hurt people's feelings. He spoke of a very vulgar man who had gotten a picture which he thought was a Ryder, and which Miller said was as vulgar as he was; that it might almost have been painted by him, although he did not think it was. The man wanted Ryder to see the picture, and Miller arranged for them to meet in his (Miller's) studio. He said that Ryder looked at the picture and then said, "I don't remember painting that." Again his courtesy.

He said that Ryder had wanted $3000 for "The Race Track," and that Morten considered buying it but felt that it was too expensive. Miller remembers being in a gallery, which he thinks was Macbeth's, when "The Race Track" was hanging; that Ryder accompanied him and Mrs. Miller to the door, and then went back and stood in front of the picture gazing at it with his hands behind his back. He repeated something that Ryder said about "The Race Track," to the effect that he felt he had gotten a nice *tone* in it; but I do not remember the exact words.

I asked him whether Montross had bought his Ryders directly from Ryder, and he said he did not know. He does not remember Ryder speaking of Montross. He said that Montross had a great veneration for Ryder's work; that Montross had a restorer who used to keep Ryder's pictures in shape. He does not remember the name of the restorer, but suggested that someone connected with Montross might remember it.

He spoke of the "Moonlit Cove" in the Phillips Memorial Gallery, and said that when he first saw it the sky was a fine gray; that the present strong blue is a color that Ryder never used.

I asked him if he had seen "The Tempest" in Ryder's possession, and he said he had never seen it before he saw it in New York a year or so ago. He spoke about the extensive "restoration" that it had undergone between the first time he saw it and the time it hung in the Macbeth exhibition.

He told the story about "The Temple of the Mind," as follows: That Ryder had been working on the picture and was dissatisfied with it, felt that it needed something. That Ryder was in Charles de Kay's house when De Kay had just returned from abroad with a lot of photographs; that Ryder as usual was thinking about his work, as every artist does, that he saw a photograph of a fountain, Miller thinks in Florence, and immediately said that that was what he needed for his picture. That night he chalked the fountain in.

I showed Miller "The Story of the Cross" from Mrs. [James] Caldwell, which he admired. I also showed him photographs of "Constance" in the Boston Museum, and of the two Addison Gallery versions of these subjects. He agreed that the Addison pictures were very weak; he pointed out that the arm of the man in "The Story of the Cross" was a spiral form, but that the arm in "The Way of the Cross" in the Addison Gallery was wood. He thought it quite possible that Mrs. Fitzpatrick had painted both pictures.

I said that in the forthcoming article I wanted to write it as if written by him in the first person singular, with an editorial note by me about the circumstances. I said I would send him my draft, that he was to do whatever he wanted with it. I asked him to add two or three hundred words of his considered opinion of Ryder's art, as this should be in his own words; and he agreed to do this.

NOTES: *Interviews and Reminiscences*

1. Giovanni Segantini (1858–99), an Italian painter of the Divisionist school, who painted landscapes and peasant subjects.
2. This work, reproduced as the frontispiece of Frederic Newlin Price, *Ryder, a Study of Appreciation* (New York, 1932), is now regarded as a forgery.
3. Hans von Marées (1837–87), a German historical painter who spent much of his time in Italy.
4. Katherine Schmidt, an American painter, wife of Yasuo Kuniyoshi, also a painter.
5. [Note by Lloyd Goodrich:] Aunt Caro [Lloyd Goodrich's mother's sister Caroline] also described this rubbish when she visited his studio; said that there was a whole heap of dirty collars.
6. Betty Burroughs, a sculptor, daughter of Bryson Burroughs, curator of paintings at the Metropolitan Museum of Art.
7. Miller's second wife.

Paintings by Ryder: A Chronological List

The following list of works serves two purposes. It records what I, drawing in part upon my discussions with Lloyd Goodrich, believe to be authentic works by Ryder. In each case, a combination of visual, technical, and documentary evidence points to his authorship. As stated in the text, the absence from this list of any given painting should not necessarily be construed as a mark against it. It is simply that the work requires further study or may not have been examined personally by Goodrich or myself.

This list also presents Ryder's works in what I believe to be their approximate order of execution. Although I discussed aspects of this matter with Goodrich, the following conclusions are mine. When available, evidence for dating, both specific and more general, is cited in the entry for each painting.

W.I.H.

Fig. A–1. *Cottage Scene (Rustic Cottage).* Early to middle 1870s. "Photo-drawing" of the work by Elbridge Kingsley, 8¼ x 7⅝″, in Forbes Library, Northampton, Mass. Location of original painting unknown

The Stable. Early to middle 1870s. Oil on canvas, 8 x 10″. The Corcoran Gallery of Art, Washington, D.C.

In the Stable. Early to middle 1870s. Oil on canvas, 21 x 32″. National Museum of American Art, Smithsonian Institution, Washington, D.C. Gift of John Gellatly.

The Red Cow. Early to middle 1870s. Oil on wood panel, 11⅜ x 12″. The Freer Gallery of Art, Washington, D.C.

The Barnyard. Early to middle 1870s. Oil on wood panel, 11⅝ x 12¼″. Munson-Williams-Proctor Institute Museum of Art, Utica, N.Y.

Cottage Scene (Rustic Cottage) (fig. A–1). Early to middle 1870s. "Photo-drawing" of the work by Elbridge Kingsley, 8¼ x 7⅝″, in Forbes Library, Northampton, Mass. Location of original painting unknown. Elbridge Kingsley coined the term "photo-drawing" to describe his method of heightening a light-toned photograph of the painting with watercolor or wash to enhance the contrast for engraving.

Evening Glow (The Old Red Cow). Early to middle 1870s. Oil on canvas, 8 x 9″. The Brooklyn Museum. Frederick Loeser Fund.

The Stable (Stable Scene). Middle 1870s. Oil on canvas, 4¼ x 7¼″. Vassar College Art Gallery, Poughkeepsie, N.Y. Gift of Mrs. Lloyd Williams, 1940.

Self-Portrait. Middle 1870s. Oil on canvas mounted on wood panel, 6½ x 5″. Collection Mrs. and Mrs. Daniel W. Dietrich II.

Pastoral Study. Middle 1870s. Oil on canvas, 23¾ x 29″. National Museum of American Art, Smithsonian Institution, Washington, D.C. Gift of John Gellatly. Probably *Cattle Piece* exhibited at the National Academy of Design (hereafter abbreviated NAD), 1876.

Late Afternoon (Landscape Near Litchfield). Middle 1870s. Oil on academy board, 10 x 9″. Private collection. Dated on the verso (not in Ryder's hand), 1876.

The Grazing Horse. Middle 1870s. Oil on canvas, 10¼ x 14¼″. The Brooklyn Museum. Graham School of Design.

Summer's Fruitful Pasture. Middle to late 1870s. Oil on wood panel, 7¾ x 9⅞″. The Brooklyn Museum. Museum Collection Fund.

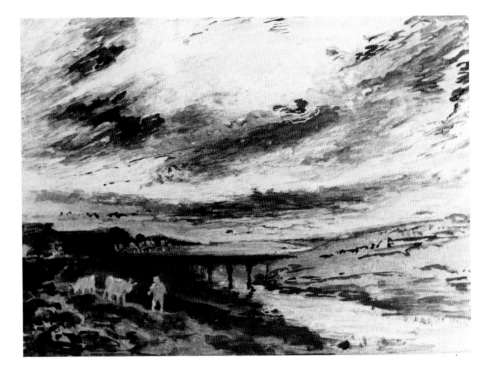

Fig. A–2. *Landscape, Late Afternoon (A Sunset)*. Late 1870s. "Photo-drawing" of the work by Elbridge Kingsley, 6⅞ x 9½", in Forbes Library, Northampton, Mass. Location of original painting unknown

The Pasture. Middle to late 1870s. Oil on canvas, 12⅛ x 15¼". North Carolina Museum of Art, Raleigh. Gift of the North Carolina Art Society (Robert F. Phifer Bequest).

The White Horse. Middle to late 1870s. Oil on canvas mounted on wood panel, 8⅛ x 10". The Art Museum, Princeton University. Gift of Alastair B. Martin.

Mending the Harness. Middle to late 1870s. Oil on canvas, 19 x 22⅝". National Gallery of Art, Washington, D.C. Gift of Sam A. Lewisohn.

The Pond. Middle to late 1870s. Oil on canvas, 12¼ x 16½". Walker Art Center, Minneapolis.

Autumn Landscape. Late 1870s. Oil on canvas, 5⅝ x 7⅞". Mr. and Mrs. Daniel W. Dietrich II.

Harlem Lowlands, November (Autumn Landscape). Late 1870s. Oil on wood panel, 9½ x 13⅛". Private collection. Exhibited at Pennsylvania Academy of the Fine Arts, 1879.

Sunset Hour (The Golden Hour). Late 1870s. Oil on canvas, 10 x 13". Collection Stephen C. Clark, Jr.

Landscape, Late Afternoon (A Sunset) (fig. A–2). Late 1870s. "Photo-drawing" of the work by Elbridge Kingsley, 6⅞ x 9½", in Forbes Library, Northampton, Mass. Location of original painting unknown.

Spring (The Spirit of Spring; The Spirit of Dawn). Late 1870s. Oil on canvas, 14⅛ x 18⅝". The Toledo (Ohio) Museum of Art.

Gift of Florence Scott Libbey, 1923. Exhibited at the Society of American Artists (hereafter abbreviated SAA), 1879. Illustrated in *Scribner's Monthly* 20 (May, 1880).

Autumn Landscape. Late 1870s. Oil on canvas, 18¼ x 24¼". Private collection. Probably *Chill November* exhibited at SAA, 1880.

Landscape with Trees (Landscape Sketch). Late 1870s. Oil on canvas mounted on wood panel, 8⅞ x 12⅜". Private collection. Given to George de Forest Brush "about 1880" (so inscribed on the painting).

The Wood Road. Late 1870s. Oil on canvas, 6½ x 7". Worcester (Mass.) Art Museum.

The Sheepfold. Late 1870s. Oil on canvas, 8½ x 10⅝". The Brooklyn Museum. Gift of A. Augustus Healy.

Diana. Late 1870s. Oil on leather, 28⅛ x 20". The Chrysler Museum, Norfolk, Va. Gift of Walter P. Chrysler, Jr.

Panel for a Screen (Children Playing with a Rabbit). Late 1870s. Oil on leather, 38½ x 20¼". National Museum of American Art, Smithsonian Institution, Washington, D.C. Gift of John Gellatly.

Panel for a Screen (Children and a Rabbit). Late 1870s. Oil on leather, 38¼ x 20¼". National Museum of American Art, Smithsonian Institution, Washington, D.C. Gift of John Gellatly.

Panel for a Screen (Female Figure). Late 1870s. Oil on leather, 38½ x 20¼". National Museum of American Art, Smithsonian Institution, Washington, D.C. Gift of John Gellatly.

Moonrise. Late 1870s. Oil on canvas, 8½ x 10⅝". The Brooklyn Museum. Museum Collection Fund. Probably *Moonlight,* exhibited at SAA, 1880.

Dancing Dryads. c. 1880. Oil on canvas, 9 x 7⅛". National Museum of American Art, Smithsonian Institution, Washington, D.C. Gift of John Gellatly. Exhibited at The Metropolitan Museum of Art, 1881.

The Lover's Boat (Moonlight on the Waters). c. 1880. Oil on wood panel, 11⅜ x 12". Private collection. Exhibited at SAA, 1881.

The Lovers (Saint Agnes' Eve). c. 1880. Oil on canvas, 11½ x 8¼". Vassar College Art Gallery, Poughkeepsie, N.Y. Gift of Mrs. Lloyd Williams, 1940. Exhibited (in all probability) as *The Two Lovers* at SAA, 1880.

By the Tomb of the Prophet. Early 1880s. Oil on wood panel, 5¾ x 11⅜". Delaware Art Museum, Wilmington.

Moonlight. Early 1880s (fig. A–3). "Photo-drawing" of the work by Elbridge Kingsley, probably in preparation for an engraving, 10 x 10⅝", in Forbes Library, Northampton, Mass. Location of original painting unknown.

At the Ford. Early 1880s. Oil on wood panel, 12 x 11⅜". Private collection.

A Stag Drinking. Early 1880s. Oil on gilded leather, 27 x 19⅛". Private collection.

A Stag and Two Does. Early 1880s. Oil on gilded leather, 27 x 19". Private collection.

The Shepherdess. Early 1880s. Oil on wood panel, 10⅛ x 6¾". The Brooklyn Museum. Frederick Loeser Art Fund.

The Curfew Hour. Early 1880s. Oil on wood panel, 7⅝ x 10". The Metropolitan Museum of Art, New York City. Rogers Fund, 1909. Exhibited at SAA, 1882.

Plodding Homeward (Homeward Plodding; Moonrise). Early 1880s. Wood engraving of the painting from *The Century Magazine,* June, 1890. Location of original painting unknown. Exhibited at SAA, 1882.

Night. Early 1880s. Oil on canvas, 12¼ x 20¼". Private collection.

The Bridge. Early 1880s. Oil on gilded leather, 10 x 26¾". The Metropolitan Museum of Art, New York City.

Shore Scene (Pirate's Isle; Smuggler's Cove). Early 1880s. Oil on gilded leather mounted on canvas, 9½ x 27¼". Georgia Museum of Art, University of Georgia, Athens. Eva Underhill Holbrook Memorial Collection of American Art, Gift of Alfred H. Holbrook.

Macbeth and the Witches. Early 1880s. Oil on canvas mounted on wood panel, 10 x 10". The Art Museum, Princeton University. Gift of Alastair B. Martin.

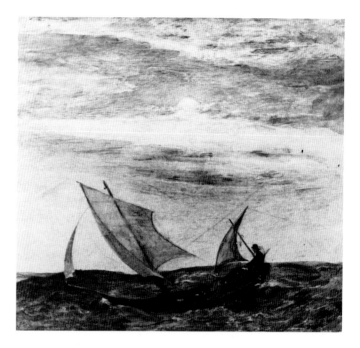

Fig. A–3. *Moonlight.* Early 1880s. "Photo-drawing" of the work by Elbridge Kingsley, 10 x 10⅝", in Forbes Library, Northampton, Mass. Location of original painting unknown

The Smugglers' Cove. Early 1880s. Oil on gilded leather, 10⅛ x 27¾". The Metropolitan Museum of Art, New York City. Rogers Fund, 1909.

Oriental Landscape. Early 1880s. Oil on gilded leather, 8½ x 26". Present location unknown.

The Gondola. Early 1880s. Oil on gilded leather, 8⅝ x 26¼". Private collection.

The Lone Horseman. Early 1880s. Oil on academy board, 8 x 14½". Private collection.

The Equestrian. Early 1880s. Oil on canvas, 9 x 12". Portland (Ore.) Art Museum. Bequest of Winslow B. Ayer.

The Culprit Fay (frame designed by Stanford White). c. 1882–86. Oil on wood panels, with mirror in center, 20¼ x 20¼". Whitney Museum of American Art, New York City. Joan Whitney Payson Bequest. Dated according to family recollections.

The Waste of Waters Is Their Field. Early 1880s. Oil on wood panel, 11¼ x 12". The Brooklyn Museum. John B. Woodward Memorial Fund. Exhibited at NAD, 1884.

Marine. Early to middle 1880s. Oil on canvas, 12⅝ x 9¾". The Carnegie Museum of Art, Pittsburgh. Howard N. Eavenson Memorial Fund, for Howard N. Eavenson Americana Collection, 1972.

Woman and Staghound (Landscape and Figure; Geraldine). Early 1880s. Oil on wood panel, 11⅜ x 5⅞". The New Britain

(Conn.) Museum of American Art. Harriet Russell Stanley Fund. Sold at the Mary Jane Morgan auction sale, New York, 1886; according to the catalogue, it was "dated 1885."

Florizel and Perdita. Early 1880s. Oil on canvas, 12¼ x 7¼″. National Museum of American Art, Smithsonian Institution, Washington, D.C. Gift of John Gellatly. Mentioned as being underway in an undated Ryder letter to Mariana Van Rensselaer [late 1883–early 1884]. Cited in De Kay, 1890.

Under a Cloud. Early to middle 1880s. Oil on canvas, 20 x 23¾″. The Metropolitan Museum of Art, New York, Gift of Alice Van Orden in memory of her husband Dr. T. Durland Van Orden, 1988.

Pegasus (The Poet on Pegasus Entering the Realm of the Muses). Early to middle 1880s. Oil on wood panel, 12 x 11⅜″. Worcester (Mass.) Art Museum. Ryder's being "engaged upon" this work is mentioned in *The Studio* (New York), April 14, 1883. Dated 1887 on verso, not in Ryder's hand.

Moonlit Cove. Early to middle 1880s. Oil on canvas, 14⅛ x 17⅛″. The Phillips Collection, Washington, D.C.

The Toilers of the Sea. c. 1883–84. Oil on wood panel, 11½ x 12″. The Metropolitan Museum of Art, New York City. George A. Hearn Fund, 1915. Exhibited at SAA, 1884.

Moonlight Marine. Early to middle 1880s. Oil on wood panel, 11⅜ x 12″. The Metropolitan Museum of Art, New York City. Samuel D. Lee Fund, 1934.

The Temple of the Mind. c. 1883–85. Oil on canvas mounted on wood panel, 17¾ x 16″. Albright-Knox Art Gallery, Buffalo, N.Y. Gift of R. B. Angus, 1918. Referred to in a Ryder letter to Thomas B. Clarke, 1885. Sold to Clarke in 1885.

Resurrection. c. 1883–85. Oil on canvas, 17⅛ x 14⅛″. The Phillips Collection, Washington, D.C. Sold at the Mary Jane Morgan auction sale, New York, 1886; according to the catalogue, it was "dated 1885." Described and illustrated in *Magazine of Art* 9 (1886).

A Country Girl (An Idyll; A Spring Song). Middle 1880s. Oil on canvas, 10⅛ x 6¼″. Maier Museum of Art, Randolph-Macon Woman's College, Lynchburg, Va.

Gay Head. Middle 1880s and later. Oil on canvas, 7½ x 12½″. The Phillips Collection, Washington, D.C.

Christ Appearing to Mary. Middle 1880s. Oil on canvas mounted on fiberboard, 14¼ x 17¼″. National Museum of American Art, Smithsonian Institution, Washington, D.C. Gift of John Gellatly. Referred to in a Ryder letter to Thomas B. Clarke, 1885. Exhibited at NAD, 1888.

The Little Maid of Arcady. Middle 1880s. Oil on wood panel, 9⅞ x 4¾″. Collection Mr. and Mrs. Daniel W. Dietrich II. Exhibited at NAD, 1886.

Oriental Camp (Arab Scene). Middle 1880s. Oil on canvas, 7¼ x 12″. Mead Art Museum, Amherst (Mass.) College.

The Hunter's Rest (Hunter and Dog). Middle 1880s. Oil on canvas, 14⅜ x 24″. Nebraska Art Association, Thomas C. Woods Memorial Collection, Sheldon Memorial Art Gallery, University of Nebraska–Lincoln.

The Sentimental Journey (Plodding Homeward). Middle to late 1880s. Oil on canvas, 12 x 10″. Canajoharie (N.Y.) Library and Art Gallery. Purchased in 1889.

Perrette (The Milkmaid). Middle to late 1880s. Oil on canvas mounted on wood panel, 12¾ x 7⅝″. Smith College Museum of Art, Northampton, Mass. Cited in De Kay, 1890. Exhibited at New York Athletic Club, 1892. Purchased in 1893.

Joan of Arc. Middle to late 1880s. Oil on canvas, 10⅛ x 7⅛″. Worcester (Mass.) Art Museum. Purchased in 1889.

The Story of the Cross. Middle to late 1880s. Oil on canvas, 14 x 11¼″. Private collection. Cited in De Kay, 1890.

Landscape. 1880s. Oil on canvas, 9 x 13″. Collection of Rita and Daniel Fraad.

Jonah. Middle 1880s to 1890 and later. Oil on canvas, 27¼ x 34⅜″. Smithsonian Institution, National Museum of American Art, Washington, D.C. Gift of John Gellatly. Working on it in 1885 (Ryder letter to Thomas B. Clarke); reproduced (in different form from the present) in De Kay, 1890.

Desdemona. Middle 1880s to middle 1890s. Oil on canvas, 14¼ x 10″. The Phillips Collection, Washington, D.C. Cited in *New York Times* as being in NAD show, 1887. The painting was seen in Ryder's studio by Sadakichi Hartmann about 1895, as reported in *Art News* 1 (March, 1897). Ryder wrote J. Alden Weir in 1896 that he had "finished" *Desdemona.*

Constance. Middle 1880s to middle 1890s and later. Oil on canvas, 28¼ x 36″. Museum of Fine Arts, Boston. Cited in *The Art Collector* 9 (December 1, 1889) as having been in the possession of "the gentleman who had long ordered it." Ryder wrote J. Alden Weir in 1896 that he had "finished" *Constance.*

The Flying Dutchman. Middle to late 1880s and later. Oil on canvas, 14¼ x 17¼″. National Museum of American Art, Smithsonian Institution, Washington, D.C. Gift of John Gellatly. Exhibited at the Third Prize Fund Exhibition, New York, 1887. Cited in *The Art Collector* 9 (December 1, 1889).

With Sloping Mast and Dipping Prow. Late 1880s. Oil on canvas, 12 x 12″. National Museum of American Art, Smithsonian Institution, Washington, D.C. Gift of John Gellatly.

Noli me Tangere (Christ and Mary). Late 1880s. Reworked after the artist's death. Oil on canvas mounted on wood panel, 14½ x 17½″. The Carnegie Museum of Art, Pittsburgh.

Landscape Sketch. c. 1888. Oil on canvas, 5¾ x 7¼″. Private collection, New York City. Study for *Siegfried and the Rhine Maidens.*

Siegfried and the Rhine Maidens. c. 1888–91. Oil on canvas, 19⅞ x 20½". National Gallery of Art, Washington, D.C. Andrew W. Mellon Collection. Exhibited at New York Athletic Club, 1891.

The Race Track (Death on a Pale Horse; The Reverse). Late 1880s to early 1890s. Oil on canvas, 28¼ x 35¼". The Cleveland Museum of Art. J. H. Wade Collection. Based on an event that took place in 1888; the painting was seen in Ryder's studio by Sadakichi Hartmann about 1895.

The Forest of Arden. Late 1880s, 1890s, and later. Oil on canvas, 19 x 15". The Metropolitan Museum of Art, New York City, Bequest of Stephen C. Clark, 1960. Ryder wrote to Mrs. Olin L. (Sylvia) Warner in 1897 about his progress on this painting. He borrowed it back from Dr. A. T. Sanden in 1898, presumably to work further on it (Ryder letter to A. T. Sanden, May 9, 1898). According to the Ferargil Galleries' account, possibly obtained from Sanden or his widow, the painting was executed in 1888, purchased by Sanden in 1892, but not delivered until 1912 (*Art News*, March 14, 1925).

Diana's Hunt. 1890s. Reworked after the artist's death? Oil on canvas, 18 x 14". The Newark (N.J.) Museum. Purchased 1955, Wallace M. Scudder Fund.

The Tempest. 1890s and later. Reworked after the artist's death. Oil on canvas, 27¾ x 35". The Detroit Institute of Arts. Gift of Dexter M. Ferry, Jr. A writer for the New York *Press*, reporting on an interview with Ryder, published December 16, 1906, said *The Tempest* had been in his studio for fifteen years (1891). Exhibited at New York Athletic Club, 1892. Ryder wrote to J. Alden Weir in 1896 that he had "a good grip on Tempest." In Ryder's possession at the time of his death.

The Canal. Early 1890s. Oil on canvas, 19 x 25". University Art Collections, Arizona State University, Tempe. Oliver B. James Collection of American Art.

Moonlight (Moonlight at Sea). Early 1890s. Oil on wood panel, 15⅞ x 17¾". National Museum of American Art, Smithsonian Institution, Washington, D.C. Gift of William T. Evans. Exhibited at Art House, Fifth Avenue (New York), 1893.

Moonlight on the Sea. Early 1890s. Oil on wood panel, 11½ x 15⅞". Wichita (Kan.) Art Museum. Roland P. Murdock Collection.

Harvest. Early to middle 1890s. Oil on canvas, 26 x 35¾". National Museum of American Art, Smithsonian Institution, Washington, D.C. Purchased in 1898.

The Canal (Essex Canal). 1890s? Reworked after the artist's death? Oil on canvas mounted on wood panel, 16½ x 20½". The Art Institute of Chicago.

The Lorelei. Early to middle 1890s and later. Oil on canvas, 22½ x 19". Private collection. Ryder wrote J. Alden Weir in 1896 that he had "finished" *The Lorelei*; he continued to work on it, however, long after that date. In Ryder's possession at the time of his death.

King Cophetua and the Beggar Maid. Early 1890s and later. Oil on canvas, 24½ x 18". National Museum of American Art, Smithsonian Institution, Washington, D.C. Gift of John Gellatly. *The Studio and Musical Review*, February 19, 1891, noted that it was in Ryder's studio "just now." In a letter to John Gellatly (1905) Ryder said he was still working on the painting.

Macbeth and the Witches. Middle 1890s and later. Reworked after the artist's death. Oil on canvas, 28¼ x 35¾". The Phillips Collection, Washington, D.C. Mentioned in a Ryder letter of 1899 to Dr. A. T. Sanden. A writer for the New York *Press*, reporting on an interview with Ryder, published December 16, 1906, said *Macbeth and the Witches* had been in his studio for seven years (1899). Remained in Ryder's possession and worked on during the first decade and the early part of the second decade of the twentieth century.

Homeward Bound. c. 1893–94. Oil on canvas mounted on wood panel, 8⅞ x 18". The Phillips Collection, Washington, D.C. Dates given in the recollections of Ryder's friend Captain John Robinson.

Marine. Middle 1890s. Oil on wood panel, 8¾ x 17¾". National Academy of Design, New York City.

Weir's Orchard. Middle or late 1890s. Oil on canvas, 17⅛ x 21". Wadsworth Atheneum, Hartford, Conn. The Ella Gallup Sumner and Mary Catlin Sumner Collection.

The Dead Bird. 1890s. Oil on wood panel, 4¾ x 10". The Phillips Collection, Washington, D.C.

The Monastery. 1890s. Oil on wood panel, 12⅞ x 9⅜". The Parrish Art Museum, Southampton, New York.

Moonlight (Marine, Moonlight). 1890s. Oil on wood panel, 11⅜ x 12". The Brooklyn Museum. Gift of Mr. and Mrs. Solton Engel.

Lord Ullin's Daughter (The Sea). 1890s. Oil on canvas, 20½ x 18⅜". National Museum of American Art, Smithsonian Institution, Washington, D.C. Gift of John Gellatly.

Passing Song. 1890s and later. Oil on wood panel, 8½ x 4⅜". National Museum of American Art, Smithsonian Institution, Washington, D.C. Gift of John Gellatly. This painting was seen in Ryder's studio by Sadakichi Hartmann about 1895. This may be the painting, in an earlier rendition, cited by De Kay, 1890, as *Melancholy.*

Moonrise, Marine (Moonlight; Moonlight Landscape). 1890s and later. Oil on canvas, 9¼ x 11⅛". Private collection. Was in Ryder's studio in 1905 (Ryder letter to Dr. A. T. Sanden).

The Windmill (The Old Mill). 1890s and later. Oil on canvas, 16 x 14". Private collection.

Landscape. c. 1897–98. Oil on canvas, 9½ x 14". The Metropolitan Museum of Art, New York City. Ryder wrote to Mrs. Olin L. (Sylvia) Warner in 1897 about his progress on this painting, a commission from Marian Y. Bloodgood. Apparently it was delivered in 1898.

1847 — Albert Pinkham Ryder born March 19 at 16 Mill Street, New Bedford, Mass., youngest of four sons, the others being William Davis, Edward Nash, and Preserved Milton, of Alexander Gage Ryder and Elizabeth Cobb Ryder.

Probably 1857 — Enters Middle Street School, a public grammar school for boys. Does not proceed to high school.

Probably 1859 — Family moves to 3 Court Street.

Probably 1867–68 — Family joins William Davis Ryder, Albert's brother, who had opened a restaurant in New York City. Before 1870, works under the guidance of the painter William E. Marshall. Remains in New York for the rest of his life.

1870–73, 1874–75 — Studies at the National Academy of Design, New York City.

1871 — Spends summer at grandfather's place in Yarmouth on Cape Cod, Mass.

1873 — First exhibits at National Academy of Design (spring). Continues to exhibit there, 1881–88.

1875 — Participates in Cottier & Co. (New York) exhibition of painters whose work was not accepted by the National Academy. Presumably about this time is befriended by Daniel Cottier and James S. Inglis, who sell his works through Cottier & Co. Joins the circle of editor and poet Richard Watson Gilder and his wife, Helena de Kay Gilder, a painter. Undoubtedly through them meets Charles de Kay, Helena's brother, an editor and critic, who becomes his champion.

1877 — Elected to membership in Society of American Artists, founded by the Gilders and members of their circle. One-month trip to London.

1878 — Exhibits work at inaugural exhibition of the Society of American Artists. Continues to exhibit there through 1887.

Late 1870s– early 1880s — Engages in decorative work for Cottier & Co.

1879 — Brother Preserved dies at the age of forty.

Probably 1880 — Moves to the Benedick Building, 80 Washington Square East. Had previously lived at Broadway and Ninth Street and with his family at 348 West Thirty-fifth Street, 280 West Fourth Street, and 16 East Twelfth Street.

1882 — Summer in Europe and North Africa with Cottier and sculptor Olin L. Warner. Returns in October.

1885 — Thomas B. Clarke, noted collector of American art, buys *The Temple of the Mind* and *Christ Appearing to Mary*.

1886 — *Resurrection* sells for $375 at Mary Jane Morgan sale, New York, the first appearance of his work at auction.

1887 — Brief trip to London.

Probably 1889 — Moves to 60 East Eleventh Street.

1890 — Charles de Kay's article (written under the pseudonym Henry Eckford) on Ryder appears in the June issue of the *Century Magazine*.

1891 — Daniel Cottier dies.

1893 — Mother dies at the age of seventy-seven.

1896 — Brief trip to London. In this year known to be located at 308 West Fifteenth Street, where he remains until 1909. Beginning of friendship with neighbors Charles and Louise Fitzpatrick about this time.

1898 — Brother William dies at the age of sixty-one.

1899 — *The Temple of the Mind* and *Christ Appearing to Mary* sell for $2,250 and $1,000, respectively, at the Thomas B. Clarke auction sale, New York, strong prices for Ryder.

1900 — About this time stops originating new pictures. Until his death reworks and repairs many of his existing paintings. Father dies at the age of eighty-six. Biography published in *National Cyclopaedia of American Biography*.

1901 — Receives silver medal from Pan-American Exposition, Buffalo, N.Y.

1902 — Elected Associate, National Academy of Design.

1905 — "Paragraphs from the Studio of a Recluse," based on remarks by Ryder expressed in an interview with Adelaide Samson, published in *Broadway Magazine*.

1906 — Elected to full membership in the National Academy of Design.

1907 — James S. Inglis dies.

1908 — Elected to the National Institute of Arts and Letters.

1909 — Moves to 308 West Sixteenth Street.

1911 — Brother Edward dies at the age of seventy-three.

1912 — Dealer William Macbeth secures and pays for another studio for him at 152 West Fourteenth Street, but he spends the majority of his time at 308 West Sixteenth Street.

1913 — Ten paintings exhibited at the Armory Show.

1915 — Health begins to fail. Spends three months in St. Vincent's Hospital, New York, for treatment of kidney infection. After this moves to a boardinghouse in New York, then to Elmhurst, Long Island, and lives with Charles and Louise Fitzpatrick, first in a boardinghouse, then at 26 Gerry Avenue.

1917 — Dies at the Fitzpatricks' home, March 28, at the age of seventy. Funeral held there on March 30. His body subsequently interred in family plot at Rural Cemetery, New Bedford.

1918 — Memorial exhibition held at the Metropolitan Museum of Art, New York, March 11–April 14.

All notes are by William Innes Homer.
Abbreviations used in the notes

AAA Archives of American Art, Smithsonian Institution, Washington, D.C.

ELC Philip Evergood–Harold O. Love collection of Ryder materials (see chapter 1, note 7, for details)

FFSC Frederic Fairchild Sherman's collection of Ryder research materials

RA Lloyd Goodrich–Albert P. Ryder Archive, University of Delaware Library, University of Delaware, Newark

Introduction

1. Frederic Fairchild Sherman, *Albert Pinkham Ryder* (New York, 1920); and Frederic Newlin Price, *Ryder, a Study of Appreciation* (New York, 1932).
2. Lloyd Goodrich, *Albert P. Ryder* (New York, 1959).
3. Lloyd Goodrich, *Albert P. Ryder Centenary Exhibition* (exhibition catalogue), Whitney Museum of American Art, New York, October 18–November 30, 1947; and Lloyd Goodrich, *Albert Pinkham Ryder* (exhibition catalogue), Corcoran Gallery of Art, Washington, D.C., April 8–May 12, 1961.
4. Lloyd Goodrich, "New Light on the Mystery of Ryder's Background," *Art News* 60 (April, 1961): 39–41, 51; and Lloyd Goodrich, "Ryder Rediscovered," *Art in America* 56 (November–December, 1968): 32–45.
5. William I. Homer, "A Group of Paintings and Drawings by Ryder," *Record of the Art Museum, Princeton University* 18 (1959): 17–33.
6. William I. Homer, "Ryder in Washington," *Burlington Magazine* 103 (June, 1961): 280–83.
7. This research material, known as the Lloyd Goodrich–Albert P. Ryder Archive (hereafter abbreviated RA), was donated by Goodrich and the Whitney Museum of American Art to the University of Delaware in 1987 and is housed in the University of Delaware Library, Newark. It includes Goodrich's research notes on Ryder; Frederic Fairchild Sherman's collection of Ryder research materials (hereafter abbreviated FFSC); the Ryder materials assembled by Alexander Shilling, a painter who knew Ryder; and an important collection of Ryder letters, poems, personal reminiscences, memorabilia, and watercolors and drawings from nature and after the Old Masters by and attributed to Ryder. This last-mentioned collection (hereafter abbreviated ELC) was purchased in 1934 by the painter Philip Evergood from Mary Fitzpatrick Mackay, the adopted daughter of Charles and Louise Fitzpatrick. The Fitzpatricks were neighbors and close friends of Ryder in New York City who took him to their Elmhurst, Long Island, New York, home and cared for him during the last two years of his life. Philip Evergood's mother, Flora, had been a friend of Louise, and as a child Philip had met Ryder and played with Mary Fitzpatrick. Philip maintained contact with the Fitzpatricks over the years, and after Louise died in 1933 (Charles had passed away about a year earlier) he purchased the collection from Mary, who was in financial need (Evergood, interview with Goodrich, October 5, 1938, typescript, RA). This collection was bought from Evergood by Harold O. Love of Detroit in 1961 and subsequently was given by him to the Whitney Museum in 1984, where it became part of the Goodrich–Ryder Archive that was donated to

the University of Delaware. A smaller group of items that remained in Evergood's attic after his death, supplementing this material and including paintings and drawings by Louise Fitzpatrick, was acquired by a private collector.

1: *Childhood and Youth*

1. The two main genealogical sources for the artist's family are C. F. Swift, *Genealogical Notes of Barnstable Families*, 2 vols. (Barnstable, Mass., 1888, 1890), and C. W. Swift, *The Rider Family of Yarmouth* (Yarmouthport, Mass., 1913). See also *National Cyclopaedia of American Biography* 10 (1900), s.v. "Ryder, Albert Pynkham [*sic*]"; "Albert P. Ryder's Criticism of James T. White & Co.'s Galley Proof," undated typescript, ELC, RA; "Albert P. Ryder—A Poe of the Brush," *New York Press*, December 16, 1906; David M. Cheney, "New Bedford's Painter of Dreams," New Bedford *Sunday Standard*, June 10, 1917; "Notes on Albert P. Ryder, obtained by G.C.B.," undated typescript, ELC, RA; typescript of family record sent to Goodrich by Norman W. Bowen of New Bedford, Massachusetts, in 1942, RA; manuscript on family genealogy compiled by Gordon L. Ryder of Kingston, Massachusetts, sent to Goodrich in 1947, RA; manuscript on family tree, author unknown, Frederic Fairchild Sherman scrapbook, FFSC, RA. I was also able to obtain burial records, citing death dates and ages at death of Ryder's immediate family, from Rural Cemetery, New Bedford.
2. "Ryder's Criticism."
3. *National Cyclopaedia* 10 (1900).
4. "G.C.B.," "Notes on Albert P. Ryder."
5. Ibid.
6. *National Cyclopaedia* 10 (1900).
7. Information from New Bedford directories, 1841, 1845, 1849, 1852, 1855, 1856, 1859, 1865, 1867–68, and 1869–70 (directories were not published on an annual basis).
8. "William Davis Ryder" (obituary), *New York Times*, March 11, 1898.
9. Bierstadt had left for Boston about 1850. After living in Europe between 1853 and 1857, he settled in New Bedford until the spring of 1859. At this point, when Ryder was only eleven, Bierstadt departed for the West, taking up residence in New York at the end of the year. He never again lived in New Bedford. Information courtesy of Nancy K. Anderson, letter to the author, February 12, 1984.
10. Marion H. Campbell to the Sunday editor of New Bedford *Standard-Times*, February 16, 1947, *Standard-Times* Archives.
11. Cheney, "New Bedford's Painter of Dreams."
12. Information from New Bedford City Documents, 1846–73, New Bedford Public Library.
13. The most complete and up-to-date information on this phase of Bierstadt's career is found in Nancy Kay Anderson, "Albert Bierstadt: the Path to California" (Ph.D. diss., University of Delaware, 1985), pp. 111–12.
14. Information from advertisements in New Bedford directories, 1852, 1855, 1856, 1859, and 1865.
15. For Ellis and his gallery, see "Leonard B. Ellis Dead" (obituary), New Bedford *Evening Standard*, March 13, 1895; "Leonard B. Ellis's Fine Art Rooms," New Bedford *Evening Standard*, January 5, 1907; "Recollection of the Old Ellis Shop," New

Bedford *Sunday Standard*, October 15, 1911; L. D. Eldred, "When Lovers of Art Gathered at Ellis's," parts 1 and 2, New Bedford *Sunday Standard*, July 24 and July 31, 1921.
16. Cheney, "New Bedford's Painter of Dreams."
17. "A Poe of the Brush." This often overlooked article, based on an unknown reporter's interview with Ryder in his studio, offers important information about his early years. Apparently Ryder placed some value upon the article because he offered to send a copy to his collector-friend Dr. A. T. Sanden (Ryder to Sanden, January 11, 1907, photostat, RA).
18. This illustration, identified with the name Albert P. Ryder, is one of several in a sketchbook inscribed on the flyleaf by his brother William D. Ryder, now lost, that was lent to Goodrich in 1948 by the proprietor of Alicat Book Shop, Yonkers, New York. It had been the property of Gertrude Ryder Smith, Ryder's niece, and includes a drawing of flowers with her first name and the date 1883 attached to it. There is also in the sketchbook another drawing, one of a running horse, inscribed "Albert P. Ryder," possibly in his hand, and a group of other unattributed drawings, making a total of sixteen, mainly copies—presumably from engravings or lithographs.
19. "A Poe of the Brush." The connection between "Sherman" and the superintendent of the tannery is deduced from two sources, never previously combined: Sherman's *Albert Pinkham Ryder* and the article "A Poe of the Brush." Sherman reported Ryder's sister-in-law's account of the young Ryder finding his way "into a studio on William Street, where an artist named Sherman . . . taught him to mix colors and somewhat of how to use them" (p. 12). The article tells of Ryder being sent by his father to a tannery to collect a bill, being entranced by the sight of Sherman's paintings, and joining with him in "a little studio down town" where the two could "just paint all we please." The New Bedford directory of 1865 indicates that a John Sherman was superintendent of the New Bedford Tanning Company, thus providing a link that connects the two fragmentary accounts into a logical whole.
20. "A Poe of the Brush."

2: *Early Years in New York*

1. "William Davis Ryder," *New York Times*.
2. The record of ownership of the hotel stretches back to Henry Brevoort in 1771. In 1880 it was named after Albert S. Rosenbaum, who purchased it in that year. (Charles H. Brunie to Goodrich, March 6, 1958, RA; and Willard H. Carr to the Editors, *Life* magazine, March 1, 1951, carbon copy, RA.) Although it is often said that William D. Ryder was the owner of the Hotel Albert, he was never anything more than the manager.
3. Ryder to Sanden, August 24, 1907, photostat, RA.
4. "A Poe of the Brush."
5. For Marshall, see "Table-Talk," *Appleton's* 5 (January 14, 1871): 55; "William Marshall Exhibition," *New York Times*, November 25, 1883; "In Marshall's Studio," *New York Daily Tribune* (illustrated supplement), June 3, 1906; "W. E. Marshall Dead" (obituary), *New York Daily Tribune*, August 30, 1906; "William E. Marshall Dead" (obituary), *New York Times*, August 30, 1906; "William E. Marshall, the Engraver," New York *Nutshell* 3 (April–June, 1917): 2. Also, valuable information about Marshall is found in an interview that his friend George Petit

LeBrun, a lawyer, conducted with Lloyd Goodrich, April 2, 1945, typescript, RA, and in a letter from LeBrun to Goodrich, January 18, 1960, RA. *The Valuable Paintings and Studio Property belonging to the Estate of William Edgar Marshall* (auction catalogue) (Anderson Art Galleries, New York, March 17, 1909) indicates that Marshall owned a copy of Titian's *Flora* in the Uffizi Gallery, Florence, Italy, and a painting attributed to Rembrandt, *John the Baptist Preaching in the Wilderness.* He purchased the latter in 1863. Presumably both were in his studio when Ryder knew him.

6. Ryder to Sanden, August 24, 1907, photostat, RA.

7. Bryson Burroughs, in *Winslow Homer, Albert P. Ryder, Thomas Eakins* (exhibition catalogue), Museum of Modern Art, New York, May, 1930, p. 13. Though we have no evidence of his meeting the painter, he was responsible for the Museum's purchase of several paintings by Ryder in 1909. None of these works has been found. The following examples by him, however—intriguing in their titles, but now lost—were sold in his estate auction (*Estate of William Edgar Marshall*): *The Devil Sowing Tares* (etching), *Jesus of Nazareth* (oil; engraving), *Christ Knocking at the Door* (drawing, medium not identified), *The Crucifixion* (drawing in pen and ink; drawing, medium not identified), *Aurora* (oil; drawing, medium not identified), *The Recessional* (oil), and *The Mark of Jupiter* (oil).

8. *Catalogue of the Sale of Mr. E. F. Milliken's Private Collection of Valuable Paintings* (auction catalogue), American Art Galleries, New York, February 2, 1902.

9. LeBrun, interview with Goodrich.

10. Ryder to Mrs. William E. Marshall, undated [1906], ELC, RA.

11. Register of Students, NAD, courtesy of Abigail Booth Gerdts. In 1871, Ryder was recorded as having been assistant to Albert Bierstadt's brother Edward, who operated a photographic studio in New York (*New York Times*, Feb. 8, 9, 1871). Information courtesy of Nancy K. Anderson.

12. Thomas Anshutz, "Discourse on Art," chapter 1 (letter to his family, c. 1874), manuscript, Archives of American Art, Smithsonian Institution, Washington, D.C. [hereafter abbreviated AAA].

13. For a discussion of teaching at the Academy, see Lois Marie Fink and Joshua C. Taylor, *Academy: The Academic Tradition in American Art* (exhibition catalogue), National Collection of Fine Arts, Washington, D.C., June 6–September 1, 1975.

14. J. Alden Weir, "Albert Pinkham Ryder, N.A.," [c. 1917], manuscript, J. Alden Weir Manuscript Collection, Brigham Young University Library, Provo, Utah.

15. Ibid.

16. James E. Kelly, "Albert Pinkham Ryder," undated typescript, RA. (See Appendix 4.)

17. Putnam to Sherman, October 22, 1937, FFSC, RA.

18. Kelly, "Albert Pinkham Ryder."

19. "A Poe of the Brush."

20. Albert P. Ryder, "Paragraphs from the Studio of a Recluse," *Broadway Magazine* 14 (September, 1905): 10. (See Appendix 1.)

21. "A Poe of the Brush."

22. Ryder, "Paragraphs," p. 10. The connection between the incident described in the text and Ryder's creative efforts during the summer following his first (1870–71) season at the National Academy was made by the interviewer who wrote "A Poe of the Brush." Despite the description cited in the text, it is not certain which painting this was. It was probably lost or destroyed.

23. [Review of National Academy of Design exhibition], New York *World*, April 15, 1873.

24. Henry Eckford [Charles de Kay], "A Modern Colorist: Albert Pinkham Ryder," *Century Magazine* 40 (June, 1890): 257.

25. Ryder, "Paragraphs," p. 10.

26. "A Poe of the Brush."

27. Putnam to Sherman, October 22, 1937.

28. Henry C. White, "A Call upon Albert P. Ryder," undated typescript, RA. (See Appendix 4.)

29. For Daniel Cottier, see "Daniel Cottier" (obituary), *New York Times*, April 8, 1891; Henry McBride [untitled obituary news article on Ryder], *New York Sun*, April 1, 1917; Margaret H. Hobler, "In Search of Daniel Cottier, Artistic Entrepreneur, 1838–1891" (Master's thesis, Hunter College, 1987); and Doreen Bolger Burke, et al., *In Pursuit of Beauty: Americans and the Aesthetic Movement* (exhibition catalogue), Metropolitan Museum of Art, New York, October 23, 1986–January 11, 1987, pp. 414–15.

30. Walter Fearon to H. Miller, January 4, 1922, RA.

31. For a discussion of these cross-currents, see Doreen Bolger Burke, "Painters and Sculptors in a Decorative Age," in Burke et al., *In Pursuit of Beauty*, pp. 295–339.

32. Clarence Cook, "Fine Arts: Society of American Artists," *New York Tribune*, April 11, 1880. "Mr. Yandell" was C. R. Yandall, a New York dealer and collector.

33. For a detailed account of Richard Watson Gilder, see Arthur John, *The Best Years of the Century* (Urbana, Ill., 1981); see also Rosamond Gilder, ed., *The Letters of Richard Watson Gilder* (Boston, 1916); and Martha Ann Fitzpatrick, "Richard Watson Gilder: Genteel Reformer," (Ph.D. diss., Catholic University of America, 1965). For his magazine work, see Frank Luther Mott, *A History of American Magazines*, vol. 3 (1865–85) (Cambridge, Mass., 1938). For Helena de Kay Gilder, see "R. W. Gilder's Widow Dies" (obituary), *New York Times*, May 29, 1916; and Charlotte Streifer Rubinstein, *American Women Artists* (Boston, 1982), pp. 140–41. Richard Watson Gilder's brother Joseph was a journalist who, with their sister Jeannette, started and served as coeditor, with her, of the *Critic*. Another brother, Robert, was a journalist and archaeologist.

34. For the most complete account of the role of the Gilders in the artistic and intellectual life of New York City, see Jennifer A. Martin Bienenstock, "The Formation and Early Years of The Society of American Artists" (Ph.D. diss., City University of New York, 1983).

35. Samuel Isham, *The History of American Painting*, new edition (New York, 1927), p. 371.

36. For a discussion of the show, see Bienenstock, "Society of American Artists," pp. 18–21. An invitation card mounted in the "Journal of Richard Watson Gilder and Helena de Kay Gilder, 1874–78," private collection (microfilm copy, AAA), cites the names of the participating artists. Many of them were students of Hunt and La Farge. See also Marchal E. Landgren, *Robert Loftin Newman, 1827–1912* (exhibition catalogue), National Collection of Fine Arts, Washington, D.C., October 26, 1973–January 6, 1974, p. 38.

37. Bienenstock gives a full account of the founding of the Society in "Society of American Artists." Earlier appraisals are found in Homer Saint-Gaudens, ed., *The Reminiscences of Augustus Saint-Gaudens* (New York, 1913), pp. 186–89; and Isham, *History of American Painting*, pp. 371–74.

38. A day-to-day personal account of the establishment of the Society is found in "Richard Watson Gilder and Helena de Kay Gilder."

39. Fink and Taylor, *Academy*, pp. 81–82.

40. William C. Brownell, "The Younger Painters of America, First Paper," *Scribner's Monthly* 20 (May, 1880): 7.

41. Quoted in "Art Notes," *New York Times*, April 1, 1883.

42. "Culture and Progress," *Scribner's Monthly* 18 (June, 1879): 312.

43. "The American Artists," *New York Times*, March 8, 1879.

44. Ibid. The painting discussed, entitled *In the Wood*, may be *The Sisters (Charity)* in the Saint Louis Art Museum, but identification remains uncertain.

45. "Art Notes," *Art Journal for 1881* (New York and London, 1881), p. 221.

46. The Gilders, as mentioned earlier in the text of this chapter, entertained Whitman at their New York home; the poet recalled, "At a time when most everybody else in their set was throwing me down they were nobly and unhesitatingly hospitable . . . without pride and without shame." (Horace Traubel, *With Walt Whitman in Camden*, vol. 2 [New York, 1907], p. 119.) R. W. Gilder presented a laudatory speech about Whitman, published in *Camden's Compliment to Walt Whitman* (Philadelphia, 1889), pp. 37–39; and a briefer tribute by Gilder's sister Jeannette was printed in the same volume. She had planned to write a biography of Whitman. (See Whitman to John Burroughs, December 12 [1878], published in Edwin Haviland Miller, ed., *Walt Whitman: The Correspondence, 1876–1885*, vol. 3 [New York, 1964], p. 141.)

47. George W. Sheldon, *Hours with Art and Artists* (New York, 1882), p. 31.

48. Eckford [De Kay], "Modern Colorist," p. 258.

49. "The National Academy Exhibition: Second Notice," *Art Amateur* 3 (June, 1880): 2.

50. "The Academy of Design," *New York Times*, March 30, 1882.

51. "The Academy of Design," *New York Times*, October 21, 1882.

52. Charles Fitzpatrick, "Albert Pinkham Ryder," undated typescript, ELC, RA, published by Kendall Taylor in "Ryder Remembered," *Archives of American Art Journal* 24 (1984): 13.

53. John Robinson, "Personal Reminiscences of Albert Pinkham Ryder," *Art in America* 13 (June, 1925): 179.

54. Kelly, "Albert Pinkham Ryder."

55. Eckford [De Kay], "Modern Colorist," p. 258.

3: Ryder and His Friends

1. Robinson, "Albert Pinkham Ryder," p. 180.

2. Ryder's letter to William R. Mead does not designate him as the recipient, nor is it dated. Ryder, however, sent it to J. Alden Weir for Mead, and Weir's daughter Dorothy inscribed the recipient's name, together with the note "mailed May 27, 1882," on the top of her typescript of the letter, which, with the original, is now lost (a photocopy of the typescript is preserved in RA). The first letter to De Kay from London is undated, but its contents clearly place it in May, 1882; the second is dated July 5, without a year, but it is obviously from 1882. Manuscript copies of the letters to De Kay by Phyllis de Kay Wheelock are preserved in RA; the originals have not been located.

3. Ryder to Mead, undated [mailed May 27, 1882].

4. Ryder to De Kay, undated [May, 1882].

5. Ryder to De Kay, July 5 [1882].

6. "Exhibition of the Art Club," *New York Times*, February 13, 1883.

7. Sadakichi Hartmann, "The Story of an American Painter" (1926), typescript, Library, Metropolitan Museum of Art, New York, p. 22. The location of Baur's sculpture of the Sphinx is unknown. Besides Hartmann, our information about Baur comes from Glenn B. Opitz, ed., *Mantle Fielding's Dictionary of American Painters, Sculptors & Engravers*, rev. ed. (Poughkeepsie, N.Y., 1986).

8. Dorothy Weir Young, *The Life and Letters of J. Alden Weir* (New Haven, Conn., 1960), p. 142.

9. The definitive work on Weir is Doreen Bolger Burke, *J. Alden Weir: An American Impressionist* (Newark, Del., 1983); see also Young, *J. Alden Weir*.

10. Quoted in J. B. Millet, ed., *J. Alden Weir, an Appreciation of His Life and Works* (New York, 1921), p. 104.

11. The most complete account of Warner's life and work is found in George Gurney, "Olin Levi Warner (1844–1886): A Catalogue Raisonné of His Sculpture and Graphic Works" (Ph.D. diss., University of Delaware, 1978).

12. Ryder to Mrs. Olin (Sylvia) Warner, undated (postmarked July 24, 1896), Olin Warner Papers, AAA.

13. Ryder to Mrs. Olin (Sylvia) Warner, January 7, 1900, Warner Papers, AAA.

14. Ryder to Mrs. Olin (Sylvia) Warner, October 12, 1897, Warner Papers, AAA.

15. Ryder to Mrs. Olin (Sylvia) Warner, January 7, 1900.

16. For Newman, see the definitive study by Landgren, *Robert Loftin Newman*.

17. Fitzpatrick, "Albert Pinkham Ryder," p. 11.

18. Landgren, *Robert Loftin Newman*, pp. 61–62; and Albert Boime, "Newman, Ryder, Couture and Hero-Worship in Art History," *American Art Journal* 3 (Fall, 1971): 11.

19. Boime, "Newman, Ryder, Couture," p. 14. Of course, as stated in chapter 2, William E. Marshall's romantic, imaginary paintings may also have served as a stimulus for Ryder's change in style.

20. "Ryder's Criticism."

21. For Inglis (pronounced Ingalls) and his collection, see *The Valuable Paintings . . . of the Late James S. Inglis . . .* (auction catalogue), American Art Galleries, New York, March 11–12, 1909; and Rosalie Warner Jones to Goodrich, October 29, 1936, RA.

22. Wood to Weir, July 7, 1899, C. E. S. Wood Collection, Huntington Library, San Marino, Calif.

23. Gustave Kobbe, "Honor for Albert P. Ryder," New York *Herald*, February 24, 1918.

24. Rosalie Warner Jones [Olin L. Warner's daughter] to Goodrich, October 29, 1936.

25. Miller, interview with Goodrich, June 15, 1938, typescript, RA. (See Appendix 4.)

26. *National Cyclopaedia* 10 (1900).

27. Information on the commission comes from a typewritten page on the back of the picture (copy in RA, page no longer present), and Mrs. John Hall Wheelock [daughter of Charles and Edwalyn de Kay] to Goodrich, April 30, 1941, and February 15, 1961, typed transcripts, RA.

28. Edwalyn (Mrs. Charles) de Kay, interview with Goodrich, May 26, 1946, typescript, RA.

4: *Europe and Ryder's Emergence as a Mature Artist*

1. *National Cyclopaedia* 10 (1900).

2. This discovery was made by H. Nichols B. Clark and was reported by Dorinda Evans, "Albert Pinkham Ryder's Use of Visual Sources," *Winterthur Portfolio* 21 (Spring, 1986): 28, n. 11.

3. In his letter to Charles de Kay, July 5 [1882], Ryder wrote, "[Cottier] doesn't cease to wonder at my seeing so much on a few months work last winter. . . ."

4. This chronological account of the countries and cities Ryder visited has been reconstructed from his letters to William R. Mead (see chapter 3, note 2); from Olin L. Warner's European account book, RA; and from letters Warner wrote his family (information on the contents of these, courtesy of Dr. George Gurney, National Museum of American Art, Smithsonian Institution, Washington, D.C.).

5. Ryder to De Kay, undated [May, 1882].

6. Ryder to Mead, undated [mailed May 27, 1882].

7. Ryder to De Kay, July 5 [1882].

8. Ibid.

9. This sketchbook (RA), measuring 5⅜ x 7⅞", contains twenty-eight drawings of Holland and Italy, some sites identified by inscription, some not.

10. Weir to Anna Baker, October 8, 1882, quoted in Young, *J. Alden Weir*, p. 157.

11. Walter Pach, *Queer Thing, Painting* (New York and London, 1938), p. 60.

12. Ryder to Mrs. William E. Marshall, July 22, 1909, ELC, RA.

13. Pach, *Queer Thing, Painting*, p. 60.

14. French, "Painter of Dreams," p. 3.

15. Fitzpatrick, "Albert Pinkham Ryder," p. 11.

16. No one knows for certain how many paintings Ryder executed. In 1959, Goodrich stated he thought he had painted about 160 pictures. (*Albert P. Ryder*, p. 117.) Goodrich arrived at this figure after long study of Ryder's oeuvre, with special attention to weeding out the forgeries. Yet earlier, when he asked Kenneth Hayes Miller, Ryder's young painter-friend, if he thought Ryder had produced 100 pictures, "Miller said he did not think that many." (Miller, interview with Goodrich, June 15, 1938.) At the time of the 1918 Ryder memorial exhibition at the Metropolitan Museum of Art, and shortly before, published estimates were lower. Gustave Kobbe, in "Honor for Albert P. Ryder," reported: "There are persons who believe that Albert P. Ryder . . . will be found not to have painted more than fifty works"; and Helen Appleton Read, in "Memorial of Albert Ryder, Canvases of Decoration," *Brooklyn Eagle*, March 24, 1918, reported, "He is said to have painted only sixty canvases in all." The checklist "Paintings by Ryder: A Chronological List" (Appendix 5), which I compiled partly in consultation with Goodrich, but which does not accept as many works as he did, cites 98 extant examples that can be securely designated as being by Ryder. A small group of additional works requiring further study might, in time, be added to this list, but my estimate is that there are only about 100 genuine works by Ryder in existence and between 20 and 30 authentic paintings that are lost. Works in the latter group are known from exhibition records, descriptions in critical reviews, early wood engravings, Elbridge Kingsley's preparatory "photo-drawings" in the Forbes Library, Northampton, Massachusetts, and photographs, mostly unpublished. Several such visual records have been included as illustrations to Appendix 5.

17. Ryder to Clarke, April 7 [1885], Thomas B. Clarke Papers, AAA.

18. Elliott Daingerfield, "Albert Pinkham Ryder, Artist and Dreamer," *Scribner's Magazine* 63 (March, 1918): 380.

19. Fitzpatrick, "Albert Pinkham Ryder," p. 9.

20. Ryder to Dr. John Pickard, November 3, 1907, Dr. John Pickard Papers, AAA, published in Allen Weller, "An Unpublished Letter by Albert P. Ryder," *Art in America* 27 (April, 1939): 102.

21. Sherman, *Albert Pinkham Ryder*, pp. 46–47. Sherman gave no source for this often-quoted account.

22. Diary of Colonel C. E. S. Wood, August 12–30, 1896, C. E. S. Wood Collection, Huntington Library, San Marino, Calif.

23. Lloyd Goodrich, interview with Rosalie Warner Jones, April 5, 1937, typescript, RA.

24. Ryder to Weir, September 23, 1897, J. Alden Weir Manuscript Collection, Brigham Young University Library.

25. Ryder to Mrs. Olin (Sylvia) Warner, October 12, 1897.

26. Sadakichi Hartmann, "A Visit to A. P. Ryder!" *Art News* 1 (March, 1897): 1.

27. Miller, interview with Goodrich, February 1, 1940, manuscript, RA.

28. Ryder, "Paragraphs," p. 10.

29. The term "plastic," often employed in art criticism during Goodrich's earlier years, and still occasionally used, is very difficult to define. It has nothing to do with the conventional dictionary definition, that is, pliable, capable of being modeled or molded, nor does it correspond to the synthetic materials in use today. Plastic, in early- to mid-century art terminology, signifies the relatedness and integration of the formal elements in a painting, separate from literary associations, often involving forms that have a degree of tactile density (though not necessarily modeled illusionistically). The formalist view of the paintings of Paul Cézanne finds significant plastic values in them.

30. Miller, interview with Goodrich, June 15, 1938.

31. *James S. Inglis*, no. 73.

32. Eckford [De Kay], "Modern Colorist," p. 252.

33. Roger E. Fry, "The Art of Albert P. Ryder," *Burlington Magazine* 13 (April, 1908): 64.

5: *Painting, Poetry, and the Creative Process*

1. Ryder to Mrs. Lloyd (Peggy) Williams [Daniel Cottier's daughter], December 25, 1911, photocopy, RA, location of original unknown: " 'All the world loves a lover' half the world loves an artist, the other half a poet—signs are good I will be called both." In a letter to his friend Harold W. Bromhead, Ryder spoke of the favorable attention given to his poetry: "I had a feeling when writing it out [an unidentified poem] for the occasion that led to its publication, that I would hear from it [the poem] in some way. Never expecting the gratifying, and of course voluntary comments it received. De Kay came down to tell me that he read it to his daughters; and they came home from school one day saying 'Papa[,] Teacher read Mr. Ryder's poem to us today.' A letter from a very gifted writer whose verses are published in the Atlantic Monthly and other publications." (Ryder to Bromhead, February 2, 1910, typescript of letter, Sherman scrapbook, FFSC, RA.)

2. Kelly, "Albert Pinkham Ryder."

3. Poem enclosed in Ryder's letter to Sanden, August, 1911, photostat, RA.

4. Ryder to Gellatly, June 20, 1909, AAA.

5. Ryder to Wood, October 2, 1899, Katherine Caldwell, Berkeley, Calif.

6. The classic study of these connections in Rensselaer W. Lee, *Ut Pictura Poesis: The Humanistic Theory of Painting* (New York, 1967).

7. For a discussion of Ryder's poems, see Richard Braddock, "The Poems of Albert Pinkham Ryder Studied in Relation to his Paintings" (Master's thesis, Columbia University, 1947); and Richard Braddock, "The Literary World of Albert Pinkham Ryder," *Gazette des beaux-arts*, 6th ser., 33 (January, 1948): 47–54.

8. Ryder, "Paragraphs," p. 10.

9. Ibid., pp. 10–11.

10. Ryder to Mrs. Olin (Sylvia) Warner, April 3, 1900, Warner Papers, AAA.

11. Joseph Lewis French, "A Painter of Dreams," *Broadway Magazine* 14 (September, 1905): 7.

12. Ryder to Sanden, August 18, 1908, photostat, RA.

13. Ryder to Sanden, November 14, 1906, photostat, RA.

14. Walter Pach, "On Albert P. Ryder," *Scribner's Magazine* 49 (January, 1911): 126–27.

15. Ryder to Sanden, August 12, 1899, photostat, RA.

16. Hartmann, "American Painter," p. 9.

17. Ryder to Wood, February 9, 1906, ELC, RA.

18. Goodrich quoted this observation by Kenneth Hayes Miller in his original manuscript for his portion of

this book but the exact date of Miller's recollection of Ryder's works is not recorded. Miller's comment was published in Lloyd Goodrich, *Albert Pinkham Ryder*, p. 13.

19. Marshall wrote the following under his signature: "New York March 25, 1868," perhaps the date on which he lent or gave the volume to Ryder. This is now owned by Mr. and Mrs. Lawrence A. Fleischman, New York City, who received it as a gift from the painter Philip Evergood. The book had been among Ryder's possessions that remained after his death at the Fitzpatricks' home at Elmhurst, Long Island.

20. Private collection. Like the Burnet volume, it had been preserved by Evergood.

21. Miller, interview with Goodrich, June 15, 1938.

22. Miller, interview with Goodrich, June 26, 1947, typescript, RA. (See Appendix 4.)

23. Miller, interview with Goodrich, June 15, 1938.

24. Miller, interview with Goodrich, November 2, 1933, manuscript, RA. (See Appendix 4.)

25. Miller, interview with Goodrich, June 15, 1938.

26. Goodrich, *Albert P. Ryder* (1959), p. 24.

27. Fitzpatrick, "Albert Pinkham Ryder," p. 11.

28. Henri Dorra ("Ryder and Romantic Painting," *Art in America* 48 [1960]: 33) has observed the similarity between Ryder's characteristic marine imagery and Millet's *The Fishing Boat* (see fig. 5–7).

29. Diane Chalmers Johnson, "Art, Nature, and Imagination in the Paintings of Albert Pinkham Ryder: Visual Sources" (Paper delivered at the Seventy-second Annual Meeting of the College Art Association of America, Toronto, Canada, February 23, 1984); and Evans, "Ryder's Use of Visual Sources," p. 28.

30. Johnson, "Art, Nature, and Imagination."

31. Evans, "Ryder's Use of Visual Sources," p. 35.

32. *New York Times*, February 26, 1893, quoted in Evans, "Ryder's Use of Visual Sources," p. 36.

33. Boime, "Newman, Ryder, Couture," pp. 15–22.

34. Evans, "Ryder's Use of Visual Sources," pp. 32–34.

35. Johnson, "Art, Nature, and Imagination."

36. Evans, "Ryder's Use of Visual Sources," pp. 36–37.

37. Hartmann, "American Painter," p. 15.

38. Johnson, "Art, Nature, and Imagination."

6: *Dating Ryder's Paintings*

1. Eckford [De Kay], "Modern Colorist," p. 257.

2. This account was provided by White, "Call upon Albert P. Ryder."

3. Walter M. Grant to an unidentified recipient, May 7, 1937, typed copy, RA, citing the recollections of the former owner's son Kendall Banning; and Kendall Banning to Walter M. Grant, undated (c. 1922), typed copy, RA.

4. Rather than repeatedly cite in the text the evidence for dating found in early exhibition records, publications, and letters, this information has been presented in Appendix 5.

5. Eckford [De Kay], "Modern Colorist," p. 257.

6. See Charles de Kay, "An American Gallery," *Magazine of Art* 9 (1886): 247. This was the first time Ryder's work appeared at auction.

7. The date does not appear to be in Ryder's hand.

8. Eckford [De Kay], "Modern Colorist," p. 256.

7: *Ryder the Man*

1. Harriet Monroe, *A Poet's Life: Seventy Years in a Changing World* (New York, 1938), pp. 193–94.

2. Kobbe, "Honor for Albert P. Ryder."

3. Ryder, "Paragraphs," p. 11.

4. Ibid., p. 10.

5. Robinson, "Albert Pinkham Ryder," p. 184.

6. The painter Philip Evergood offered his reminiscences of Louise Fitzpatrick in "The Master's Favorite Disciple," undated typescript, ELC, RA, published by Kendall Taylor in "Ryder Remembered," *Archives of American Art Journal* 24 (1984): 5–8.

7. Ibid., p. 7.

8. Ibid., pp. 5–6.

9. Ryder to Sanden, March 4, 1911, photostat, RA.

10. Evergood, "Master's Favorite Disciple," p. 7.

11. Ryder to Sanden, March 4, 1911.

12. Ryder to Sanden, February 28, 1910, photostat, RA.

13. Fitzpatrick, "Albert Pinkham Ryder," p. 11.

14. Robinson, "Albert Pinkham Ryder," p. 187.

15. Ryder to Mrs. Lloyd (Peggy) Williams, August 29, 1913, photocopy, RA.

16. As told by Jeanne Judson, "A Recluse for the Sake of His Art Was the Late Albert P. Ryder," *New York Sun*, April 29, 1917.

17. Miller, interview with Goodrich, June 15, 1938.

18. Untitled manuscript concerning Davies and Ryder, probably by Mrs. G. B. Hollister [1920], RA. A very similar account by Mrs. Hollister's husband, G. B. Hollister, appears in full in Appendix 4.

19. Miller, interview with Goodrich, June 15, 1938.

20. Hartmann, "American Painter," p. 12.

21. Fitzpatrick, "Albert Pinkham Ryder," p. 13.

22. Robinson, "Albert Pinkham Ryder," p. 179.

23. Fitzpatrick, "Albert Pinkham Ryder," p. 8.

24. Miller, interview with Goodrich, June 26, 1947. Marsden Hartley, who met Ryder in 1909, recalled that Ryder "was habitually clothed in rust-grey clothing—a grey woolly sweater and a grey wool skull-cap or a kind of tam-o-shanter." (Hartley, "A. P. Ryder: 'The Light That Never Was' " [c. 1929], manuscript, Beinecke Rare Book and Manuscript Library, Yale University, New Haven, Conn.) (See Appendix 4.)

25. Hartley, " 'The Light That Never Was.' "

26. According to Boughton's reminiscences, "Davies suggested bringing him to the studio to be photographed." (Alice Boughton, *Photographing the Famous* [New York (1928)], p. 74.) Three of her portraits of Ryder have been reproduced in the present book (the frontispiece and figs. 7–1 and 10–1); the last was undoubtedly taken later than the first two. The Library of Congress, Washington, D.C., owns the negatives of these prints and four other Ryder portraits by her.

27. Fitzpatrick, "Albert Pinkham Ryder," p. 8.

28. Ryder, "Paragraphs," p. 10.

29. White, "Call upon Albert P. Ryder."

30. Paul Dougherty, interview with Goodrich, April 27 [no year indicated], typescript, RA.

31. Miller, interview with Goodrich, June 15, 1938.

32. Ibid.

33. Fitzpatrick, "Albert Pinkham Ryder," pp. 8–9.

34. Miller, interview with Goodrich, November 2, 1933.

35. Miller, interview with Goodrich, June 6, 1938. But in a later interview, Miller explained that the price of a good dinner was actually thirty-five cents then. (Miller to Goodrich, June 26, 1947.)

36. Fitzpatrick, "Albert Pinkham Ryder," p. 8.

37. Emerson C. Burkhart to Goodrich, March 5, 1941, RA.

38. Sherman, *Albert Pinkham Ryder*, p. 25.

39. Diary of Colonel Wood, August 12–30, 1896.

8: *Growing Recognition*

1. J. M. T., "The American Artists Exhibition," *Art Amateur* 11 (1884): 30.

2. Ripley Hitchcock, "Spring Exhibition, National Academy," *Art Review* 1 (April, 1887): 3.

3. M[ariana] G[riswold] Van Rensselaer, "The Society of American Artists, New York.—I," *American Architect and Building News* 11 (May 13, 1882): 219.

4. [Charles de Kay], "Pictures at the Academy," *New York Times*, March 31, 1883.

5. Clarence Cook, *Art and Artists of Our Time*, vol. 3 (New York, 1888), p. 255.

6. Eckford [De Kay], "Modern Colorist," pp. 250–59.

7. Ibid., p. 252.

8. William Howe Downes and Frank Torrey Robinson, "Later American Masters," *New England Magazine* 14 (April, 1896): 150.

9. Hartmann, "Visit to A. P. Ryder!" pp. 1–3.

10. "Ryder's Criticism."

11. Ryder to Mariana Griswold Van Rensselaer, undated [late 1883–early 1884], Library, Metropolitan Museum of Art, New York.

12. Ryder to De Kay, February 12, 1903, AAA.

13. Ryder to Wood, October 2, 1899.

14. Ryder to E. B. Greenshields, undated [1889], photocopy, RA, location of original unknown.

15. "Ryder's Criticism."

16. Ryder to Clarke, undated [1885], Thomas B. Clarke Papers, AAA.

17. Eckford [De Kay], "Modern Colorist," pp. 255–59.

18. Ibid., pp. 252–53.

19. R. B. Angus was a wealthy banker and financier who belonged to the syndicate responsible for constructing the Canadian Pacific Railway. He was also president of the Montreal Art Association. Sir William Van Horne worked his way to the top of the railroad industry, becoming president of the Canadian Pacific Railway in 1888, then chairman of the board. Edward B. Greenshields entered the family wholesale dry goods business and eventually became its president. According to *Canadian Men and Women of the Time* (Henry James Morgan, ed., Toronto, 1912), all three were among the twenty-three men who, according to the *Montreal Standard*, were at the basis of Canadian finance.

20. Eckford [De Kay], "Modern Colorist," p. 258.

21. Prices in this section of the text were taken from priced auction catalogues and periodical accounts in the collections of the Frick Art Reference Library, the Metropolitan Museum of Art Library, and the New York Public Library, all of New York City.

22. Mrs. Olin (Sylvia) Warner to Wood, January 11, 1899, Huntington Library.

23. Morten's collection, as of November, 1915, was described in Ryder's letter to Morten of that date, AAA.

24. Miller, interview with Goodrich, June 26, 1947.

25. Advertisement for "Dr. Sanden Electric Belt," *New York Tribune*, November 6, 1898. Information about Sanden has been gleaned mainly from Ryder's letters to him (RA).

26. Harrison Smith Morris, *Confessions in Art* (New York, 1930), p. 168.

27. Thomas Casilaer Cole, "Notes on Chas. M. Dewey's Comments on Price's book," undated manuscript, Thomas Casilaer Cole Papers, AAA.

28. Ryder to Sanden, May 15, 1899, photostat, RA.

29. Ryder to Sanden, August 12, 1899.

30. These works are: *Geraldine* (better known as *Woman with Staghound* [fig. 8–6]), and "a small golden landscape," probably the one called *Landscape* (oil on canvas, 9 x 13″) in The Fraad Collection, New York City. (Wood to Goodrich, May 14, 1939, RA.)

31. This correspondence was published, in part, in Young, *J. Alden Weir.*

32. I believe *Landscape with Trees and Cattle*, which Gellatly bought in 1920, is uncharacteristic of Ryder. Rather than being a deliberate fake, it is probably by an earlier or contemporary artist whose work resembled Ryder's.

33. Ryder's friend Albert Groll reported that Ryder "al-

ways disliked" Gellatly. (Groll, interview with Evelyn Eastwood, September 14, 1946, manuscript, AAA.)

34. For Evans, see William H. Truettner, "William T. Evans, Collector of American Paintings," *American Art Journal* 3 (Fall, 1971): 50–79.

35. Charles de Kay, *Catalogue of American Paintings belonging to William T. Evans . . .* (auction catalogue), American Art Galleries, New York, January 31–February 2, 1900, p. 6.

9: *The New Century*

1. Miller, interview with Goodrich, February 1, 1940.
2. This was reported, on the basis of an interview with Ireland, by Thomas B. Brumbaugh, "Albert Pinkham Ryder to John Gellatly: A Correspondence," *Gazette des beaux-arts* 6th ser., 80 (December, 1972): 370, n. 7. Brumbaugh stated: "He [Ireland] thinks there were many others on similar missions after 1900."
3. Salvator Anthony Guarino, "A Visit to Albert P. Ryder," February 22, 1919, manuscript, FFSC, RA. (See Appendix 4.)
4. Ryder to Evans, April 5, 1910, National Museum of American Art, Smithsonian Institution, Washington, D.C.
5. Ryder to Macbeth, November 9, 1911, photocopy, RA. Ryder told Kenneth Hayes Miller, "Most color is too clean." (Miller interview with Goodrich, October, 1942, manuscript, RA.) According to Marsden Hartley, Ryder habitually would "scum" over his paintings with ashes "from the little heaps that lay around his asthmatic little stove. . . . " (" 'The Light That Never Was.' ")
6. Putnam to Sherman, October 22, 1937.
7. Ryder to Sanden, September 26, 1900, photostat, RA.
8. Norman W. Bowen, interview with Goodrich, July 28, 1942, manuscript, RA.
9. Ryder to Sanden, October 19, 1909, photostat, RA.
10. Fitzpatrick, "Albert Pinkham Ryder," p. 13.
11. McBride [untitled obituary news article], New York *Sun*.
12. For the acquisition of the new studio, see Robert McIntyre to Goodrich, January 7, 1947, RA; and Miller, interview with Goodrich, June 26, 1947.
13. Kelly, "Albert Pinkham Ryder."
14. [James Gibbons Huneker], "Seen in the World of Art: A Painter of Genius in New York, but Known to Few," New York *Sun*, June 26, 1910. Similarly, Huneker's story "The Lost Master," published as chapter 14 of *Unicorns* (New York, 1921), is based on a visit with Ryder in his studio. The latter story is less inclined toward fiction than the former.
15. French, "Painter of Dreams," p. 5.
16. Ibid., p. 8.
17. Ibid., p. 3.
18. Ryder to Pickard, November 3, 1907.
19. Fry, "Art of Albert P. Ryder," pp. 63–64.
20. Pach, "On Albert P. Ryder," pp. 125–28.
21. Ibid., p. 127.
22. Hartmann, *History of American Art*, p. 317.
23. Charles Caffin, *The Story of American Painting* (New York, 1907), p. 221.
24. Ibid., p. 218.
25. This account of Davies and Ryder is from the untitled manuscript probably by Mrs. G. B. Hollister.
26. This event was chronicled by Kuhn in A.B.L. [Aline B. Louchheim], "Ryder Seen by Marsden Hartley, Walt Kuhn, Yasuo Kuniyoshi, Reginald Marsh, Kenneth Hayes Miller," *Art News* 46 (November, 1947): 30: "He looked around at the paintings, grunted a few times, and nodded his head," Kuhn recalled. "We got to the center of the Armory, where

there were the cubicles in which Ryder was the only American honored with Cézanne, Van Gogh, and Gauguin, and he just nodded some more."

27. Marsden Hartley, "Mr. Montross Comes and Believes," undated manuscript, Beinecke Rare Book and Manuscript Library, Yale University, New Haven, Conn.
28. These are found in "Mr. Montross Comes and Believes"; "A. P. Ryder: 'The Light That Never Was' "; "Albert P. Ryder," *Seven Arts* 2 (May, 1917): 93–96; "Albert Pinkham Ryder," in *The New Caravan*, ed. Alfred Kreymborg, Lewis Mumford, and Paul Rosenfeld (New York, 1936), pp. 540–51.
29. "Albert Pinkham Ryder,"*The New Caravan* p. 545.
30. Hartley, "Albert P. Ryder," *Seven Arts*, p. 96.
31. Hartley, "Mr. Montross Comes and Believes."
32. I discussed Hartley's relationship to Ryder in my paper "Marsden Hartley, Albert Pinkham Ryder, and the Mystical Tradition," delivered at the Seventy-fourth Annual Meeting of the College Art Association of America, New York, February 13, 1986.
33. Miller's recollections of Ryder are contained in his interviews with Lloyd Goodrich (RA): November 2, 1933; March 8, June 15, June 27, and November 1, 1938; February 1, 1940; October, 1942; and June 26, 1947. See also A.B.L. [Louchheim], "Ryder," pp. 29–30.
34. Ryder to Miller, April 20, 1910, Kenneth Hayes Miller Papers, AAA.
35. These letters are located in the Miller Papers, AAA.
36. Miller to Dunn, October 10, 1915, Miller Papers, AAA. For Miller's creative development, see Lincoln Rothschild, *To Keep Art Alive* (Philadelphia, 1974).
37. William Innes Homer, *Robert Henri and His Circle* (Ithaca, N.Y., 1969), p. 129.
38. Ibid., p. 130.
39. For Kent, see David Traxel, *An American Saga: The Life and Times of Rockwell Kent* (New York, 1986); and Richard V. West, *"An Enkindled Eye": The Paintings of Rockwell Kent* (exhibition catalogue), Santa Barbara (Calif.) Museum of Art, June 29–September 1, 1985.
40. For Manigault, see *Paintings by E. Middleton Manigault* (exhibition catalogue), Norton Gallery of Art, West Palm Beach, Fla., 1983; and Manigault scrapbook, Whitney Museum of American Art, New York.
41. Eilshemius quoted in William Schack, *And He Sat among the Ashes* (New York, 1939), p. 151.
42. Duncan Phillips, "Albert Ryder," *American Magazine of Art* 7 (August, 1916): 389. Although this article was published while Ryder was alive, there is no evidence that Phillips met the painter.
43. Louise Fitzpatrick to Vose, November 15, 1917, Butler Institute of American Art, Youngstown, Ohio.
44. Evergood, interview with Goodrich.
45. See Louise Fitzpatrick to Wood, C. E. S. Wood Collection (Huntington Library): December 9, 1917; March 7, 1918; April 17, 1918; and undated letter [c. 1918].
46. Goodrich reported the following remarks by Kenneth Hayes Miller: "He said that he was sure that Mrs. Fitzpatrick had painted fake Ryders and had passed them off as genuine. He said that when he took the pictures out [to Elmhurst, L.I.] for Ryder to see, which he doubted, she was furious at him." (Miller, interview with Goodrich, June 27, 1938, manuscript, RA.) The dealer Frederic Newlin Price's inventory lists *Pasture at Evening* (Metropolitan Museum of Art, New York), now regarded as a forgery, as coming from Mrs. Fitzpatrick. (See Burke, *American Paintings*, pp. 32–34.)
47. William M. Ladd was a wealthy banker, a member of the firm of Ladd and Tilton, of Portland, Oregon.

Charles E. Ladd, president of Portland Planing Mills and a banker, was his brother. Their sister Helen Ladd married Henry Corbett, also a banker.

48. For Montross, see James W. Lane, "Newman Emerson Montross," *Creative Art* 12 (January, 1933): 51–54; for Macbeth and his contribution, see *The Role of the Macbeth Galleries*, introduction by E. P. Richardson and R. G. McIntyre (exhibition catalogue), American Federation of Arts, New York, October, 1962–May, 1963; and Macbeth Gallery Papers, AAA. For his collection of Ryders, see Kobbe, "Honor for Albert P. Ryder."
49. For Vose, see Robert Taylor, "Robert Vose, 82, is Dean of Boston's Art Dealers," *Boston Sunday Herald*, July 31, 1955; Peter Bermingham, *American Art in the Barbizon Mood* (exhibition catalogue), National Collection of Fine Arts, Washington, D.C., January 23–April 20, 1975, pp. 44–45; also, Robert C. Vose, Jr., interview with the author, December 8, 1987, manuscript. Copies of Robert Vose's letters are preserved in the archives of the Vose Galleries of Boston.
50. Ralph Seymour, "A Summary of the Gellatly Collection" (1932), manuscript, National Museum of American Art, Smithsonian Institution, Washington, D.C.
51. Cited in Young, *J. Alden Weir*, p. 228.
52. Ibid., p. 244. Miller, as mentioned earlier, reported that Ryder had at one time asked $3,000 for *The Race Track*. It would seem that Ryder set prices according to his whim.
53. Ibid., p. 252.
54. Ibid., p. 256.
55. This was not as great an honor as it might seem. Eighty-three other artists received silver medals at this exposition. (Thirty-three received gold medals.) *Catalogue of the Exhibition of Fine Arts* (Pan-American Exposition, Buffalo, N.Y., 1901), pp. viii–ix.
56. Information courtesy of Nancy Johnson, librarian, American Academy and Institute of Arts and Letters, New York. (Letter to the author, July 21, 1988.)
57. These were *Pastoral Study* (fig. 5–15), *Moonlight Marine* (fig. 4–5), *Moonlit Cove* (fig. 11–9), *Diana* (fig. 11–17), *The Hunter's Rest* (fig. 6–20), *In the Stable* (fig. 6–9), *The Lovers (Saint Agnes' Eve)* (fig. 11–15), *Pegasus* (plate 3), *Resurrection* (fig. 4–9), and *At the Ford* (private collection).
58. Milton W. Brown, *The Story of the Armory Show* (n.p., 1963), p. 75.
59. Walt Kuhn's recollections in A.B.L. [Louchheim], "Ryder," p. 30.
60. Joseph Edgar Chamberlin, "Ultra Moderns in a Live Art Exhibition at 69th's Armory," New York *Evening Mail*, February 17, 1913, Walt Kuhn scrapbook, Armory Show Papers, AAA.
61. Charles Caffin, "International Stirs the Public," New York *North American*, March 10, 1913, Walt Kuhn scrapbook, Armory Show Papers.

10: *Old Age and Posthumous Fame*

1. For the interpretation of Ryder's physical symptoms, based on the artist's letters and death certificate, I am indebted to Maurice J. Leon, M.D., of Bethesda, Maryland.
2. Cole, "Chas. M. Dewey's Comments."
3. Alfred Kreymborg, *Troubador: An Autobiography* (New York, 1925), p. 115.
4. Hartmann, "American Painter," pp. 44–45.
5. Cited in Young, *J. Alden Weir*, p. 223.
6. Fitzpatrick, "Albert Pinkham Ryder," p. 12.
7. Jean Gibran and Kahlil Gibran, *Kahlil Gibran, His Life and World* (Boston, 1974), p. 302.
8. Miller to Dunn, September 21, 1915, Miller Papers, AAA.

9. Miller to Rhoda Dunn, October 29, 1915, Miller Papers, AAA.
10. Kobbe, "Honor for Albert P. Ryder."
11. Cited in Young, *J. Alden Weir*, p. 252.
12. Fitzpatrick, "Albert Pinkham Ryder," p. 14.
13. Miller to Dunn, February 23, 1916, Miller Papers, AAA.
14. Miller, interview with Goodrich, 1942.
15. Fitzpatrick, "Albert Pinkham Ryder," p. 14.
16. Certificate of Death, Department of Health of the City of New York, March 28, 1917, no. 1565.
17. "Albert Pinkham Rider [*sic*], 'Poet Artist' Dead," unidentified and undated clipping, ELC, RA, identified the minister as the Reverend H. B. Belcher, a pastor of the Methodist Church.
18. The record of those attending is found in Miller to Dunn, April 14, 1917, Miller Papers, AAA; and Weir to Wood, March 30, 1917, cited in Young, *J. Alden Weir*, p. 256.
19. Young, *J. Alden Weir*, p. 256.
20. Fitzpatrick, "Albert Pinkham Ryder," p. 14.
21. Gertrude Ryder Smith to Mrs. Charles (Louise) Fitzpatrick, March 30, 1917, ELC, RA.
22. Burial card and Order for Deposit in Receiving Tomb, Rural Cemetery, City of New Bedford, Mass. No will has been found. An account of the distribution of Ryder's effects was provided by Thomas Casilaer Cole's "Chas. M. Dewey's Comments": "All that he left in the way of personal valuables was a little box containing two brass watch chains, a couple of souvenir buttons and collar buttons, a couple of old coins [written above the line] of absolutely no intrinsic value, and these Mr. Dewey gave to me. The only other thing was a cameo ring, a companion one to others made at the same time—one belonging to Olin Warner and the other to Alden Weir—all three devoted brotherly artist friends. This ring, although Mrs. Warner asked Mr. Dewey to give to me, went to Daniel Cottier's daughter, as Ryder had requested it should. All else that he left was the clothing he wore, his easel, a wooden chest for fire wood, a chair, and 5 or 6 canvasses." Cole was an artist who had befriended Dewey.
23. "Tribute to Memory of Albert Pinkham Ryder," New Bedford *Morning Mercury*, May 29, 1917.
24. The obituary in the New York *Sun*, March 29, 1917, had a subhead that referred to Ryder as the "Whitman of the Brush." The obituary in the *New York Evening Journal*, March 29, 1917, stated: "He was as free from rules in his manner of painting as Walt Whitman was in his use of words."
25. For the former comparison, see Judson, "Recluse for the Sake of His Art;" for the latter, see Cheney, "New Bedford's Painter of Dreams."
26. J. W. Young, interview with Goodrich, March, 1937, typescript, RA.
27. Cole, "Chas. M. Dewey's Comments."
28. Albert Milch, interview with Goodrich, March 4, 1937, manuscript, RA.
29. In a letter to Colonel Wood, December 9, 1917, Louise Fitzpatrick said that she thought Dewey had some of the pictures that "they took away" (from the Fitzpatrick home where Ryder died), but she reported to Wood, "[Dewey] said they were not in a state to be sold yet." This last remark strongly suggests that Dewey was planning to work on Ryder's remaining paintings to get them into shape to be sold.
30. Vose to Burroughs, August 24, 1918, copy, Vose Galleries of Boston. A search through the Vose papers revealed no evidence of such a list; this is not surprising because, according to Robert C. Vose, Jr., many of the gallery's pre-1920 records were destroyed.
31. The paintings shown were *Macbeth and the Witches*, *Moonlight Marine*, and *Resurrection* (Arts and Decoration, 7 [May, 1917], p. 368).

32. Dewey to Sherman, June 17, 1917, Sherman Papers, AAA.
33. Sherman included a chapter, "Some Paintings by Albert Pinkham Ryder," in his *Landscape and Figure Painters of America* (New York, 1917), pp. 33–39. For Sherman, see his "Biographical Notes," undated typescript, Sherman Papers, AAA.
34. Such annotated photographs appear in FFSC, RA, and in Sherman Papers, AAA.
35. For example, Sherman sold *Homeward Bound*, which he had purchased from Captain John Robinson for $1,000 in 1919, to Duncan Phillips for $12,500 in 1921. This was one of the highest recorded prices for a Ryder up to that time. For an account of this transaction, see Sherman, "Biographical Notes."
36. Detailed records of the procedures followed for this show are found in the Archives of the Metropolitan Museum of Art, New York.
37. Sherman thought *Night and the Sea* (present location unknown), lent by Dewey, had been heavily repainted by him. Under the photograph of the work in his album, "Photographs of Paintings by Albert Pinkham Ryder," FFSC, RA, Sherman wrote: "This is an unfinished picture left at Ryder's death and completed by Charles Melville Dewey. With the exception of the design, which is Ryder's, the painting is practically Dewey's." *The Canal* (*Essex Canal*) (fig. 11–22), in Dewey's hands shortly after Ryder's death but lent to the show by John Gellatly, and *Diana's Hunt* (fig. 11–23), lent by Dewey, may also have been retouched (see chapter 11 for a discussion of these two examples). Sherman also thought *Under a Cloud* (fig. 8–9), lent by Dr. A. T. Sanden, had undergone restoration (see Sherman's remarks in "Photographs of Paintings"); Sanden presumably bought all of his paintings directly from Ryder. *The Flight into Egypt* (International Business Machines Corp., New York City), lent by Dewey, and *The Way of the Cross* (Addison Gallery of American Art, Andover, Mass.), lent by Louise Fitzpatrick, display questionable stylistic traits and require further study.
38. Bryson Burroughs, in *Loan Exhibition of the Works of Albert P. Ryder* (exhibition catalogue), Metropolitan Museum of Art, New York, March 11–April 14, 1918, p. v.
39. Ibid.
40. Read, "Memorial of Albert Ryder."
41. "Ryder Exhibition at Metropolitan Museum," *New York Times Magazine*, March 10, 1918.
42. "Ryder and Clever Painting," New York *Post*, April 9, 1918.
43. "Ryder Exhibition at Metropolitan Museum."

11: *Forgeries and Alterations of Ryder's Work*

1. This chapter utilizes, but expands upon, material previously presented to the public in my article, "Observations on Ryder Forgeries," *American Art Journal* 20 (1988): 35–52; and my paper "Will the Real Mr. Ryder Please Stand Up?" delivered at the Seventy-sixth Annual Meeting of the College Art Association of America, Houston, Texas, February 11, 1988.
2. This estimate was provided by Lloyd Goodrich in numerous conversations with me. Judging by the forged paintings that are brought to my attention every few weeks, the number continues to grow. Of course, some of these works had appeared before and have now resurfaced. Goodrich often said a painting he had declared a forgery might reappear at fifteen- or twenty-year intervals, the owners being different in each instance.
3. Ryder to Morten, November, 1915: "I am sorry to say, a great many spurious Ryders have lately come into the market. . . ." Cole, "Chas. M. Dewey's

Comments," related Dewey's account of Ryder's response to the forgeries: "He was made very angry . . . by the numerous fakes that were painted and sold in imitation of his work. There were several very clever and talented young painters, who themselves would have been fine artists had they been more original, who made money by sometimes selling very clever imitations of Ryder. Mr. Dewey said he used to tease Ryder by showing him these when he came across them, and by drawing Ryder's attention to them. But he finally desisted doing so, as he saw it was no use, and that it always deeply angered Ryder, who was made very unhappy by these imitations and fakes of his work."
4. To my knowledge, the largest single collection of forgeries, now used for study, is in the RA. Over the years, Goodrich had collected twelve examples, which came with the RA when it was given to the University of Delaware. Since then, two additional forgeries, a gift from the Vose Galleries of Boston, have been added to the RA.
5. My comments are based on the hundreds of photographs of forgeries in the RA, together with my own photographs of forgeries taken or collected over the last four years.
6. Goodrich discovered a factory for phony Ryders in Philadelphia run by someone named Bogas, "which is much too good to be true." (Alfred V. Frankenstein to Goodrich, September 16, 1947, RA.)
7. Goodrich, *Albert Pinkham Ryder*, p. 117.
8. For the magazine *Art in America*, of which he was editor, Sherman wrote articles on the "discovery" of new Ryder paintings, the illustrations of which correspond to works that are now thought to be questionable. See, for example, "The Marines of Albert P. Ryder," *Art in America* 8 (December, 1919): 28–32; "Four Paintings by Albert Pinkham Ryder," *Art in America* 9 (October, 1921), 260–68; and "Two Marines by Albert P. Ryder," *Art in America* 12 (October, 1924): 296–300.
9. Sherman expressed his views in "Some Paintings Erroneously Attributed to Albert Pinkham Ryder," *Art in America* 24 (October, 1936): 160–61, citing Price; and, without mentioning Price, in "Paintings Erroneously Attributed to Albert Pinkham Ryder," *Art in America* 25 (April, 1937): 87–89. In the same spirit, Charles Melville Dewey's views on the number of forgeries reproduced in Price's book were reported by Cole, "Chas. M. Dewey's Comments." Though Sherman was no friend of Dewey's, the two men were largely in agreement about which works in Price's volume were forgeries.
10. See "Ferargil Galleries Acquire Famous Sanden Group of Ryders," *Art News* 22 (February 9, 1924): 5.
11. Dr. Harlan B. Phillips, "Lloyd Goodrich Reminisces," transcript of a taped oral history interview, 1962–63, 511-page typescript, AAA, gives Goodrich's own account of his response to this show (p. 403).
12. Goodrich, interview with the author, January 20, 1984, typescript.
13. The account of these studies is derived mainly from the following sources: Lloyd Goodrich, unpublished typescript written for *Life* magazine, January 4, 1951, RA; Phillips, "Lloyd Goodrich Reminisces," pp. 406–8, 410–14; Goodrich, interview with the author; Keck, interview with the author, January 14–15, 1988, typescript.
14. Goodrich reported that the most useful methods of examination were found to be X-ray radiographs and ultraviolet light, in that order. Keck pointed out to Goodrich that pigment analysis was not particularly helpful because the pigments used by Ryder would have been equally available to forgers, especially the early ones. (Phillips, "Lloyd Goodrich Reminisces,"

pp. 410–11; and Keck, interview with the author, January 14–15, 1988.)

15. Goodrich, *Albert Pinkham Ryder*, p. 120.

16. Since the time of Goodrich's investigations, neutron activation autoradiographs have also helped to clarify Ryder's technical procedures and have complemented information gained from X-ray radiographs. In autoradiography, the painting is bombarded with thermal neutrons; then X-ray films are placed in contact with the painting at various intervals of time chosen to correspond with "half-lives" of typical pigments. The films, when developed, reveal "the distribution (location and density) of those pigments and other painting materials that contain radioactive elements at the time of exposure." (Maryan Wynn Ainsworth et al., "Paintings by Van Dyck, Vermeer, and Rembrandt Reconsidered through Autoradiography," in *Art and Autoradiography: Insights into the Genesis of Paintings by Rembrandt, Van Dyck, and Vermeer* [New York, 1982], p. 9.) Autoradiographs are particularly useful because they present information about the multiple layers of a painter's composition and help to identify and locate certain pigments; this information is not blocked by white lead grounds or linings. For the application of this method to the paintings of Ralph Blakelock and Ryder, see Maurice J. Cotter et al., "A Study of the Material and Techniques Used by Some Nineteenth Century American Oil Painters by Means of Neutron Activation Autoradiography," preliminary report (n.p., n.d. [1972]); and *Applicazione dei metodi nucleari nel campo delle opere d'arte* (Proceedings of the Accademia Nazionale dei Lincei, Rome-Venice, May 24–29, 1973) (Rome, 1976). For Ryder, see Burke, *American Paintings*, pp. 20, 23, and 24. Recently, Richard Wolbers of the University of Delaware has employed a unique procedure of biological staining to reveal the identity, in-

termingling, and stratigraphy of the various layers in the fabrication of oil paintings, including those of Ryder.

17. Goodrich, unpublished typescript, 1951. After the Goodrich-Keck-Baur study of Price's pictures was completed, Goodrich continued to work with Keck, and occasionally also with Baur, in the examination of authentic and forged Ryders. With the cooperation of the Metropolitan Museum of Art's laboratories, Goodrich had radiographs made of a number of authentic and forged Ryders in connection with the exhibition of the artist's work he arranged for the Whitney Museum of American Art in 1947. (See Phillips, "Lloyd Goodrich Reminisces," p. 417.)

18. Goodrich, interview with the author.

19. Ibid. Goodrich, through his personal acquaintance with Price and Walker, especially the latter, determined Walker's innocence.

20. Goodrich, unpublished typescript, 1951.

21. Mrs. Carlyle (Rosalie) Jones [Olin L. Warner's daughter] to Bartlett H. Hayes, Jr., October 19, 1953, Addison Gallery of American Art, Andover, Mass. She undoubtedly became aware of this practice through her continuing friendships with members of the Ryder circle.

22. It has also been reported that Ryder sometimes signed works by younger artists as a favor, to enable them to sell such works at higher prices. Letter to the Editor by Hope Aspell, *Life*, March 19, 1951, p. 15.

23. Evergood, interview with Goodrich. Louise Fitzpatrick quoted Ryder as saying, "Louise, you paint this for me—you know how to do it—use such-and-such a color and put it on just so."

24. Young, interview with Goodrich.

25. Frederic Fairchild Sherman, unpublished typescript of part eight ("Restorations, Incorrectly Attributed

Works and Copies by Other Hands") for his proposed expanded edition of *Albert Pinkham Ryder*, Sherman Papers, AAA.

26. Pach, *Queer Thing, Painting*, p. 62.

27. Louise Fitzpatrick to Wood, March 7, 1918.

28. Louise Fitzpatrick to Wood, April 17, 1918.

29. Vose to Burroughs, August 14, 1918, copy, Vose Galleries of Boston.

30. Sherman, part eight ("Restorations").

31. Ibid.

32. Louise Fitzpatrick to Wood, April 17, 1918.

33. Louise Fitzpatrick to Wood, undated [c. 1918].

34. Vose to Wood, October 2, 1918, C. E. S. Wood Collection.

35. Milch, interview with Goodrich.

36. Ibid.

37. Frederic Fairchild Sherman, remarks under the photograph of the painting in his album ("Photographs of Paintings"), FFSC, RA.

38. David Karel, *Horatio Walker* (exhibition catalogue), Musée de Québec, September 25–November 23, 1986, p. 71, n. 13, suggests that Walker may have produced forged Ryders.

39. Marsden Hartley, who knew *Macbeth and the Witches* from seeing it in Ryder's studio, remarked that it was "restored and varnished out of all plausible import in the Ryder sense of things. This picture was better in its soiled condition as many restored pictures often are—and in Ryder's case the mysterious intention of this particular picture was augmented by its soiled condition for restoration has prettified it out of bounds." (Hartley, " 'The Light That Never Was.' ")

40. See Sheldon Keck, "Albert Pinkham Ryder: His Technical Procedures," in this volume for a fuller discussion of this matter.

Books and Catalogues

Applicazione dei metodi nucleari nel campo delle opere d'arte. Proceedings of the Accademia Nazionale dei Lincei, Rome-Venice, May 24–29, 1973. Rome, 1976.

Baur, John I. H. *American Painting in the Nineteenth Century.* New York, 1953.

————. *Revolution and Tradition in American Art.* Cambridge, Mass., 1951.

Bermingham, Peter. *American Art in the Barbizon Mood* (exhibition catalogue). Washington, D.C.: National Collection of Fine Arts, January 23–April 20, 1975.

Boime, Albert. *Thomas Couture and the Eclectic Vision.* New Haven, Conn., 1980.

Boughton, Alice. *Photographing the Famous.* New York, 1928.

Brown, Milton W. *The Story of the Armory Show.* N.p., 1963.

Burke, Doreen Bolger. "Albert Pinkham Ryder." In *A Catalogue of Works by Artists Born between 1846 and 1864,* pp. 7–34. *American Paintings in the Metropolitan Museum of Art.* Vol. 3. New York, 1980.

————. *J. Alden Weir: An American Impressionist.* Newark, Del., 1983

Burke, Doreen Bolger, et al. *In Pursuit of Beauty: Americans and the Aesthetic Movement* (exhibition catalogue). New York: Metropolitan Museum of Art, October 23, 1986–January 11, 1987.

Burroughs, Alan. *Limners and Likenesses, Three Centuries of American Painting.* Cambridge, Mass., 1936.

Caffin, Charles. *The Story of American Painting.* New York, 1907.

Cahill, Holger, and Barr, Alfred H., Jr., eds. *Art in America in Modern Times.* New York, 1934.

Catalogue of the Exhibition of Fine Arts. Buffalo, N.Y.: Pan-American Exposition, 1901.

Catalogue of the Sale of Mr. E. F. Milliken's Private Collection of Valuable Paintings (auction catalogue). New York: American Art Galleries, February 2, 1902.

Catalogue of the Thomas B. Clarke Collection of American Pictures (exhibition catalogue). Philadelphia: Pennsylvania Academy of the Fine Arts, October 15–November 28, 1891.

Cheney, Sheldon. *The Story of Modern Art.* New York, 1941.

Clark, Eliot. *History of the National Academy of Design, 1825–1953.* New York, 1954.

Cook, Clarence. *Art and Artists of Our Time.* Vol. 3. New York, 1888.

Corn, Wanda M. *The Color of Mood: American Tonalism, 1880–1910* (exhibition catalogue). San Francisco: M. H. De Young Memorial Museum and the California Palace of the Legion of Honor, January 22–April 2, 1972.

Cortissoz, Royal. *American Artists.* New York and London, 1923.

Cortissoz, Royal, et al. *The Book of Alexander Shilling.* New York, 1937.

Craven, Thomas. *Men of Art.* New York, 1931.

Davidson, Abraham H. *The Eccentrics and Other Visionary Painters.* New York, 1978.

De Kay, Charles. *Catalogue of American Paintings belonging to William T. Evans . . .* (auction catalogue). New York: American Art Galleries, January 31–February 2, 1900.

The Edwin C. Shaw Collection of American Impressionist and Tonalist Painting (exhibition catalogue). Text by Carolyn Kinder Carr and Margot Jackson; catalogue by William Robinson. Akron, Ohio: Akron Art Museum, April 19–June 29, 1986.

Eldredge, Charles C. *American Imagination and Symbolist Painting* (exhibition catalogue). New York: Grey Art Gallery and Study Center, New York University, October 24–December 8, 1979.

Fink, Lois Marie, and Taylor, Joshua C. *Academy: The Academic Tradition in American Art* (exhibition catalogue). Washington, D.C.: National Collection of Fine Arts, June 6–September 1, 1975.

Gibran, Jean, and Gibran, Kahlil. *Kahlil Gibran, His Life and World.* Boston, 1974.

Gilder, Rosamund, ed. *The Letters of Richard Watson Gilder.* Boston, 1916.

Goodrich, Lloyd. *Albert P. Ryder.* New York, 1959.

————. *Albert P. Ryder Centenary Exhibition* (exhibition catalogue). New York: Whitney Museum of American Art, October 18–November 30, 1947.

————. *Albert Pinkham Ryder* (exhibition catalogue). Washington, D.C.: Corcoran Gallery of Art, April 8–May 12, 1961.

Harrison, James A., ed. *Life and Letters of Edgar Allan Poe.* Vol. 2. New York, [1902–03].

Hartley, Marsden. *Adventures in the Arts.* New York, 1921.

Hartmann, Sadakichi. *A History of American Art.* Boston, 1902.

Hills, Patricia. *Turn-of-the-Century America: Paintings, Graphics, Photographs, 1890–1910* (exhibition catalogue). New York: Whitney Museum of American Art, June 30–October 2, 1977.

Homer, William Innes. *Robert Henri and His Circle.* Ithaca, N.Y., 1969.

Huneker, James Gibbons. *Unicorns.* New York, 1921.

Isham, Samuel. *The History of American Painting.* New ed. New York, 1927.

John, Arthur. *The Best Years of the Century.* Urbana, Ill., 1981.

Karel, David. *Horatio Walker* (exhibition catalogue). Quebec: Musée de Québec, September 25–November 23, 1986.

Kazin, Alfred. *A Walker in the City.* New York, 1951.

Kreymborg, Alfred. *Troubador: An Autobiography.* New York, 1925.

La Follette, Suzanne. *Art in America, from Colonial Times to Present Day.* New York, 1929.

Landgren, Marchal E. *American Pupils of Thomas Couture* (exhibition catalogue). [College Park]: University of Maryland Art Gallery, March 19–April 26, 1970.

————. *Robert Loftin Newman, 1827–1912* (exhibition catalogue). Washington, D.C.: National Collection of Fine Arts, October 26, 1973–January 6, 1974.

Larkin, Oliver W. *Art and Life in America.* New York, 1949.

Lears, T. J. Jackson. *No Place of Grace: Antimodernism and the Transformation of American Culture 1880–1920.* New York, 1981.

Lee, Rensselaer W. *Ut Pictura Poesis: The Humanistic Theory of Painting.* New York, 1967.

Loan Exhibition of the Works of Albert P. Ryder (exhibition catalogue). Introduction by Bryson Burroughs. New York: Metropolitan Museum of Art, March 11–April 14, 1918.

Low, Will H. *A Painter's Progress.* New York, 1910.

Mather, Frank Jewett. *The American Spirit in Art. The Pageant of America.* Vol. 12. Edited by Ralph Henry Gabriel. New York, 1927.

————. *Estimates in Art, Series II: Sixteen Essays on American Painters of the Nineteenth Century.* New York, 1931.

Mather, Frank Jewett, Jr.; Burroughs, Bryson; and Goodrich, Lloyd. *Winslow Homer, Albert P. Ryder, Thomas Eakins* (exhibition catalogue). New York: Museum of Modern Art, May, 1930.

Meixner, Laura L. *An International Episode: Millet, Monet and Their North American Counterparts* (exhibition catalogue). Memphis, Tenn.: Dixon Gallery and Gardens, November 21–December 23, 1982.

Miller, Edwin Haviland, ed. *Walt Whitman: The Correspondence, 1876–1885.* Vol. 3. New York, 1964.

Millet, J. B., ed. *J. Alden Weir, an Appreciation of His Life and Works.* New York, 1921.

Monroe, Harriet. *A Poet's Life: Seventy Years in a Changing World.* New York, 1938.

Morris, Harrison Smith. *Confessions in Art.* New York, 1930.

Mott, Frank. *A History of American Magazines.* Vol. 3 (1865–85). Cambridge, Mass., 1938.

Mumford, Lewis. *The Brown Decades: A Study of the Arts in America, 1865–95.* New York, 1931.

Neuhaus, Eugene. *The History and Ideals of American Art.* Stanford, Calif., 1931.

Novak, Barbara. *American Painting of the Nineteenth Century: Realism, Idealism, and the American Experience.* 2nd ed. New York, 1979.

Pach, Walter. *Queer Thing, Painting.* New York and London, 1938.

Paintings by E. Middleton Manigault (exhibition catalogue). West Palm Beach, Fla.: Norton Gallery of Art, 1983.

Phillips, Duncan. *The Artist Sees Differently.* Vol. 2. New York and Washington, D.C., 1931.

————. *A Collection in the Making.* New York and Washington, D.C., 1926.

Price, Frederic Newlin. *Ryder, a Study of Appreciation.* New York, 1932.

Richardson, E. P. *Painting in America: The Story of 450 Years.* New York, 1956.

The Role of the Macbeth Galleries (exhibition catalogue). Introductions by E. P. Richardson and R. G. McIntyre. New York: American Federation of Arts, October, 1962–May, 1963.

Rosenblum, Robert. *Modern Painting and the Northern Romantic Tradition.* New York, 1975.

Rosenfeld, Daniel, and Workman, Robert G. *The Spirit of Barbizon: France and America* (exhibition catalogue). San Francisco: Art Museum Association of America, 1986 (exhibition organized by the Museum of Art, Rhode Island School of Design).

Rosenfeld, Paul. "Albert P. Ryder." In *Port of New York: Essays on Fourteen American Moderns*, pp. 3–17. New York, 1924.

Rothschild, Lincoln. *To Keep Art Alive: The Effort of Kenneth Hayes Miller, American Painter (1876–1952)*. Philadelphia, 1974.

Rubinstein, Charlotte Streifer. *American Women Artists*. Boston, 1982.

Saint-Gaudens, Homer, ed. *The Reminiscences of Augustus Saint-Gaudens*. New York, 1913.

Schack, William. *And He Sat among the Ashes: A Biography of Louis M. Eilshemius*. New York, 1939.

Schwab, Arnold T. *James Gibbons Huneker, Critic of the Seven Arts*. Stanford, Calif., 1963.

Sheldon, G[eorge] W[illiam]. *American Painters*. New York, 1881.

———. *Hours with Art and Artists*. New York, 1882.

———. *Recent Ideals of American Art*. New York and London, 1988.

Sherman, Frederic Fairchild. *Albert Pinkham Ryder*. New York, 1920.

———. *Landscape and Figure Painters of America*. New York, 1917.

Soby, James Thrall, and Miller, Dorothy C. *Romantic Painting in America* (exhibition catalogue). New York: Museum of Modern Art, 1943.

Swift, C. F. *Genealogical Notes of Barnstable Families*. 2 vols. Barnstable, Mass., 1888, 1890.

Swift, C. W. *The Rider Family of Yarmouth*. Yarmouthport, Mass., 1913.

Traubel, Horace. *With Walt Whitman in Camden*. Vol. 2. New York, 1907.

Traxel, David. *An American Saga: The Life and Times of Rockwell Kent*. New York, 1986.

The Valuable Paintings and Studio Property belonging to the Estate of William Edgar Marshall (auction catalogue). New York: Anderson Art Galleries, March 17, 1909.

The Valuable Paintings…of the Late James S. Inglis… (auction catalogue). New York: American Art Galleries, March 11–12, 1909.

West, Richard V. *"An Enkindled Eye": The Paintings of Rockwell Kent* (exhibition catalogue). Santa Barbara, Calif.: Santa Barbara Museum of Art, June 29–September 1, 1985.

White, Henry Coke. *The Life and Art of Dwight William Tryon*. Boston and New York, 1930.

Wilson, Richard Guy; Pilgrim, Dianne H.; and Murray, Richard N. *The American Renaissance, 1876–1917* (exhibition catalogue). Brooklyn: The Brooklyn Museum, October 13–December 30, 1979.

Wright, Brooks. *The Artist and the Unicorn, the Lives of Arthur B. Davies*. New City, N.Y., 1978.

Young, Dorothy Weir. *The Life and Letters of J. Alden Weir*. Edited by Lawrence W. Chisholm. New Haven, Conn., 1960.

Articles

"The Academy Exhibition." *Harper's Weekly*, April 7, 1888, p. 250.

"The Academy of Design." *New York Times*, March 30, 1882.

"The Academy of Design." *New York Times*, October 21, 1882.

"Acquisitions." *Bulletin of the Worcester Art Museum* 10 (October, 1919): 51.

"A. P. Ryder Dies; Great Native Painter" (obituary). *New York Evening Journal*, March 29, 1917.

"Albert P. Ryder." *Glasgow* (Scotland) *Herald*, July 1, 1921.

"Albert P. Ryder—A Poe of the Brush." *New York Press*, December 16, 1906.

"Albert P. Ryder—Died March 28, 1917." *American Art News* 15 (March 31, 1917): 4.

"Albert P. Ryder Dead" (obituary). *New York Times*, March 29, 1917.

"Albert P. Ryder Memorial at Museum." N.p., [1918].

"Albert P. Ryder of Art Fame is Dead" (obituary). New York *Sun*, March 29, 1917.

"Albert P. Ryder's Mystic Art." *Current Literature* 45 (September, 1908): 290–92.

"Albert Pinkham Ryder" (obituary). *American Art Annual* 14 (1917): 327.

"The American Artists." *New York Times*, March 8, 1879.

"Art and Artists: Albert P. Ryder's Paintings at Metropolitan Museum." Springfield (Mass.) *Republican*, March 21, 1918.

"Art at the Lotos Club." *New York Times*, December 26, 1896.

"Art Notes." *Art Journal for 1881* (New York and London, 1881), p. 221.

"Art Notes." *New York Times*, April 1, 1883.

"Art Notes." *New York Times*, April 7, 1891.

Baldinger, Wallace A. "The Art of Eakins, Homer, and Ryder: A Social Revaluation." *Art Quarterly* 9 (Summer, 1946): 213–33.

"The Bard Beats Hanover." *New York Times*, May 16, 1888.

Barker, Virgil. "Albert Pinkham Ryder." *Creative Art* 5 (December, 1929): 838–42.

Beck, Walter de S. "Albert Pinkham Ryder: An Appreciation." *International Studio* 70 (April, 1920): xxxvii–xlvi.

Boime, Albert. "Newman, Ryder, Couture and Hero-Worship in Art History." *American Art Journal* 3 (Fall, 1971): 5–22.

Braddock, Richard. "The Literary World of Albert Pinkham Ryder." *Gazette des beaux-arts* 6th ser., 33 (January, 1948): 47–54.

Britton, James. "The Late A. P. Ryder Great Colorist A Friend of Gedney Bunce." Hartford (Conn.) *Times*, April 2, 1917.

Brown, Gaye L. "Albert Pinkham Ryder's *Joan of Arc*: The Damsel in Distress." *Worcester Art Museum Journal* 3 (1979–80): 37–51.

Brownell, William C. "The Younger Painters of America, First Paper." *Scribner's Monthly* 20 (May, 1880): 1–15.

Brumbaugh, Thomas B. "Albert Pinkham Ryder to John Gellatly: A Correspondence." *Gazette des beaux-arts* 6th ser., 80 (December, 1972): 361–70.

———. "The Gellatly Legacy." *Art News* 67 (September, 1968): 48–51, 58–60.

B[urroughs], B[ryson]. "Recent Acquisitions, Two Pictures by Ryder." *Bulletin of the Metropolitan Museum of Art* 4 (May, 1909): 88–89, 92.

Burroughs, Bryson. "Albert Pinkham Ryder." *Arts* 16 (May, 1930): 638.

———. "Moonlight—Marine. A Painting by Albert P. Ryder." *Bulletin of the Metropolitan Museum of Art* 29 (June, 1934): 105–6.

———. "Recent Purchases out of the Hearn Fund." *Bulletin of the Metropolitan Museum of Art* 10 (April, 1915): 81, 85.

Caffin, Charles. "International Stirs the Public." New York *North American*, March 10, 1913.

Cary, Elizabeth Luther. "Degas and Ryder Seen as Two Contrasting Types of Science and Mysticism." New York *Evening Post*, January 25, 1919.

Chamberlin, Joseph Edgar. "Ultra Moderns in a Live Art Exhibition at 69th's Armory." New York *Evening Mail*, February 17, 1913.

Cheney, David M. "New Bedford's Painter of Dreams." New Bedford *Sunday Standard*, June 10, 1917.

"Cleveland Buys Ryder's *Race Track*." *Art News* 26 (January 28, 1928): 1, 6.

Coates, Robert M. "The Art Galleries," *New Yorker* 23 (November 1, 1947): 80, 82–83.

Cook, Clarence. "Fine Arts: Society of American Artists." *New York Tribune*, April 11, 1880.

Cortissoz, Royal. "The Visions of a Man of Genius." *New York Tribune*, March 10, 1918.

Craven, Thomas. "An American Master: Albert Pinkham Ryder." *American Mercury* 12 (December, 1929): 490–97.

"The Critic" [Alfred Trumble?]. "Albert P. Ryder." *Art Collector* 9 (December 1, 1898): 37.

"Culture and Progress." *Scribner's Monthly* 18 (June, 1879): 312.

"Culture and Progress." *Scribner's Monthly* 20 (May, 1880): 314.

Daingerfield, Elliott. "Albert Pinkham Ryder, Artist and Dreamer." *Scribner's Magazine* 63 (March, 1918): 380–84.

"Daniel Cottier" (obituary). *New York Times*, April 8, 1891.

De Kay, Charles. "An American Gallery." *Magazine of Art* 9 (1886): 245–49.

———. "Lessons of the Comparative Art Exhibition." *New York Times*, November 20, 1904.

———. "Schools of Painting in America." In *Schools of Painting*, by Mary Innes, pp. 351–92. New York and London, 1911.

[De Kay, Charles.] "Pictures at the Academy." *New York Times*, March 31, 1883.

Dorra, Henri. "Ryder and Romantic Painting." *Art in America* 48 (1960): 23–33.

Downes, William Howe, and Robinson, Frank Torrey. "Later American Masters." *New England Magazine* 14 (April, 1896): 131–51.

"Dr. Sanden Electric Belt" (advertisement). *New York Tribune*, November 6, 1898.

Eckford, Henry [Charles de Kay]. "A Modern Colorist: Albert Pinkham Ryder." *Century Magazine* 40 (June, 1890): 250–59.

Eldred, L. D. "When Lovers of Art Gathered at Ellis's," parts 1 and 2. New Bedford *Sunday Standard*, July 24 and July 31, 1921.

Evans, Dorinda. "Albert Pinkham Ryder's Use of Visual Sources." *Winterthur Portfolio* 21 (Spring, 1986): 21–40.

Evergood, Philip. "The Master's Favorite Disciple." In Kendall Taylor, "Ryder Remembered." *Archives of American Art Journal* 24 (1984): 5–8.

"Exhibition of the Art Club." *New York Times*, February 13, 1883.

"Ferargil Galleries Acquire Famous Sanden Group of Ryders." *Art News* 22 (February 9, 1924): 5.

Fitzpatrick, Charles. "Albert Pinkham Ryder." In Kendall Taylor, "Ryder Remembered." *Archives of American Art Journal* 24 (1984): 8–16.

"Form and Moonlight: The Art of Albert Pinkham Ryder." *MD Magazine*, June, 1981, pp. 120–25.

French, Joseph Lewis. "A Painter of Dreams." *Broadway Magazine* 14 (September, 1905): 3–9.

Fry, Roger E. "The Art of Albert P. Ryder." *Burlington Magazine* 13 (April, 1908): 63–64.

"The Gallery: The National Academy of Design." *Art Amateur* 18 (May, 1888): 132.

"Genius in Hiding." Chicago *Times-Herald* [?], [date?]. (Offprint or tearsheet designated, in print, "[From the Times-Herald, Chicago, March 24, '69]," ELC, RA. Internal evidence suggests that the article was written in the mid-1890s. A search of the newspaper's archives, however, has revealed neither the article nor its date.)

Gerdts, William H. "The Square Format and Proto-Modernism in American Painting." *Arts* 50 (June, 1976): 70–75.

Goodrich, Lloyd. "New Light on the Mystery of Ryder's Background." *Art News* 60 (April, 1961), 39–41, 51.

———. "Realism and Romanticism in Homer, Eakins, and Ryder." *Art Quarterly* 12 (1949): 17–28.

———. "Ryder Rediscovered." *Art in America* 56 (November–December, 1968): 32–45.

Goossen, E. C. " 'Student of the Night': Albert Pinkham Ryder." *Vogue*, August 15, 1970, pp. 94–97, 138.

Hartley, Marsden. "Albert P. Ryder." *Seven Arts* 2 (May, 1917): 93–96.

———. "Albert Pinkham Ryder." In *The New Caravan*, edited by Alfred Kreymborg, Lewis Mumford, and Paul Rosenfeld, pp. 540–51. New York, 1936.

Hartmann, Sadakichi. "Albert Pinkham Ryder." *Magazine of Art* 31 (September, 1938): 500–03, 550–51.

———. "Eremites of the Brush." *American Mercury* 11 (June, 1927): 192–96.

———. "A Visit to A. P. Ryder!" *Art News* 1 (March, 1897): 1–3.

Hitchcock, Ripley. "Spring Exhibition, National Academy." *Art Review* 1 (April, 1887): 3.

Homer, William I. "Albert Pinkham Ryder: *The Barnyard*." In *Masterworks of American Art from the Munson-Williams-Proctor Institute*, p. 77. New York, 1989.

———. "*The Flying Dutchman*, a Drawing by Albert Pinkham Ryder." *Porticus* 9 (1986): 10–15.

———. "A Group of Paintings and Drawings by Ryder." *Record of the Art Museum, Princeton University* 18 (1959): 17–33.

———. "Observations on Ryder Forgeries." *American Art Journal* 20 (1988): 35–52.

———. "Ryder in Washington." *Burlington Magazine* 103 (June, 1961): 280–83.

Howe and Torrey [William Howe Downes and Frank Torrey Robinson]. "Some Living American Painters." *Art Interchange* 34 (May, 1895): 132–33.

[Huneker, James Gibbons.] "Seen in the World of Art: A Painter of Genius in New York, but Known to Few." New York *Sun*, June 26, 1910.

Hyde, William H. "Ryder as I Knew Him." *Arts* 16 (May, 1930): 597–98.

"In Marshall's Studio." *New York Daily Tribune* (illustrated supplement), June 3, 1906.

Jewell, Edward Alden. "Ryder Paintings Put on Exhibition... Several Fine Marines." *New York Times*, October 18, 1935.

Johns, Elizabeth. "Albert Pinkham Ryder: Some Thoughts on His Subject Matter." *Arts* 54 (November, 1979): 164–71.

———. "Arthur B. Davies and Albert Pinkham Ryder: The 'Fix' of the Art Historian." *Arts* 56 (January, 1982): 70–74.

Judson, Jeanne. "A Recluse for the Sake of His Art Was the Late Albert P. Ryder." New York *Sun*, April 29, 1917.

Katz, Leslie. "The Emblems of A. P. Ryder." *Arts Magazine* 35 (September, 1961): 50–55.

Kobbe, Gustave. "Honor for Albert P. Ryder," New York *Herald*, February 24, 1918.

Kuspit, Donald. "Ryder's Expressiveness." *Jahrbuch für Amerikastudien* 8 (1983): 219–25.

L[ouchheim], A[line] B. "Ryder Seen by Marsden Hartley, Walt Kuhn, Yasuo Kuniyoshi, Reginald Marsh, Kenneth Hayes Miller." *Art News* 46 (November, 1947): 28–31.

Lane, James W. "Newman Emerson Montross." *Creative Art* 12 (January, 1933): 31–34.

———. "A View of Two Naive Romantics." *Art News* 38 (November 11, 1939): 9, 16.

"Leonard B. Ellis Dead" (obituary). New Bedford *Evening Standard*, March 13, 1895.

"Leonard B. Ellis's Fine Art Rooms." New Bedford *Evening Standard*, January 5, 1907.

M[illiken], W[illiam] M. *The Race Track* or *Death on a Pale Horse* by Albert Pinkham Ryder." *Bulletin of the Cleveland Museum of Art* 15th Year (March, 1928): 65–71.

McBride, Henry. "The Death of Albert P. Ryder." *Fine Arts Journal* (Chicago) 35 (May, 1917), 368–69.

———. [Untitled obituary news article.] New York *Sun* April 1, 1917.

Mather, Frank Jewett. "Albert Pinkham Ryder's Beginnings." *Art in America* 9 (April, 1921): 119–27.

———. "The Romantic Spirit in American Art." *Nation* 104 (April 12, 1917): 427.

"Most Imaginative Painter This Country Has Yet Produced." *Current Opinion* 62 (May, 1917): 350–51.

"Mr. A. P. Ryder, Artist, Dies at 70." New York *Herald*, March 29, 1917.

"Mr. Ryder's Pictures." Boston *Evening Transcript*, April 25, 1918.

Mumford, Lewis. "The Brown Decades: Art." *Scribner's Magazine* 90 (October, 1931): 361–72.

———. "A Synopsis of Ryder." *New Yorker* 11 (November 2, 1935): 69.

"The National Academy Exhibition: Second Notice." *Art Amateur* 3 (June, 1880): 2.

"New Bedford-Born Painter Subject of Interesting Paper." New Bedford *Sunday Standard-Times*, September 21, 1944.

"New Paintings by Americans." *New York Times*, March 21, 1882.

"A Notable Exception." *Fine Arts Journal* (Chicago) 36 (September, 1918): 48.

"The Office Window: A Hermit Painter and His Followers." New York *Evening Mail*, February 4, 1915.

"Our Veritable Old Masters." *Literary Digest* 105 (June 7, 1930): 19–20.

Pach, Walter. "On Albert P. Ryder." *Scribner's Magazine* 49 (January, 1911): 125–28.

Phillips, Duncan. "Albert Ryder." *American Magazine of Art* 7 (August, 1916): 387–91.

Pincus-Witten, Robert. "On Target: Symbolist Roots of American Abstraction." *Arts* 50 (April, 1976): 84.

"A Poet's Painter." *Literary Digest* 54 (April 21, 1917): 1164–66.

Price, F. Newlin. "Albert Pinkham Ryder." *International Studio* 81 (July, 1925): 282–88.

R., Q. "The Solitary in Art." *Christian Science Monitor*, April 1, 1918.

Read, Helen Appleton. "Memorial of Albert Ryder: Canvases of Decoration." *Brooklyn Eagle*, March 24, 1918.

"Recollections of the Old Ellis Shop." New Bedford *Sunday Standard*, October 15, 1911.

[Review of National Academy of Design exhibition.] New York *World*, April 15, 1873.

Robinson, John. "Personal Reminiscences of Albert Pinkham Ryder." *Art in America* 13 (June, 1925): 176–87.

Rosenfeld, Paul. "American Painting." *Dial* 71 (December, 1921): 649–55.

"R. W. Gilder's Widow Dies" (obituary). *New York Times*, May 29, 1916.

Ryder, Albert P. "Paragraphs from the Studio of a Recluse." *Broadway Magazine* 14 (September, 1905): 10–11.

"Ryder and Clever Painting." New York *Post*, April 9, 1918.

"Ryder Exhibition at Metropolitan Museum." *New York Times Magazine*, March 10, 1918.

"Ryder, New Bedford Artist, Described as 'Pioneer Poet.' " New Bedford *Sunday Standard Times*, June 29, 1947.

Sargent, Winthrop. "Nocturnal Genius." *Life*, February 26, 1951, pp. 87–96, 101–2.

Schnakenberg, H. E. "Albert P. Ryder." *Arts* 6 (November, 1924): 271–75.

Sherman, Frederic Fairchild. "Albert P. Ryder's Jonah." *Art in America* 8 (February, 1920): 81–82.

———. "Albert P. Ryder's Poetic Fancies." *Art in America* 15 (December, 1926): 40–44.

———. "An Albert Pinkham Ryder Exhibition." *Art in America* 24 (January, 1936): 44.

———. "Four Paintings by Albert Pinkham Ryder." *Art in America* 9 (October, 1921): 260–68.

———. "The Marines of Albert P. Ryder." *Art in America* 8 (December, 1919): 28–32.

———. "Notes on the Art of Albert P. Ryder." *Art in America* 25 (October, 1937): 167–73.

———. "Paintings Erroneously Attributed to Albert Pinkham Ryder." *Art in America* 25 (April, 1937): 87–89.

———. "Some Likenesses of Albert Pinkham Ryder." *Art in America* 26 (January, 1938): 32–35.

———. "Some Paintings by Alfred Pinckham [*sic*] Ryder." *Art in America* 5 (April, 1917): 155–62.

———. "Some Paintings Erroneously Attributed to Albert Pinkham Ryder." *Art in America* 24 (October, 1936): 160–61.

———. "Sunset at Sea Painted by Albert Pinkham Ryder." *Art in America* 25 (July, 1937): 126–27.

———. "Two Marines by Albert P. Ryder." *Art in America* 12 (October, 1924): 296–300.

———. "Two Unpublished Paintings by Albert Pinkham Ryder." *Art in America* 14 (December, 1925): 23–25.

———. "Unpublished Paintings by Albert Pinkham Ryder." *Art in America* 8 (April, 1920): 129–37.

"The Spring Academy." *New York Times*, March 31, 1888.

Stein, Leo. "Albert Ryder." *New Republic* 14 (April 27, 1918): 385–86.

"Studio Notes." *Studio* 1 (April 14, 1883): 139.

T., J. M. "The American Artists Exhibition." *Art Amateur* 11 (1884): 30.

"Table-Talk." *Appleton's* 5 (January 14, 1871): 55.

Taylor, Robert. "Robert Vose, 82, is Dean of Boston's Art Dealers." *Boston Sunday Herald*, July 31, 1955.

"Tribute to Memory of Albert Pinkham Ryder." New Bedford *Morning Mercury*, May 29, 1917.

Truettner, William H. "William T. Evans, Collector of American Paintings." *American Art Journal* 3 (Fall, 1971): 50–79.

"The Twelfth Annual Exhibition of Selected Paintings by American Artists at the Albright Art Gallery." *Academy Notes* (Buffalo Fine Arts Academy, Albright Art Gallery), July–September, 1918, pp. 75–76.

[Untitled review of Ryder memorial exhibition.] New Bedford *Mercury*, March 13, 1918.

Van Rensselaer, M[ariana] G[riswold]. "The Society of American Artists, New York.—I." *American Architect and Building News* 11 (May 13, 1882): 219.

W[eir], R[aymond]. "Paintings by Albert P. Ryder and Odilon Redon." *Bulletin of the Worcester Art Museum* 10 (October, 1919): 46–49.

Watson, Forbes. "The Innocent Bystander." *American Magazine of Art* 28 (February, 1936): 112–18, 122–23.

———. [Untitled obituary news article.] New York *Evening Post*, March 31, 1917.

Weinberg, H. Barbara. "Thomas B. Clarke: Foremost Patron of American Art from 1872 to 1899." *American Art Journal* 8 (May, 1976): 52–83.

Weller, Allen. "An Unpublished Letter by Albert P. Ryder." *Art in America* 27 (April, 1939): 101–2.

"W. E. Marshall Dead" (obituary). *New York Daily Tribune*, August 30, 1906.

"William Davis Ryder" (obituary). *New York Times*, March 11, 1898.

"William E. Marshall, the Engraver." New York *Nutshell* 3 (April–June, 1917): 2.

"William E. Marshall Dead" (obituary). *New York Times*, August 30, 1906.

"William Marshall Exhibition." *New York Times*, November 25, 1883.

Unpublished material

Anderson, Nancy Kay. "Albert Bierstadt: The Path to California." Ph.D. dissertation, University of Delaware, 1985.

Bienenstock, Jennifer A. Martin. "The Formation and Early Years of The Society of American Artists." Ph.D. dissertation, City University of New York, 1983.

Braddock, Richard. "The Poems of Albert Pinkham Ryder Studied in Relation to His Person and His Paintings." Master's thesis, Columbia University, 1947.

Cotter, Maurice J., et al. "A Study of the Material and Techniques Used by Some Nineteenth Century American Oil Painters by Means of Neutron Activation Autoradiography," preliminary report, n.p., n.d. [1972].

Fitzpatrick, Martha Ann. "Richard Watson Gilder: Genteel Reformer." Ph.D. dissertation, Catholic University of America, 1965.

Gurney, George. "Olin Levi Warner (1844–1896): A Catalogue Raisonné of His Sculpture and Graphic Works." Ph.D. dissertation, University of Delaware, 1978.

Hartmann, Sadakichi. "The Story of an American Painter." 1926. Typescript. Library, Metropolitan Museum of Art, New York City.

Hobbs, Susan. "John La Farge and the Genteel Tradition in American Art, 1875–1910." Ph.D. dissertation, Cornell University, 1974.

Hobler, Margaret H. "In Search of Daniel Cottier, Artistic Entrepreneur, 1838–1891." Master's thesis, Hunter College, 1987.

Homer, William I. "Marsden Hartley, Albert Pinkham Ryder, and the Mystical Tradition." Paper delivered at the Seventy-fourth Annual Meeting of the College Art Association of America, New York, February 13, 1986.

———. "Will the Real Mr. Ryder Please Stand Up?" Paper delivered at the Seventy-sixth Annual Meeting of the College Art Association of America, Houston, Texas, February 11, 1988.

Johnson, Diane Chalmers. "Art, Nature, and Imagination in the Paintings of Albert Pinkham Ryder: Visual Sources." Paper delivered at the Seventy-second Annual Meeting of the College Art Association of America, Toronto, February 23, 1984.

Kingsley, Elbridge. "Autobiography." Undated typescript. Forbes Library, Northampton, Mass.

Myers, Mary Elizabeth Kennerly. "Sadakichi Hartmann's Albert Pinkham Ryder: The Story of an American Painter, to Those Who Occasionally Bother about Esthetic Functions." Master's thesis, Vanderbilt University, 1974.

Biographical Dictionaries

Appleton's Cyclopaedia of American Biography. 1888 ed. S.v. "Ryder, Albert Pinkham."

Dictionary of American Biography. 1935 ed. S.v. "Ryder, Albert Pinkham."

Earle, Helen L., comp. *Biographical Sketches of American Artists.* Lansing, Mich., 1916. S.v. "Ryder, Albert Pinkham."

The Index of Twentieth Century Artists 1 (February, 1934). S.v. "Ryder, Albert Pynkham [sic]."

Koehler, S. R., comp. *The United States Art Directory and Year Book.* 2 vols. New York, 1882–84. Rpt., New York, 1976. S.v. "Artists' Directory."

Morgan, Henry James, ed. *Canadian Men and Women of the Time.* Toronto, 1912.

National Cyclopaedia of American Biography 10 (1900). S.v. "Albert Pinkham Ryder—Painter."

Opitz, Glenn B., ed. *Mantle Fielding's Dictionary of American Painters, Sculptors & Engravers.* Rev. ed. Poughkeepsie, N.Y., 1986. S.v. "Ryder, Albert P."

Who's Who in America 9 (1916–17). S.v. "Ryder, Albert Pinkham."

Manuscript Collections

Armory Show Papers. AAA.

Bryson Burroughs Correspondence (concerning Ryder memorial exhibition, 1918). Archives, The Metropolitan Museum of Art, New York City.

Thomas B. Clarke Papers. AAA.

Thomas Casilaer Cole Papers. AAA.

Philip Evergood Papers. Private collection.

Ferargil Galleries (New York City) Papers. AAA.

Richard Watson Gilder Papers. New York Public Library, New York City.

Richard Watson and Helena de Kay Gilder Papers. Private collection.

Lloyd Goodrich–Albert P. Ryder Archive. University of Delaware Library, University of Delaware, Newark.

Marsden Hartley Papers. Beinecke Rare Book and Manuscript Library, Yale University, New Haven, Conn.

Sheldon Keck Conservation Records. The Brooklyn Museum, Brooklyn, N.Y.

Elbridge Kingsley Papers. Forbes Library, Northampton, Mass.

Macbeth Gallery (New York City) Papers. AAA.

Kenneth Hayes Miller Papers. AAA.

National Academy of Design, New York City. Register of Members of the Life School; Register of Students of the Antique School.

Dr. John Pickard Papers. AAA.

Frederic Newlin Price Papers. AAA.

Cornelia (Quinton) Sage Correspondence. Albright-Knox Art Gallery, Buffalo, N.Y.

Frederic Fairchild Sherman Papers. AAA.

Vose Galleries of Boston (Mass). Archives.

Olin L. Warner Papers. AAA.

J. Alden Weir Papers. Harold B. Lee Library, Brigham Young University, Provo, Utah.

Charles Erskine Scott Wood Collection. Huntington Library, San Marino, Calif.

Public Documents

New Bedford City Documents, 1846–73. New Bedford (Mass.) Public Library.

Rural Cemetery, New Bedford, Mass. Burial records, Ryder family.

INDEX

PHOTOGRAPH CREDITS